Piero della Francesca

PHAIDON

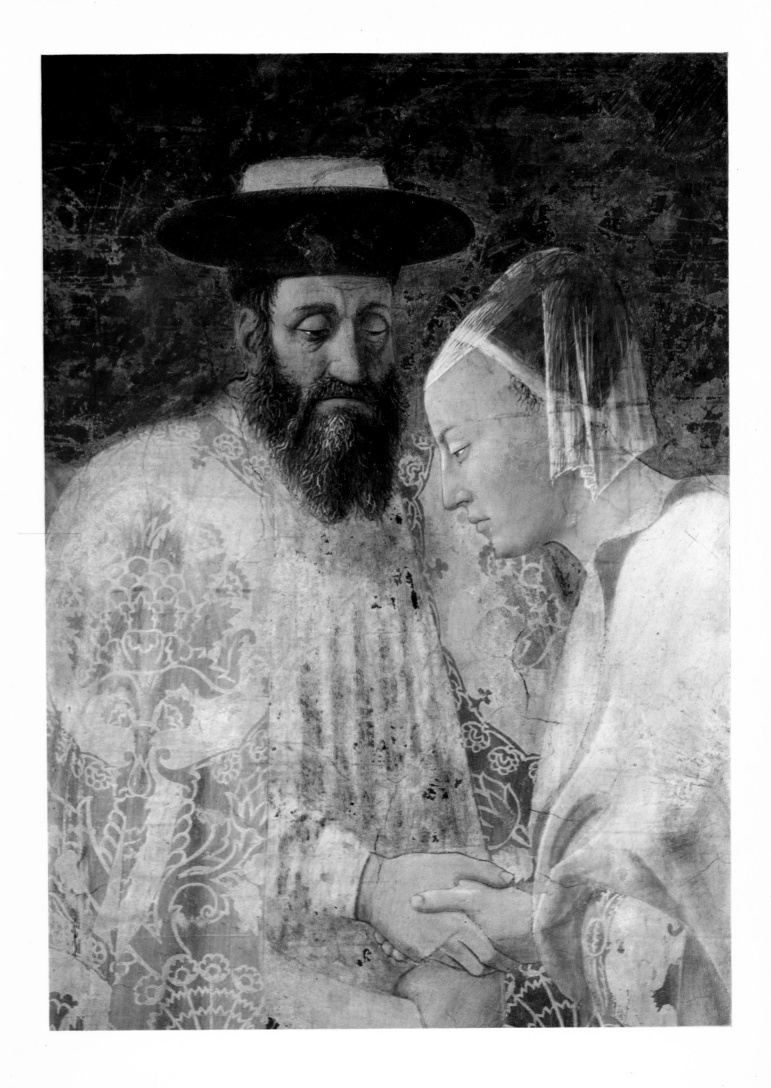

KENNETH CLARK

Piero della Francesca

COMPLETE EDITION

PHAIDON *London & New York*

© 1969 Phaidon Press Ltd · 5 Cromwell Place · London S.W.7
First published 1951
Second Edition, revised, 1969

Phaidon Publishers Inc. New York
Distributors in the United States : Frederick A. Praeger Inc.
111 Fourth Avenue, New York, 10003

Library of Congress Catalog Card Number : 69–19805

S B N 7148 1380 X
Printed by Hunt Barnard & Co. Ltd · Aylesbury · Bucks
Made in Great Britain

Contents

to Henry Moore

Preface

Preface to the first edition

The text which follows is not intended to be a full, critical biography of Piero della Francesca but a guide to the appreciation of his work. For this reason it does not examine in detail questions of connoisseurship. No attempt has been made to enumerate Piero's pupils or to estimate his influence: to have done so would have been to overweight the book.

Among many whom I would like to thank for their help are the Earl of Crawford and Balcarres, who, from his great knowledge of Renaissance art, has given advice and encouragement at every stage of the book, Dr. Margaret Whinney, who has kindly read the proofs, and Miss Nicky Mariano, who has answered some difficult questions. As usual, I am indebted to the Warburg Institute for patiently examining the problems I have put to them.

Both author and publisher must express their thanks to Cav. Cipriani for the admirable photographs which he took especially for this book, and which must commend it to amateurs, whatever its other defects.

Kenneth Clark, 1951

Preface to the second edition

This book has been out of print for some sixteen years. During this time a number of books and articles on Piero della Francesca have appeared, including a new edition of Professor Longhi's classic and an exhaustive compendium by Oreste del Buono and Pier Luigi de' Vecchi, *L'Opera completa di Piero della Francesca*. These have naturally involved some additions and corrections to my text; but I have altered it as little as possible. The most troublesome section is that which deals with the Brera altarpiece. This mysterious work has become an art-historian's gymnasium and to have mentioned only a part of what has been published about it during the last fifteen years would have been to overload the end of my work. In spite of so much ingenuity, the position is still uncertain and my conclusions are tentative. The last twenty years of Piero's life still seem to me completely baffling.

During the same period practically all Piero's pictures have been cleaned, and thus many of the plates in this edition have been done from new photographs. An exception is the Arezzo frescoes. These have been drastically restored on the new Italian principle by which damaged portions are filled in with neutral colour and areas of well-preserved paint are left in isolation. By a curious paradox this 'formalist' approach has become fashionable at a period when historians are paying more attention to subject-matter and iconography. In the case of Piero's frescoes, the well-preserved patches have gained considerably from cleaning, but the dramatic quality of such a scene as the Victory of Constantine has been lost. I have therefore reproduced a number of the old photographs taken specially for this book, but have included some new photographs and details of the cleaned frescoes.

Piero della Francesca

QUIETLY, inexorably, almost unobserved, Piero della Francesca has taken his place as one of the greatest artists of the fifteenth century, and thus one of the greatest artists who have ever lived. Few of our bewildering revolutions of taste would have been more incomprehensible to the aesthetes of the nineteenth century. They could have explained and deplored the frenzied and fitful character of modern painting, its lack of settled conviction and need for stronger stimuli. But our discovery of the calm, majestic art of Piero della Francesca would have left them astonished and slightly jealous. Because the quattrocento was *their* discovery. It was Ruskin, Pater, the Pre-Raphaelites, and the amateurs whom they inspired, who first recognized the beauties of Botticelli, Fra Filippo, Bellini, Carpaccio, Mantegna and a dozen others. Fra Angelico and Perugino had been discovered a generation earlier. Masaccio was an august and slightly disturbing name. Ghirlandajo represented the academism of the movement, and became the hero of the text-books. But Piero della Francesca was almost entirely omitted. The only reference to him in the thirty-nine volumes of Ruskin's works is trifling and accidental.[1] Crowe and Cavalcaselle, who were perhaps the first to recognize his greatness and, in their stilted language, give a remarkably just estimate of his art, are clearly astonished to find themselves comparing him, at some points, with Ghirlandajo. If we ask what the English aesthetes of the nineteenth century were looking for in quattrocento art, the answer must be found in the work of their own painters, in Burne-Jones, for example. We see that they breathed the last gentle exhalations of the Romantic movement, and they looked above all for grace, for the expression of wistful sentiment, or for a certain charming naïvety, as of Carpaccio's St. Ursula, or Ghirlandajo's dying Santa Fina; and, on the technical side, they looked for decorative detail, for the brocades and peacocks of Pintoricchio or the arabesques of Botticelli. Piero gave them none of these things. He is not a romantic. His faces, though they sometimes suggest great depths, are devoid of sentiment. He thinks in mass rather than in line, is sparing of detail, and seldom indulges in rich texture for its own sake. Still less is he naïve. Although deeply conscious of the prime factors in life and art, he is far from being primitive. He is, in the full, critical sense of the word, a classic artist, and to a large extent his rediscovery was part of a new classicism, of which Cézanne and Seurat were the living manifestations. It is not surprising that the admirers of Cézanne took a different view of quattrocento art from the admirers of Burne-Jones. They were looking not for fantasy, but for order; not for grace, but for solidity. The word 'blocks', applied to Piero's figures as a term of reproach by Crowe and Cavalcaselle, became a term of praise in the new concept of pictorial architecture. In particular Piero's application of geometry, not only to the whole compositions but to individual figures, was in harmony with the

spirit which was later to find expression in Cubism and its derivatives. This was the period in which our whole notion of 'the primitive' was transformed. It ceased to be quaint and became heroic. Chinese art no longer meant a porcelain bowl of the Manchu dynasty, but a stone carving of Wei or T'ang. The sculptures of twelfth-century France and archaic Greece were seen to come from the same source of inspiration as those of the most remote and exotic peoples. And on this new Olympus Piero took his place, not, as before, amongst those who prepared the way, but as a master of the highest achievement. In this position he will remain, even when the tide of taste which carried him there has withdrawn.

Piero was born between the years 1410 and 1420, in the little town of Borgo San Sepolcro.[2] His father, Benedetto dei Franceschi, was a shoemaker; his mother was called Romana di Perino da Monterchi. We know nothing whatever about his family and need spend no time in speculating about his inheritance and early upbringing. Borgo San Sepolcro, on the other hand, presents today very much the same aspect as it did in Piero's time, and everyone who has visited it has felt its affinity with his work. It lies in a flat, fertile valley formed by the upper waters of the Tiber. On one side, close beside it are steep hills, and the mountain road which leads to Urbino; on the other, the road runs straight as a die across the valley to Anghiari and to the hills which separate the Tiber from the Arno. Just as Vézelay seems to lie at the heart of France, so Borgo lies at the heart of Italy. It is what we in England would call a small market town, about the size of Blandford or Thame, the sort of town in which a man may know every inhabitant, and almost every stone. And it combines, as ancient centres of a settled way of life so often do, intimacy with grandeur. It is compact, solid, proportionate, and at its centre, made the more luminous by contrast with the narrow streets, is a white, open piazza, with a cathedral and civic offices, their arcades and pilasters rising from the slightly irregular surface of the ground as unselfconsciously as the buttresses of a barn. This piazza was the centre of Piero's earthly life. When still quite young he was elected a city councillor: his first important commission was for the cathedral, his greatest single painting is in the town hall opposite. At every epoch of his career, whether working for the Dukes of Ferrara or Urbino, or for the Pope himself, he would return home to discharge local business and execute commissions for local bodies. For the last fifteen years of his life he never left Borgo San Sepolcro, where he was recognized as the great man of the town, and where, in fact, his fame continued until overtaken by the present fashion for his work.

When Piero was a boy Borgo looked, for its painting, to Siena. In the nearest big town, Arezzo, there was a masterpiece by Pietro Lorenzetti. So from the first Piero must have thought of colour as an essential factor of the art, not merely, as the tradition of Giotto maintained, an adjunct to form. But Sienese art alone, graceful, sensuous and empirical, could not satisfy him, and it is not surprising that the first document to mention him tells us that he is in Florence. It is dated 7 September 1439, and records payments from the hospital of Santa Maria Nuova to Domenico Veneziano for frescoes in the choir of S. Egidio, to which is added in the margin the precious information *Pietro di Benedetto dal Borgho a San Sepolchro sta collui*—'is with him'. This is usually taken as proving that Piero was Domenico's pupil, but the assumption rests on two

inferences which are not conclusive: first, that the words *sta con lui* imply the relationship of master and apprentice; and secondly, that some of Domenico's surviving works, which resemble those of Piero, can be dated before 1440, or at least reflect the style he was practising then. It is true that the words *sta con lui* are sometimes used in this sense,[3] but in 1439 Piero was perhaps as much as twenty-seven years old, an age when apprenticeship was usually over, and the words are open to the more general interpretation of residence or association. It is also true that Domenico's earliest surviving works (*Figure* 2), which seem to date from soon after 1440, show in an accomplished form qualities which we find in Piero. The Madonna of the Carnesecchi in the National Gallery (*Figure* 3) still reveals in the pose, the carriage of the head, and even in the marble inlays, elements with which we become familiar in Piero's mature paintings. The Santa Lucia altar-piece in the Uffizi has his feeling for atmosphere, his blonde tonality and his way of modelling by reflected light. But by the time these pictures were painted Piero was back in Borgo, and engaged on a work which shows him in complete possession of his own style. Such characteristics as he seems to owe to Domenico both may have derived, at an earlier date, from a common source.[4]

In 1438, Domenico Veneziano, who was in Umbria, wrote a letter to Cosimo de' Medici asking for employment. In his letter he mentions as the leading painters in Florence, whose work he hopes to equal, Fra Angelico and Fra Filippo, thus implying that he was already familiar with the artistic life of Florence. Was Piero with him then, or had he been with him on a previous visit, as would be the case if he were really Domenico's pupil? Or did Domenico find him in Florence, and engage him there as an assistant of known ability? Our brief document gives us no clue to any of these problems. But there are reasons against assuming (as is sometimes done) that Piero paid his first visit to Florence in 1439. His mastery of the Florentine tradition of form and

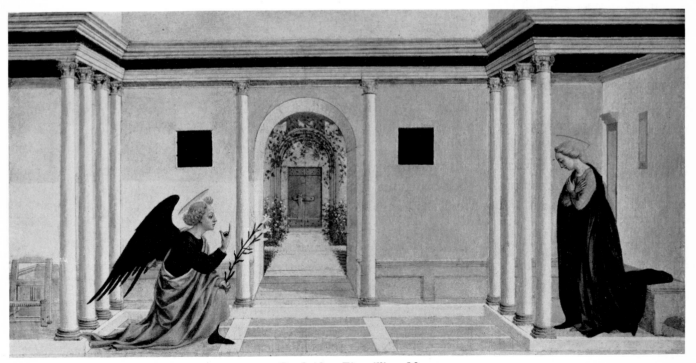

1. Domenico Veneziano: THE ANNUNCIATION. *Cambridge, Fitzwilliam Museum*

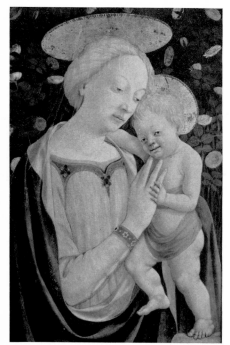

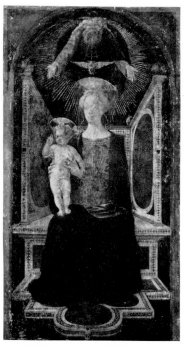

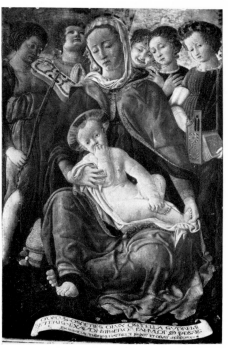

2. Domenico Veneziano:
VIRGIN AND CHILD.
Washington, National Gallery of Art

3. Domenico Veneziano:
MADONNA AND CHILD.
London, National Gallery

4. Domenico di Bartolo:
MADONNA OF HUMILITY.
Siena, Gallery

pictorial science could hardly have been acquired at the age of twenty-seven, when his style would have already been formed. Moreover, his knowledge of mathematics and geometry, which could have been gained only in Florence, seems to imply that he passed many years there before returning to his native town. It therefore seems probable (and we have nothing better to offer than possibilities) that Piero went to Florence soon after ending his apprenticeship to a local painter,[5] that is to say in about 1435. We must therefore try to answer the question, how would a young provincial, magnificently endowed both in brain and eye, but otherwise entirely obscure, have responded to the arts in Florence between the years 1435 and 1440?

He would, to begin with, have looked for work which resembled that of his own master and other local heroes: and he would have found plenty of it. The greater part of the painting being done in Florence at that date was bright, linear and Gothic. But this Gothicism was of two kinds, the wiry, angular Tuscan of the Biccis, and the flowing, northern Gothicism to which Gentile da Fabriano's visit of 1423 had given so much impetus. The first must always have been antipathetic to Piero; but in the second he found one quality which delighted him, and which was to influence him all his life — lightness and delicacy of modelling. To have combined this blonde atmospheric tone in heads and hands with the rich embroidery of draperies and the tapestry-like particularization of landscape is the great achievement of this Burgundian style; and like many other attributes of the so-called International Gothic we may trace it back into the fourteenth century. But about 1420 it achieved a new fullness and luminosity. We have only to look at the sweet blonde heads of Gentile da Fabriano's Quaratesi Madonna, and Masolino's frescoes at Castiglione d'Olona (*Figure* 5) and compare them with the angels in Piero's Baptism, to see how much he could have learnt from them even without the intervention of Domenico Veneziano: and Domenico himself was following the same models.

Masolino, if the tangle of his chronology did not preclude all certainty, could be claimed as an important influence. And through Masolino, we can imagine, Piero

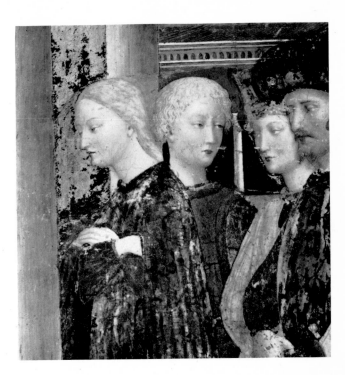

5. Masolino: HEADS. Detail from the frescoes in the Baptistery at *Castiglione d'Olona*

was led to study that small group of Florentine artists whose work must at first have seemed so strange to him, the prophetic masters of the humanist style, Brunellesco, Donatello and Masaccio. To us their work towers gigantically in the foreground, but in 1435 it seemed the experiment of a small group which time might still eclipse. Especially was this true of painting. Donatello and Brunellesco by their public commissions were generally known and accepted. But Masaccio had died at twenty-nine, leaving only two outstanding works, the Sagra and the unfinished cycle in the Carmine, and no painter had dared to follow up his discoveries. Masolino, after the awe-inspiring collaboration of the Carmine, had relapsed into his natural Gothicism (*Figure* 5). Fra Filippo, having attempted the Masacciesque with desperate uncertainty, had recognized that he was gifted for line rather than mass, grace rather than grandeur. Curiously enough the artist who digested with the least discomfort the young revolutionary's pictorial discoveries was the oldest of the group, the painter who more than any other may seem to be 'breathing the last enchantments of the Middle Ages', Beato Angelico (*Figures* 8, 9). Beguiled by the innocence of his colouring, we do not at first sight perceive how firm a grasp of the new science underlies his compositions and his forms. The large saints on the shutters of the Linaiuoli Madonna of 1433 show the influence of Masaccio unmistakably, and if, as there is reason to believe, some small panels date from about five years earlier, then we may say that Beato Angelico had felt with peculiar clarity the living presence of the young genius.[6] But, unlike Masolino, he made Masaccio's science his own, as we can see in the great Coronation of the Virgin in the Louvre.[7] This may have been Piero's first fountain of inspiration, for there he could find calm certainty of form combined with a heavenly brightness of tone, and the intellectual discipline of perspective, subordinate to the divine vision.

But although Piero may have been introduced to Masaccio through those more comprehensible artists who had already undergone his influence, in the end it was the prolonged contemplation of the Carmine frescoes (*Figure* 7) themselves which moulded his style.[8] From them he learnt the majestic tempo, the grave gestures, the vision of an ennobled humanity, which characterize all his work. And on the technical

side he learnt the architecture of drapery and the grouping of figures in space. Drapery, in all the greatest schools of design, has been a principal means of denoting that foregone conclusion which we call a sense of form. We have only to think of Greek, Chinese, Romanesque and all phases of Gothic art, to realize that although logically trivial it is formally paramount. The reason lies in its ambivalent relation to fact. Up to a point, drapery may follow the laws which govern its appearance, the character of woven material, the pull of gravity and the structure which it covers. But beyond this point it can be treated with far greater freedom than the other elements of a picture, and so can become the untrammelled expression of the form will. It can curl, it can swirl, it can billow, it can melt; or it can resist the eye with a structure of humps and hollows as durable as a rock modelled by the waves. Masaccio, basing himself on Giotto, created that grand architectural drapery (*Figures* 6, 7, 11) which became to the high Renaissance an instrument of harmonious certainty only less important than the nude. It is designed to emphasize the solid reality of his figures, and to this end he elaborates the scheme of an enveloping sheath, which encloses and reveals a central core. Piero's principles of decoration led him to use, in his groups, a flatter and more geometric scheme of drapery; but in single figures, such as the Magdalen in Arezzo Cathedral (*Plate* 109), he continued Masaccio's use of a simple columnar tunic, contained and given greater plastic force by an enveloping cloak.

With the second lesson learnt in the Carmine, the grouping of figures in space, we reach the subject of perspective; and this is of such central importance in the study of Piero that its full treatment must be postponed till it can be illustrated by his own work. The desire to represent solid bodies in correct naturalistic relation to one another

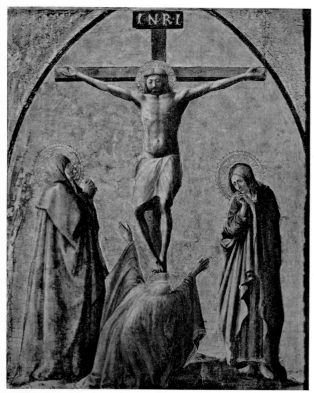

6. Masaccio: THE CRUCIFIXION.
Naples, National Museum

7. Masaccio: ST. PETER. Detail from the frescoes in the Brancacci Chapel. *Florence, Santa Maria del Carmine*

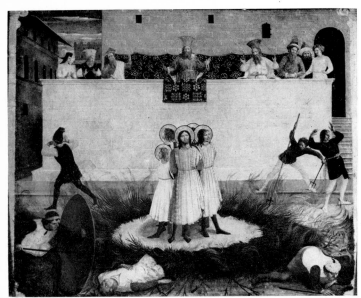

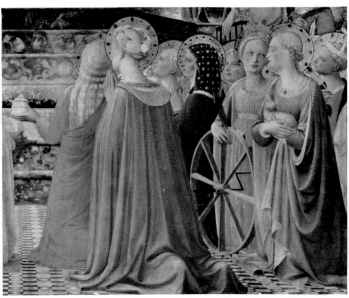

8. Beato Angelico: AN ATTEMPT TO BURN SS. COSMOS
AND DAMIAN. *Dublin, National Gallery of Ireland*

9. Beato Angelico: GROUP OF SAINTS. Detail from the
CORONATION OF THE VIRGIN. *Paris, Louvre*

appeared in both northern and Italian painting in the ten years between 1415 and
1425; in the north the Van Eycks achieved this aim by empirical means, and in Florence
it was put on to a theoretical, that is to say, mathematical, basis by Brunellesco. Brunel-
lesco was the oldest and the most intellectual of the humanist revolutionaries. It was he,
no doubt, who taught his science of space to Masaccio and Donatello, and persuaded
them of its importance. Masaccio had mastered it before his death in 1427; Donatello
showed his understanding of it in his Siena relief of 1428. By 1435 it had ceased to be
the mystery of a small clique, and had become the common endeavour of all the more
ambitious artists — Ghiberti, Fra Filippo, and even, as we have seen, Fra Angelico.
And in this year it received its earliest written statement in the *Della Pittura* of Leon
Battista Alberti, the first treatise on the theory of painting ever written.

The illegitimate son of a famous Florentine family, Alberti had recently returned to
Florence from an exile passed in Venice and Bologna. Like Piero himself he had been
brought up among the arts of colour, texture and line. The first sight of the formal art
of Florence seemed to him like the recovery of a lost paradise of the intellect; and as
the pupil of famous humanists he identified this lost paradise with antiquity. He had
an aptitude for theoretical exposition and a head for figures. He was active, curious
and magnificently handsome. He immediately gained the friendship of Brunellesco
and Donatello and others of the more advanced artists,[9] and became the expositor of
their ideas. As a painter and sculptor he was no more than a dilettante, and at this date
he had not yet manifested the genius for architecture by which, of his many gifts, he
is best remembered. But he must have been a formidable figure on the fringe of art,
arguing, theorizing, quoting (for he was trained in the law as well as the humanities)
from classical precedent, and somewhat alarming, we may suppose, by his restless
and relentless intellect the more conservative craftsmen of the Florentine workshops.
Whether or not he met the young provincial from Borgo San Sepolcro is not recorded.
Our sense of Piero's character suggests to us that at this time he was content to learn
in obscurity. But that Piero came into contact with the ideas of which Alberti was the
most active spokesman is unquestionable. The mastery of perspective and of the laws
of proportion which appears in his work soon after his return to Borgo shows that
he learnt them from one of those to whom they were a gospel. If Piero had learnt

15

11. Masaccio: ST. PAUL. *Pisa, Museum*

10. Masaccio: MADONNA AND CHILD. *London, National Gallery*

perspective at second hand he might have achieved the receding colonnades of Jacopo Bellini's sketch-book, but he could not have breathed the air of mathematical proportion, as he does in every picture. So we may suppose that between 1435 and 1440 Piero frequented the company of Brunellesco, Alberti and Donatello. And the mathematics he learnt he absorbed partly through the brain and partly through the senses; partly through the teachings of Toscanelli, partly through the vaults and arcades of the Innocenti and the Pazzi Chapel. The *lucida ordo*, the belief in divine proportion, took root in his spirit during these early years, and was to expand there for the rest of his life.

One other event which took place during Piero's residence in Florence may be mentioned, the Council of 1439, in which the Emperor of the East visited Florence in the hopes of securing the unity of Christendom against the Turks. San Sepolcro and Arezzo were bourgeois towns, where men lived plainly and dressed simply. Even in Florence Piero would have moved among craftsmen, scholars and tradesmen, hard-headed men with a taste for argument and practical jokes. But in the processions and assemblies which dignified the Council of Florence he must have been made aware of an opposite way of life. The craftsmen-painters of Florence were in general much delighted by this display of dressing up, as we know from Benozzo Gozzoli's Procession of the Magi. But to Piero, who belonged by nature to the austere, heroic tradition of Masaccio, the sight of the Emperor Paleologus, grave and remote upon his white horse, and of his retinue, encased in the last stiff splendours of the ancient world, must have stirred a part of his imagination which Masaccio's rough-hewn humanity could never have touched. Fifteen years later these memories were to provide the climate of his two greatest frescoes at Arezzo (*Plates* 36, 51).

By 1442 Piero was back in Borgo San Sepolcro, as a document tells us that in this year he was made a councillor of the people. That he achieved this distinction at a

16

comparatively early age may have been due to his Florentine connections, because in the preceding year the Pope had sold Borgo to Florence. An important artistic event had taken place there during his absence. In 1437 the commission for the high altar of the church of San Francesco had been taken away from Antonio d'Anghiari and given to a painter of genius, Sassetta. His subject was the glory of St. Francis, with scenes from his life, and the greater part of his altar-piece still survives (*Figure* 16).[10] In 1442 this masterpiece must have been well on its way towards completion, and we may be permitted to imagine Piero's feelings on seeing it for the first time: his delight in the landscapes, so much truer and more pictorially significant than any he had seen in Florence; his admiration for the silvery tone, subtler and holding more possibilities of atmospheric treatment than the golden innocence of Angelico; and, above all, his feeling that here, in contrast to the intellectual productions of Florence, was a work of religious art, a work inspired by belief in the validity of certain images, and their power to communicate directly with our spirits. The year after Sassetta had completed his St. Francis, in 1445, the same Company gave Piero his first recorded commission, the Madonna della Misericordia;[11] and it would be interesting to know the name of the art lover in that small, provincial society to whom posterity is so greatly indebted, for commissions like these are the result of faith, insight and patience on the part of the patron as well as of genius on the part of the artist. As usual in the fifteenth century, the contract contained many stipulations which were not carried out. The picture was to be all by Piero's own hand and finished in 1448. In fact a considerable part was painted by assistants, and it was probably not finished till about ten years after the date agreed; a document of 1462, in which Piero's brother receives payment from the Company of the Misericordia, may still refer to the commission of 1445.

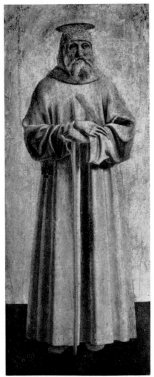 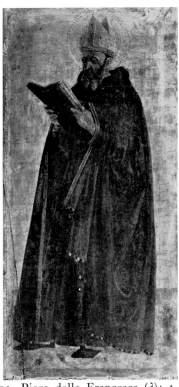 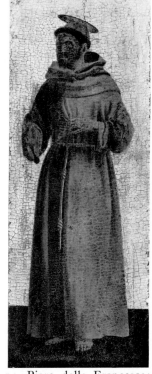

12. Piero della Francesca (?): ST. BENEDICT

13. Piero della Francesca (?): A SAINTED BISHOP

14. Piero della Francesca: ST. FRANCIS

Details from the Misericordia Madonna (Plate 2). *Borgo San Sepolcro, Palazzo Communale*

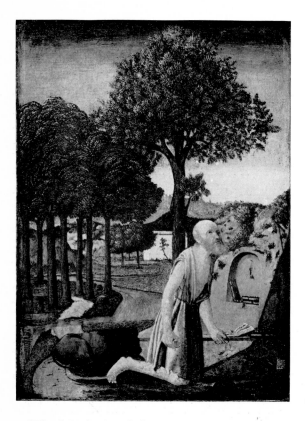

15. Piero della Francesca:
ST. JEROME IN PENITENCE.
Signed and dated 1450.
Over-painted about 50 years later.
Berlin-Dahlem, Gemäldegalerie

The Madonna della Misericordia (*Plates* 1–13), after various vicissitudes, including the loss of its frame, dismemberment and damage by fire, is still in San Sepolcro and exhibited in the Palazzo Communale. A first sight of the original is disappointing, as its condition is so uneven that we cannot bring the whole into focus. The central group has been restored; the saints to the right have been left dry and discoloured and seem to be beyond restoration.[12] Moreover the execution itself is uneven, for even in this, his first known commission, Piero has made free use of assistants. The Madonna and four large saints are certainly from his hand, as are the Crucifixion and Annunciation. Of the smaller saints, the two which have been placed either side of the Annunciation, Saints Francis and Benedict (*Figures* 12, 14), may be admitted with few reservations; of the others only the sainted bishop (*Figure* 13), top right, has a claim. The other saints are by an assistant of no great merit; but the predella panels, although they seem to follow Piero's design (at least in the Noli me Tangere and the Maries at the Sepulchre) are executed by an artist with a strong personal flavour whose identity has not been established (*Figures* 17, 18).[13]

The dated commission of the Misericordia polyptych is a less helpful document than might be supposed because it is clear that various parts were painted at varying dates. It is usually asserted that the four large saints were done first, partly because they are the clumsiest and partly because the closest to Masaccio. One of these is St. Bernardino, who was not officially canonized till 1450, and it is hard to believe that Piero did not begin the altar-piece till two years after he was supposed to have completed it. In fact the two saints to the left, St. Sebastian and St. John the Baptist (*Plate* 8), seem to have been painted considerably earlier. In spite of a certain grandeur they have a rustic awkwardness which is not found again in his work, and the St. Sebastian is probably painted direct from a young man in the workshop. His commonplace features (*Plate* 10) suggest that Piero's power of idealization, which appears to be a faculty of his nature, was in fact achieved gradually. But such chronological niceties must be put forward with diffidence. Our evidence is unusually meagre. We have only

18

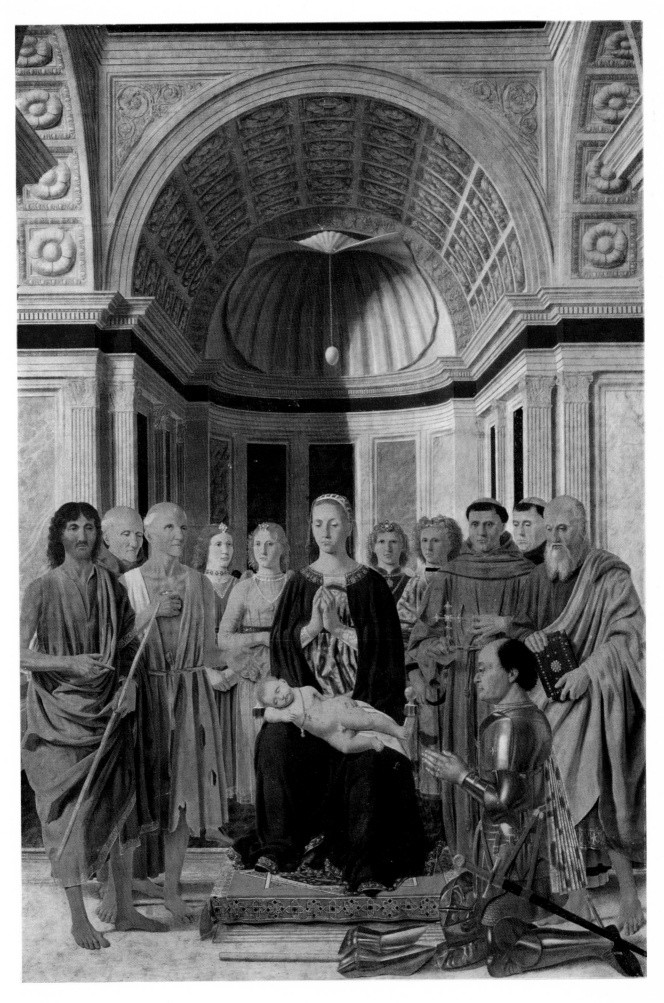

MADONNA AND CHILD WITH SAINTS AND ANGELS ADORED BY FEDERIGO DA MONTEFELTRO. *Milan, Brera*

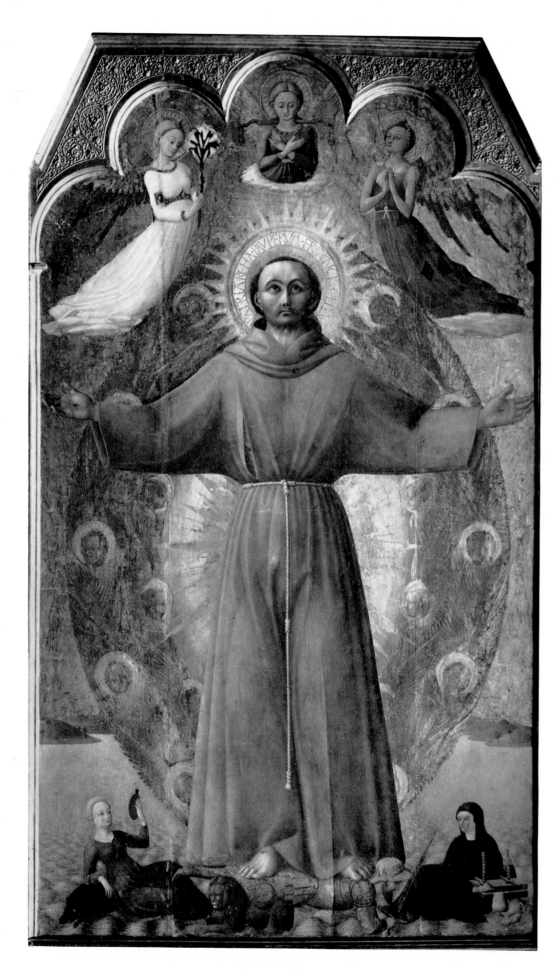

16. Sassetta: ST. FRANCIS IN ECSTASY. *Florence, I Tatti (Harvard University, Berenson Collection)*

one work which can be dated exactly; few of the others can be dated to within five years. We have not the slightest indication of how he painted before 1445, and our next fixed point is the Rimini fresco of 1451. Nor is chronology, in this instance, of cardinal importance, for Piero is not one of those artists, like Giovanni Bellini, whose life is a perpetual series of discoveries and of ever widening reponses; and whose development the biographer must try to follow year by year. It is true that we can perceive revealing differences between his earlier and later work. But his central core, solid and unmistakable, presents itself to us with as little preliminary explanation as an iceberg.

To any student of Italian art the Madonna della Misericordia must immediately suggest comparison with Masaccio's altar-piece, painted in 1426 for the Church of the Carmine in Pisa.[14] The polyptych form, still insisted upon by provincial communities,

17–18. School of Piero della Francesca: THE THREE MARIES AT THE SEPULCHRE; NOLI ME TANGERE. Predella of the Misericordia Madonna (Plate 2). *Borgo San Sepolcro, Palazzo Communale*

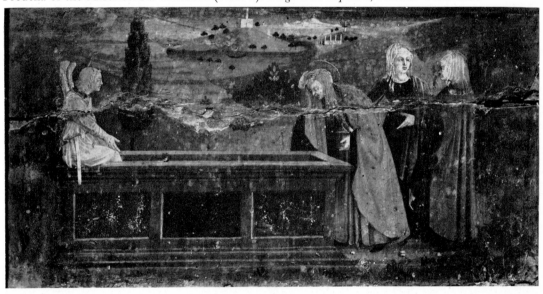

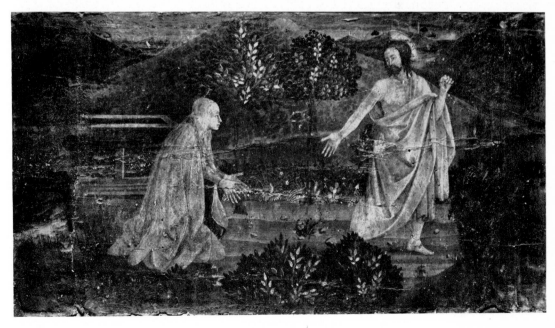

has presented both painters with the same problem: how to reconcile the conflict between the new realistic plasticity and the old symbolic flatness of gold. It is difficult to judge their solutions, as both pictures have lost their original frames; and deeply carved gold frames would have made a difference to the general effect. The figures would have gained plasticity by being, so to say, in niches. But making all allowances, we may say that Masaccio's figures are like pieces of polychrome sculpture standing out in front of the gold which surrounds them; whereas Piero is so conscious of the universality of light that his gold ground itself becomes atmospheric, as it sometimes does in the finest Sienese painting, and by its luminosity satisfies us as a truer symbol of the sky than could be achieved by naturalistic blue. This is due to his delicacy of modelling, still perceptible in those parts which are tolerably well preserved.

Comparison with Masaccio's Carmine altar-piece leads us to speculate if this work was known to Piero. This is usually denied by his biographers on the grounds that we have no evidence of Piero's having visited Pisa; for historians are always reluctant to admit that artists can travel without their knowledge. But given Piero's interest in the new humanist painting it is not difficult to imagine that he travelled the fifty miles to Pisa to see one of the rare works of Masaccio; and this probability is borne out by several similarities in the two paintings. The resemblance between the saints from the frame may be accidental, although remarkably close; but that between the two Crucifixions seems to me essential and inescapable. Even the differences have a bearing on one another. In Masaccio's Crucifixion (*Figure* 6) the gesture of the Magdalen has a northern abandonment to emotion which reminds us of Donatello. In the Piero this emotional gesture is transferred to the St. John, whose open arms and thrown-back head are balanced by the raised hands of the Virgin (*Plate* 3). These too, are Donatellian figures, and together with the violent foreshortening of the St. John they suggest that this part of the altar-pieces was painted when the memory of Florentine art was strongest in Piero's mind. But he was not Florentine enough to attempt, as Masaccio has done, the foreshortening of Christ's body seen from below. His science of perception was of a different kind and relates more particularly to light. A dawning light passes over the figure of Our Lord and before this luminous sky the Virgin and St. John are silhouetted with a truth of tone and economy which remind us of certain works by Daumier and Degas.

It is in the central panel of the Virgin (*Plate* 1) that Piero is furthest from Masaccio and most himself. Her pose is surely inspired by Sassetta's St. Francis (*Figure* 16), and like him she is a worshipful image. We can almost fancy that her robe covers one of those ancient sacred objects, no more than a lump of stone or a log of wood, to which years of devotion have given a mysterious sanctity.[15] Yet compared to the St. Francis she is modelled by light, and the members of the Misericordia who kneel within the cave of her cloak breathe the air which we breathe, only finer and more luminous. Among them we notice types which recur in Piero's work (*Plates* 5–6), and which have led historians to claim that he has represented identifiable individuals. The man kneeling on the left, for example, reminds us of the donor in the Venice St. Jerome (*Plate* 14) and of a portrait head in the Decapitation of Chosroes at Arezzo. But Piero, like all classic artists, raised humanity to a limited number of ideal types. These he imposed on all but the most individualized faces, so that it is unwise to draw

definite conclusions from such similarities. Perhaps this is also true of the man looking upwards, his face slightly in foreshortening, who bears so strong a likeness to the sleeping soldier in the Resurrection in Borgo San Sepolcro (*Plate* 105). On the grounds of a resemblance to the woodcut portrait in Vasari's *Lives*,[16] these heads have been claimed as self-portraits, and although it is the practice of modern criticism to dismiss all such claims as a part of sacristan's patter, these two heads, and several others like them, recur in such a way as to give the suggestion some substance. At least they represent Piero's first mental image of normal man, and so are self-portraits in a real sense. The female members of the Company, on the other hand, have a slightly different character from those who appear in the Arezzo frescoes, and may suggest a phase of Piero's work which is lost, for they remind us of the type used by his Ferrarese and North Italian followers.

The same light which envelops the little figures sheltering under her mantle plays round the head of the Virgin herself (*Plate* 11); and any disappointment which we may have felt in the altar-piece as a whole is forgotten in the contemplation of this superb image. Piero's subtleties of tone reveal a shape remarkably like that of the finest Congo masks in the balance of convex and concave, the large domed projection of the forehead and the concentration of features hollowed out from the lower part of the oval. But this comparison serves also to emphasize the ways in which his sense of form has evolved beyond that of the negro carver. This head is in no way a mask. We never doubt that its formal consistency will continue all round, and it is a shock to realize that we shall never see the back. This is largely due to the superb column of the neck, where, for the first time, we see one of the basic elements of his art.

Piero had the power of creating forms which immediately satisfy us by their completeness; forms which reconcile the mathematical laws of proportion with the stress and tension of growth, forms which combine the resilience of a tree trunk with the precision of a pre-dynastic jar. Such concentration on pure form places a certain restraint on those inflections which communicate sentiment; and the Virgin has that air of remoteness which early admirers of Piero, brought up on the languorous glances of the Pre-Raphaelites or the unabashed rhetoric of Raphael, found so cold and aloof. For this reason she has been compared to those images embodying the spiritual state of non-attachment to which the Far Eastern religions aspire. But set her beside the smiling Buddha heads of Indo-China or China itself, and how strongly she asserts her Mediterranean humanity! Behind her serenity there is even something stubbornly sensual, which means, perhaps, no more than that she is a young peasant, part of the creative process which is her occupation, and which has taught her the need for mercy and protection.

Piero's biographers have usually agreed that the Baptism in the National Gallery (*Plates* 16–21) must be placed among his early works. It is true that the angels bear some resemblance to Domenico Veneziano and even to Masolino. On the other hand the touch is freer and more assured than in the Misericordia Madonna, and the landscape is close to the background of the Battle of Constantine at Arezzo (*Plate* 57), which must date from 1458–60. All we can say is that it was painted early in his maturity, and shows his powers at their freshest. It is in a relatively good state of preservation, and may give those who have not visited Arezzo some idea of Piero's

The Baptism

unique beauty of colouring. He differs from almost all the great colourists in European painting in that his colour is pale and cool. Vermeer and, at his best, Corot are almost the only other painters who have explored this range of cool, silvery colour without degenerating into mere coldness, and in each case this has been achieved by a perfect sense of atmosphere. But Piero differs from Vermeer in that his pictures are conceived in a far lighter general tone. He starts his exploration from the high, bright plateau of Gothic painting, whereas Vermeer emerges from the shadows of Caravaggio. The light which illuminates Piero's figures casts no dark shadows, but reveals every form by delicate reflection. As a result the colours retain their virtues and the decorative unity of the surface is unbroken; middle tones tell as darks, and very slight transitions from one light tone to another have an extraordinary poignant effect. But this fastidious love of shapes and colours for their own sakes never relapses into mere decoration, for it is combined with a feeling for depth; and this, in European art, has meant a feeling for reality. The luminous sky and distant landscape reflected in the waters of the Jordan make a pattern perfectly in harmony with the surrounding leaves and grasses, and yet we feel that between them and Christ's legs there is an immense distance of air and light. It is this ability to unite pattern with depth which relates Piero with a painter temperamentally dissimilar from him, Cézanne. As in Cézanne's water-colours, every object is perceived in three different relations simultaneously, as flat pattern, as form in space and as a relation of colour: and perhaps we should say that it is through this last relationship that the other two are achieved. Even Cézanne, starting as one of the richest of colourists, found that this exacting aim led to an eventual restriction of his palette. He gradually limited himself to the few colours which were completely under his control. So it was with Piero. Compared to the rich palette of a modern painter, the colours ground and prepared for his day's work must have looked frugal to the point of parsimony. For in the hands of one who uses it creatively the word 'colour' means almost the reverse of its connotation in popular speech. There it means number, variety and contrast, the colours of the herbaceous border, which have, to be sure, their own appeal, and can even be used in art – in Persian miniatures, for example. But colour used to reshape the world as part of a consistent philosophy must be restricted to those colours which are on easy terms with one another. Shouting will get them nowhere. It is only in quiet discourse together that a new truth may emerge. *La vérité est dans une nuance.*

The relationship of colours should, and in great artists always does, correspond to a similar relationship of forms. The impact on one another of Piero's slaty blue and ochre, or porphyry and serpentine, has the same degree of resonance as the impact of the arcs, spheres and cylinders which constitute his form world. Both are muted without being deadened. They are without sharpness, without edges, full, complete and continuous. The column of a Greek temple, designed on mathematical principles yet given life by most delicate *entasis*, seems to be the modulus of all his forms. In the Baptism there is the white column of the tree, the columnar drapery of the angels, and the row of feet and ankles, shining with a kind of stored-up radiance, like the columns and capitals which rise from the shallow promontory of Delos.

How far the relationship of Piero's forms is in fact a matter of calculation, how far due to his own harmonious temperament, we shall consider later in connexion with

some of his more schematic works. Yet even in the Baptism, the least rigidly mathematical of all his paintings, we are at once conscious of a geometric framework; and a few seconds' analysis shows us that it is divided into thirds horizontally, and into quarters vertically. The horizontal divisions come, of course, on the line of the Dove's wings and the line of angels' hands, Christ's loin-cloth and the Baptist's left hand; the vertical divisions are the pink angel's columnar drapery, the central line of the Christ and the back of St. John. These divisions form a central square, which is again divided into thirds and quarters, and a triangle drawn within this square, having its apex at the Dove and its base at the lower horizontal, gives the central motive of the design. It is the kind of simple geometric scheme which Alberti used in his façades,[17] and, as with Alberti, we perceive only gradually how far the modulus of proportion is applied in detail. In fact, it is questionable if Piero calculated many of the minor relationships; more probably once the main scaffolding of proportion was established the details fell into place as a result of his own instinct for the general harmony.

The creation of this family of forms and colours was necessarily accompanied by the invention of an idealized humanity. In the Baptism (and it is the chief argument for its early date) the process of idealization is still not quite complete. Whereas the St. Sebastian in the Misericordia Polyptych (*Plate* 10) was taken too directly from the model, the three angels (*Plate* 21) are not quite real enough. They are enchantingly pink and fair, but lack that firm consistency which denotes an assured imagination. They are often compared to the figures of Masolino; they also have a superficial similarity with the Sienese charmers of the later quattrocento, and we are reminded that Matteo di Giovanni originated from Borgo San Sepolcro and returned there in 1465 to paint two lateral panels for Piero's Baptism.[18] A lack of imaginative certainty is also perceptible in the head of Christ, at least if we compare it to that of the Risen Christ in San Sepolcro (*Plate* 106), and His body is far less classical. This is Piero before he had been to Rome. Technically the Baptism is handled with a looseness and lightness which we find nowhere else in his work. The two main figures are solidly painted, but in the rest of the panel the figures have been put in over the landscape in a tempera almost as thin as watercolour (*Plate* 21).

This freshness of handling is the accompaniment of some direct observations which are excluded from his larger monumental paintings, in particular the young man pulling off his shirt (*Plate* 17), whose limpid nudity contrasts with the stiff robes of the Jewish priests on the further shore. And here, for the first time, we have occasion to observe how much more profound was Piero's thought than is usually believed. Because he was so great a decorative painter we are tempted to dwell on his form and colour alone, and omit what used to be called the literary side of his work. But the bare description of this figure in the Baptism has revealed its meaning. His white, naked body, of a wonderful purity of outline, symbolizes the new life of baptism as compared with the heavy folds and formal headgear of the Law. Can we go further and say that Piero intended some meaning in the fact that his head is still hidden in the folds of his shirt? The longer we study Piero the more this kind of interpretation becomes inevitable. The formal motives which have fascinated him, the struggle going on inside a covering, the mystery of an object before it is unveiled, are themselves the aesthetic expression of the Christian idea: that John's baptism was only the first step

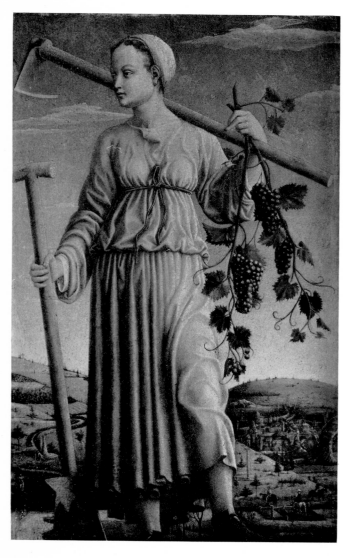

19. Francesco Cossa (?): AUTUMN.
Berlin-Dahlem, Gemäldegalerie

to regeneration and that struggle must precede enlightenment.

This background of the Baptism reminds us of a small picture at Venice (*Plate* 14) in which a middle-aged man in the plain tunic of the bourgeoisie kneels before St. Jerome in order to receive spiritual guidance, and, it would seem, rebuke. This is practically[19] the only survivor of the many small works which Vasari records as having existed in Urbino, but which, even in his day, had been destroyed. It contains a landscape very close to that of the Baptism, and in fact both represent views of Borgo San Sepolcro (*Plate* 19), seen from different angles.[20] In the Baptism the town is seen from the west, with the straight Anghiari road leading to the shallow Tiber. In the St. Jerome it is much nearer and seen from further south. The same isolated house with the tower comes into both, and helps us to situate the point of view. Such a degree of naturalism in the 1450s, almost ten years before Baldovinetti and Pollajuolo had discovered the panorama of the Val d'Arno, is contrary to our idea of early quattrocento painting. But in every way the landscape of the Baptism is one of Piero's most surprising creations. It bears no resemblance to any of the current stylizations of nature, either the simplified, sculptural landscapes of Beato Angelico or the tidy scenic convention of Rogier van der Weyden, which for thirty years had a somewhat negative effect on Italian painting. Instead, the excited blots and scribbles from which the distant hillsides are evoked have all the character of a direct experience, and may well be the result of sketches done on the spot.

26

Vasari tells us that he was called to Ferrara by Duke Borso, and painted in many rooms in the palace. These frescoes disappeared soon after they were painted, probably in 1469, when the palace was largely rebuilt, but this visit to Ferrara was of lasting importance both to North Italian art and to Piero himself. In spite of Vasari's reference to Duke Borso, there are several reasons for believing that this visit took place before 1450, that is to say, before Borso had assumed power.

It was a moment when the Court of Ferrara, under the civilizing influence of Lionello d'Este, had become a centre of artistic patronage. Lionello and his brother Meliaduso were close friends of Alberti, who had spent much time at Ferrara in the forties, had dedicated works to both the brothers, and had there made his first essays in architecture. Lionello was engaged in that activity to which Renaissance princes gave such prolonged attention, the decoration of his study. The Studio del Belfiore no longer exists, but a number of allegorical figures which seem to be connected with this enterprise have come down to us. Two in the Strozzi collection, although apparently of a later date, show Piero's influence in tonality and architecture, and there is one masterpiece of Ferrarese painting, the figure of Autumn in Berlin (*Figure* 19), in which the dignity of the pose and architecture of the draperies is not only reminiscent, but worthy of him. True, this picture must have been painted at a considerably later date, but comparison with the central figure of the group in the Urbino Flagellation (*Plate* 23) or the peasant who watches the exhumation of the Cross at Arezzo (*Plate* 61) makes it impossible to doubt Piero's influence, and proves that it must have continued long after his visit.

We know that Lionello d'Este's studio also contained inlaid panelling — *intarsie* —

20. Cristofero da Lendinara: ST. JOHN THE EVANGELIST. Intarsia. *Modena, Cathedral*

21. Cristofero da Lendinara: ST. MATTHEW. Intarsia. *Modena, Cathedral*

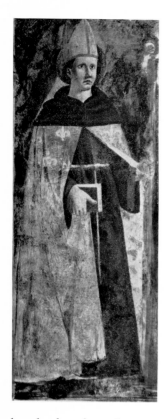

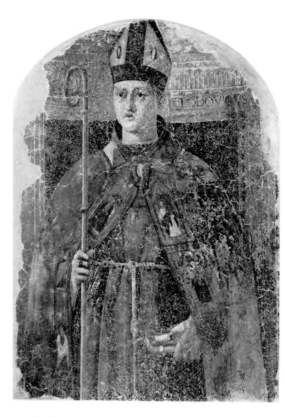

22. Workshop of Piero della Francesca: ST. LUDOVIC. *Arezzo, San Francesco*

23. Piero della Francesca: ST. LUDOVIC Borgo San Sepolcro, Palazzo Communale

by the brothers Lorenzo and Cristofero da Lendinara, and here the connexion with Piero is more definite, for Pacioli, who knew them both intimately, says that Piero held Lorenzo 'dear to him as a brother'. It is certain that the Lendinara brothers used Piero's designs, and some of these works have survived, although these, too, are from a later date. The closest to Piero are those in the sacristy of Modena Cathedral, one of which is signed by Cristofero and dated 1477 (*Figures* 20, 21). They consist of half figures of the four Evangelists, Piero-esque in type and in the large disposition of area. Others are in S. Martino at Lucca. They include towns on hills, their architecture simplified into geometrical patterns which were a favourite subject for *intarsie*; and a bishop blessing, which bears considerable resemblance to two of Piero's mitred figures, the St. Ludovic at Arezzo (executed by Giovanni de Piamonte) and the St. Ludovic at Borgo (*Figures* 22, 23). The history and iconography of *intarsie* is unexplored and sparsely documented. In about 1450 the linear style of early *intarsie*, with drawing on the inlaid wood, yielded to a style based on mass and texture, far more in accordance with the character of the medium. It was at this point that the characteristic motives of *intarsie* appeared – lutes, faceted cups, astrolabes, piled-up instruments of precision. Vasari tells us that this style was due to the designs of Uccello, and this is borne out by the frequent appearance of *mazzocchi* and other vehicles of decorative geometry that are to be found in Uccello's work. But Piero also, by his calculated areas and his synthesis of atmosphere and texture, was well qualified to enrich the style and extend the thematic material of *intarsie*. The representation of architectural perspectives and regular solids probably both derive from him. It would be most valuable to know if he had already made use of these motives in the *intarsie* at Ferrara, for it would be an indication of how early Piero's geometrical interests began to detach themselves from his painting; but, alas, no trace of them remains. As so often in the history of Renaissance art, the key piece is missing.

If Piero left a permanent mark on the painting of Ferrara, it is certain that this visit also had a decisive influence on Piero; for he may then have come in contact with the

great artist who is thought to have spent the year 1449 as court painter to the Estes, Rogier van der Weyden.

Piero's interest in Flemish painting, which lasted throughout his life, and increased during his later years, seems, at first, to be incompatible with the classic and geometric basis of his art: but in fact it springs from the same conception of art as a form of knowledge. His temperament inclined him to the abstract knowledge of mathematics, but he was sufficiently a painter to value the empirical knowledge of perception, and he recognized that, in this branch, Flemish painters had surpassed those of Italy.[21] In particular the play of light on texture seemed to him worthy of assimilation into his monumental style, and examples of this will be found in practically all his subsequent paintings. This adoption of Van Eyckian light also involved, to some extent, the use of the oil medium. Apparently he had learnt the use of oil as a finishing medium as early as his association with Domenico Veneziano;[22] and a stipulation in the contract for the Misericordia Madonna that he should periodically inspect his painting to see how it was lasting, is usually taken as indication that it was painted, in part, at least, in the new medium. Vasari records that Rogier taught the use of oil paint to the leading painters of Ferrara, and after Piero's contact with him there can be no doubt that he could use the medium with complete assurance, although in fact all his pictures seem to be on a basis of tempera. But this change of medium, on which the older historians of art, from Vasari onwards, have laid such stress, is only a materialistic way of stating the change in vision which took place in Italian art as a result of Flemish influence.

From Ferrara it is a short journey to Rimini, and it is easy to explain (though no documents exist) why Borso d'Este should have recommended Piero to his fellow tyrant, Sigismondo Malatesta. Moreover, Alberti, after his first experiments in architecture in Ferrara, was engaged in the formidable task of turning the old church of Rimini, San Francesco (*Figure* 24), into a temple in honour of Sigismondo and his

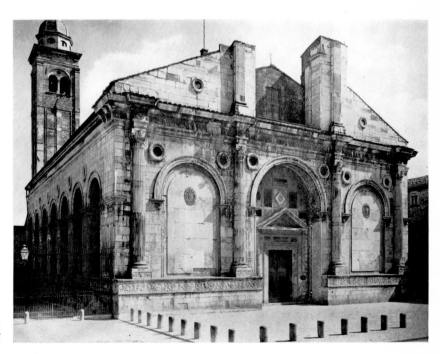

24. Leon Battista Alberti:
TEMPIO MALATESTIANO, *Rimini*

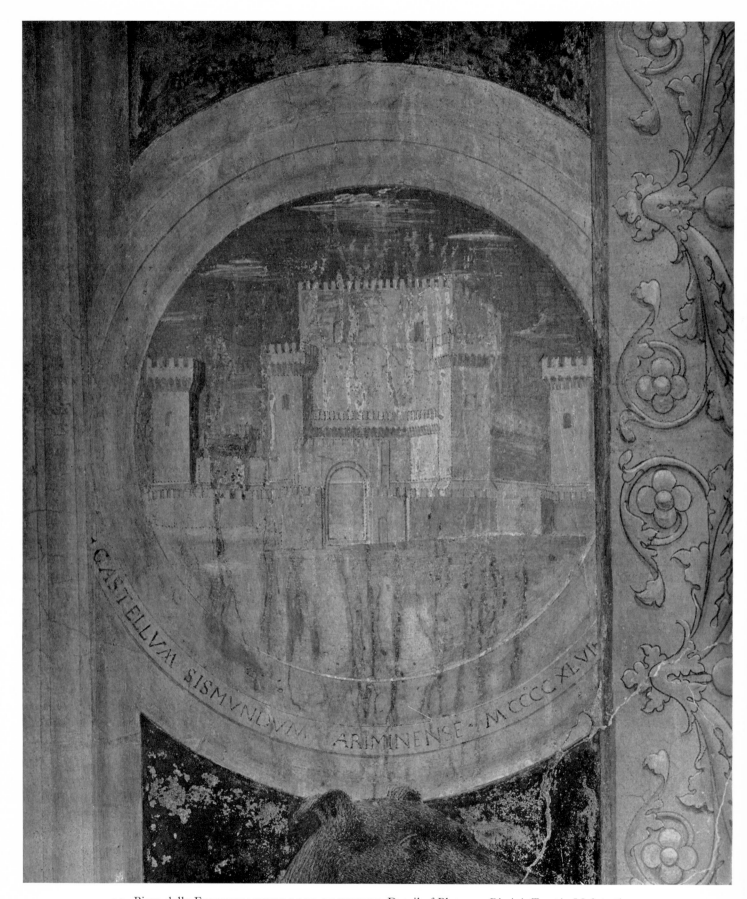

25. Piero della Francesca: THE ROCCA OF RIMINI. Detail of Plate 22. *Rimini, Tempio Malatestiano*

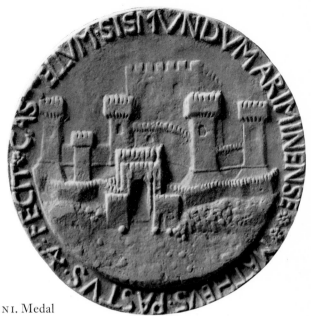

26. Matteo dei Pasti: THE ROCCA OF RIMINI. Medal

mistress, Isotta. This work was begun in 1450, and the following year Piero completed a fresco in the Chapel of the Relics, representing Malatesta kneeling before his patron saint, San Sigismondo (*Plates* 22, 25–27). It is signed *Petri de Burgo opus* and is said to have borne the date, now effaced, MCCCCLI. The Rimini wall-painting differs from Piero's other work in that it is primarily a decoration, subordinate to the architectural effect of its setting. His other frescoes, although marvellous decoration in their own right, dominate the buildings in which they are painted. But in the Tempio he has felt so strongly the powerful presence of Alberti that his figures may seem to have been little more than adjuncts to a preconceived scheme of embellishment. This has become more apparent since a recent restoration, which, although it has left the fresco in rather an untidy condition, gives us a truer indication of Piero's intentions. Far from the archaic clarity which the old photographs convey, we can see now that the fresco must once have been as splendid as an illuminated page, with fanciful simulacra of marble, jade-green swags of leaves with coral fruit and a profusion of lapis blue. Even the white hound once had a blue collar, which matched the lining of St. Sigismund's cloak. Instead of Malatesta's austere triangle being made to stand out against a light background by means of heavy outlines, like an Egyptian relief, he was the centre of a pattern of fastidious brilliance. His patron saint was balanced by his dearest creation, the castle of Rimini, which is seen, white against a blue sky, through the round window to the right.[23] They are united to one another by a rhythmic movement, in which the two hounds play a prominent part, and the orb of St. Sigismund seems like a seed from which has sprung the larger circle. Closely connected with this decorative formalism is the fact that Piero was working for an aristocratic tyrant. His other frescoes, executed for bourgeois patrons, aim at the illusion of reality and depth; but in the Rimini fresco almost everything is conceived in the vein of heraldic unreality, not only the coats of arms and the hounds, balancing each other like armorial supporters, but Malatesta himself, in his short stiff cloak, like a figure from a pack of Tarocchi cards (*Plates* 25, 27). Even the architectural members, the pilasters, swags and border, do not attempt to create an illusion of depth, and the perspective of the floor is purely decorative. The only exception is the St. Sigismund, whose plastic, three-quarter pose situates him in a different world, and this, too, is an echo of medieval painting, where the sacred personages were on a higher plane of reality than the detached donors in profile. At

first sight he recalls the Solomon in the Arezzo frescoes (*Plate* 42), but comparison shows that Solomon's head is painted with greater freedom and confidence. The St. Sigismund is more careful, more delicate, and with something still of Burgundian smoothness. The difference between them suggests a development of some years, and it is worth noticing that there is a certain resemblance between the lighting of the St. Sigismund and the head of Christ in the Baptism (*Plate* 18).

Cleaning has also transformed the head of Sigismondo Malatesta, and here the change is pure gain, for he has recovered his characteristic profile. Whoever had painted in the light background had attempted to make him more handsome by straightening his nose, thus producing a puzzling discrepancy with the likeness on Matteo dei Pasti's medals of 1446. We can now see that Piero's first recorded portrait was as true as that which he was to paint fifteen years later of Malatesta's enemy, the Duke of Urbino (*Plate* 98).

Piero's work at Rimini turns into a certainty what has hitherto been only an hypothesis, that he was closely acquainted with Leon Battista Alberti. Thenceforward there is evidence that this friendship lasted until the end of Alberti's life, in 1472, and its influence on Piero was incalculable. The Alberti whom Piero encountered at Rimini was considerably changed from the restless, theoretical young man whom he may have met in Florence fifteen years earlier. In these years Alberti had achieved that quasi-universal mastery the desire for which had made him so impatient. He had written authoritatively on jurisprudence, morals, shipbuilding, architecture, mathematics, the training of horses, and the tranquillity of the soul. His early portrait on a bronze plaque, probably from his own hand, shows him like a racehorse, with dilated nostril, trembling at the starting tape; in Matteo dei Pasti's medal, which dates from 1446–50, his features have settled into middle-aged accomplishment and disillusion.

Of all his achievements the most satisfying was the façade of the Tempio itself

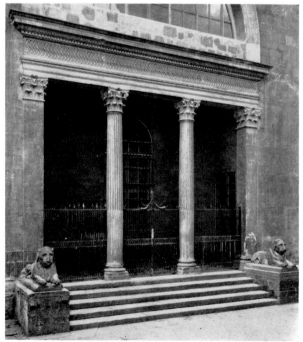

27. Leon Battista Alberti:
SANTO SEPOLCRO RUCELLAI. *Florence*

28. Leon Battista Alberti:
SAN PANCRAZIO, *Florence*

(*Figure* 24), and we can imagine the profound effect that its design must have had on Piero. At that date it had not, of course, been built, but we know from Matteo dei Pasti's medal of 1450 that the drawings for the elevation existed, and there is no difficulty in supposing that Piero had access to them. That these drawings were unusually detailed is clear from the fact that Alberti habitually left the construction of his buildings to masons, and conducted operations by correspondence; and their completeness is proved by his celebrated letter to Matteo dei Pasti, in which he forbids him to make a change of detail because by doing so *si discorda tutta quella musica*. This preconceived harmony, established in the mind, down to the smallest detail of colour or texture, must in itself have held great fascination for Piero. But he was also delighted by the actual style which Alberti had created; and since he was to adopt it so thoroughly that the backgrounds of his pictures are like a realization of Alberti's dreams, we must attempt a short description of its character.

The architecture of Alberti differs fundamentally from that of Brunellesco and his followers in that it depends on effects of mass rather than line or movement. In contrast with the springiness of Brunellesco it reflects the Roman *gravitas* which was part of Alberti's character; and it follows far more closely the antique models which Alberti had studied in Rome. He rejected, as unclassical, the most familiar of all Brunellesco's motives, the light, flowing arcade placed on columns of the Innocenti and the Santa Croce cloisters. And his use of marble inlay is completely at variance with Brunellesco's use of stone on plaster. This has been well described as 'drawing on the wall', and, in Brunellesco's designs, is a means of carrying the linear rhythm round a building, accelerating the movement of our eyes, like a sort of streamlining. Alberti's encrustations aim at the reverse effect, at richness of texture and a measured, static order. Here, too, he imagined that he was following classical antiquity, for the Roman buildings which he had studied were to a large extent covered with marble. But his long residence in Venice had given him a particular fondness for plaques and panels of porphyry and sumptuous marble, those delights of the eye with which, since the fourth Crusade, the builders of Venice had been so prodigal. Ornament he had defined as 'a certain brightness auxiliary to beauty', and this cryptic saying becomes understandable when we contemplate the harmonious disposition of precious inlays which once gave colour to the façades of the Tempio Malatestiano and Santa Maria Novella. Today, they are discoloured by dust, but one small building in Florence designed by Alberti, the Santo Sepolcro Rucellai in the church of San Pancrazio (*Figure* 27), still gives us some idea of the intention of his inlays and the finesse of his detail.

The influence of all these characteristics is clearly seen in one of Piero's most perfect works, the small picture of the Flagellation (*Plates* 23, 24), exhibited in the palace of Urbino, and formerly in the sacristy of the cathedral. The graceful Corinthian order, the plain entablature, the marble inlays, are completely Albertian, and could not have been found in the works of any other Renaissance architect before that date. The portico is, in fact, very like that of Alberti's San Pancrazio (*Figure* 28), but carried out with the brilliance and finish of the Santo Sepolcro Rucellai. This derivation from Alberti is one of the few things about the Flagellation which are secure, for its date and subject and principles of design are alike mysterious. Biographers of Piero have generally accepted the theory that the three men on the right represent the wicked

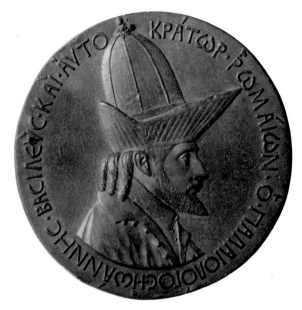

29. Piero della Francesca: PROFILE OF CONSTANTINE.
Detail of Plate 51. *Arezzo, San Francesco*

30. Pisanello: THE EMPEROR
PALAEOLOGUS. Medal

Count of Urbino, Oddantonio, between his two evil counsellors, Manfredo dei Carpi and Tommaso dell' Agnello, and that the Flagellation of Our Lord symbolizes the Count's assassination, which took place in 1444. This theory may be dismissed for a number of reasons.[24] The arcadian figure in the centre, with simple tunic and bare feet, is clearly not a dissolute tyrant, nor are the two grave personages who stand beside him at all like evil counsellors; there is no reason why Piero should have been asked to commemorate an event which was regarded as a much-needed deliverance, still less to symbolize it by the sufferings of Christ. Finally the date of 1444 is wholly inadmissible, for it is inconceivable that Piero could have invented this architectural style without the example of Alberti, and at that time Alberti was only beginning to turn his attention to the subject, and, as far as we know, had made no designs.[25] Indeed this fiction would not have been worth mentioning were it not still given currency in nearly all recent studies of Piero, including the new edition of Professor Longhi's monograph. On stylistic evidence the Flagellation must have been painted after 1451, but the resemblance of the bucolic figure to the angels in the Baptism (*Plate* 21), and a certain lightness in the handling, suggest a date before 1460. The architecture is similar to that of Solomon's palace in the Arezzo fresco (*Plate* 36), the head of the oriental not unlike that of Constantine (*Plate* 55); so we may tentatively place the Flagellation between 1455 and 1460, the years of Piero's greatest activity.

The subject remains obscure. This is not, obviously, a picture of the Flagellation with three indifferent onlookers, but a picture of three important figures, two of them symbolical and one a portrait, whose thoughts are expressed by the sufferings of Our Lord. The Flagellation symbolizes the tribulations of the Church, and in these years the Christian Church did in fact suffer one of its greatest setbacks, the taking of Constantinople by the infidel in 1453. The bearded man is clearly a type of learned Greek and bears a certain resemblance to the Emperor John Palaeologus. In the first edition of this book I suggested that Piero's picture might be connected with the fall, and commemorate one of the Councils held to consider how it should be met, perhaps the Council of Mantua of 1459. The inscription which formerly ran along the base of the panel, *Convenerunt in unum*, does not contradict the hypothesis.[26] An alternative

34

suggestion is that the Palaeologus figure represents the late Emperor's brother Thomas who visited Rome in 1461 with the important relic of the head of St. Andrew. But none of these explanations accounts for the arcadian youth in the centre, and no-one has succeeded in identifying the subject of the portrait on the right. His rich Van Eyckian robe suggests that he was a person of rank, for the citizens of Borgo and Arezzo who appear in Piero's other works are always dressed in the plain tunics of the bourgeoisie. But the numerous medals representing the princes of Mantua, Urbino and the Marches have yielded no identity.

The Flagellation is also enigmatic in its design. No other painting that has come down to us, except perhaps Uccello's Deluge, is so complete an expression of the Renaissance *mystique* of measurement, known as *prospettiva*. It is, of course, a masterpiece of perspective in the modern sense. Nothing could involve nicer calculation than the diminution of the black inlays on the marble beams, and the black and white pavement is even more complicated. Some conception of the labour which lies behind the correct foreshortening of this pavement may be gained from a drawing in Piero's own book on perspective (*Figure* 63), where a similar calculation is expounded. But in addition to perspective as the science of depth, there is no doubt that the surface design of the picture is based on a scheme of mathematical ratios far more complicated than that of the Baptism. Piero, who enjoyed such intellectual games, has provided us with a clue in the band of black marble inlay which figures so prominently in the design over the head of the bearded 'Greek'. It is (what it would immediately appear to be) his unit of measurement. The whole picture is ten of these units by seven. The central column (which, of course, is not central, but exactly half a unit to the right) is four units high and half a unit wide. The two chief leaps in perspective, that from the foreground to the inlaid pavement, and that from the entablature to the black inlay of the first beam, are one unit each. To press the matter further would weary the unmathematical;[27] but some allusion to this mania for measurement is essential, as it is wholly characteristic of Piero and, as we shall see, occupied a great part of his later life.

All these puzzles, iconographical and mathematical, have kept us from an appreciation of the picture as a whole. In actual experience they do not precede our delight in its beauty, but follow and perhaps revive it. Our first impression is one of a perfect and precious harmony, but not a harmony of concession or relaxation. On the contrary, it arises out of an interplay of space of a most hazardous nature, the balance of a void and solid, of space created and space filled. Yet it is precisely this balance which makes the picture; for neither void nor solid is as satisfying in isolation (*Plate* 24). Each becomes static. Together they create a tension, as well as a balance, which gives them life. The vitality with which space and shape react on each other is, as usual, borne out in the colours. The main impression is of a contrast between the white marble and grape or purple, in drapery and inlay, but this dominant chord is the background of some accents sharper and more brilliant than is usual in Piero, the pink, blue and red of Pilate, for example, or the bright scarlet tunic just visible under the brocaded cloak of the figure on the right. These colours are held together by unity of atmosphere. The actual group of the Flagellation achieves a beauty of tone more subtle, perhaps, than any other passage in his work, so that the forms are almost dis-

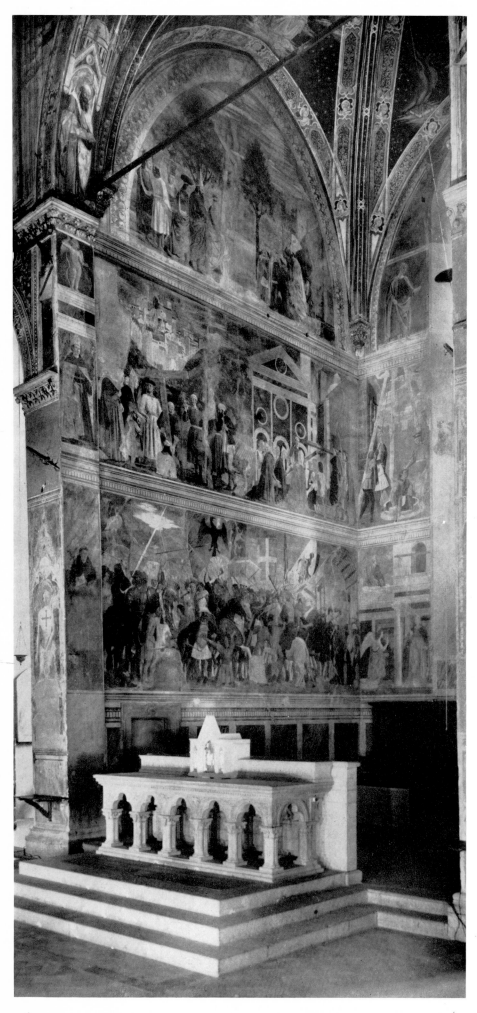

31. THE CHURCH OF
SAN FRANCESCO AT AREZZO:
THE EAST WALL

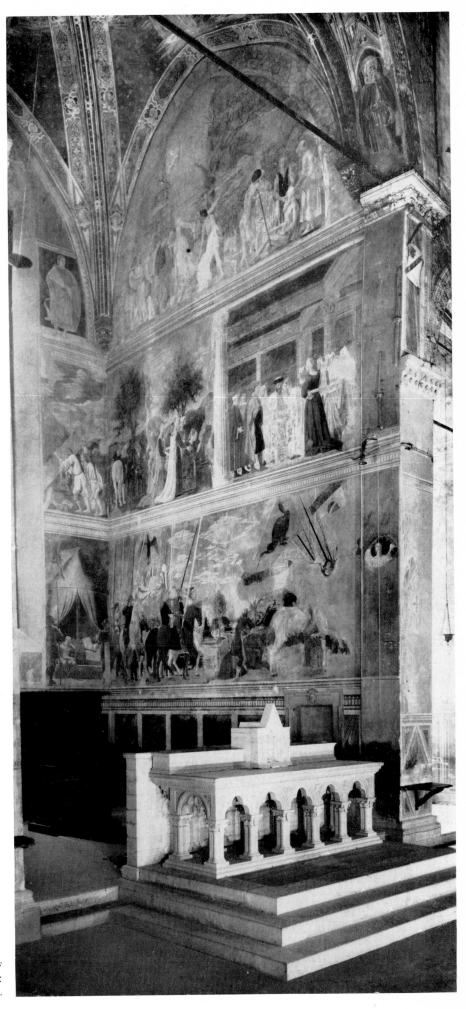

32. THE CHURCH OF
SAN FRANCESCO AT AREZZO:
THE WEST WALL

solved in reflected light, and would disturb us by their translucence were they not so firmly grasped. Piero's peculiar pleasure in the play of light is shown in a detail which immediately recalls Vermeer, the studded door between Christ and the flagellator, where the light strikes on each stud exactly as it does on Vermeer's leather chairs. The miraculous quality of the Flagellation is due to this sense of atmospheric depth being completely united with the calculated depth of perspective: in other words, by the two modes of realization, the perceptual and the conceptual, being entirely at one.

We have now reached the centre of Piero's career, the frescoes in the church of San Francesco at Arezzo (*Plates* 28–92), which, ever since they were painted, have been considered his chief claim to immortality. In spite of their contemporary renown, we know very few facts about them. We know that as early as 1427 members of the Bacci family, then the richest in Arezzo, had put aside a sum of money for the decoration of the choir; and that twenty years later they gave the commission to the old-fashioned Florentine artist, Bicci di Lorenzo.[28] He had almost finished the vaulting and the choir arch in 1452 when he died. It seems that Piero was called in almost immediately, as he completed two prophets in the niches of the archivolt (*Plates* 86, 87) which Bicci had begun and added two heads of angels to the decoration of the vault. The decoration of the chapel was to occupy him, with one major interruption, for the next twelve years.

As was usual in Tuscan wall decoration from Giotto onwards, the frescoes fill the choir with long horizontal scenes placed one above the other. The proportion of those on the main walls is a twelfth longer than the double square; in the upright scenes, which are either side of the window, it is proportionately shorter. The top scenes run up into the vault, giving a proportion at the highest point of 2 to 3. Originally the scheme was carried on to the pilasters of the archivolt, but of this only fragments remain; and the whole chapel has suffered severely from decay, especially the main west wall.[29]

The subject of the frescoes is the story of the True Cross, and the incidents are drawn from several sources, more particularly from the *Legenda Aurea* of Jacopo Voragine. A free version of Voragine's compilation, with various cuts and additions, was printed by Caxton, and the quotations which follow are from his beautiful text. The legend of the True Cross first became popular as a subject for painting in Franciscan churches at the end of the fourteenth century, when Agnolo Gaddi depicted it in the choir of Santa Croce, Florence; another cycle is in Volterra by his follower, Cenni di Francesco. This choice reflected the mania for relics which reached its height in these years, and pictorially it offered an opportunity of pageant and anecdote for which the half-secularized religious art of the late Middle Ages sought every excuse. But such reasons do not completely account for its choice by the Bacci family, some forty years later, and its enthusiastic acceptance by Piero. Probably the subject of the frescoes, like that of the Flagellation, was chosen in response to events of the day. They were begun at the moment when the infidels' triumph at Constantinople seemed inevitable, and finished after that triumph was accomplished. They deal with the reverse process, and their chief scenes represent two famous victories over the infidel, that of Constantine over Maxentius and of Heraclius over Chosroes. The latter is not

even part of the traditional legend of the Invention of the Cross, and the presence of a second battle would be difficult to explain unless we allow that the frescoes are in some sense propaganda for a Crusade.

This is all that we know, or believe ourselves to know, about the frescoes in Arezzo. The rest we must derive from contemplation of the works themselves, and it will vary according to our responses, our faculty of comparison and our command of symbolic language. No doubt, when we enter the choir of San Francesco, we all experience more or less the same emotion, the same feeling of solemn joy, of beatific lightness. What is it which gives us this sense of breathing the air of a more harmonious planet? We sit in the choir stalls and try to come nearer to these august creations, and as we approach they recede. We squeeze the petals of these majestic flowers in hopes that their scent may linger in the air long enough for classification, and in a second it becomes inert. And there we sit, dumbly, hopefully waiting for that divine moment to return. Perhaps the best way to come closer to a full understanding of Piero's intention is, for a time, to abandon the analysis of form, colour or design, and simply to follow the story, as Piero's patrons must have done, from scene to scene. At least such a procedure has the merit of occupying our conscious minds and leaving our unconscious free to discover and absorb what it can.

The story opens on the west wall with the old age and death of Adam (*Plates* 28–35). Seth has gone to the Paradise Terrestrial to ask for oil of mercy, but the archangel Michael has given him 'a branch of the tree that Adam ate of, and said to him that when that bore fruit he should be gerished and whole. When Seth came again he found his father dead, and planted this tree upon his grave; and it endured there unto the time of Solomon.' In the fresco this story is told in two parts. On the right the Patriarch, seated on the ground, announces his approaching end to his descendants, for whom death from old age is a new and incomprehensible event. Only Eve, standing behind him, seems to understand the melancholy certainty of his words. In the distance, beyond this group, and barely visible from the ground, we can discern Seth and the Angel. On the left Adam has died. His body, slightly in foreshortening, lies rigid on the ground, while Seth, whose figure has been almost entirely obliterated in a large area of damage, kneels behind him and plants the branch in his mouth. One of his children raises her arms and cries out in grief, but for the others sorrow is mixed with astonishment, and even with incredulity, at this strange new manifestation. Following the narration of Voragine we pass straight to Solomon and Sheba (*Plates* 36–44). The branch in Adam's mouth has grown into a tree so magnificent that the vainglorious king has had it cut down for his palace. But it will not fit anywhere, and finally it is used as a bridge over the river Siloam. As before, the fresco is divided into two halves. On the left (*Plate* 37) the Queen of Sheba and her retinue have dismounted, and as they approach the palace the Queen is inspired to recognize the sacred wood. She kneels in adoration, while her ladies stand behind her. On the right (*Plate* 38) she is received by Solomon, and bends over his hand in an attitude of reverence for his wisdom. But she tells him of her intimation that on this mysterious tree shall be nailed a Man 'by whom the realm of the Jews shall be defaced and cease'. 'Solomon, for this cause, made it be taken and dolven deep in the ground.' This is the subject of the first of the upright scenes beside the window (*Plates* 45, 49), in which three men are carrying the beam in

order to bury it, oblivious of the mouth of hell which yawns prophetically at their feet.[30] Piero, with his usual love of double meanings, has made the first of these men into a prophetic vision of Christ carrying the Cross. He then passes straight to the rediscovery of the Cross by St. Helena, omitting not only the story of the Passion, which would have been out of place in this chivalric recital, but also the legend of how the wood was found by the Jews and made into the Cross, although this is contained in Voragine and was depicted by Agnolo Gaddi in Santa Croce. The rediscovery is prefaced, as in the *Golden Legend*, by an account of the dream and victory of Constantine. The empire has been menaced by the invading army of Maxentius. 'When Constantine had assembled his host he went and set them against the other party, but as soon as he began to pass the river he was much afeared, because he should on the morn have battle. And in the night, as he slept in his bed, an angel awoke him and showed to him the sign of the Cross in heaven.' And on it was written 'In this sign shalt thou conquer'. In the other upright space to the right of the window (*Plates* 46–48–50) we see this episode portrayed with unforgettable simplicity and completeness of imagination. The King sleeps in his tent on the battle-field, his weary adjutant sits watching at the foot of his bed, and two soldiers, like the armed men in the trial scene of the *Magic Flute*, stand on guard outside. In the distance the tents of Constantine's army are seen by moonlight, but the whole foreground is illuminated by the radiance which streams from the angel who points to Constantine and bids him look for the sign of the Cross. From this night-scene we pass to the most perfect morning light in all Renaissance painting (*Plates* 51-57). On the left Constantine and his army advance with a calm, predestined movement, as if under the spell of their divine assurance, 'his horses' hooves moving softly, as though shod with felt'.[31] Constantine himself, his countenance clearly recalling the remembered likeness of John Palaeologus,[32] carries in his right hand, which he must keep immaculate in battle, a simple white cross.[33] To the right the army of Maxentius, faced with this sublime momentum, turns in flight

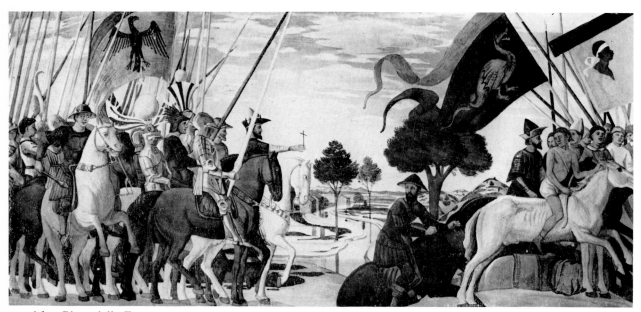

33. After Piero della Francesca: THE BATTLE OF CONSTANTINE.
Copy by Ramboux of the fresco in Arezzo (Plate 51). *Düsseldorf, Academy*

without striking a blow. Of this episode only the horseman emerging from the water, morose and undignified, has survived more or less intact. This is particularly regrettable as the chief figure, a nude riding bareback on a white horse, was specially praised by Vasari, who, in matters of this kind, usually shows good judgement. We can form some conception of him from a water-colour copy executed by the painter Ramboux (*Figure* 33), in the early years of the last century,[34] and can see how the steady movement of Constantine's army was contrasted with the disorganized rout of his enemies, at first awkwardly labouring, then bounding precipitately out of the picture.

We now pass to the other side of the chapel, and are shown in three episodes how, after the death of Constantine, the Empress Helena discovers the True Cross and proves its authenticity (*Plates* 58–72). The first of these episodes tells the story of a Jew named Judas, who knew of the whereabouts of the Cross, and was placed in a dry well and threatened with starvation until he revealed them. After six days he announced that he was willing to do so, and was hauled out, as we see in the fresco (*Plates* 58, 63). He leads the Empress to the spot where, in Caxton's words, 'the earth moved and a fume of great sweetness was felt, in such wise that Judas smote his hands together for joy and said "In truth, Jesu Christ, thou art the Saviour of the World". After this Judas was baptized and was named Quiriacus, and after was made Bishop of Jerusalem. After digging twenty paces deep, three crosses were discovered and shown to the Queen; and because he knew not which was the Cross of Our Lord, Judas laid them in the middle of the city and abode the demonstration of God; and about the hour of noon there was the corpse of a young man brought to be buried. Judas retained the bier and laid upon it one of the crosses, and after the second, and when he laid on it the third, anon the body that was dead came again to life.' All this is clearly set out in the middle fresco of the east wall. To the left Judas is dragging one of the crosses from the ground, watched attentively by the Empress, her retinue and her dwarf (*Plate* 61). A courtier in white points to what is being done, and St. Helena makes a gesture of royal

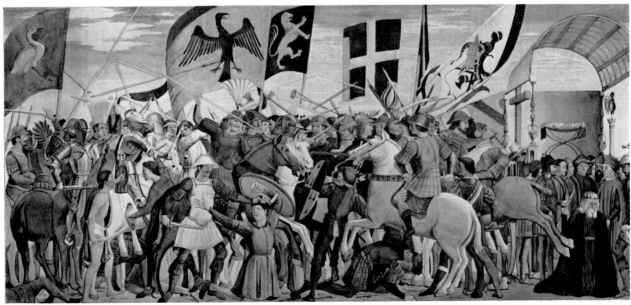

34. After Piero della Francesca: THE VICTORY OF HERACLIUS.
Copy by Ramboux of the fresco in Arezzo (Plate 73). *Düsseldorf, Academy*

approval. Another cross has already been recovered, and is held by one of a group of three peasants who have been helping with the work. To the right we are 'in the middle of the city', as is shown by a beautiful church façade in the style of Alberti. Judas holds the Cross over the body of the young man, who sits up in his bier, while the Queen and her ladies kneel in wonder and reverence (*Plate* 67).

There remain two more scenes which are to be found in another section of the *Golden Legend: The Exaltation of the Holy Cross.* Three hundred years after its discovery Chosroes, King of the Persians took it from Jerusalem and 'set it up on the right side of his throne instead of the Son, and a cock on the left side instead of the Holy Ghost and commanded that he should be called Father'. Heraclius, Emperor of the East, then made war on him, and defeated him after a sanguinary battle. This episode is shown in the lowest fresco on the east wall (*Plates* 73–79), and forms a pendant to the bloodless battle of Constantine. It is indeed, as Vasari observed, a terrible slaughter, 'an almost incredible scene of wounded, fallen and dead', in which at first neither side seems to have an advantage.[35] Indeed it is not perfectly clear to which party the combatants belong, and some of the more exotic, the Chinese warrior, for example, seem to be on the side of the Emperor. But to the right the scene takes on a more serious character. In place of the elaborate melée there is the empty space of Chosroes' sacriligious throne. His son is stabbed in the throat, with a blow of sacramental gravity, and his head falls back, so that it seems to lie at the foot of the Cross. Chosroes himself kneels, surrounded by his impassive victors, awaiting decapitation; and we observe that his head closely resembles that of God the Father, in the adjoining picture of St. Helena and the Angel. Among his judges are several obvious portraits, and Vasari tells us that these are members of the Bacci family and other gentlemen of Arezzo, who paid for the work.[36] Finally, at the apex of the last wall, Heraclius brings back the Cross to Jerusalem (*Plates* 80–85). He and his retinue advance bearing the Cross, their height made more impressive by their colossal headgear, while on the right the men of Jerusalem kneel in adoration.

This short description of Piero's theme should have corrected one misinterpretation of his art which was common among earlier writers: that he was a decorative artist, concerned solely with the arrangement of shapes and colours, and not with the dramatic presentation of his subjects. The very sequence and arrangement of the episodes proves that this is not the case. Piero shows a remarkable sense of contrast. Thus the scene of primitive life, with its naked or skin-clad figures, is followed by the restrained splendour and decorum of Solomon's court; the night-scene of Constantine's dream is followed by the dawn light of his victory, and the severely static scene in which the Cross is discovered and recognized is in contrast to the confused and jarring battle below it. True, Piero's dramatic sense is often expressed with such restraint that we may overlook it in our admiration for his design; just as in Racine the beautiful movement of his alexandrines may carry us past some agonizing revelation before we are aware of it. True also, that Piero's drama is hardly ever conveyed through facial expression, but rather through gesture and inclination. In this, as in so much, he is essentially Greek, and at the opposite pole to those Germanic artists who rely on grimace to catch the spectator's eye. In the Arezzo frescoes, however, there are scenes and types in which the dramatic power is evident at the first glance. Such in particular

is the Death of Adam, with its range of feeling from resignation and incredulity to unrestrained misery. Nor does the concept of Piero as the impassive co-ordinator of form allow for his Adam and Eve, two figures which show a literary imagination of a high order. The distressing physical characteristics of old age are accepted and set down with a severe formality which makes them both dignified and touching (*Plates* 34, 35). Their two heads must be amongst the noblest representations in art of decrepitude—at least before the work of Rembrandt; for Bellini's old men are still robust, and Michelangelo's Cumaean Sibyl, which the Eve so clearly foreshadows, is charged with terrible energy. But Piero's Adam and Eve are worn out, and by their extreme old age seem to increase the feeling of primitive antiquity, of patriarchal time, which is the key in which the whole scene is imagined.

Having followed the story of the frescoes, we may now return to those elements of colour and design from which, as we are now told, our satisfaction in their beauty is derived. Anyone visiting the church of San Francesco should stand for a minute or two outside the choir in such a way that he may see, one after the other, the whole of each wall. This more distant view is revealing in many ways. It shows how the dramatic contrast between the scenes, already referred to, is supported by a contrast in design. It also shows how a single principle of construction runs through all the compositions. Each one is divided a little to the right of the centre by a strongly marked vertical which acts as a sort of caesura. On the west wall, for example, the tree in the Death of Adam, the Corinthian pillar of Solomon's palace, and the distant tree in the background of Constantine's Victory, are all on the same line, giving a square composition to the right, an oblong to the left. In the oblong the composition is in terms of movement, in the square it is static. This rule is broken in Constantine's Victory, and the design of Maxentius scrambling diagonally out of the corner of his square adds greatly to the dramatic effect. The value of this metre may be seen by looking at the east wall, in which, for reasons to be discussed later, it has been less rigorously applied. The scene of Discovery and Recognition conforms to it perfectly; but in the scene above, the right-hand square is too abruptly cut off, and we are left with an awkward, empty centre. Perhaps some gesture by the man holding the Cross and the distant landscape, both now destroyed by damage, would have helped to carry us through this transition. In the final scene of battle this principle of composition is almost completely abandoned, although a vestige is preserved in the vertical standard which rises above the head of the rider on the white horse. No doubt the change was made intentionally, and was intended by Piero partly to indicate the desperate evenness of the battle, as opposed to Constantine's victory, and partly to emphasize Chosroes' abandoned throne on the extreme right; but from the decorative point of view this sacrifice of metre is unfortunate and accounts more than anything else for the feeling of uneasiness which the Victory of Heraclius arouses in every visitor to San Francesco.

The difference which we have described between the design of the east and west walls is perceptible also in the colour. Put very shortly, the tonality of the west wall is much cooler, dominated by grey and white, green and blue; the east wall, although still light, is warmer, with much pink, lilac and grape purple to set off the blue and white. Both are beautiful, but the former is more exquisite and more personal. It has

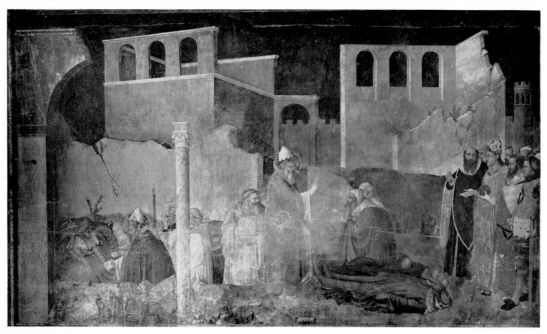

35. Maso di Banco: ST. SYLVESTER. *Florence, Santa Croce*

that silvery air which, as has already been said in writing of the Baptism, was the atmosphere in which he breathed most freely. On the same page reference was made to the frugality of Piero's palette, and it may now be convenient to give some general indication what colours it contained. They are, fundamentally, the colours of the Tuscan vineyard, grey olives, brown earth, purple grapes, green vineleaves, often turned to blue by the copper sulphate spray; amongst them the peasants in blue cotton dresses, which have faded to lavender, and white oxen, dominating the whole by their bulk and snowy splendour. To enliven this grave harmony he adds two warm colours, a pink and a subdued red, both used rather sparingly, and, as it were, decoratively, rather than functionally. Finally there are certain colours which he conceives to be of special dignity, and reserves for great occasions, a deeper red, on the verge of porphyry, and a blue like a Mandarin's robe. All these colours are used on a scheme of muted complementaries. A warm tint always balances a cool one. Underlying his designs is an almost heraldic symmetry, but, as with all his applications of theory, this is usually disguised. A section in which it is obvious is the group to the left of the Sheba-Solomon episode, where the two pages balance each other almost like playing cards, one facing us, one showing his back, one in a white hat, one in a black, one in red doublet and grey hose, the other the reverse, and so forth through every detail.[37] Usually the correspondence is much more subtle, so that we come to accept this perfect balance as a natural consequence of Piero's harmonious world, instead of a carefully calculated means by which that world was created. The description of colours which the reader cannot see is wearisome and frustrating, but one example may help to give some idea of the extreme subtlety which underlies Piero's large and candid orchestration. In the advancing army of Constantine we are at once aware of the interplay of warm and cool tones in the brown, white and mole-grey horses, and we notice how each horse has been given in its harness a touch of some bright contrasting colour—red on the grey, green on the brown, yellow on the white. But it is some time before we observe that the same has taken place with the lances. Only two of them are completely white, and they are in the background, thus giving relief to the others. From graded white they work up to buff and grey, warm and cool, some even pink,

44

others mole colour, finally green and yellow. The whole of this passage, with its two strange white balls pitted like moons, or like the calyx of some gigantic flower, and its saffron banner enhancing the chill of the pale blue sky, is of incomparable beauty, and of all Piero's visions is that which comes closest to the purity of Platonic art.

A distinction has just been implied between functional and decorative colour. It may stand, for there were undoubtedly certain colours which Piero used in Alberti's sense of decoration 'to give added brightness', and not in order to convey the truth of the scene. But fundamentally the antithesis is a false one, for one of the peculiar beauties of Piero's frescoes is that they are, in every particular, conceived as decoration. They differ radically from the majority of Florentine frescoes, from Giotto to Ghirlandajo, in that they never obliterate the surface of the wall as the first factor in decorative unity. The St. Sylvester frescoes in Santa Croce (*Figure* 35), by the painter known as Maso, in this, as in much else, are the only precedents for Piero's approach. This principle of composition means that the main action of each scene takes place parallel with the wall surface, and that the actors are either in profile or so arranged that their most characteristic outlines are on almost the same plane. It is an expedient which in unskilful hands produces a starved and artificial effect, as many modern decorations show. Piero avoids this by ingenious use of perspective, which, though scarcely perceptible at the first glance, gives the scenes their consistent basis of reality. The point of vision is kept low. In the middle band it is a sixth of the way up, that is to say, about level with the knees. In the battle-scenes, because they are lower, the vanishing point is slightly higher, but not more than waist high. This is contrary to the advice in Alberti's *Della Pittura* where, like a true academic, he instructs the painter to make his vanishing point on the level of his heads. Piero's scheme gives the figures the majestic proportions of a frieze, but allows just enough beyond them to situate them in space. Their precise position is defined by eaves and architraves in steep perspective, and he has added a few foreshortened objects—the Cross which resuscitates the corpse, the canopy of Chosroes's throne—which are designed to avoid the effect of flatness without disturbing the surface. But these are kept to the sides of the compositions, and the fact that Piero, the great master of perspective, has used it so unobtrusively, shows how strongly he felt that the plane of the wall was the true nexus of decoration.

While considering decoration, it is worth amplifying a hint contained in the opening paragraph of this essay: that Piero is far removed from the decorators of the quattrocento, from Benozzo Gozzoli to Pintoricchio. He was emphatically not one of those who, in Leonardo's phrase, 'live by the beauty of blue and gold'. This, which retarded his recognition in the nineteenth century, has helped finally to confirm his greatness, for we now recognize that he, almost alone of mid-fifteenth-century painters, withstood the general drift towards decorative triviality which took place from about 1460 to 1475, and which represented a renunciation of the heroic ideals of the first humanist artists. This is also an answer to the problem which has often puzzled students of Renaissance art, why the greatest painter of the period was never employed in Florence and is not named in contemporary Florentine records. Jealousy alone does not answer the question, for Florence had welcomed Gentile da Fabriano and Domenico Veneziano. But what we may call the art-workers-guild style of the 1460s

45

Piero's Pictorial Architecture

was pre-eminently a Florentine fashion, a bourgeois version of Gentile's aristocratic manner. It was a style which had, for the Medicean circle, a social or literary importance, and was bound up with their whole way of life. When we remember the letters from toadies, both clerical and secular, asking the Medici's advice before commissioning an artist, we realize how unlikely it was that an outsider should be employed. And to this style Piero would not conform. Unlike the democratic Florentines of his youth, he loved grandeur and exalted ceremony; but he achieved it by stateliness of carriage, magnanimity of gesture and the unvarying nobility of every shape, rather than by profusion of rich brocades. Most of his dresses are of the utmost simplicity. Solomon it is true, wears a robe of sybaritic splendour but his courtiers are dressed in everyday clothes (*Plate* 38), the Queen of Sheba in a plain white cloak, and her ladies in an austere simplification of contemporary costume. Piero's beauty of texture resides in a synthesis of colour and tone, and not in the stuff represented: in other words, it is the product of spirit and not of matter.

We may now approach the Arezzo frescoes more nearly, and study the construction of the individual scenes. Within the main division already noted—oblong, caesura, square—are many of those devices of pictorial architecture which, as our study of the Flagellation has shown, are both bafflingly complex and astonishingly simple. It is characteristic of Piero's curious economy of mind that the background of the Flagellation (*Plate* 23) and the Meeting of Solomon and Sheba (*Plate* 38) should be almost the same architectural scheme reversed; almost, but not quite, for we are just inside the atrium of the Flagellation, and just outside Solomon's palace. The same love of small variations on a single norm is perceptible in the actual figures. Two of the ladies who stand behind the kneeling Queen (*Plates* 40, 44) have profiles so similar that they seem to have been pricked from the same cartoon. The difference between them begins only with the line of their necks, but it develops into a complete contrast. Similarly the two ladies with horned head-dresses (*Plates* 38, 44) without and within the palace are from the same cartoon reversed, a fact which cannot be explained by idleness or lack of invention, but by a feeling of the importance of repetition as an element in design, familiar in architecture and music, but rare in painting.[38] Perhaps only a painter brought up in the traditions of heraldry and receiving his first instruction, it may well be, from a painter of flags and banners, could have employed so unselfconsciously this elementary form of balance. But manifestly the chief way in which Piero achieves his pictorial architecture is through his power of assimilating what he sees to certain simple geometric forms. This, too, is a part of his equipment which has appealed to contemporary artists, though they have not always shown his knowledge of geometry. And although a geometric framework underlies most of his designs, he is careful to prevent its becoming obtrusive or barren. He will trace the main line of a neck or shoulder in a perfect arc, and then go over the outline so that it has the inflexion of life. Only in certain head-dresses is the original abstract shape allowed to remain unmodified; and in a few passages where the paint has worn thin we may follow his procedure. Such a one is the conical cap worn by the Empress Helena as she kneels before the Cross (*Plate* 68); we can see the mathematical labour he expended on this simple-looking form, and we know from his treatise on perspective what prodigies of calculation were involved in forms of greater complexity.

46

36. HERCULES CARRYING THE HEAVENS.
Metope from the Temple at Olympia.
Olympia, Museum

37. HERCULES CLEANSING THE AUGEAN
STABLES. Metope from the Temple at Olympia.
Olympia, Museum

As a result Piero's compositions combine the restful illusion of extreme simplicity with the inexhaustible quality of variation. All his main divisions are just off centre; everything which appears to work out pat, is in fact subtly irregular. We may take as an example the Dream of Constantine (*Plate* 46), which seems at first to be the most symmetrical of his designs. But the apex of the tent and the point of the parted curtains are not in line, and neither is central. All the main lines of the picture bear up to the left, and are then brought back by the angel's dramatic gesture. Moreover, the perspective is extremely complex, because although it has a single vanishing point, it is taken from four distances; one to include the background tents, the next the two armed men, the next the seated page, and the nearest the head of the sleeping king. These devices, we can be sure, were carefully thought out, and often had a special meaning for Piero. But when all this is granted, we feel that his calculations were inseparable from an instinctive sense of how to make one area tell against another; and, as with a great musician, mathematics alone would not have achieved his perfect harmonies. In those sections of the Arezzo frescoes where the execution is largely by pupils, although no doubt everything is placed according to his design, there is a diminution of harmony due to minute adjustments of contour or tone: and we see that in the end, like all the great classic artists, he justifies the Crocean theory of art, for however carefully his work is planned it is only in the immediate act of creation that it assumes its essential quality of new life.

Hitherto we have been scrutinizing the frescoes as if they were in an aesthetic vacuum. We must look at them once more in order to see what other works of art they recall. Strangely enough they remind us, beyond anything else, of works which Piero can never have seen, the late archaic sculpture of Greece (*Figures* 36, 37), as we know it from the sculptures of Olympia, and other work of the early fifth century. The resemblance lies not only in the largeness of form and nobility of gesture, but in the perfect balance between a plastic and decorative style; and beyond this there is an underlying similarity of metre. We feel that, although Piero had never seen these

47

masterpieces of Greek art,[39] he had deduced from the proportions of classic architecture something of the rhythm which, when that architecture was evolved, had been concentrated in its decorative sculpture. This Greek spirit is most apparent in the scene of the death of Adam (*Plate* 28), where the striding figure on the left vividly recalls the Hercules cleansing the Augean stables in a metope at Olympia (*Figure* 37); and, on the right, the young man with his back turned to us, leaning on a stick, is remarkably close to the style associated with Myron. Even the Adam, so un-Greek as an idea, is modelled with the severity of the fifth-century reliefs in the National Museum of Athens. Piero's innate classicism is, indeed, one of the many mysterious things about him. Almost alone of the great painters of his time, he never includes a reminiscence of classical art for its own sake. He scarcely ever borrows a pose from the antique, still less does he ornament his compositions with reliefs, medals or similar antiquarian trophies. And yet of all his contemporaries he is, perhaps, the one who approaches most nearly the highest style of antiquity, and thus shows us that Greek sculpture owes as much to Euclid as to Homer.[40]

Beside this classical Mediterranean style, and combined with it in perfect harmony, are pictorial devices which Piero clearly derives from a northern source: in particular the dramatic, artificial illumination of Constantine's Dream (*Plate* 46). Night-pieces appear in manuscripts such as the *Très Riches Heures* and *Turin Hours* early in the century, and by about 1450 it was quite usual in Flemish art to represent the Nativity lit by a torch or lantern, and the angels appearing to the shepherds in a blaze of heavenly radiance. Such was the inspiration of Piero's angel who swoops down on the sleeping king with the compelling force of divine revelation. The way in which this dramatic effect of light is combined with large, simple areas, reminds us of the miniatures in King René's *Livre de Cœur d'Amour espris* of 1457 (*Figure* 38); in fact the

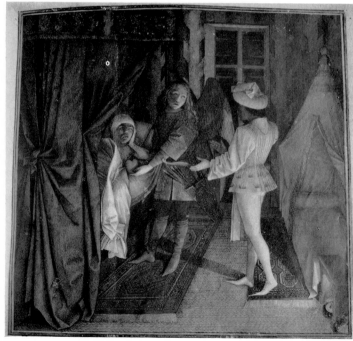

38. The 'René Master': AMOUR TAKES THE KING'S HEART. From the 'Livre de Coeur d'Amour espris'. *Vienna, State Library*

39. Georges de la Tour: ST. SEBASTIAN. *Berlin–Dahlem, Gemäldegalerie*

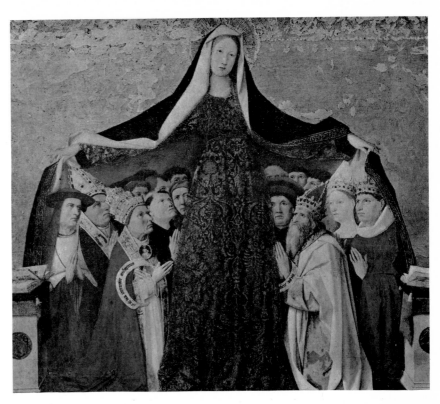

40. Charonton:
THE VIRGIN OF MERCY (Detail).
Chantilly, Musée Condé

correspondence is so close and subtle that we are tempted to believe that the illustrator of this book, like Fouquet himself, was acquainted with Piero's work. The whole interaction of Piero and French paintings in the 1450s (*Figure* 40), is completely mysterious; and must remain so until the discovery of some fortunate document: perhaps in the end it demonstrates no more than a certain affinity with the French temperament, for it is in the night-pieces of a seventeenth-century French artist who can never have known his work, Georges de la Tour (*Figure* 39), that we find the closest parallel to the Dream of Constantine. He, too, discovers in the light of lantern or candle, with its large areas of shadow and simplification of planes, a means of uniting mystery and certainty, intimacy with religious grandeur. In monumental art the chief representation of illuminated darkness which follows that of Piero is Raphael's Liberation of St. Peter in the Vatican; and it is perhaps no coincidence that, according to Vasari, this scene occupies one of the walls originally decorated by Piero.

The third way in which the Arezzo frescoes recall other works of art has already been suggested. They can hardly be independent of Uccello's paintings of the Rout of San Romano (*Figure* 41), which originally decorated the Medici Palace in the Via Larga. True, scenes of medieval battle might, in the nature of the subject, bear a strong accidental resemblance to each other: but the likeness of the horsemen advancing from the left, the decorative use of their lances and the horses' legs, and many other details, are too close for coincidence. To admit a connexion between the two compositions raises difficulties of chronology, and necessitates some unwelcome hypotheses; but to deny it is to sacrifice an obvious truth in order that specialists may not be inconvenienced. Uccello's battles were painted between 1456 and 1459, and it is precisely in these years that we may date the Victory of Constantine. The question therefore arises whether Uccello visited Arezzo, or Piero visited Florence; and, of the two, the latter hypothesis is the more probable. Uccello was the older and better-known painter. He had been famous for his invention and his mastery of perspective since the thirties, and although Piero, when he was Domenico Veneziano's assistant, may not have met him personally, there is reason to believe that he knew Uccello's

49

work. It is unlikely that Uccello visited the provincial city of Arezzo in the 1450s; far more probable that Piero paid one more visit to the centre of art and science, in which, twenty years earlier, he had formed his style. And, in fact, although there is no evidence that he was employed there, there are many traces of Piero's influence in Florence round the year 1460. They are to be found in the work of Baldovinetti, whose Virgin and Child in the Louvre actually bore Piero's name until Mr. Berenson gave it to its real author; and they are unmistakable in such minor works as the predella of the Carrand triptych by Giovanni di Francesco, in the Casa Buonarroti. It is hard to believe that all these artists visited Arezzo; far easier to suppose that Piero, for some reason which is not recorded, was in Florence about the year 1458. Once in Florence we can have no doubt that the new decorations in the Medici Palace would be his first interest.[41] Not only were they amongst the most beautiful and striking things done since Domenico's frescoes in Sant' Egidio, but they had a quality which appealed to him particularly—the combination of heraldry and science. He must have delighted in the decorative use of banners and armour, and above all been impressed by Uccello's power of reducing what he saw to fundamental shapes—arcs, spheres, cylinders—and combining these into intricate and coherent designs. Although he fell short of Piero in so much, in this particular gift Uccello surpassed him. There is, in the Rout of San Romano, a fullness of pattern which excels even that of the Battle of Constantine. Not one square foot of the Uccello but provides a complete and inventive design. Compared to the Victory of Heraclius the superiority of the Rout in this respect is even more marked.

It remains to mention several frescoes in San Francesco which are outside the main series. They include two figures of prophets on the window wall (*Plates* 86, 87), a bearded bishop on the entrance arch, evidently begun by Bicci and finished under Piero's supervision, and several fragmentary figures on the walls beneath it, also executed by pupils. One head of an angel (*Plate* 92), left in isolation, seems to be by Piero's own hand, and bears a considerable resemblance to the central figure on the right of the Flagellation. Other figures, on the opposite arch, seem to be the work of pupils; and a St. Ludovic and a Cupid in a decorative style (*Figures* 22, 42) suggest that Piero has turned to account some of his cartoons for *intarsie*. Of the prophets beside

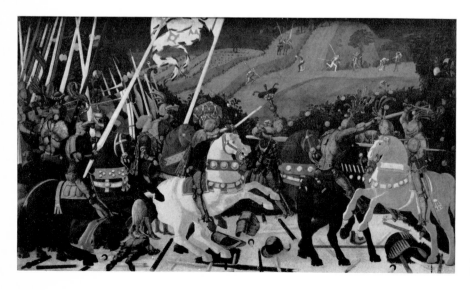

41. Uccello: THE ROUT OF SAN ROMANO. *London, National Gallery*

42. Piero della Francesca (?):
CUPID. *Arezzo, San Francesco*

the window, he to the right (*Plate* 87), is a noble invention, a young, upright figure, with a fearless classic face, like one of Piero's angels grown a few years older; but his companion to the left (*Plate* 86) leans forward rather uncomfortably, and betrays, in a certain crudity of modelling, and, in the curious convention of the hair, the execution of Giovanni de Piamonte. Far the most important of these scenes outside the main cycle is the one at the bottom of the window wall to the east (*Plates* 88–91). This is usually described as the Annunciation; but it seems improbable that Piero, who thought so deeply about the significance of each subject, would have included an episode completely unrelated to the rest of his scheme. Moreover the angel is not bearing a lily, but a martyr's palm, and the dove is nowhere visible. After long hesitation I have decided that this scene must represent St. Helena receiving the news of her death. The fact that it so closely resembles an Annunciation is another example of Piero's love of double meanings, like the Burying of the Wood on the opposite wall. But although in this way it could be related to the main theme, the inclusion of this subject appears to be an afterthought, and there are stylistic reasons for thinking that it was painted later than the rest of the series. The angel's head, it is true, is similar to some of the warriors in the Victory of Heraclius; but the St. Helena reminds us of the altar-piece of San Bernardino at Urbino, now in the Brera (*Plate* 132), not only in the bearing of her head, but in the cut of the cloak and almost identical head-dress. Moreover, the rich architecture, with its delicate ornament and intarsiated doors, recalls the palace of Urbino. The scene can hardly be as late as the Brera altar-piece, but it may well have been painted after Piero's return from Urbino to Arezzo in 1466, and can be taken as the first specimen of Piero's later manner. In composition it follows the scheme which we have observed in his oblong scenes: the main division is to the right of the centre; the left-hand panel is conceived in terms of movement, the right in *stasis*. The formal construction of the St. Helena's head and shoulders, based on a series of related arcs, is repeated in the design of the round-headed window in the upper storey of her house. Before this window is a wooden bar supported on an iron bracket, from which

51

hangs down a piece of looped cord. This is a key to the plan on which the lower right-hand panel is constructed and may be compared with such a contrivance as the windlass in Seurat's *Phare à Honfleur*. A white column, chief emblem of Piero's art, holds the centre of the stage and imposes its metre on the living protagonists. As Professor Longhi has observed, if the Christian legend were forgotten, we might suppose this scene to represent an act of worship in which the object of devotion was a column, held sacred on account of the divine laws which have governed its proportions.

Before leaving the Arezzo frescoes it is necessary to examine the question of their chronology in greater detail, as it affects the dating of other work done during the same years. Supposing the frescoes to have been begun soon after 1452, when were they finished? Had they been completed in 1459 when, as we know, Piero was in Rome; or did he return to work on them after this visit, but before 1466, when they are referred to in terms which imply that they were substantially completed?[42] Our evidence can be drawn only from study of the works themselves, and this suggests that the whole scheme was subject to one major interruption. Between the west and the east walls, there is, as we have observed, a very marked difference of colour and tone. The west wall is painted almost entirely without the visible help of pupils, and the last fresco of the series, Constantine's Victory (*Plate* 51), is the most personal of all. The east wall begins[43] with a scene—Heraclius bringing the Cross to Jerusalem (*Plate* 81)—which is largely executed by pupils. Moreover, it is out of its place in the story. We can infer that Piero, when, for some reason, he could give less attention to the work, reserved for himself the subject which interested him most, the Discovery and Proof of the Cross (*Plate* 59), and let his pupils get on with a less interesting subject during his absence. Even in the Discovery there are traces of pupils' work, and the final battle is full of it. Assuming, then, that there was a break, when did it take place? We have seen that Uccello's Rout of San Romano (*Figure* 41), painted about the year 1458, was almost certainly the inspiration of Piero's Battle of Constantine, the last picture on the west wall. As the major interruption in the series occurs immediately after that, we can, with some confidence, put forward the suggestion that it was caused by Piero's summons to the Vatican. The five or six years he would have spent on the west wall would not be too long a period for this work, especially as it included finishing Bicci di Lorenzo's work on the vaults: moreover, the National Gallery Baptism and the Urbino Flagellation probably belong to the beginning and the middle of this period. Another five years is, so to say, available for the work on the east wall, but during that time Piero, as we have seen, was content to leave a great part of the execution to pupils. We can notice a change in the pupils' work which corresponds with some signed pictures. The curious mannerisms in the Burying of the Wood (*Plate* 45) are similar to those of Giovanni de Piamonte (*Figure* 43), as we know him in a signed and dated work of 1456.[44] The less characteristic hand in the Victory of Heraclius (*Plate* 73) may be that of the local painter, Lorentino d'Andrea, who from 1466 onwards signed a number of works in Arezzo which caricature Piero's drawing, but reproduce with some comprehension his colours and tone. Can we point to any other differences in the east wall which would suggest a visit to Rome? Certainly not in the Discovery and Proof of the Cross, which is completely Tuscan in type and architecture. But in the Victory of Heraclius we may feel that to the memory of Uccello has been added that of

43. Giovanni de Piamonte: VIRGIN AND CHILD
ENTHRONED WITH SAINTS AND ANGELS.
Città di Castello, S. Maria delle Grazie

recently seen battle-pieces of antiquity. The rider on a white horse with a wounded man crouching at his feet is undoubtedly inspired by a relief on the Arch of Constantine,[45] and given this clue to the manner in which Piero translated the style of antiquity into his own, we recognize that the whole composition is greatly influenced by those battles which, since the time of Alexander, had played so great a part in antique art. Perhaps its very lack of clarity, as opposed to the Battle of Constantine, is in part due to this derivation.

We may now examine the other work which Piero was doing between 1452-3, when he undertook the Arezzo frescoes, and 1466, when, as we have seen, his work there was completed. Of his frescoes in the Vatican, no trace remains, and Vasari may be correct in saying that they were done in the room which is now known as the Stanza d'Eliodoro, and that Raphael was instructed to paint his decorations on top of them. He may also be correct in saying that Raphael had copies made of certain parts of those frescoes, although the passage contains inconsistencies which make us question its accuracy.[46] That he worked in the Papal apartment is certain, for we have a document recording the payment of 150 florins for 'paintings made in the room of his Holiness our Lord the Pope'. The only visible evidence of his activity in Rome is a fresco in Santa Maria Maggiore, representing St. Luke the Evangelist (*Plate* 104). Although generally accepted by modern critics, a certain coarseness of type and facture suggests that it is the work of a pupil.

The earliest of the surviving paintings of this period is the Madonna del Parto (*Plates* 95-97), which may date from immediately after his visit to Rome. It is one of the few great works of art which are still relatively inaccessible, and to visit it offers some of the pleasures of a pilgrimage. Only after much wandering and misdirection do we reach a rustic cemetery on a hill a few miles outside the village of Monterchi, where the custodian seems to understand that nature of our quest; and it is with scepticism and apprehension that we see her open the doors of a tiny graveyard chapel. In this heightened state of perception we are suddenly confronted with the splendid presence

53

of the Madonna, rising up, 'full without boast', only a few feet away from us. That this effect, as of a sudden revelation, was in Piero's mind, is evident from the device of the two angels pulling back the curtain.[47] What prompted Piero, at the height of his powers, to work for such a remote community we do not know; remembering that his mother came from Monterchi, it is conceivable that she was buried in the cemetery, and that this painting was her memorial.[48] But this theory does not explain the peculiar subject of the Virgin pointing to her pregnant womb, a subject which never occurs again in Italian painting. Critics have maintained that the execution was by Lorentino, partly because the two angels are taken from the same cartoon reversed. But, as we have seen, Piero resorted to this economical device in one of his most carefully considered frescoes, and with the Madonna of Monterchi the absolute symmetry of the angels' outlines has the effect of repetition in a ritual and increases her hieratic quality. It is possible that the drapery was carried out by assistants, but the Virgin's head is undoubtedly from Piero's hand. Like the Misericordia Madonna, it reminds us of the finest Buddhist sculpture in its calm detachment, and is even more oriental in its outlines. This effect is enhanced by the flat blue dress—Piero's precious mandarin blue, delicately faded—which is little more than a silhouette, and so has come to make the impression of an early Chinese painting. It is characteristic of him that this refined and sacred style should be united to a gesture as natural and shameless as the speech of a peasant.

From this rustic chapel we may follow Piero to the court of Urbino. No doubt he had been there in the fifties, on his way to and from the Marches, but his frequent residence there belongs to the next decade. The palace, that pure expression of the finest humanism, in its reason, harmony and light, was in course of construction. Federigo da Montefeltro was at the height of his fame as a general, and had begun

44. Pedro Berruguete:
FEDERIGO DA MONTEFELTRO.
Rome, Palazzo Barberini

45. Piero della Francesca:
FEDERIGO DA MONTEFELTRO.
Detail from Plate 132.
Milan, Brera

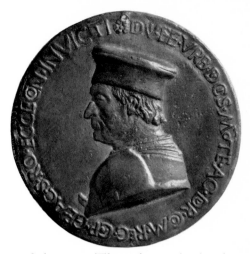

46. Sperandio: FEDERIGO DA MONTEFELTRO. Medal

to occupy his leisure with enlightened patronage of the arts. There is no doubt that Piero found the atmosphere congenial and accepted any commissions which were given him there. According to Vasari, much of his work in Urbino was destroyed, but at least we still have the most personal of all his commissions, his portraits in the Uffizi of the Duke[49] and his wife, Battista Sforza. A portrait of the Duke is mentioned in a poem by a certain Ferabò, who was in Urbino in 1465, but left it in 1466, a year in which Piero himself was in Arezzo. If this picture was one of the two in the Uffizi, then they must date from about 1465. But the fact that Ferabò does not mention the Duchess's portrait may imply that he was referring to another picture. In that case the Uffizi pictures could be as late as 1470.

The portraits are in the form of a diptych, painted on both sides (*Plates* 98–103). On the front the Duke and Duchess are represented bust-length, facing one another in profile; on the reverse they sit in triumphal chariots, attended by the Virtues, and advance towards each other along a rocky ledge. On both sides the backgrounds are panoramic views of the Duke's dominions, unsurpassed in the quattrocento for their truth and atmospheric beauty. Originally the two panels must have been divided by no more than a thin fillet, for the landscapes are continuous, and they would gain considerably if they could be reframed in this way. The 1460s was the great decade of distant views in Florentine art, but Pollajuolo's panoramas of the Val d'Arno, engrossing as they are, have not the enchantment of Piero's shining lake and gentle hills, enisled in mist. The Florentine backgrounds are topography, almost cartography, compared to Piero's poetical contemplation; and as before, we see the lyric quality of atmospheric truth. To have placed in front of these delicate, aerial distances the massive profiles of the Duke and Duchess was a feat involving the finest mastery, both of design and tone. We can gauge its difficulty from two portraits of the Bentivoglios by a Ferrarese artist, now in the National Gallery, Washington, which, it is reasonable to suppose, were painted in rivalry with the Urbino diptych. Skilful as the painter is, he has had to introduce a dark curtain behind each profile by way of transition to the landscape. The conjunction of a portrait head and a distant landscape, with its immense stride in scale, was no doubt invented by Jan van Eyck, in such a picture as the Virgin of the Chancellor Rolin; but Piero has given it a different character by uniting it with the profile pose. Van Eyck's three-quarter-face poses invite penetration into space; the profile arrests it. Yet the profile gives a far more monumental and decorative effect. In the 1400s, Italian portraiture was still predominantly in profile, deriving both from the donor tradition and the practice of medallists. Piero, who, as his Constantine head suggests, was influenced by Pisanello (*Figures* 29, 30), has

55

equalled his skill in filling a space, and his delicate sense of low relief. In bringing together the profile and the distance, he has not only relied on tone, but has found in the Duke's face details, warts and wrinkles and stray hairs, which can be rendered on the same scale and with the same character as the roads and trees which lie half a mile behind him (*Plate* 99). These physiognomical details do not disturb us because they are subordinate to an outline of magnificent character and force. The curious structure of the Duke's nose, due to an accident in a tournament which cost him his other eye, has given him the look of some sacred bird, which the profile pose, by its remoteness, has enhanced. We feel that his face was almost a work of art before Piero began to paint him. This, as we know from other portraits of the Duke (*Figures* 44–46), is a delusion but it gives the measure of Piero's success in turning the mutable envelope of human personality into his own unchanging values. The Duke's olive skin, black hair and red hat stand out decisively; the Duchess's ivory pallor is almost of the same tone as the sky. He speaks boldly, she hardly whispers, 'an excellent thing in woman'. Her hair, with the delicate texture of St. Porchaire faïence, is as plastic as a marble carving by Piero's colleague at Urbino, Francesco Laurana. Her brocaded sleeve is of Van Eyckian richness. But her expression is lifeless, her eye little more than a conventional symbol; and in spite of the precise articulation of her profile, we feel that she was not allowed to give Piero many sittings. This may account for the fact that although she cannot have been more than twenty-five years old when the portrait was painted it gives no impression of vitality or youth (*Plate* 99).

The Triumphs on the back (*Plates* 102, 103) are the most sparkling, and, we may be forgiven for saying, the most Mozartian of all Piero's works. Many a visitor to the Uffizi, turning into the Sala delle Carte, after a surfeit of large, brown canvases, must have found them like a refreshing spring, light, pure, translucent. Piero has taken the formal, familiar motive of the Triumph, known from a hundred cassone fronts and illustrations to Petrarch, and has persuaded us to accept it, with much of its wearisome symbolism, by sheer pictorial skill. The painting of every inch is a joy to the eye, and certain passages, the secular Virtues, for example, are painted with a jewelled touch unequalled except, perhaps, by Watteau. But these silken details are subordinate to a general movement of colour across the two scenes. The Duke's Triumph begins with decent splendour. His car is covered with red and yellow draperies, his faldstool is crimson; this passes into the blue and white of the Cardinal Virtues, and so to the exquisite brightness of white horses with red harness against the white lake. With the Duchess's panel we pass into a gentle shade. Her dun-coloured unicorns are as close in tone to the distant fields as were the Duke's white horses to the lake, but they are muted, and her car has no red and yellow covering; her attendant Virtues are soberly dressed, but the shot orange robe of Faith raises our spirits and prepares us for the last perfect chord, the Duchess's deep crimson, set off by white and grey.

The Urbino diptych shows Piero as a poet of colour and tone, celebrating, through his art, the ideals of a civilized court. His other great work of the period springs from the opposite side of his nature, that earthy, peasant quality to which frequent reference has been made in these pages. For all his intellectual deliberation, and his refinement of taste, this remains the chief motive in Piero's art; and nowhere do we feel more strongly the sense of a natural force growing irresistibly out of the earth than we do in

the picture of the Resurrection, which is still to be found in the Town Hall of Borgo San Sepolcro (*Plates* 105–108). The year of its execution is unknown, but the classical modelling of the torsos suggests a date after the visit to Rome; the landscape, on the other hand, is still close to the Battle of Constantine. We may hazard a date about 1462–4, that is to say during the period of the later scenes at Arezzo, to which it bears considerable resemblance. Unlike them, however, it is entirely from his own hand. Vasari says that it was Piero's best work in Borgo; we may go further and say that it is one of the supreme works of painting in the world.

The Resurrection (*Plate* 105), like the Madonna of the Misericordia, is above all a religious picture. Piero has used his mathematical science to create a sacred image which will command our belief in a mystery. Masaccio's frescoes in the Carmine are of miracles performed in the interest of humanity, charitable works which are well within the range of human sympathy and understanding. But before Piero's risen Christ we are suddenly conscious of values for which no rational statement is adequate; we are struck with a feeling of awe, older and less reasonable than that inspired by the Blessed Angelico. This country god, who rises in the grey light while human beings are still asleep, has been worshipped ever since man first knew that seed is not dead in the winter earth, but will force its way upwards through an iron crust. Later He will become a god of rejoicing, but His first emergence is painful and involuntary. He seems to be part of the dream which lies so heavily on the sleeping soldiers, and has Himself the doomed and distant gaze of a somnambulist.[51]

The effect of the Resurrection is more austerely architectural than that of the Baptism, and is in fact based on a design like the elevation of a Renaissance church. One or two analogous elevations are to be found in Francesco di Giorgio's notebooks, although compared to them the triangles in the upper half of Piero's design are closer to the section of a medieval cathedral. As usual he has employed his perspective for emotive, and even symbolic, purposes. He has deliberately made use of two points of vision. In the lower part the vanishing point is somewhere in the sarcophagus, so that we see the heads of the sleeping soldiers from below. But in the upper two thirds, our point of vision rises till it is level with the head of Christ. His figure is therefore able to maintain its frontal majesty, as if he were a Pantocrator from the apse of a Byzantine cathedral. In order that we shall not be uncomfortably aware of this change, Piero has enclosed the lower perspective scheme by the side of the sarcophagus, and to the upper scheme he has given a background of hills, rising sharply, so that our higher point of vision does not involve looking down on a landscape. The fresco is painted in a style of classic largeness. The sleeping soldier, with armour *alla romana*, is one of the few figures in Piero's work which definitely recall the antique; no doubt the influence of his visit to Rome is also perceptible in the body of Christ, but there it is perfectly assimilated, so that we are not reminded of antiquarian fragments, but of the living art of Olympia. The foreshortened head of the soldier beneath Christ's banner has already been mentioned as the traditional likeness of the artist, and if, as Leonardo and other Renaissance theorists maintained, when we draw an idea of man we are really drawing ourselves, this theory can be supported without reserve. The head of the Christ is outside and beyond his ordinary range, and shows, by contrast with the Baptism, how Piero had come to discover in himself new depths of spiritual understanding.

Other Works in Arezzo

In 1466 Piero was once again in Arezzo, when he signed an agreement[52] with the Company of the Annunciation to paint their new banner. This document is of interest from many points of view. In the first place it tells us that, when the Company decided to have a new banner 'as beautiful as thought or act could make it', they asked members of their Company in Florence if there was a good or sufficient master there. And on receiving an unfavourable reply they unanimously decided on 'Maestro Pietro di Benedetto dal Borgo Santo Sepolchro, he who painted the main chapel of S. Francesco in Arezzo'. The agreement then goes on to say that the banner must be painted with the Annunciation on both sides. The faces of Our Lady and the Arch-angel must be as gentle and beautiful as the faces of angels; it must be executed in fine colours and gold, with ultramarine blue, and must be painted in oils. In spite of this up-to-date stipulation, which has been often quoted by historians of the technique of painting, the document as a whole breathes the spirit of the Middle Ages, and gives us a vivid impression of Piero's patrons, devoted, scrupulous, and proud of their extravagance. Two years later the banner, which had been painted at the Villa della Bastia, near Borgo, on account of the plague, was brought, with ceremony, to Arezzo, and shown to the whole Company, whose members examined it in detail and were satisfied that the Maestro Pietro had carried out his undertakings. Alas, it is now lost, like so many works in the same form by the great artists of the Renaissance.

It was probably during one of these visits to Arezzo that Piero executed the other works in the city mentioned by Vasari, but of these only one survives, the St. Mary Magdalen in the cathedral (*Plate* 109). She is in complete contrast to the Madonna del Parto, at once more masterly and less poetic. Instead of a flat mandarin's robe, the St. Mary's drapery is the most sculptural in all Piero's work. The large folds of her cloak envelop and, by a loop, reveal a plastic central core, as do the draperies of Masaccio and Donatello. The draperies in the Arezzo frescoes are far less Florentine, and why Piero, at this stage of his development, should have reverted to forms which he had assimilated and discarded twenty-five years earlier it is hard to say. A possible reason is that he employed a weightier system of folds in single static figures than in groups involving movement. At all events this type of drapery is visible in several altar-pieces containing isolated figures which belong to the same date.

The first of these is the polyptych which Piero executed for the high altar of S. Agostino in Borgo San Sepolcro (*Plates* 110–117). Vasari speaks of it as a thing much praised, and we have two documents concerning it. The first is an agreement, dated 4 October 1454, in which a citizen, Angelo Giovanni Simone Angeli, undertakes to present the altar-piece to the church, and commissions Piero to execute it. This document refers to another more detailed specification, now lost; it also enjoins the use of gold and silver. The second is a receipt for payment to Piero, dated 14 November 1469; it states that a further payment is to be made, but, as this sum is named, the altar-piece may well have been completed. Thanks to the scholarly insight of Mr. Millard Meiss,[53] we can be certain that four of the chief panels of this altar-piece survive. They are a St. Augustine (*Plate* 110), the patron saint of the church, now in the Museum of Antique Art in Lisbon; a St. Michael (*Plate* 111), the patron of the donor, now in the National Gallery, London; a St. John the Evangelist (*Plate* 112), in the Frick Collection, New York, and a St. Nicholas of Tolentino (*Plate* 113), a favourite

58

47. Workshop of Piero della Francesca:
THE CRUCIFIXION.
New York, Rockefeller Collection

48. Cristofero da Lendinara:
MADONNA AND CHILD.
Modena, Gallery

saint of the Augustinians, in the Poldi-Pezzoli Museum, Milan. They are full-length figures, standing in front of a marble balustrade, and were originally arranged two either side of a painting of the Virgin, either a Coronation or a Virgin and Child enthroned. The base of her throne is continued into the panels of St. Michael and St. John; but the picture itself is lost. There has been much speculation as to her original appearance, and some unconvincing suggestions have been put forward. Perhaps we may gain some idea of her character from a picture in Modena signed by Cristofero da Lendinara, and dated 1482 (*Figure* 48), which is certainly based on a lost Piero of the date and character of the S. Agostino altar-piece. But the broad base of her throne suggests that she may have been raised above the heads of the saints, thus anticipating the design of Antonello's San Cassiano altar-piece. Three small panels of holy persons by an assistant of Piero,[54] which, since two of them are in Augustinian habit, must have originally formed a part of the altar-piece, probably decorated the pilasters at the sides. Scholars have expressed surprise that Piero should have 'reverted' to an old-fashioned form of polyptych. But in 1454 altar-pieces in which all the protagonists were contained in the same space were rare outside Florence, and even in Florence they were exceptional. In spite of the instructions in the commission, Piero has not used gold except in the side panels which were considered as part of the frame, and there is no reason to believe that he has made any concessions to provincial taste.

Without the central Madonna it is, of course, impossible to judge the effect of the whole; but the saints alone give a sense of the overall design, the two outside figures being like solid buttresses, hands and crosses giving an ascending line; while the two inside figures have a circular rhythm, no doubt in contrast with the architectural mass of the Virgin's throne. They are vigorously characterized, especially the two solid figures at the extremities. The St. Augustine's head is an embodiment of intellect and will unusual in Piero's work; the St. Nicholas is one of his exercises in the Flemish

59

49–50. Workshop of Piero della Francesca: THE PRESENTATION IN THE TEMPLE AND THE AGONY IN THE GARDEN; TWO SAINTS AND THE ANNUNCIATION.
Details from the cope of St. Augustine (Plate 110). *Lisbon, Museum of Antique Art*

manner, probably because it is a portrait. There are also many passages of beautiful and luminous painting, St. Michael's armour and pearl-sewn ornaments, for example, or the crystal shaft of St. Augustine's crozier. But there is also evidence that a good deal of work was left to assistants. The numerous scenes on St. Augustine's cope (*Figures* 49, 50), although of interest for the study of Piero's iconography,[55] are certainly not by his hand; and the three small figures of saints, although closer to Piero's design than the similar figures which decorated the frame of the Misericordia Madonna, are the work of a different pupil. We cannot help feeling that the S. Agostino altar-piece was a commission which Piero found a slight drag on his time during the years when he was at work on the Arezzo frescoes, the Resurrection and the Urbino portraits; and that when at last he brought himself to complete it he had lost interest in it.

This leads us to a larger and more crucial question. Was he not, after about the year 1470, beginning to lose interest in painting altogether? This question, at first sight foolishly, and even arrogantly, speculative, is forced into our minds by the dispassionate consideration of his later work, which shows, with one equivocal exception, a

marked decline in freshness, colouring and coherency. It is popularly supposed that the greatest artists go on improving to the end, and such, of course, there have been — Giovanni Bellini, Titian, Rembrandt, Cézanne. But in poetry those from whom inspiration has suddenly or gradually departed are at least equally numerous, and equally great. Racine, Shakespeare, Wordsworth, to name no more, all experienced the drying up of the creative faculties, and met the disaster in different ways — Racine by silence, Shakespeare by writing, as in a dream, some diffuse and uneven works, Wordsworth by substituting for inspiration an earnest common sense. Piero inclined towards the Shakespearian course. For ten years he continued to paint admirably, sometimes nobly, but frigidly, without heart or appetite, and with the increasing help of assistants, as if the occupation bored him. There are beautiful passages in these later works, just as there are in *Cymbeline* or *A Winter's Tale*, but they grow less frequent, and further removed from the main gist of the subject. Then, soon after 1480, he ceased to paint altogether, and for fourteen years lived at Borgo San Sepolcro, compiling his treatises on Perspective and the Five Regular Bodies, in which the practice of painting becomes increasingly a distant memory.

As a prelude to this most delicate problem, we may first examine the exception which has been described as equivocal. This is the Nativity in the National Gallery (*Plates* 118–121), and the epithet may be justified by the fact that one eminent historian of Italian art has published it twice (in the same book) as both the earliest and the latest of Piero's works, whereas another has denied that it is by him at all. There can be no reasonable doubt that it is a late work, and its beauty prevents us from doubting its authenticity, but it is exceptional and can be explained only by an effort of imagination.

The Nativity is generally referred to as unfinished, and all theories of its date and purpose have been based on this assumption. But a recent examination has proved beyond reasonable doubt that the two shepherds on the right are the victims of an earlier restorer. In an effort, perhaps, to remove some encrusted dirt or old repainting he has begun to scrape them, and reduced them to their present pitiful condition, in which, however, certain traces of their finished state are still visible. Unfinished to a lesser degree the picture may have been, and the fact that it comes from the family of the painter suggests that it was an experiment, or something done for his own satisfaction without thought of a patron or of a special architectural setting. It embodies, more than any other work, Piero's long-standing interest in Flemish art. This is most obvious in the child, who, in contrast to the square, muscular infants in the Perugia and Sinigallia pictures, is the pathetic new-born babe of Hugo van der Goes (*Figure* 51).[56] The icongraphical motive by which the Child lies on His mother's cloak is from the same source. But Flemish painting has had a more subtle influence than this. If we compare the feet and ankles of the angels in the Nativity with those of the nearby Baptism (*Plates* 19, 119) we can see that whereas the latter are like the shafts of a column carved by light, the former are contained by nervous and articulate outlines. They are, it is true, beautifully modelled, but the sense of a form existing from within, in accordance with some ideal scheme, has been exchanged for an eagerness to describe and define. Something of the same process has taken place in the landscape. In the background of the Baptism (*Plate* 20) reality was evoked by a series of blots so free that examined closely they seem almost accidental. The landscape of

the Nativity (*Plate* 118) still has Piero's beautiful contrast of light and dark, but the darks are the tight, round trees and bushes of Rogier, with their leaves carefully described, and their trunks growing neatly straight down from their centres. Piero has been faced with the problems of combining these Flemish ways of seeing with his own sense of spatial construction, and this has led him to adopt a design less strictly architectural than that of the Baptism or the Flagellation. It is based on the relation of a right-angle triangle, in which the hypotenuse falls diagonally across the picture, to a rectangle; and these shapes, superimposed in the cowshed, are dispersed in the triangle of the kneeling Virgin and the close-knit rectangle of the angels. These two units are, indeed, perfectly combined by the line of the angels' lutes no less than by the movement of the Virgin's mantle which flows before their feet. But the use of diagonal recession, in contrast to a group so perfectly frontal that it might be a relief, is something which Piero, in his earlier work, would not have attempted. The quintet of angels in itself is one of the few things in his work which can be detached from its context without discomfort, one of the few passages, so to say, made for an anthology. It must owe something to the memory of Luca della Robbia's Cantoria (*Figure* 52), one of the works most admired in 'advanced' circles when Piero was first in Florence. The proportion of the group, the decorative use of the instruments, the open mouths, even the type of dress are all strongly reminiscent. But compared to della Robbia's players on the psaltery and cithara, Piero's choir is, paradoxically, more sculptural. The folds of his angels' draperies fall in a firm, logical sequence, beside which della Robbia's flowing lines look strangely haphazard.

To anyone standing in front of the Nativity all this talk of influences, Flemish or Florentine, and of geometrical combinations, must seem beside the point. His whole attention will be focused on the harmony of blues which unfolds with cool and steady radiance in the lucid atmosphere. Of all Piero's works, this is the one whose voice we hear first. Not only the angels but the colours seem to sing, and with a note so celestially pure that we feel as if he had discovered some new instrument. In fact this is the same silvery tone which irradiates the Triumphs on the reverse of the Urbino diptych, but both scale and steadiness have been increased. To combine the fleeting with the permanent, the intimate with the divine, is one of the most lovable achievements of art, the achievement of Mozart, Vermeer and certain epitaphs in the Greek anthology.

51. Hugo van der Goes:
THE INFANT CHRIST.
Detail from the Portinari altarpiece.
Florence, Uffizi

52. Luca della Robbia:
PSALTERY AND CITHARA.
Florence, Opera del Duomo

What induced in Piero, at a time when painting was beginning to lose its interest for him, this mood of intimacy and lyrical freedom we cannot tell; and we can hardly resist the old fable of the silver-throated swan, invented by poets to symbolize the moment when the gift of poetry was leaving them, and their last notes seemed to have an unprecedented beauty.

The work in which Piero's declining inspiration is first apparent is the altar-piece now in the gallery of Perugia (*Plates* 122–127, 129, 131). It is not documented, but from internal evidence we can say that its execution, like that of all Piero's altar-pieces, must have extended over some years. The assistant who worked on it, and executed the St. Claire and St. Agatha (*Figures* 53, 54), is certainly he who painted the small saints from the S. Agostino polyptych (*Figures* 55–57); on the other hand there are places —the infant Christ, for example—which seem to be of the same date as the Sinigallia Madonna. This slow execution may be connected with the picture's curious form. The lower half is provincially conservative, with a late Gothic frame, whose cusps and crockets assort ill with Piero's classic shapes, and a gold background whose incised design prevents him from giving it the atmospheric quality which he achieved in his first altar-piece, twenty years earlier. We might be able to accept this section by itself, as an exercise in an old-fashioned manner, were it not joined to the upper half, representing the Annunciation (*Plate* 127). This has for its real subject exactly those new elements of vision which the older style excluded, systematic recession in depth, and the direct play of light. In consequence scholars have suggested that the two parts were not originally intended to go together, and were assembled after Piero's time. For the latter proposition there is no evidence; on the contrary the panels on which the Annunciation is painted seem to have been designed to fit on to the irregular base; and although the gable must have been cut down to its present curious shape, if it had been much longer it would have become overpowering. It seems improbable that Piero should, from the start, have conceived the altar-piece with two such disparate sections, and we may reasonably suppose that, as his patrons pressed him, he looked

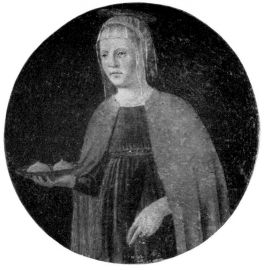

53–54. Workshop of Piero della Francesca: ST. CLAIRE; ST. AGATHA. From the predella of the Perugia Altar-piece (Plate 124). *Perugia, Gallery*

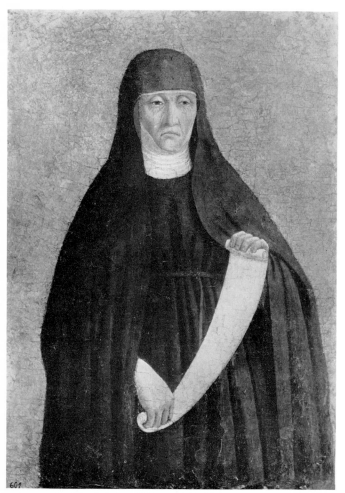
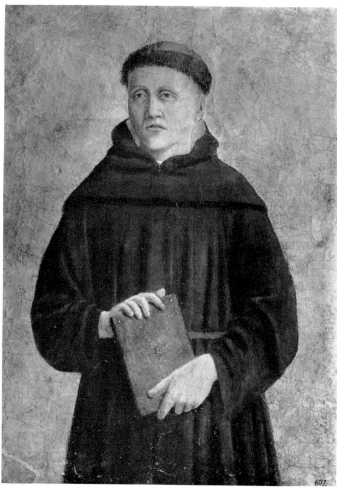

55-56. Workshop of Piero della Francesca: ST. MONICA; AN AUGUSTINIAN MONK. From the S. Agostino Altar-piece. *New York, Frick Collection*

64

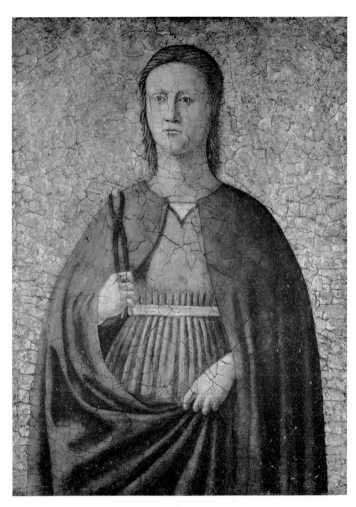

57. Workshop of Piero della Francesca:
ST. APOLLONIA.
From the S. Agostino Altarpiece.
Washington, National Gallery of Art
(*Samuel H. Kress Collection*)

round his workshop for material which would satisfy them, and finally put together this strange agglomeration. Even so, the execution is largely the work of an assistant, who seems to have been entirely responsible for painting the saints Anthony, John Baptist and Francis. Piero himself seems to have taken more interest in the St. Elizabeth of Hungary (*Plate* 126), whose nobly sculptural figure follows a drapery scheme similar to that of the Magdalen at Arezzo (*Plate* 109). Her white hood is painted with a delicacy of observation outside the range of his pupils, and her head is so similar to the St. Michael from S. Agostino (*Plate* 111) that we can hardly accept one as his work and reject the other. It appears that he also did most of the work on the Child, whose members, and in particular His arms, are painted with great mastery. Unfortunately this is not a very consoling image of the infant Saviour. We feel that He may conceivably grow up into Piero's St. Augustine, but not into the Jesus of Christian tradition. At first sight the Virgin enthroned (*Plate* 129) seems too dull and wooden to have been painted by Piero himself, but it is hard to say that her head is of a different quality from that of the Virgin Annunciate in the panel above.

The Annunciation (*Plate* 127) remains, however, a puzzling work, which it is difficult to fit into our concept of Piero. At first sight the blue shadows of the colonnade and the pinkish marble which closes the vista make an attractive impression; and perhaps no-one but Piero himself could have painted the roof and floor of the receding cloister. But on analysis the composition is seen to be without the precision which has marked Piero's other designs of similar complexity. The architecture lacks the harmonious certainty which we find in the background of the Flagellation and the Arezzo frescoes. The relation of the arch to the architrave is unconvincing, and the

65

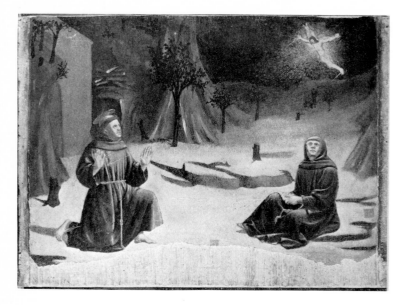

58. Piero della Francesca:
ST. FRANCIS RECEIVING THE STIGMATA.
From the predella of the Perugia Altar-piece.
Perugia, Gallery

cornice is mean. Nor are the figures situated in space with the finality of the Flagellation; indeed it is some time before we realize that the Virgin is *behind* the first columns to the right, and the discovery, when we make it, shocks us by a sense of disproportion. Her figure becomes uncomfortably big, and we are not sure whether she is meant to be standing or kneeling. Even the angel, the most satisfactory part of the whole altarpiece, shows no sense of pre-ordained relationship with the architecture; and compared to the splendid profiles at Arezzo, his outline lacks accent and conviction.

The three predelle of the altar-piece present rather a different problem. Damaged as they are, and in places crudely restored, they show many signs of being painted by Piero himself, and with a good deal more heart than the rest. The scene in which St. Anthony resuscitates the child (*Plate* 122) is beautifully spaced, and the hands detach themselves from the background with that peculiar sense of carving in low relief which we have seen from the portrait of Sigismondo onwards. St. Anthony's follower, relatively well preserved, shows Piero's authentic touch. The same is true of the Stigmatization of St. Francis (*Figure* 58), where the free, blotty painting of the trees, no less than the beautiful tone of the Saint, is inimitable. It reminds us that, in addition to the Dream of Constantine, Piero did other night-scenes now lost, in particular an Agony in the Garden in S. Francesco at Sargiano, which Vasari records as one of his best works.[57] The third scene in which St. Elizabeth saves a child who has fallen down a well (*Plate* 123), is damaged almost beyond recognition. Yet here too there is the kind of bold, volumetric relationship which we saw in Piero's designs for *intarsie*. The broken drum of the well-head is a noble invention, and is related to the two arcs, light and dark, of head-dress and door, in a way which modern purists of design may admire. But although it is a pleasure to come on the authentic Piero in these predelle, we must admit that they were always roughly painted and can never have had the precious, concentrated handling of his small early pieces. And thus, equally with the shop-produced saints above, they confirm his feeling of impatience.

With the Perugia altar-piece we may associate a small Virgin and Child (*Plate* 130) which seems to have been painted during his residence at Urbino, and is now exhibited in the palace, having been brought there from a church near Sinigallia. It is usually placed last in the sequence of his works because it shows, in an extreme form, the peculiarities of his latest style. But it is close to the picture at Perugia, both in colour and handling; the Virgin's head is similar to the St. Elizabeth, in both the Child is of

66

the same Masacciesque type,[58] and even details, like the niche with shelves, occur in both pictures. Unlike his other late works, the Sinigallia Madonna does not seem to have been executed by a pupil, but the actual handling is exceptionally dry, without the freshness and spontaneity of the Flagellation or the Triumphs. Perhaps Piero was trying to achieve, in tempera, the smoothness of Flemish oil painting, so much admired in Urbino after 1470. Indeed the whole composition, with its half-length figures, its light passing through glass window panes into a darkened room on the left, and its basket of linen in a niche on the right, is clearly inspired by a Flemish original. The small Madonnas of Van Eyck, Rogier van den Weyden and their followers, painted for private devotion, had aimed at a feeling of naturalness and intimacy. Somewhat perversely, Piero has placed in this Flemish setting figures of a formidable detachment. The Virgin's head is human enough, but her pose is massively frontal and, instead of the new-born baby of his Nativity, Piero has given her a Child like an infant Emperor on a late Roman ivory. As for the angel on the left, he is the most daunting of all Piero's creations, and seems to forbid, by his glare, our penetration into the sunlit room behind him.

The Sinigallia Madonna, grey and frozen though it is, shows in its background that some spark of interest in painting is still alight. A more complete instance of Piero's loss of pictorial appetite is the altar-piece in the Brera, representing the Virgin and Child with saints and angels, and Federigo Montefeltro kneeling at her feet (*Plate 132, and Colour-Plate facing p. 18*).

No work by Piero has been the subject of more conflicting opinions and more intensive research. The older generation of art historians, from Calvalcaselle to Adolfo Venturi, put off by its monotony of design and deadness of execution, considered it to be the work of a pupil. Hendy, in 1967, described it as 'his last and greatest picture'. Its provenance and intention have been equally the subject of re-assessment. For over a century scholars accepted the tradition that it was painted in 1472 to commemorate the birth of the Duke's only son, Guidobaldo and the subsequent death of his wife Battista Sforza;[59] and supported this theory by the fact that the picture formerly stood on the high altar of the Church of S. Bernardino, a mile outside Urbino. Millard Meiss has shown that the Duchess was buried in the church of S. Donato, and the church of S. Bernardino was not consecrated till 1491, nine years after the death of Duke Federigo. It was built with the intention of becoming a mausoleum for the Duke and his family, but their tombs were not completed there till the 16th century. We are thus left with no evidence except what we can deduce from the picture itself.

We may begin by observing that it is a great and solemn work, over which no pains have been spared. The suggestion that Piero should have allowed such an important commission to be carried out by assistants is not at all convincing. In fact the architecture of the chapel before which the figures are assembled, is of a magnificence and clarity that even Piero never surpassed. The design recalls Alberti's greatest work, S. Andrea in Mantua,[60] but the decorative detail is Piero's own and is rendered with his unfailing sense of light. The way in which a shaft of sun strikes the top of the shell and the egg suspended in front of a pool of shadow, shows a poetry of controlled observation as the background of the Flagellation. When, however, our eye moves down from this noble setting to the group of figures it contains, it is hard

to avoid a feeling of disappointment. We may admire their motionless gravity; their refusal to impress is itself impressive. But they do little to fulfil the sense of space so magnificently promised by the architecture. Although the four angels are standing behind the throne, their heads seem to be almost on the same line as the six saints. This effect has been much increased by the two heads that appear over the shoulders of the saints on either side, S. Bernardino on the left, St. Peter Martyr on the right. Remove these intrusive heads, and a sense of interval is immediately re-established. There can be no reasonable doubt that the composition was originally conceived without them.

Compared to the figures in Piero's frescoes, compared even to the side panels from S. Agostino, all the saints in the Brera Altarpiece seem to lack weight and vigour and at least three of them make the impression of stock figures from Piero's workshop. The St. John to the right is almost a repetition of the St. Simon Zelotes from S. Agostino, the Baptist recalls the Baptist at Perugia, and the insubstantial figure of St. Jerome seems to have appeared in a lost picture which inspired Bartolommeo della Gatta. Only the St. Francis, with his crystal cross, adds something to our conception of Piero. The kneeling Duke supports the same conclusion. His head is taken from the drawing made for the Uffizi portrait, but without the accents and inflections of outline that give the earlier likeness its vitality. His hands are not by Piero, but by one of the Flemish artists employed in Urbino in the 1470's.[61]

These hands, obviously painted from life, show that the altar-piece must date from before the Duke's death in 1482, and was therefore not originally intended for S. Bernardino, which, as we have seen, was consecrated in 1491. Far from Piero having adapted his architectural background to the style of the church, it is probable that the builder of the church[62] had Piero's magnificent niche in mind, and designed a setting that would modestly enhance its splendour. Although we have no documentary evidence for the picture's original position, we have some indications of its date. For one thing Federigo was given the Order of the Garter by Edward IV in 1474, and it is prominently displayed in both the later portraits of the Duke by the Urbino Flemings.[63] Secondly, in these pictures, and in a bronze relief by Francesco di Giorgio, he is accompanied by his son Guidobaldo. In the Urbino portrait Guidobaldo is actually holding a sceptre, although he cannot be more than four years old and there can be no doubt that Federigo wished to use every means of establishing him as his heir. The absence of both the garter and the heir apparent from such a solemn, official work as the Brera Altarpiece is a very strong argument that it was painted before 1474, and although the document that associates it with the birth of Guidobaldo is obviously unreliable, it may include an element of truth.[64]

There remains the problem of the intrusive heads. That of S. Bernardino could be conveniently explained by saying that it was added when the altar-piece was removed from its original position to the high altar of the newly built mausoleum. The head of St. Peter Martyr is far more difficult to explain. It has for long been accepted without question as a portrait of Luca Pacioli, the famous mathematician, who was a friend, although ultimately a treacherous friend, to Piero. Pacioli was a Franciscan friar, and as Professor Millard Meiss has pointed out, he cannot conceivably have been represented as a Dominican saint. A comparison of this head with the

unquestionable portrait of Pacioli by Jacopo de' Barbari at Naples is equally conclusive. Mouth, nose, eyes and the general proportions of the face all differ. To the historian the head of Peter Martyr is as troublesome as that of S. Bernardino is convenient. Whereas the other heads in the altar-piece are idealized and done, it would seem, from existing drawings, the Peter Martyr is clearly a portrait painted from the life. What Dominican monk in Urbino was considered worthy of seeing his likeness included in this courtly work, which was shortly to occupy the place of honour in the Duke's burial place?

There may be another reason for the defects of the Brera altar-piece. Historians are reluctant, on the whole rightly, to explain an artist's peculiarities of style by physical accidents; but in the case of Piero we have several indications which it would be unwise altogether to ignore. Vasari, at the end of his life of Piero, says that in his sixtieth year Piero went blind from a cataract (*per un catarro acceccò*); and this is confirmed by a certain Marco di Longaro, a lantern maker, who told Berto degli Alberti that when he was a child he had led Piero della Francesca by the hand. Both these testimonies date from the 1550s, so are not conclusive evidence. And against them we have specimens of Piero's writing, small and precise, dating from 1490. But it is possible for a very short-sighted man to write clearly with his eye an inch or two from the surface of the paper, and not be able to see a model at four feet. The combination of large, simple areas with focal points of minute detail, which appears in all Piero's work, suggests that he was always short-sighted, and this, combined with cataract, would have made him incapable of painting from life. This would explain why the figures in the Brera Altarpiece seem to be done from old drawings, and are related to the architecture in a way that has a mathematical, but not a visual, basis. It would also explain the fact that although Piero could paint the Duke's head from an old cartoon, he could do nothing about his hands, so that the Duke had them added by another artist. But the limitation of Piero's eyesight, that cut him off from visual impressions, would not have prevented him from designing architecture. We have seen that ever since his acquaintance with Alberti at Rimini the study of architecture absorbed a great part of his attention. Not only did he make it the basis of his compositions, but he introduced into several of them, the Flagellation, for example, and the Proof of the Cross, buildings showing such professional knowledge and originality that we are led to ask if he himself was actually employed as architect. Such a suggestion is not as far fetched as it at first sight appears. Of the two greatest artists of Urbino, Bramante started his life as a painter, and Raphael ended his as an architect. Piero himself left it on record that he was the trusted friend and adviser of Federigo in all matters of art.[65] Did he, as such court artists usually did, also advise him on the construction and decoration of his palace? There is hardly a scrap of evidence, either for or against.[66] But it seems to me probable that, while the construction was carried out by the military architect and engineer, Luciano Laurana, the decoration was greatly influenced by Piero. The exquisite style of architectural ornament which we see in the Urbino Flagellation (*Plate* 23) must antedate the building of all but the foundations of the palace by over ten years. Even the Brera altar-piece (*Plate* 132) dates from a time when the first doors and windows were being designed. Walking through the palace we are everywhere aware of the perfect balance between richness and severity, between

delicate detail and simplicity of surface, between space condensed and space expanded, which is characteristic of Piero's architecture as we know it from his paintings. Having said this, we must grant that the beautiful arcaded courtyard by which the palace is best known has no parallel in Piero's work. The cloister in the Perugia Annunciation (*Plate* 127) has a different character, and an insistent repetition more characteristic of Signorelli's architecture than of Piero's. Nor do we see anything of an arcaded courtyard in the perspective fantasies executed in his workshop, apparently during his residence at Urbino.[67] One of these (*Plate* 128), which still hangs in the palace, seems to me to have been painted by Piero himself: it is entirely in his range of colour, and has a certainty of tone far superior to the others. In execution it is at least equal to the Sinigallia Madonna, which hangs opposite to it.

This exclusive interest in architecture in Piero's last paintings is not surprising. Luca Pacioli begins his book *Divina Proportione* with a distinction between *opinioni* and *certezze*, and suggests that the latter, which alone are worthy of attention, can be achieved by perspective.[68] As a vehicle of *certezze* the measurable proportions of architecture were more satisfactory than the uncertainties of flesh and vegetation. This had already been recognized by Brunellesco, whose famous demonstration of perspective represented the piazza of San Giovanni in Florence, with all the lines diminishing toward a central point.[69] This picture must have been known to Piero; but in imitating it he has used entirely Albertian ingredients, so that his perspectives are almost like illustrations of that section in Alberti's *De Re Aedificatoria* in which he describes the *città ideale*. It shows all the features described by Alberti, the noble porticos with their entablatures of stone, the terraces at the top for taking the air, and in the centre, the circular Temple adorned with columns. It is Piero's last tribute to the great intelligence which had so decisively influenced his life.

With the Brera altar-piece and the architectural perspective we reach the end of Piero's career as a painter. By our reckoning he still had almost twenty years to live. In these years he wrote three treatises to show how the visible world might be reduced to mathematical order by perspective or by the extension of solid geometry. In so doing he proved himself one of the chief mathematicians of his age. This seems to us a matter for regret, but we must remember how differently it appeared to Piero's contemporaries. We are aware that, although art has not greatly improved since the fifteenth century, mathematics has developed beyond recognition. But Piero's contemporaries could not foresee this. To them his contribution to arithmetic and geometry was at least as important as his contribution to painting; in the sixteenth century, perhaps, it seemed even more so, for during that time painting changed to a startling degree and was believed to have progressed, whereas mathematics made comparatively little progress until a hundred years after his death.

Nor was the transference of his interest from painting to mathematics as surprising then as it would be today. In the Renaissance it was assumed that art was a form of knowledge or science. Plato had laid down that there were four fundamental arts – arithmetic, geometry, harmony, astronomy. These alone combined the qualities which lifted them above the accidents and impurities of the physical world. They were certain, they were demonstrable, and they were productive of fresh unities, be they congruities or harmonies, which could be recognized as reflecting some divine plan.

Painting must aspire to the condition of these liberal arts, and it was through arithmetic and geometry that such status could be achieved. For this reason Alberti's *Della Pittura* begins like a book of Euclid; and Leonardo da Vinci opens his *Treatise on Painting* with the words, 'let no one who is not a mathematician read my works'. This Platonic basis of art-theory led the Renaissance artists to attach to the concept of perspective an almost magical importance. For, in spite of a show of reason, there is about their search for absolute certainties something of the alchemists' enthusiasm for the philosophers' stone; and it is with a kind of respectful incredulity that we at first turn the pages of the book in which Piero has set himself to expound his conclusions, the *De Prospettiva Pingendi*. [70] This book has come down to us in two contemporary manuscripts, both of which have drawings and diagrams by Piero himself. One of these, in the Palatine Library at Parma, is in Italian, and is written throughout in Piero's own hand. The other, in the Ambrosian Library, Milan, is in Latin. It was translated, under Piero's direction, by his friend Matteo dal Borgo, and was written by a scribe, though Piero has added several autograph notes in Latin. It is more accurate than the Italian text, and although some illuminations which it contains are unfinished it may be the copy which Piero refers to as being in Federigo Montefeltro's library: at least it is hard to believe that Piero can have drawn his painfully laborious diagrams a third time. Neither MS. is dated, but as the book was presented to Federigo it must have been written before 1482, the year of his death.

At this date the occupation of Piero's lifetime was still uppermost in his mind, and the book is addressed to painters. It opens with a statement clearly taken from Alberti's *Della Pittura*. 'Painting contains within itself three principal parts, drawing, composition, and colouring. By drawing we mean the profiles and contours within which things are contained. By composition we mean how these profiles and contours may be situated proportionately in their proper places. By colouring we mean how to give things their colours as they appear, light or dark, according as the light varies them. Of these parts I intend to deal only with composition, which we call perspective; including however, certain elements of drawing, because without that perspective cannot be demonstrated.' It is interesting to compare the words used for these three divisions by Alberti and Piero. In the *Della Pittura* they are *circonscrizione, composizione, recezione di lumi*; in Piero's book they are *disegno, commensuratio, colorare*. For the first and last Piero has been content to drop Alberti's analytic form and use the current term. But for composition he has adopted a word which makes clear from the start how he envisages it, *commensuratio*. Measurement is indeed his subject, and in the first two books he follows a strictly geometrical method. Perhaps he felt that even the most intellectual painter would find this too abstract, for the third book opens with something like an apology. Many painters blame perspective, he says, because they do not understand how its principles can be applied to all forms. But what is painting if it does not show the surface of things as they are diminished or aggrandized in relation to the eye? Things near will always be seen through a wider angle than things far away, and as the mind alone cannot judge their measurement, so perspective is necessary to discern every quantity proportionately, as in a true science. The demonstration thus introduced begins with simple solids, proceeds to columns and capitals and thence to the human head. This last is of a more than specialized interest.

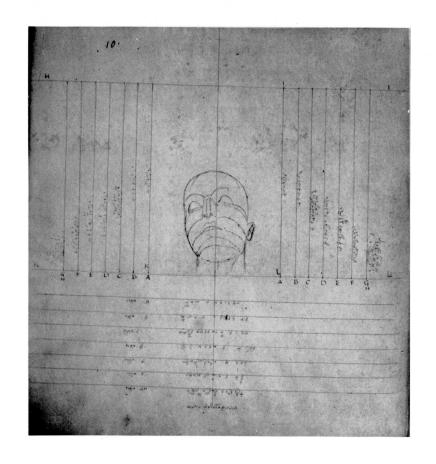

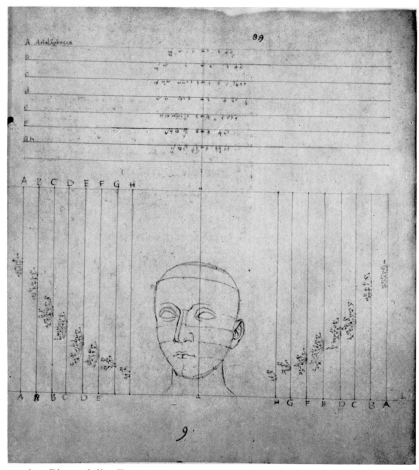

59–60. Piero della Francesca: MEASURED HEADS. From 'De Prospettiva Pingendi'. *Milan, Ambrosiana*

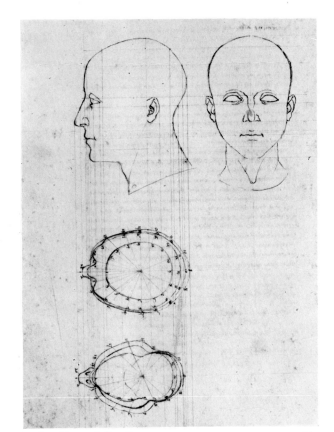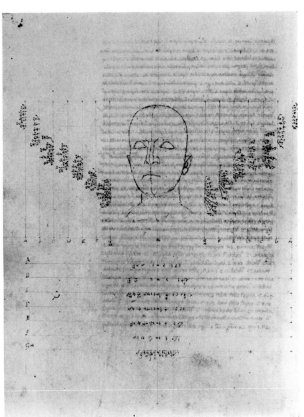

61–62. Piero della Francesca: MEASURED HEADS. From 'De Prospettiva Pingendi'. *Parma, Biblioteca Palatina*

Even although we may not feel inclined to follow Piero's mathematics, we must be fascinated by those heads in which he maps out every plane of the face (*Figures* 59–62), and gives the numerical progression by which they expand and diminish. This is done partly by a system similar to the 'pointing' by which a sculptor copies or enlarges from a model, and partly by cutting the head in sections seen from above or below. The most elaborate example of the 'pointing' method is on f. 67 recto, and no doubt a mathematically minded sculptor could carry out this model almost exactly. In this drawing, and in practically all the other illustrations, the head is reduced to the bald essentials of a barber's block. Yet these diagrams have a kind of beauty which depends not only on *commensuratio*, but on the detached purity of Piero's line.

The *De Prospettiva Pingendi* has been little referred to by writers on Piero's art, but, dry and abstract though it is, it helps to elucidate his aims, and after perusing it we return to his paintings with fresh understanding. True, it never again touches on the subject of colour mentioned in the opening paragraph, and the question how far his harmonies of tone and colour have a theoretical basis must remain unanswered. But it contains a number of drawings of architecture which can be related to his pictures;[65] and, more important still, Piero's diagrams, even if we do not attempt to unriddle them, fill the mind with a sense of harmonious construction. Having seen how pavements, wellheads, columns, arches and other space-controlling forms are submitted to the same lucid and rigorous system of measurement, we can look at his paintings with a more developed consciousness of their beautiful consistency.

In his two later writings the drift of Piero's interest away from painting and towards mathematics is far more apparent. They consist of a small book in Italian on arithmetic and geometry in the Laurentian Library, Florence, and a larger work in Latin on the five regular bodies, *De Quinque Corporibus Regolaribus*, in the Library of the Vatican.[72] The former is in Piero's own hand, the latter is by a scribe, but, as with the

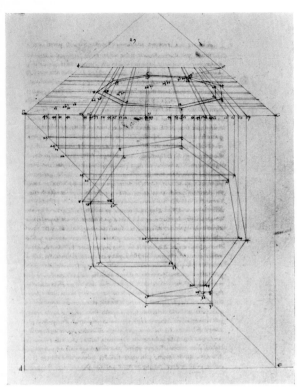

63. Piero della Francesca: THE PERSPECTIVE OF AN
INLAID PAVEMENT. From 'De Prospettiva Pingendi'. *Parma, Biblioteca Palatina.*

Latin version of the *Perspective*, the figures are drawn by Piero himself. It is the copy presented to the library of Urbino, and opens with the dedicatory letter to Duke Guidobaldo, already referred to, in which Piero speaks of it as a work of his extreme old age, written 'in order that his wits might not go torpid with disuse', and asks him to place it on his shelves beside that book on perspective which he had completed many years previously. If this is to be taken literally the book cannot have been written much before 1490. The specimens of Piero's handwriting which it contains are still neat, but the letters are formed with painful deliberation.

The *De Quinque Corporibus Regolaribus* is Piero's final expression of the *mystique* of number which had fascinated him all his life. The idea that the whole complex of appearances should be reducible to five shapes which, because they were geometrically complete and regular, partook of divine perfection, is ultimately derived from Pythagoras and involves some of the magical hocus-pocus of Pythagoreanism. It had reached the Renaissance through the *Timaeus*, a book which seemed to the Middle Ages to give Plato's authority to their own symbolical modes of thought. The modern reader may therefore find it difficult to understand the serious spirit in which Piero devoted the last years of his life to what may seem to be of little more importance than a chess problem. Yet if we grant that harmony, or proportion, is the chief intellectual revelation of the divine; and if we grant, furthermore, that the laws of proportion can be stated accurately only through number: we must allow that the attempt to discover harmonious and mathematically satisfying shapes is worthy of the most serious effort. And then, if we agree with Plato that there must be some reality underlying the chaotic or formless objects which surround us, is it not a short step to supposing that these real, or essential, forms should be the bodies which we have established by calculation as mathematically perfect?

Yes: all this may be allowed; and yet we feel that this last phase of Piero's art was

74

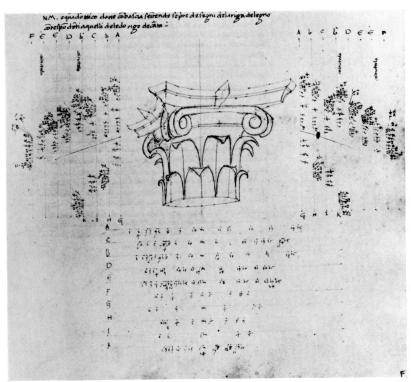

64. Piero della Francesca. A CAPITAL. From 'De Prospettiva Pingendi'.
Parma, Biblioteca Palatina

in a real sense a decadence. A means had become an end, the ideal had been emptied of life, the central fire which warmed and animated those austere constructions, so that they were no longer abstract but the word made flesh, had been extinguished.

In the manuscript on perspective there is a drawing of a head thrown back, numbered so that the foreshortening may be stated accurately (*Figure* 59).[73] The extreme economy and certainty with which it is done gives this pure diagram considerable beauty. Such must have been the drawings which preceded the heads in Piero's frescoes, and some such study of foreshortening must, in particular, have served as a basis for the head of the sleeping soldier in the Resurrection (*Plate* 107). To compare the drawing with the fresco is to recognize the deep reserve of humanity with which Piero in his finest work could cover the Euclidean framework of his forms. We see that what Matthew Arnold would have called his criticism of life, his convictions, that is to say, about the place and destiny of man, were, as in an artist of his stature they always must be, completely central in his art. Two unconscious beliefs direct his imagination: his belief in the continuity of life and in the nearness of God. Man is content to pursue his labours because he knows that God may stand beside him and, with the same unhurried movement, indicate how the work shall be done. No painter has shown more clearly the common foundations, in Mediterranean culture, of Christianity and paganism. His Madonna is the great mother, his risen Christ the slain god; his altar is set up on the threshing floor, his saints have trodden in the wine-press. It is a serious antiquity, without either the frenzies of Dionysus or the lighter impulses of the Olympians. Yet it is more profoundly antique. This unquestioning sense of brotherhood, of dignity, of the returning seasons, and of the miraculous, has survived many changes of dogma and organization, and yet may save Western man from the consequences of materialism.

All this Piero expressed through shapes and colours which are entirely at one with

Conclusion

his philosophy. He was unusually conscious of the way in which formal and dramatic elements must be made to coincide. It is no accident that the Queen of Sheba's attendant who points out to her the sacred wood, also indicates precisely the vanishing point of perspective. The longer we study his pictures, the fuller of such double meanings we discover them to be. But the interdependence of form and content is achieved by something deeper than an intellectual process. Piero's forms are of the same blood. They are 'brothers and sisters at ease within the ancestral hall of space'.[74] By a very detailed description we might be able to analyse this relationship. But we cannot describe the quality of these forms without resorting to moral analogies. The strict logician may object to this procedure and ask by what right we say that one arc is cruel and one is gentle, one curve is noble and another mean? Yet we can all recognize these things as surely as we can recognize cruelty or tenderness in the minute diameter of the eye. The perfect unity of Piero's forms, transcending calculation, rested on confidence in the harmony of creation; and at some point this confidence left him. There remained the apparatus by which this belief in harmony had been expressed, an apparatus so elaborate and convincing that it had seemed almost to be the thing itself; but turned out, once the breath of life had left it, to be no nearer to the essence of art than all the other theories of prosody, of counterpoint, of prismatic colour by which great artists have liberated and controlled their need to identify themselves with the creative process of nature.

1. It occurs in *Fors Clavigera*, letter 22, October 1872, where Ruskin speaks of a pupil taking his master's name, and says 'the prettiest instance of all, "Piero della Francesca", means "Francesca's Peter", because he was chiefly trained by his mother'. This legend, which is taken from Vasari, was rejected by the first scientific students of Renaissance art, who wished to restore the form *Piero dei Franceschi*. It is true that in the notice of his death he is referred to as *M. Piero di Benedetto de' Franceschi*. But two contemporary records concerned with his commission for the Company of the Misericordia at Borgo use the form *della Francesca* (cf. Gronau in *Repertorium f. Kunstwissenschaft*, 1900, p. 393). By contemporary usage his mother could be called 'la Francesca' (cf. la Gioconda), and the use of this form in documents of 1458 and 1462 does seem to imply that his father had long been dead and his mother was thought of locally as the head of the family. Vasari, whose life of Piero is unusually accurate, may therefore be recording a correct tradition.

2. The first considerable monograph on Piero della Francesca, by Professor Roberto Longhi, was published in 1927. It was reprinted with appendixes of new material in 1942 and again in 1947. It is a brilliant book, full of learning, insight and ingenuity, and is not likely to be superseded. The most exhaustive and up to date book is by Oreste del Buono and Pier Luigi de' Vecchi, *L'Opera completa di Piero della Francesca*, 1967. The most recent book in English is by Philip Hendy, *Piero della Francesca and the Early Renaissance*, 1968.

3. An interesting parallel is the accusation of Leonardo da Vinci of 1476, which says of him '*sta con Andrea del Verrochio*'. In the Latin version later used this is translated *manet*. Leonardo was twenty-four at the time.

4. It is possible that Piero co-operated with Domenico again, after his return to Borgo. Vasari (ii. 495) says that 'he painted in company with Domenico di Venezia at Santa Maria di Loreto, and began to work on the ceiling of the sacristy but was interrupted by the plague'. The plague was at Loreto from 1447 to 1452. Vasari's life of Piero contains so much correct information that this may be true.

5. Perhaps Antonio d'Anghiari, who in 1430 signed a contract to paint the high altar of San Francesco at Borgo San Sepolcro but was passed over in favour of Sassetta; but as none of his works survive, we are once more in a desert of conjecture. We may also mention the suggestive similarity between Piero's early work and the Virgin and Child by Domenico di Bartolo (*Figure* 4) in the Pinacoteca, Siena, signed and dated 1433.

6. Cf. Longhi, 'Fatti di Masolino e di Masaccio' in *La Critica d'Arte*, 1940. Of its many ingenious hypotheses, that relating to Beato Angelico seems the most convincing.

7. From San Domenico at Fiesole, and undated as usual, but for many reasons probably earlier than 1440. Even more remarkable is the Piero-esque character of design in two of the predelle of Angelico's San Marco altar-piece, which seems to have been executed in 1438. These are The Attempted Burning of SS. Cosmas and Damian in the National Gallery of Ireland, Dublin (*Figure* 8), and The Miracle of the Camel in the Museum of S. Marco, Florence. The disposition of area, the geometric frontality of presentation and the use of perspective at the sides all suggest Piero rather than Angelico. On the other hand, the actual execution bears no resemblance to that of Piero.

8. It is, however, noteworthy that his name is not included by Vasari in the list of artists who studied in the Carmine Chapel.

9. The *Della Pittura* is prefaced by a dedicatory letter addressed to Brunellesco as to an intimate friend. It refers to Donatello as 'nostro amicissimo' and names three others as revivers of the arts, Ghiberti, Luca della Robbia and Masaccio. Cf. K. Clark, 'L. B. Alberti on Painting', *Proceedings of the British Academy*, vol. xxx. An imaginative and convincing assessment of Alberti's influence on contemporary artists is in Krautheimer, *Lorenzo Ghiberti*.

10. The central part with St. Francis in glory is in the Berenson Collection, Settignano (*Figure* 16); seven scenes from the Life are in the National Gallery, London; an eighth at Chantilly. On the back was a Virgin and Child, in the Louvre, and full-length panels of St. John the Baptist and the Blessed Ranieri, also in the Berenson Collection.

11. The Company was probably influenced in its choice of subject by a famous Madonna della Misericordia in the church of Sta Maria delle Grazie, Arezzo. It is a typical work of late gothic painting, and Piero's contract which was printed by Milanesi in *Il Buonarroti*, 1885, iii, is completely medieval in spirit, e.g. it stipulates that the picture shall be *deauratam de fino auro et coloratam de finis coloribus et maxime de azurro ultramarino*.

12. Since 1951 the whole altar-piece has been restored and the general effect is much improved, particularly that of the Crucifixion.

13. He was probably a miniaturist, but Professor Salmi's suggestion, *Rivista d'Arte*, 1942, that he was a Camaldolese monk named Giuliano Amedei is not entirely convincing.

14. Central Madonna and Child in the National Gallery, London (*Figure* 10); Crucifixion in the gallery of Naples (*Figure* 6); Saints from the frame in the galleries of Pisa and Berlin, and in the Lanckoronski Collection, Vienna. Predella in Berlin.

15. Charles de Tolnay in a beautiful article *Conceptions religieuses dans la peinture de Piero della Francesca* (*Arte Antica e Moderna*, 1963, *p.* 4) points out that the columnar form of the Virgin's figure was probably intended to symbolize the church, an idea developed by the apse-like form of her cloak.

16. This woodcut is said by G. le Monnier in a note to Vasari, ii. 488, to have been taken from a self-portrait in the possession of Piero's heirs, the Franceschi-Marini family. Milanesi adds the note that this portrait was a copy. It has since disappeared. A portrait supposed to represent Piero, and belonging to the same family, published in the *Rassegna d'Arte*, 1920, p. 111, is a full length of the late sixteenth century attributed to Santi di Tito. It shows Piero with a moustache, and is no more than a commemorative effigy.

17. The Tempio is based on thirds, Santa Maria Novella on quarters; cf. Wittkower, *Journal of the Warburg Institute*, vol. vi, Nos. 1–2 (1940–1).

18. These panels are now exhibited in the Palazzo Communale of Borgo San Sepolcro.

19. 'Practically', because the St. Jerome in Penitence in Berlin (*Figure* 15) may be considered a partial survivor. Longhi was correct in saying that the figure of the saint and his rocky niche were by Piero, the landscape by a later hand. Recent restoration has shown that it was a finished picture from Piero's own hand, over-painted by some conventional artist of the late 15th century. It is inscribed PETRI DE BVRGO OPVS MCCCCL.

20. Professor Longhi believes that the background of the St. Jerome does not represent Borgo, but that the number of chimney pots indicate some town in the Veneto.

21. Cavalcaselle, in his intelligent summary of Piero's style, says, 'He enjoyed a happy conjunction of the talents which adorned the Van Eycks and Leonardo da Vinci'.

22. Not only does Vasari, ii. 676, imply that the S. Egidio decorations were finished in oil, but the account books of Santa Maria Nuova record several payments to Domenico for linseed oil. It is in connexion with one of these payments that Piero's name is mentioned as Domenico's associate, cf. *Giornale Storico degli Archivi Toscani*, 1862, p. 4.

23. It is commonly said to have been taken from the reverse of Matteo dei Pasti's medal of Sigismondo (*Figures* 25, 26), cf. Hill, *Corpus* 164a. But the two views, although taken from the same point, are not identical, and could be independent of one another.

24. Denistoun, *Memoirs of the Dukes of Urbino*, 1851, ii. 199, quoted it as the most probable of several suggestions. He says that the three figures 'are generally called at Urbino the successive sovereigns, Oddantonio, Federigo and Guidobaldo'. Such an absurd tradition proves that their identities were completely forgotten.

25. He began writing the *De Re Aedificatoria* in 1442, but it was not finished before Lionello d'Este's death in 1450. The completed MS. seems to date from 1452.

26. From the second Psalm, verse 2. It is part of the service for Good Friday, and often appears in illuminated MSS. with illustrations of the Flagellation.

27. A very elaborate study of the perspective of the Flagellation was published by R. Wittkower and B. A. R. Carter in the *Journal of the Warburg and Courtauld Institutes*, XVI, 1953, 3–4, pp. 292–304.

28. It is notable that Bicci di Lorenzo had been the daily labourer employed by Domenico Veneziano when he and Piero were at work on the decoration of S. Egidio in 1439.

29. Actually the window faces south-west, so the terms east and west applied to the side walls are not strictly accurate, but are perhaps clearer than left and right. For the condition of the frescoes, see p. 225.

30. First noted by Philip Hendy, *Piero della Francesca and the Early Renaissance*, 1968, p. 86.

31. Longhi, *Piero della Francesca, Frescoes in Colour*, p. 13. One of the many touches of poetical imagery which give a special value to his criticism.

32. Warburg and others have supposed that Piero took the likeness of Paleologus from Pisanello's medal of 1439 (*Figures* 29, 30), but this is not entirely true. The characteristic shapes and rhythms of the two heads are different. As has been said above, Piero almost certainly saw Paleologus with his own eyes.

33. Voragine says that the Cross carried by Constantine was gold, but Piero's Cross was always white, thus satisfying aesthetic rather than iconographical requirements.

34. A. Warburg, *Gesammelte Schriften*, i. 253.

35. It is just possible that Piero had been an eye-witness of a battle, as the battle of Anghiari, later to be immortalized by Leonardo da Vinci, was fought outside the walls of Borgo San Sepolcro in June 1440.

36. The identification of likenesses is notoriously misleading, but it is hard not to believe that the man in profile to the left of the group is the same man, grown somewhat heavier with age, as he who kneels on the left of the Madonna della Misericordia.

37. It is one of the few parts of the wall which were partly executed by a pupil, probably Giovanni de Piamonte, whose rather aggressive glossiness is apparent in the horses' heads.

38. This process of fitting parts together, so much at variance with an organic concept of art, is usual among classical artists. Maillol frequently put different heads on the same body, and the writer has seen him wander round with an arm looking for some torso on which it would look well. It is interesting to note that Vasari records Piero as having built up his compositions with the help of small clay models covered with soft cloth. This procedure, which was followed by many classical artists, above all by Nicolas Poussin, seems to have existed already in the workshop of Masaccio.

39. It is possible that Piero had some fragments of Graeco-Roman painting. His light tonality, the large simple modelling of his forms and the way in which they are placed in front of panels of marble are reminiscent of such antique paintings as those from Boscoreale in the Metropolitan Museum, New York. No doubt that much more painting was then visible in Rome than is recorded.

40. It is possible that Piero's classicism was in fact recognized in his lifetime. In Giovanni Santi's rhyming chronicle are the lines
Masaccio d' l'Andrein, Paolo Ocelli
Antonio e Pier si gratni dissegnatore
Piero di Burgo antico pui' di quelli
Dennistoun, who first published the chronicle in his *Memoirs of the Duke of Urbino*, 1851, vol. II, p. 456, assumes that Santi, being hard up for a rhyme, could think of nothing better to say about Piero but that he was older than the brothers Pollajuolo. But the natural word would have been *vecchio*, and Longhi may be right in thinking that by *antico* Santi meant classical. Only twenty years later the Mantuan court

sculptor Bonacolsi was known as Antico on account of the classical character of his work.

41. He must also have seen the recent works of Andrea del Castagno, the Last Supper and Resurrection in S. Apollonia, the two chapels in the Servi, and the decorative wall-paintings of famous men and women at Legnaia. Piero evidently had Castagno's Resurrection in mind when he painted his masterpiece at Borgo San Sepolcro; and there may be a memory of the decorations at Legnaia in two fragments of fresco from San Sepolcro, the Hercules in the Gardner Museum, Boston, and a Young Saint (St. Julian?) recently discovered in the choir of S. Agostino and now in the Borgo San Sepolcro Pinacoteca (pl. 93).

42. See p. 58.

43. The reader should perhaps be reminded that in a large decorative scheme, frescoes were invariably painted from the top downwards. Otherwise the damp ran down and stained the completed decorations below.

44. In the church of Santa Maria delle Grazie, Città di Castello. I give his name as he signed it, since we have no other evidence for the spelling. The importance of this signature was first recognized by Professor Longhi.

45. Cf. A. Warburg; *Gesammelte Schriften*, i. 253.

46. He says that Piero worked 'in competition with Bramante of Milan'. If by this he meant, as is generally supposed, the Milanese painter known as Bramantino, the statement is absurd, for Bramantino was only born in about 1475. It would even be too early for Bramante of Urbino. In the life of Raphael, Vasari adds the information that only one of Piero's scenes was finished, which may be an attempt to extenuate the vandalism of their destruction, but is perhaps borne out by the fact that Piero cannot have been in Rome for very long. For the documentary evidence of Piero in Rome, cf. G. Zippel in *Rassegna d'Arte*, 1919, p. 87.

47. The same motive was used by Andrea del Castagno in his frescoes in the Villa Pandolfini at Legnaia, painted about 1450.

48. It is significant that Vasari mentions her death, which he says was the reason for Piero's return from Rome.

49. Actually Count. He was not created a Duke till 1474.

50. Hendy, *op cit.*, p. 136 points out that Ferabò's poem, entitled *The likeness of the Prince painted by Piero di Burgo addresses the Prince himself* does not

mention the Duchess's portrait or the Triumphs, and so may refer to another portrait of the Duke. He considers that the diptych was probably painted after the Duchess's death in 1472. The fact that her head was evidently not painted from life would support this hypothesis, and Hendy also points out that the verses under her portrait seem to refer to her in the past tense. But had she recently died they would surely have been in a different tone; nor do the Triumphs at all suggest that the diptych commemorates the major tragedy in the Duke's life. Ferabò's verses may well refer to another picture, but the diptych must surely date from before 1472.

51. Charles de Tolnay (loc. cit.) points out that whereas on the left hand side of the fresco the landscape is in shadow and the trees are bare, to the right the trees are in leaf and hills have caught the first light of dawn.

52. Published by Milanesi, *Sulla Storia dell' Arte Toscana Scritti Vari*. Siena, 1873, p. 299.

53. Cf. *The Art Bulletin*, vol. xxiii, 1941, p. 53. Actually he published three of the panels and prognosticated that there must have been a fourth representing St. Augustine. This was subsequently published by K. Clark in *The Burlington Magazine*, vol. lxxxix, 1947, p. 205.

54. A St. Monica and an unidentified Augustinian in the Frick Collection, New York (*Figures* 55, 56); and a St. Apollonia in the National Gallery of Art, Washington, Samuel H. Kress Collection (*Figure* 57). Professor Longhi (loc. cit., p. 186) believes that the Crucifixion in the Rockefeller collection, New York (*Figure* 56), was part of the predella of the same altar-piece. It may have been executed in part by the same assistant who painted the small scenes on St. Augustine's cope (*Figures* 49, 50).

55. Cf. K. Clark, *Burlington Magazine*, loc. cit.

56. Definitely more like Hugo van der Goes and his followers than Rogier. True, Rogier's work had been known to Piero since 1450, and Hugo's Portinari altar-piece dates from 1475. But Hugo's work may have preceded him to Italy, and his fellow student, Justus of Ghent, probably arrived there in 1468. Piero's baby also reminds us of the Nativity at Autun by Hugo's French follower known as the Maître de Moulins.

57. Vasari, ii. 497, 'un Christo che di notte ora nel orto, bellissimo'. Perhaps a reminiscence of this occurs in one of the scenes on St. Augustine's cope, (*Figure* 49).

58. Strangely enough they are most like the Child in the Virgin and St. Anne in the Uffizi which is one of Masaccio's earliest works, perhaps done in collaboration with Masolino.

59. It goes back to a note in the records of the convent of S. Bernardino which says 'about this time (1472) the altar-piece of the high altar was painted by Fra Bartolommeo, called Fra Carnovale, because the Virgin is a portrait of the Duchess Battista Sforza, and the Infant on the Virgin's lap is the likeness of the son born to the Duke of the said Duchess'. This was first quoted by Pungileone *Elogio Storica di Giovanni Santi*, 1822, p. 53. But Crowe and Cavalcaselle, who saw the note, say (vol. v, p. 30) that it was in an eighteenth century hand; and the reference to 'Fra Bartolommeo, called Fra Carnovale' does nothing to confirm its credibility.

60. S. Andrea was being built from 1472 to 1494. But this is no guide to the date of the altar-piece, as Piero certainly had access to Alberti's designs.

61. See page 231.

62. Attributed by Papini to Francesco di Giorgio, but on no reliable evidence. He gives reasons to believe that the barrel vaulted choir of S. Bernardino is a later addition, replacing a semicircular apse, such as those that exist in the transepts. R. Papini, *Francesco di Giorgio Architetto*, vol. i, p. 112.

63. The portrait with Guidobaldo from the library, now in Urbino, and the portrait group of the Duke and his courtiers listening to a humanist teacher at Windsor Castle.

64. For a recent discussion of the altar-piece see M. Meiss, *Art Bulletin*, 1966, pp. 203-206.

65. In the prefatory letter to the *Quinque Corporibus Regolaribus*, addressed to Duke Guidobaldo. A translation of the relevant part will be found in Denistoun, loc. cit., ii. 196.

66. Salmi, *Piero della Francesca Architetto*, bases his arguments on the architectural character of Piero's own house at Borgo San Sepolcro, now destroyed but known from engravings. The most persuasive circumstance is that, from the dismissal of Laurana in 1472 to the appointment of Francesco di Giorgio in 1477, no architect is recorded as being in charge of the important work then being executed at the Palace of Urbino; and during these years Piero was apparently Federigo's adviser in all matters of taste and design.

67. They are in the palace of Urbino, the Walters Collection, Baltimore, the Gemäldegalerie, Berlin and formerly, the Schlossmuseum, Berlin. They are most fully discussed by Fiske Kimball in *Art Bulletin*, 1927, p. 125, who, however, puts forward the fantastic

hypothesis that they were painted by Laurana.

68. Pacioli may be quoting Piero's words. It is now proved beyond question that a great part of the *Divina Proportione* is an unacknowledged, but practically direct, translation into Italian of Piero's Latin MS. *De Quinque Corporibus Regolaribus*. Cf. Jordan in *Jahrbuch der kgl. Preuss. Kunstslg.*, i. 1880. The indignant accusation of plagiarism with which Vasari opens and closes his life of Piero is therefore justified. It is, however, fair to say that Pacioli pays an enthusiastic tribute to Piero, both as an artist and as a master of perspective, in the dedication of his *Summa de Arithmetica*.

69. Vasari, ii. 332; Manetti, *Vita di Filippo di ser Brunellesco*, ed. Elena Toesca, pp. 10–12.

70. The most recent edition of the *De Prospettiva Pingendi* is by G. Nicco Fasola, Florence, 1942. It has an admirable, if somewhat abstruse, introduction, and supersedes the earlier standard edition by Winterberg (Strassburg, 1899). The references of the two original manuscripts are as follows: Parma,

Biblioteca Palatina, 1576; Milan, Biblioteca Ambrosiana, Cod. Ambr. C. 307 inf.

71. Such are the capital on f. 55 recto (*Figure* 64) which is of the same type as that in the 'Annunciation' at Arezzo, and the coffered niche on f. 81 recto which is similar to that of the Virgin's throne in the Perugia altar-piece.

72. The former is Ashb. 359* and is entitled *Del abaco*. The latter is Urbinas 632. The second part of Ashb. 359* appears to be a sort of sketch for Urbinas 632, and contains many of the same diagrams. Pacioli's *De Divina Proportione*, although in Italian, is closer to Urbinas 632. Perhaps it is based on a third text in Italian now lost. The *De Quinque Corporibus Regolaribus* was published by Mancini in 1915.

73. On f. 76 recto of the Parma MS., and f. 103 verso of the Ambrosian. The latter is, as usual, the more interesting drawing, and shows a more aesthetic and less mathematical outlook.

74. One of many beautiful descriptions of Piero's art in Adrian Stokes, *Art and Science*.

The Plates

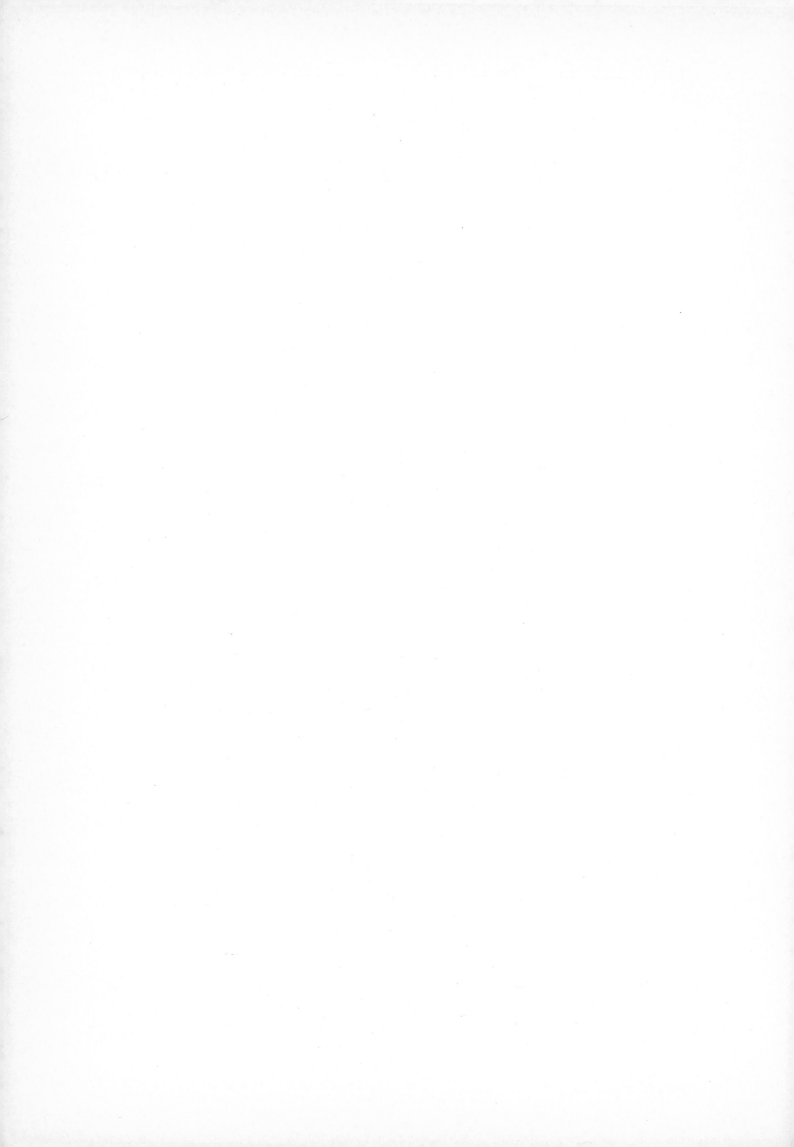

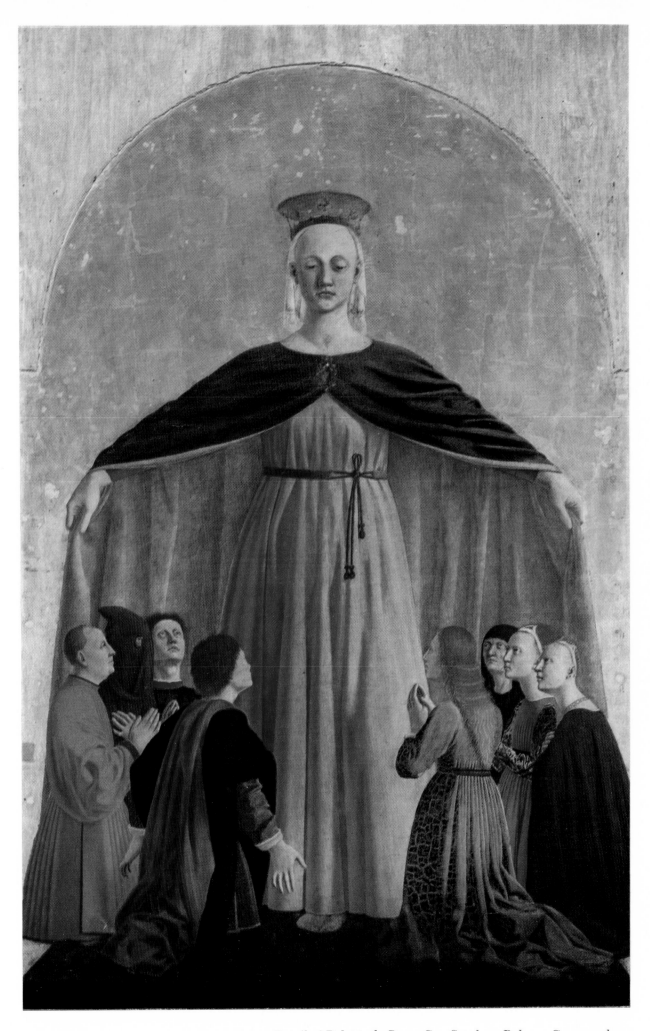

I. MADONNA DELLA MISERICORDIA. *Detail of Polyptych. Borgo San Sepolcro, Palazzo Communale*

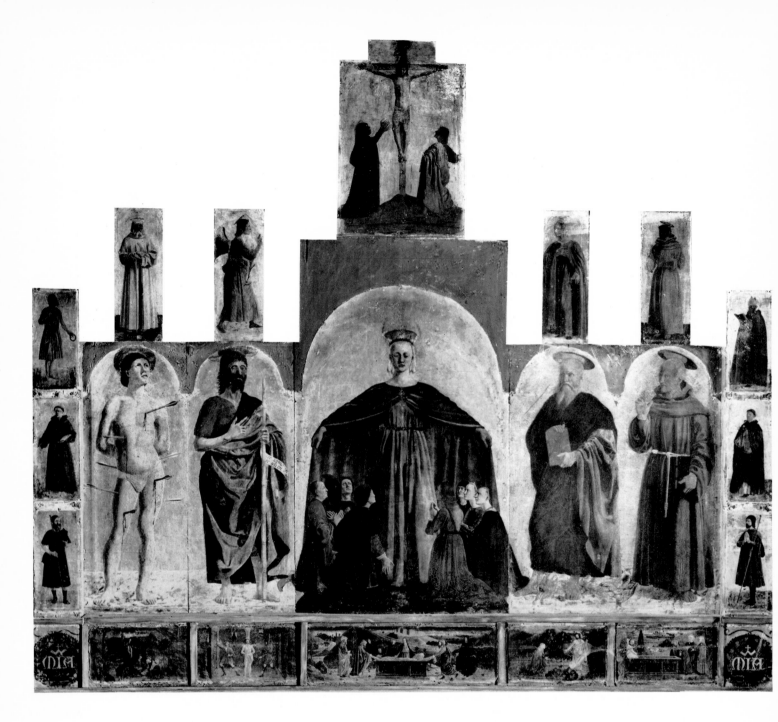

2. MADONNA DELLA MISERICORDIA. *Polyptych. Borgo San Sepolcro, Palazzo Communale*

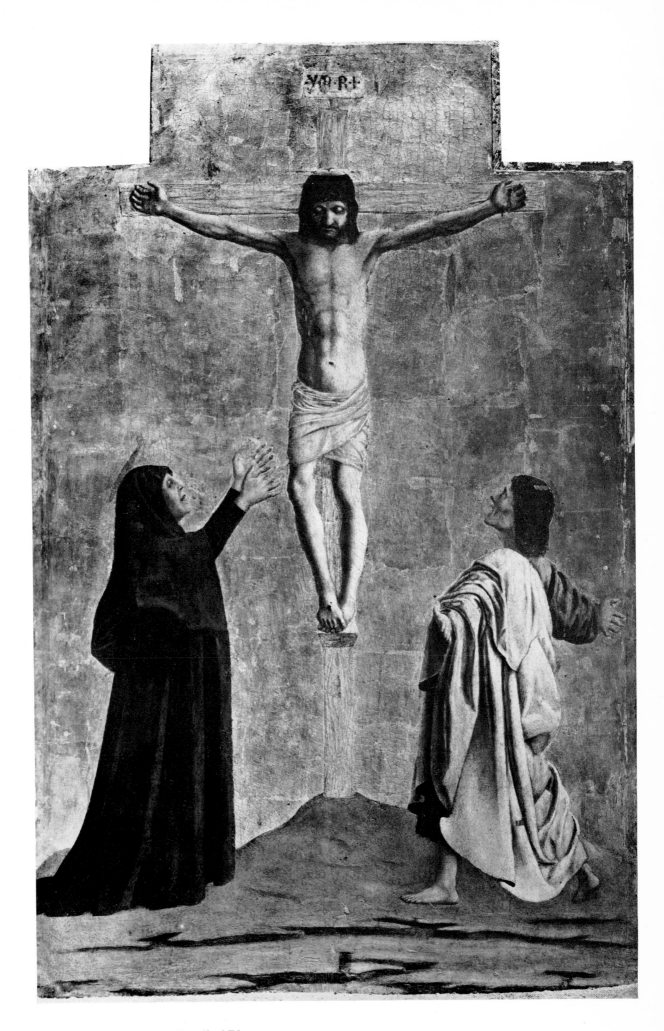

3. THE CRUCIFIXION. *Detail of Plate 2*

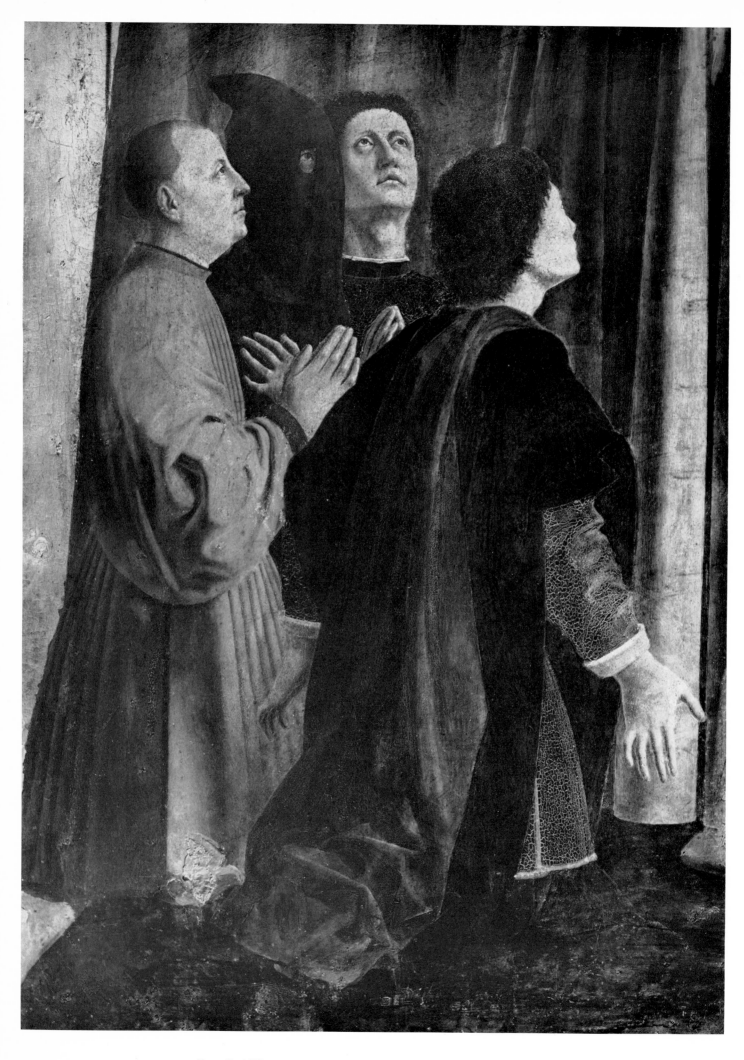

4. GROUP OF WORSHIPPERS. *Detail of Plate 2*

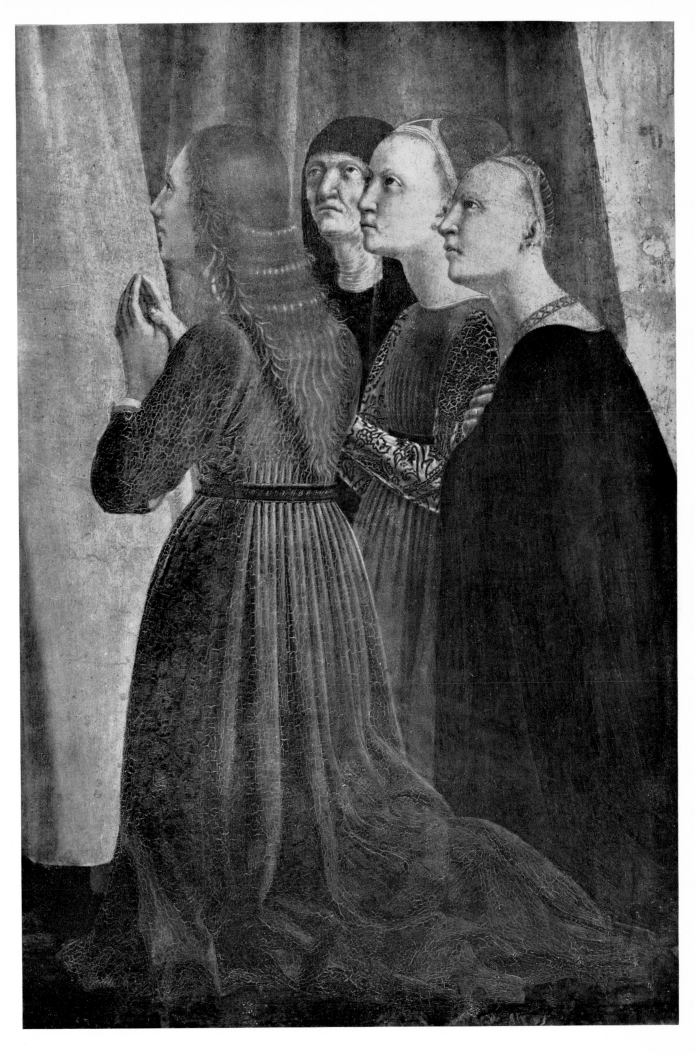

5. GROUP OF WORSHIPPERS. *Detail of Plate 2*

6. HEADS OF WORSHIPPERS. *Detail of Plate 2*

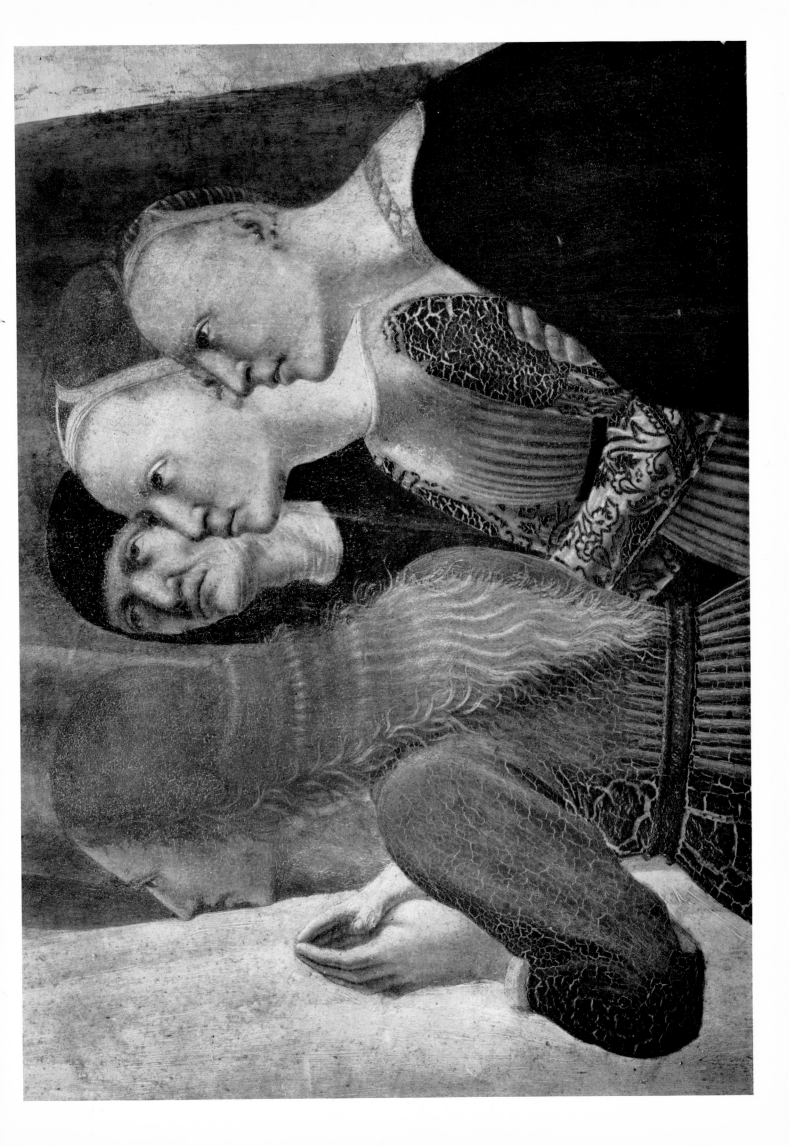

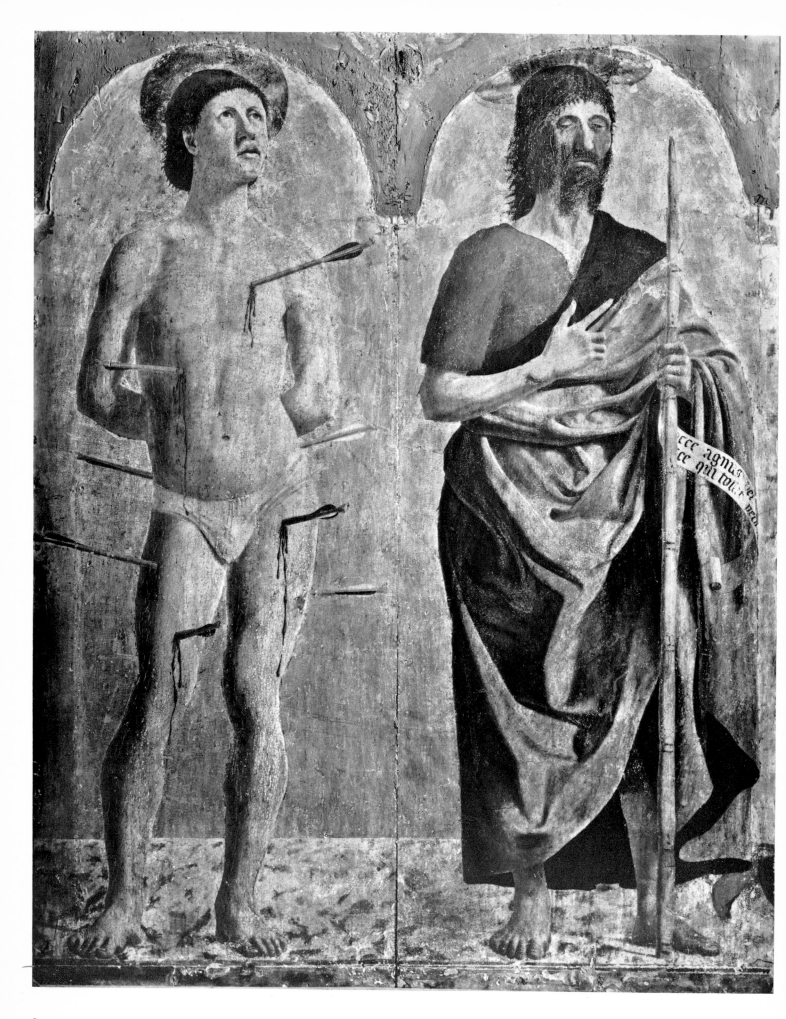

8. ST. SEBASTIAN AND ST. JOHN THE BAPTIST. *Detail of Plate 2*

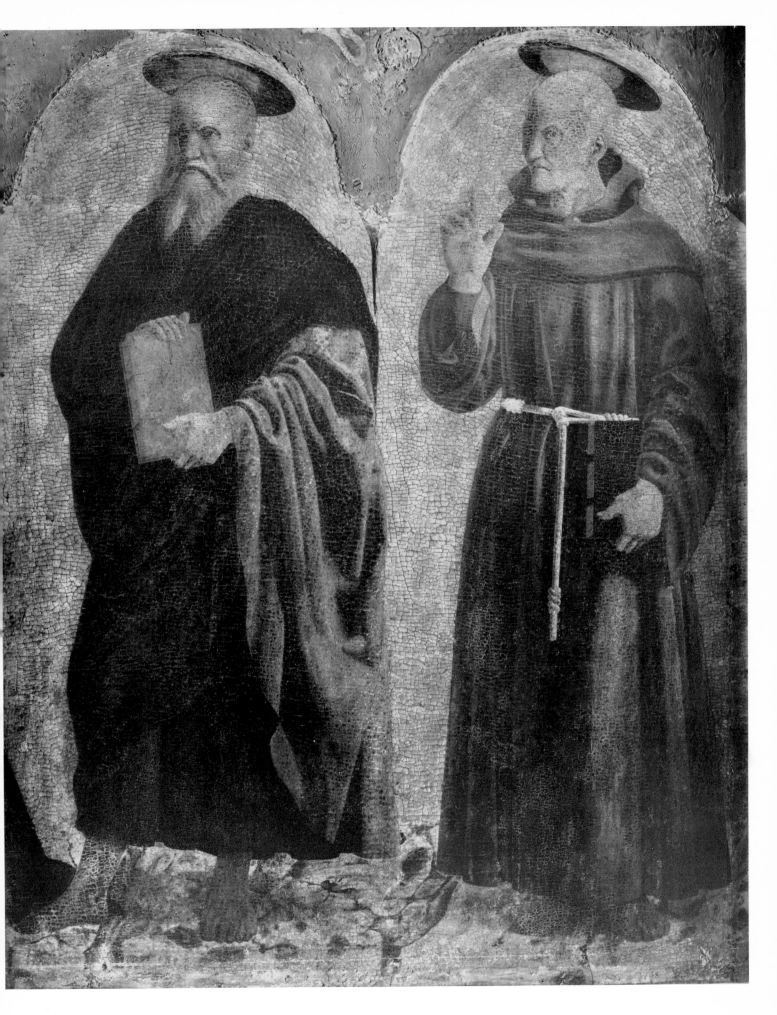

9. ST. ANDREW AND ST. BERNARDINO. *Detail of Plate 2*

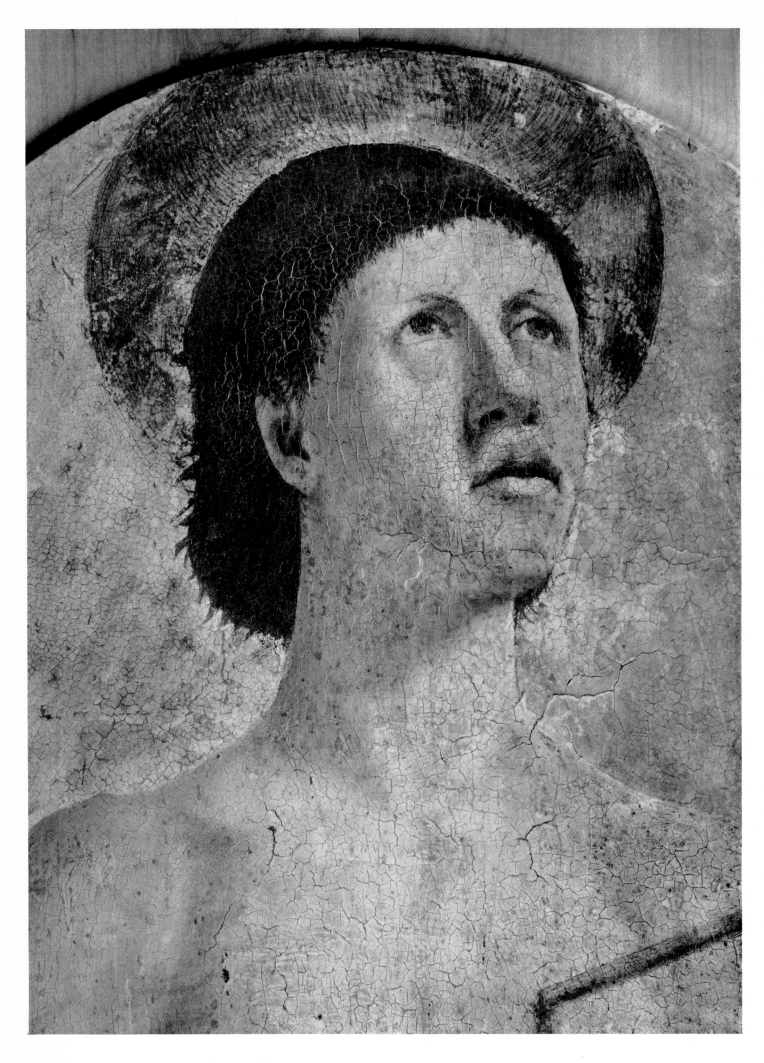

10. HEAD OF ST. SEBASTIAN. *Detail of Plate 2*

11. HEAD OF THE MADONNA DELLA MISERICORDIA. *Detail of Plate 2*

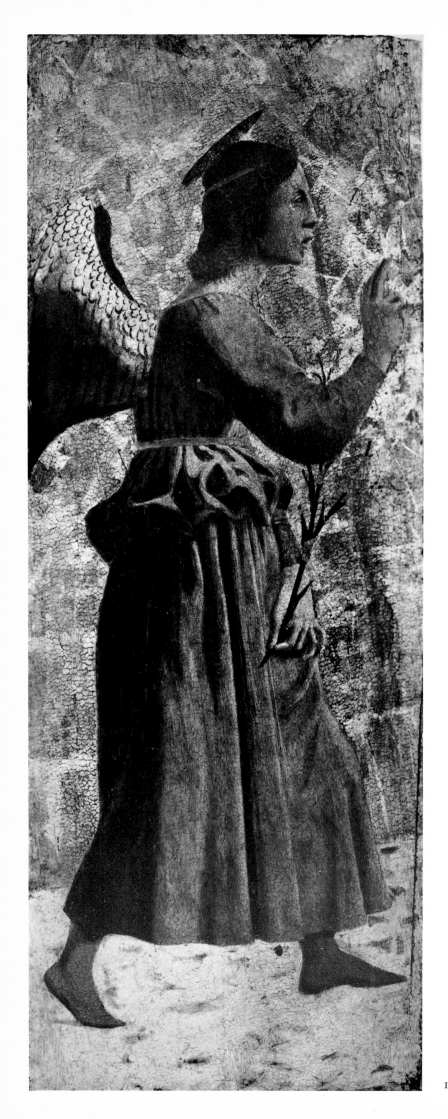

12. THE ARCHANGEL GABRIEL. *Detail of Plate 2*

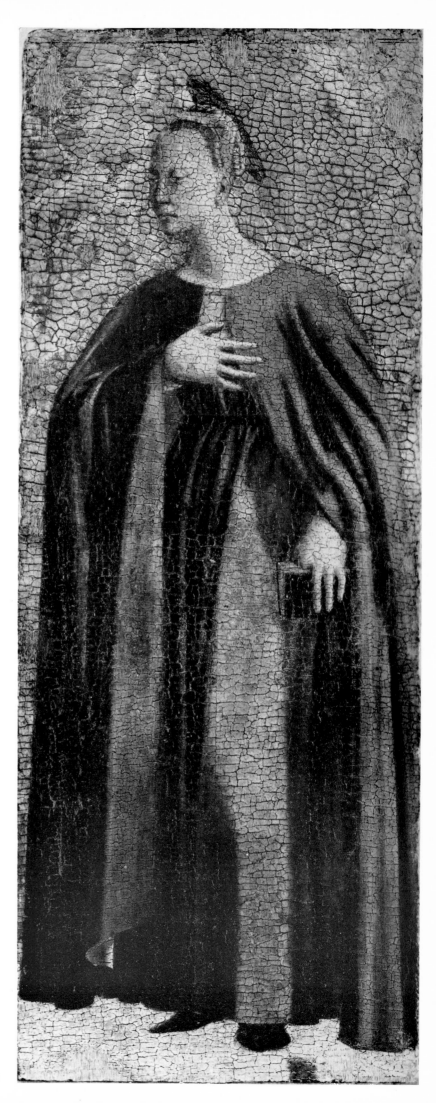

13. THE VIRGIN ANNUNCIATE. *Detail of Plate 2*

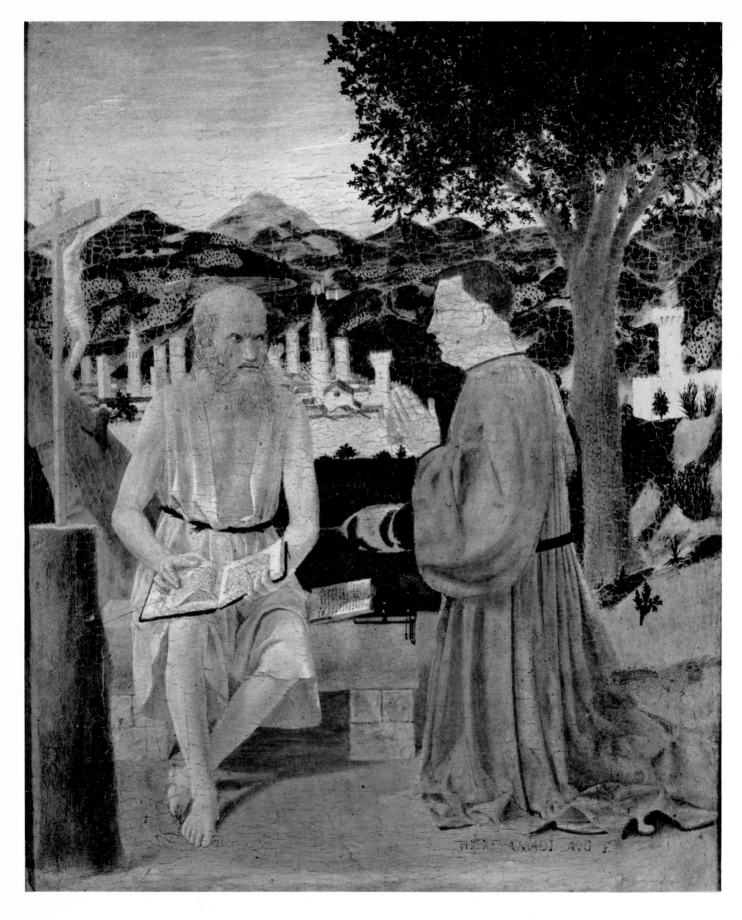

14. ST. JEROME AND A DONOR. *Venice, Galleria dell' Accademia*

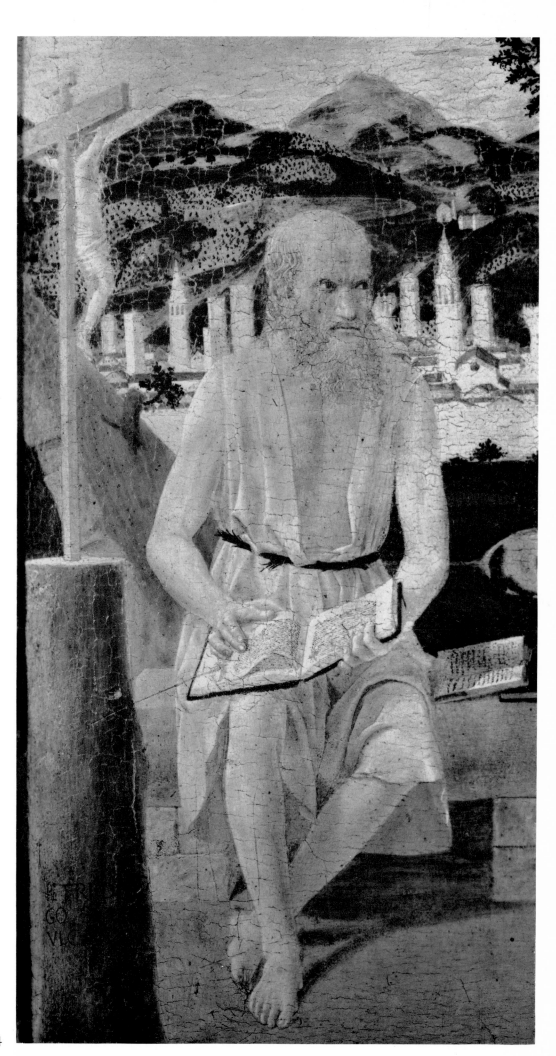

15. ST. JEROME. *Detail of Plate* 14

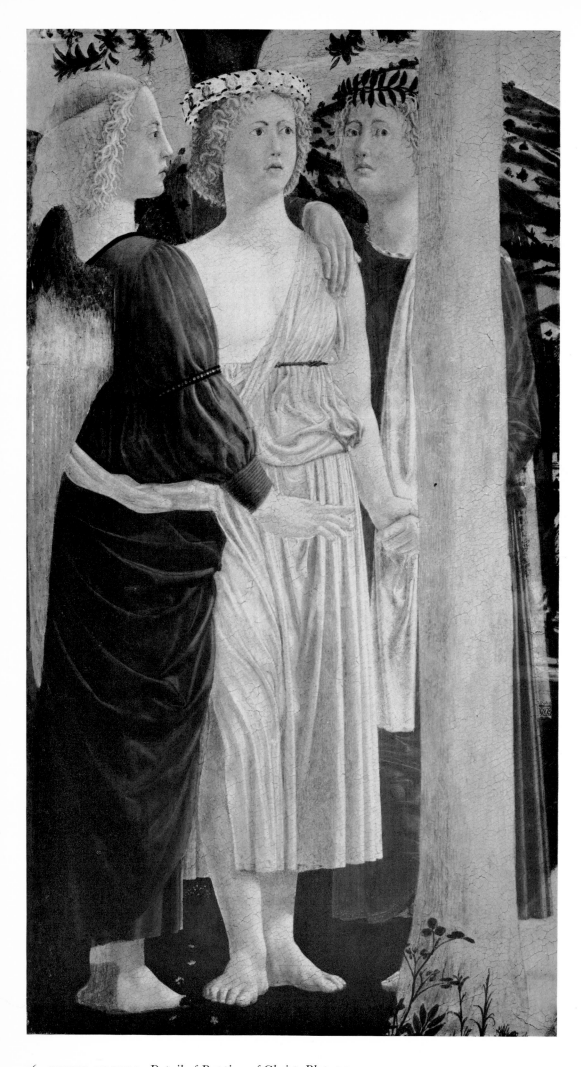

16. THREE ANGELS. *Detail of Baptism of Christ, Plate 19*

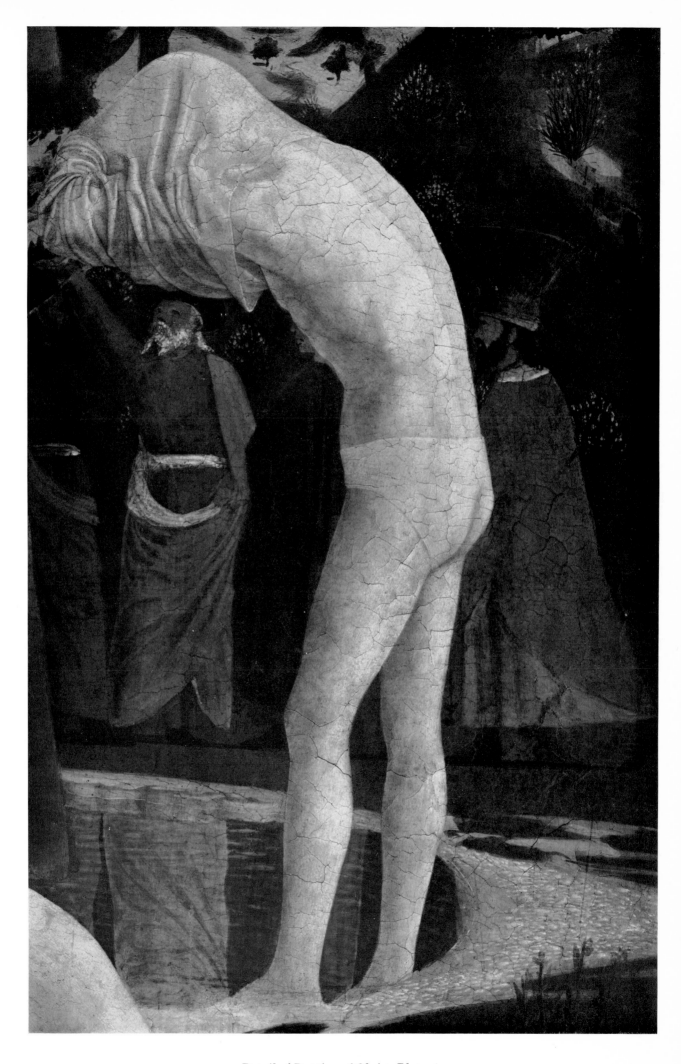

17. MAN PULLING OFF HIS SHIRT. *Detail of Baptism of Christ, Plate 19*

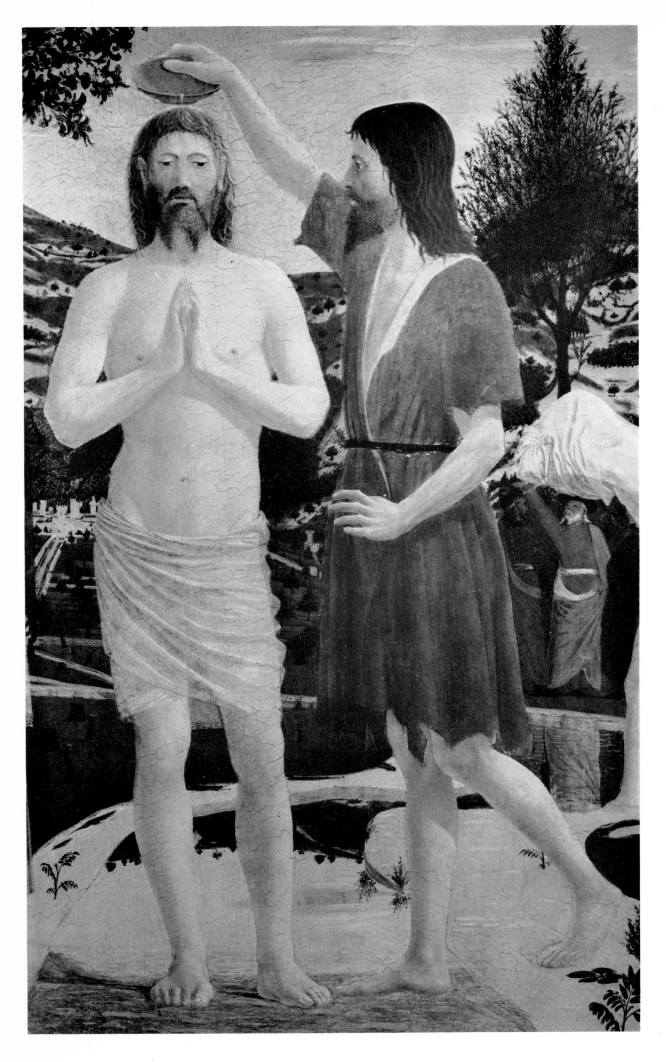

18. THE BAPTISM OF CHRIST. *Detail of Plate 19*

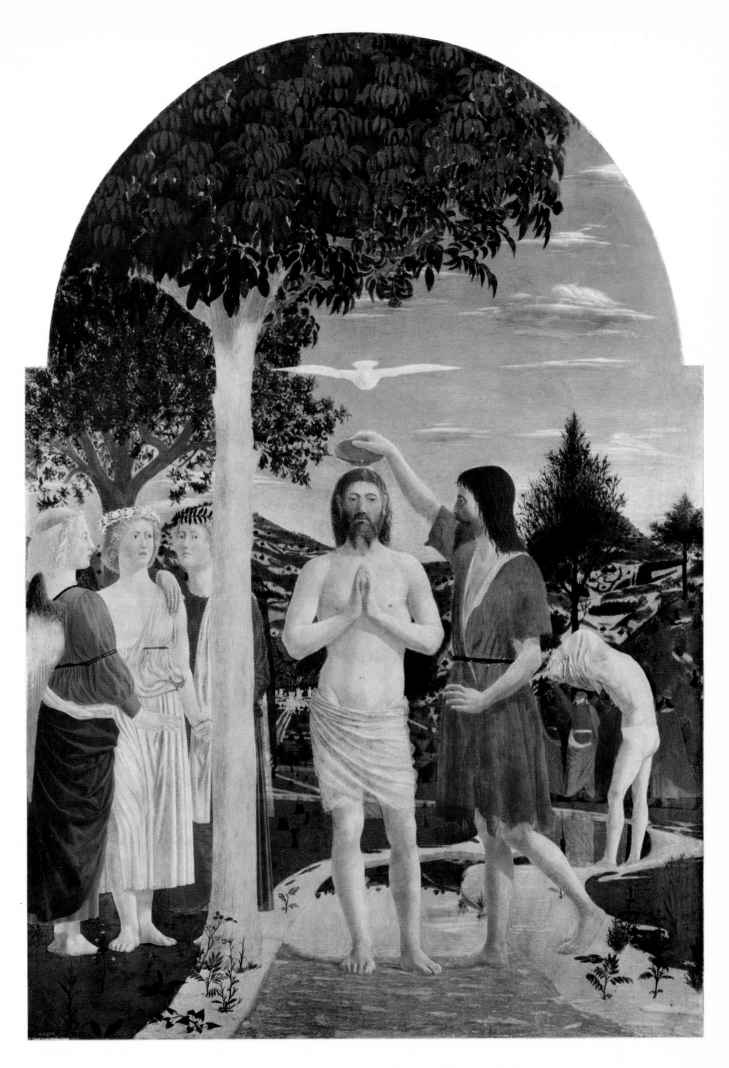

19. THE BAPTISM OF CHRIST. *London, National Gallery*

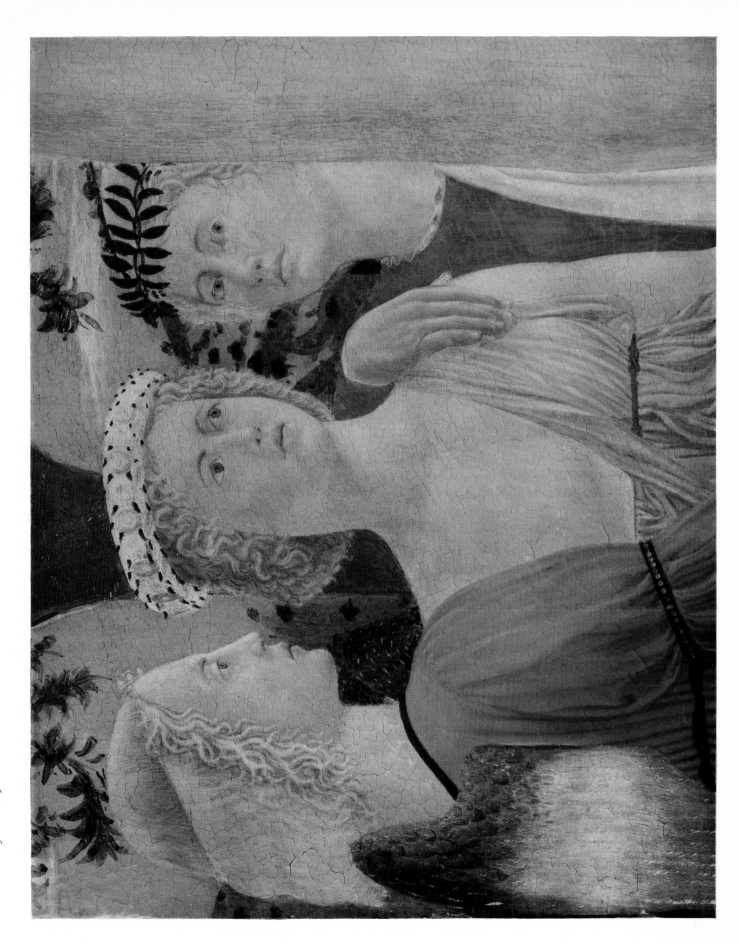

22. SIGISMONDO MALATESTA KNEELING BEFORE HIS PATRON SAINT. *Rimini, San Francesco*

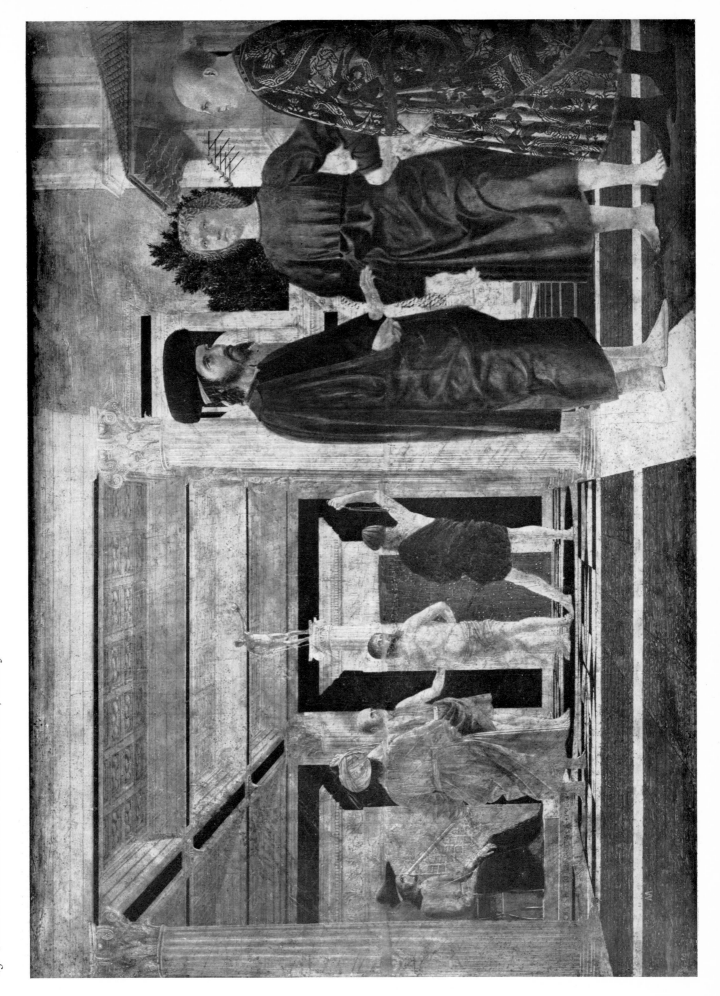

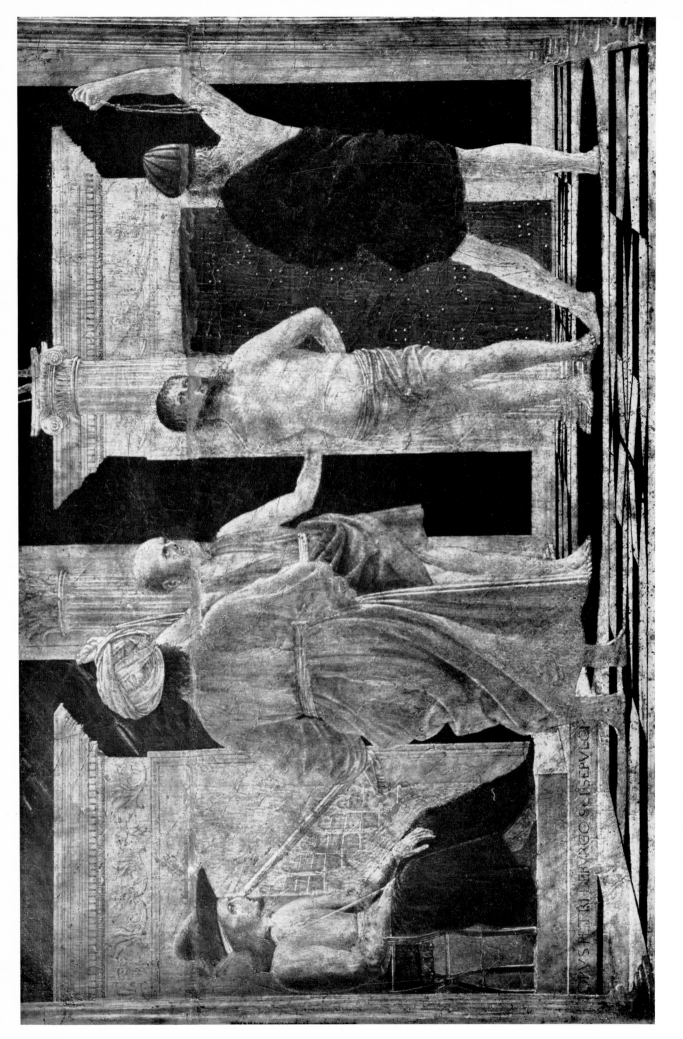

24. THE FLAGELLATION. *Detail of Plate 23*

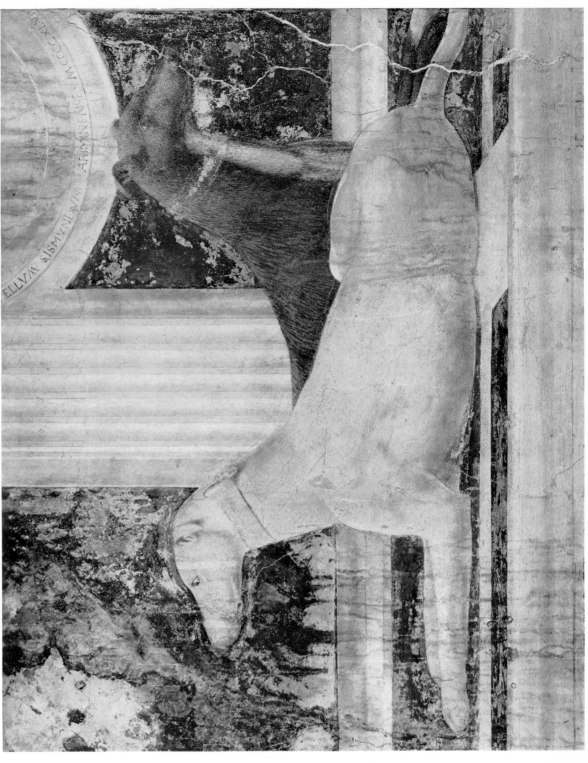

25. TWO HOUNDS. *Detail of Plate 22*

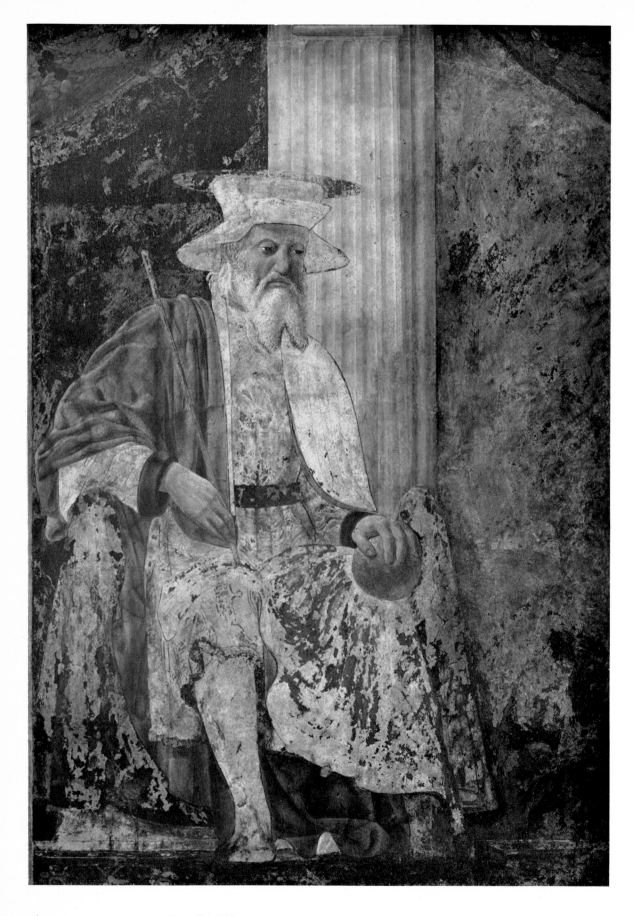

26. SAN SIGISMONDO. *Detail of Plate 22*

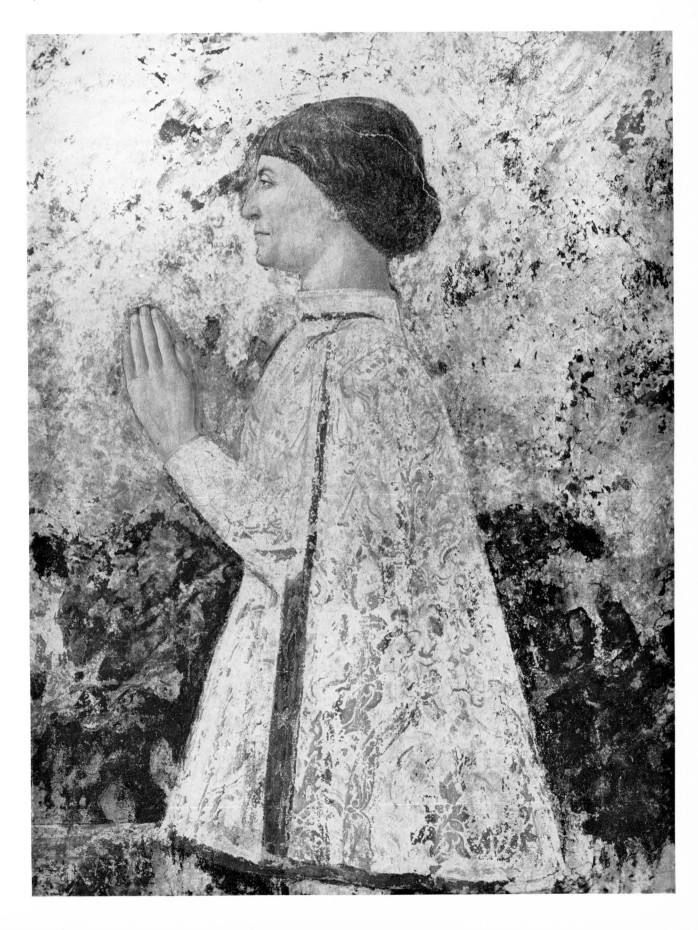

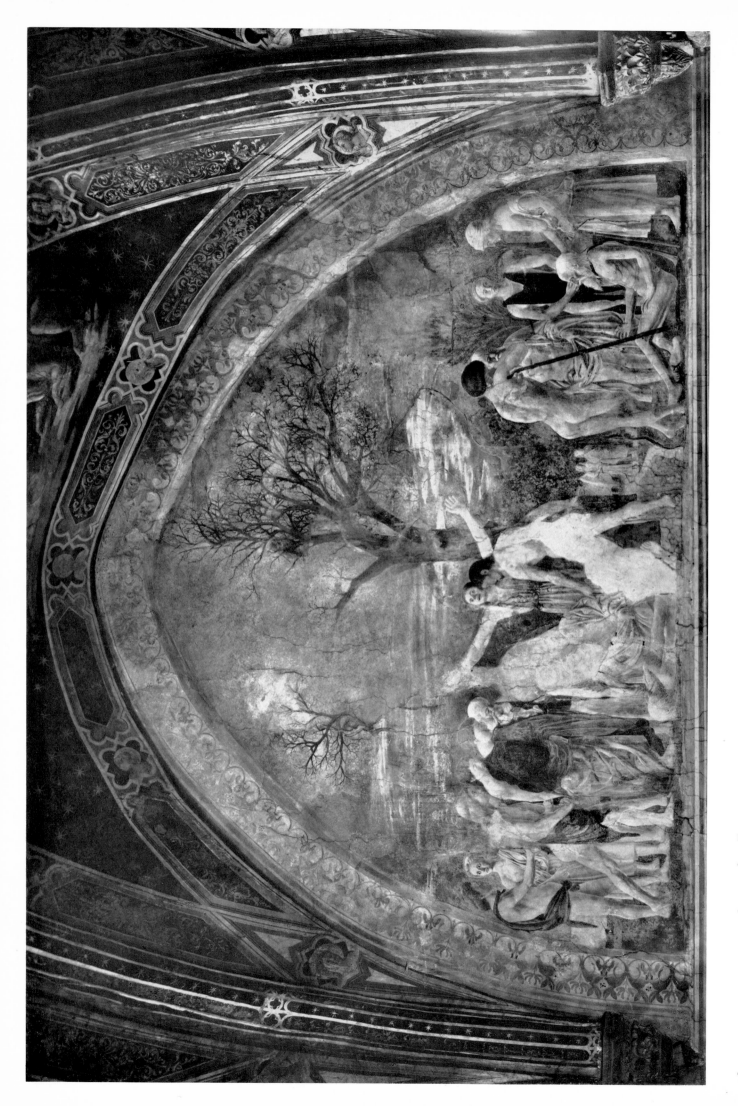

28. THE DEATH OF ADAM. *Arezzo, San Francesco*

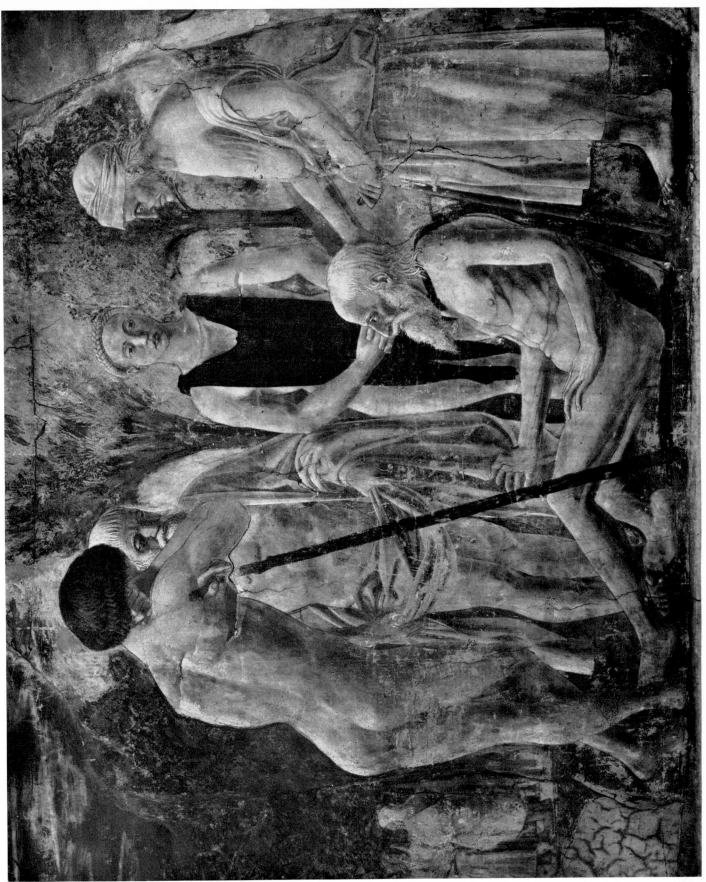

29. ADAM ANNOUNCING
HIS DEATH. *Detail of Plate 28*

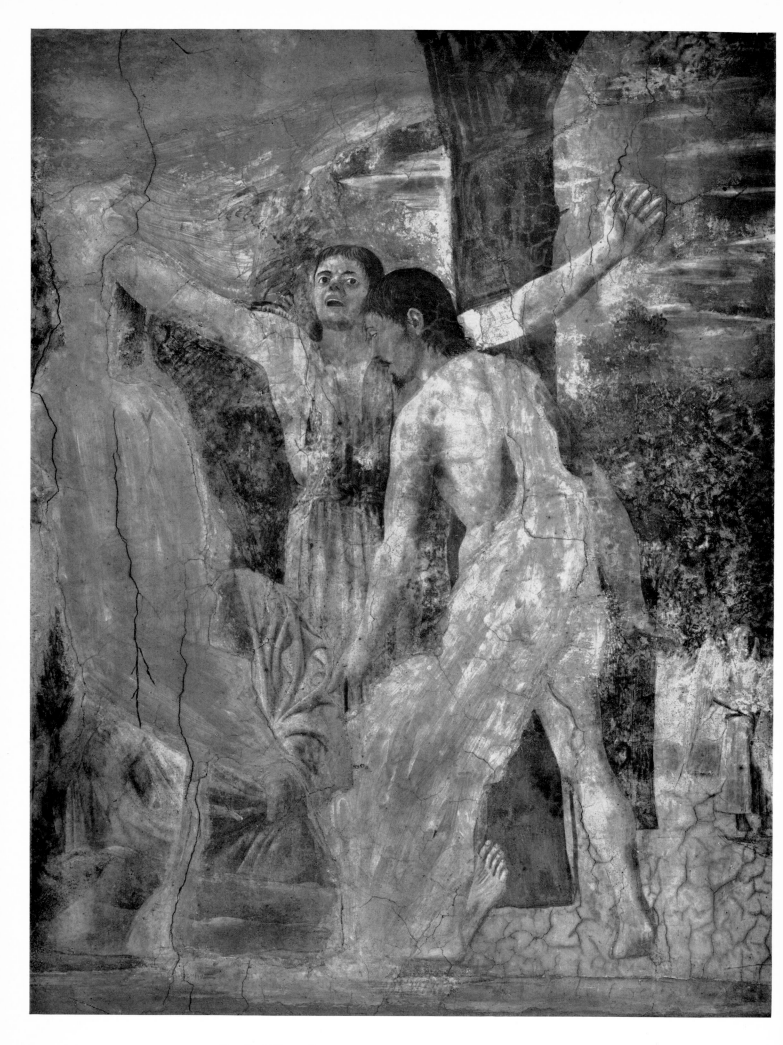

30. TWO CHILDREN OF ADAM. *Detail of Plate 28*

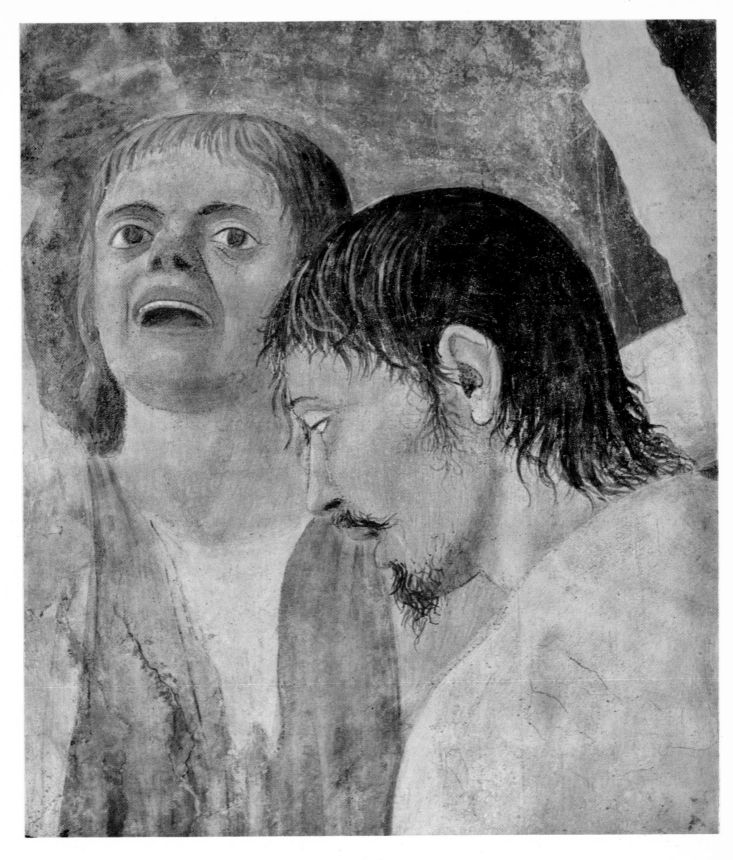

31. TWO CHILDREN OF ADAM. *Detail of Plate 28*

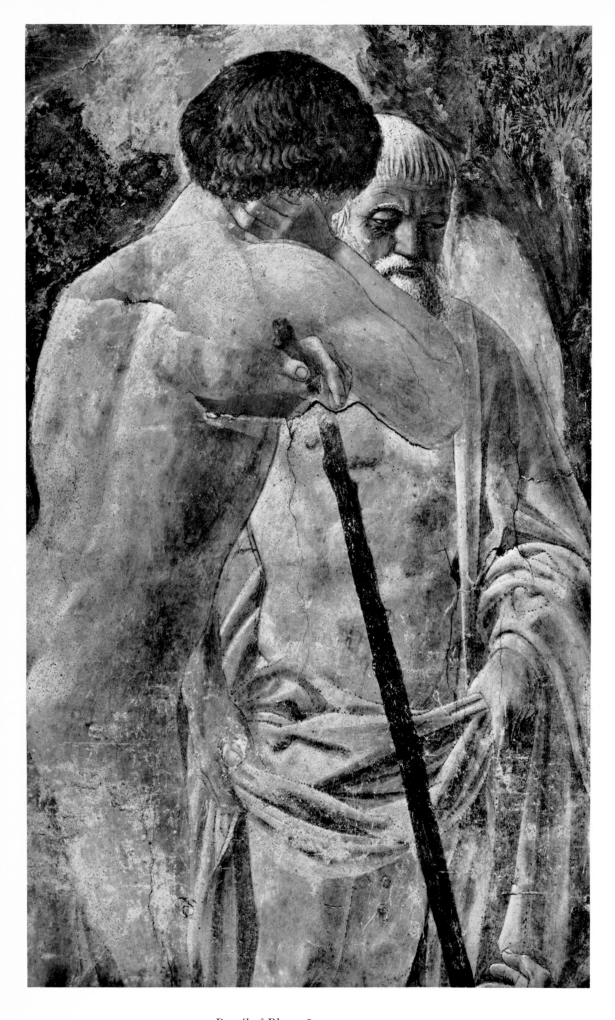

32. TWO CHILDREN OF ADAM. *Detail of Plate 28*

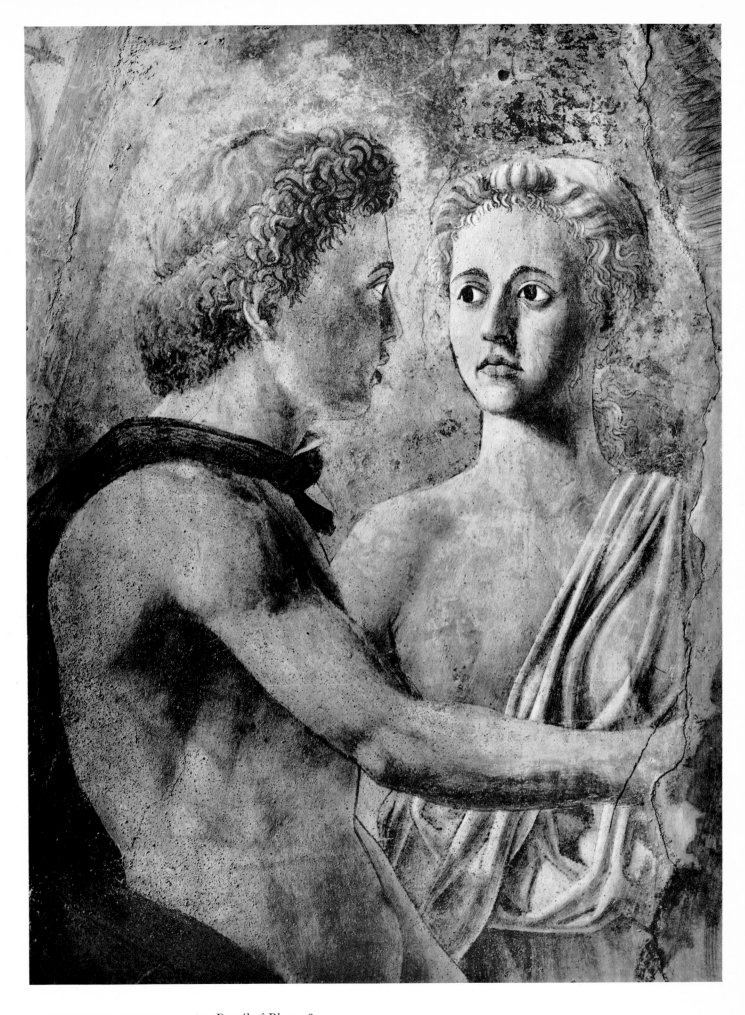

33. TWO CHILDREN OF ADAM. *Detail of Plate 28*

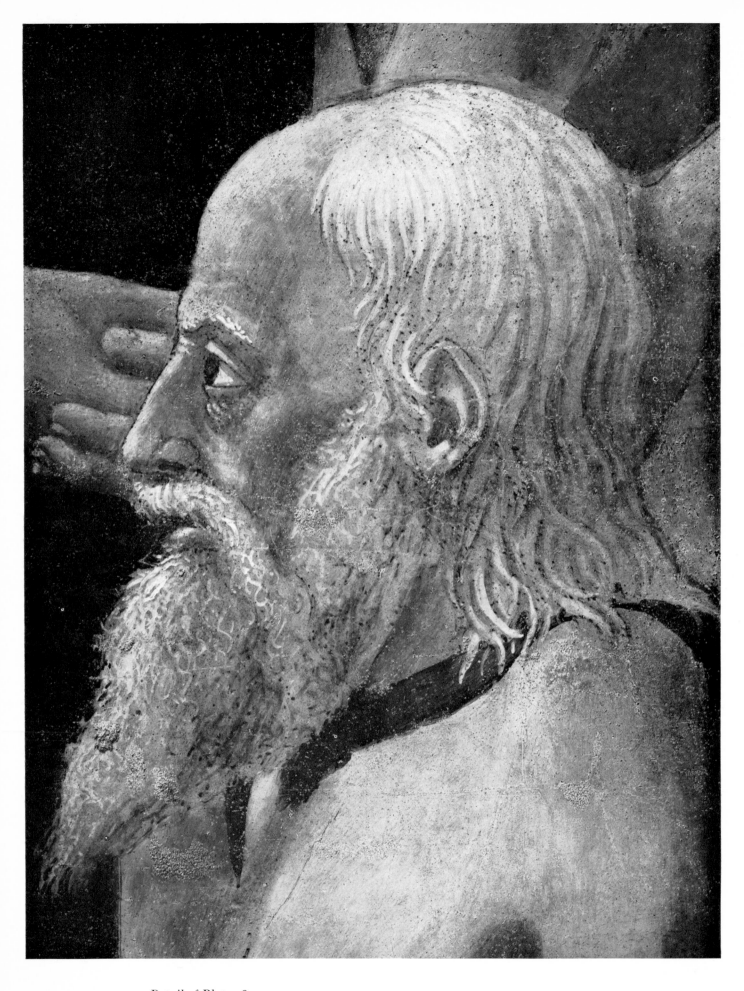

34. HEAD OF ADAM. *Detail of Plate 28*

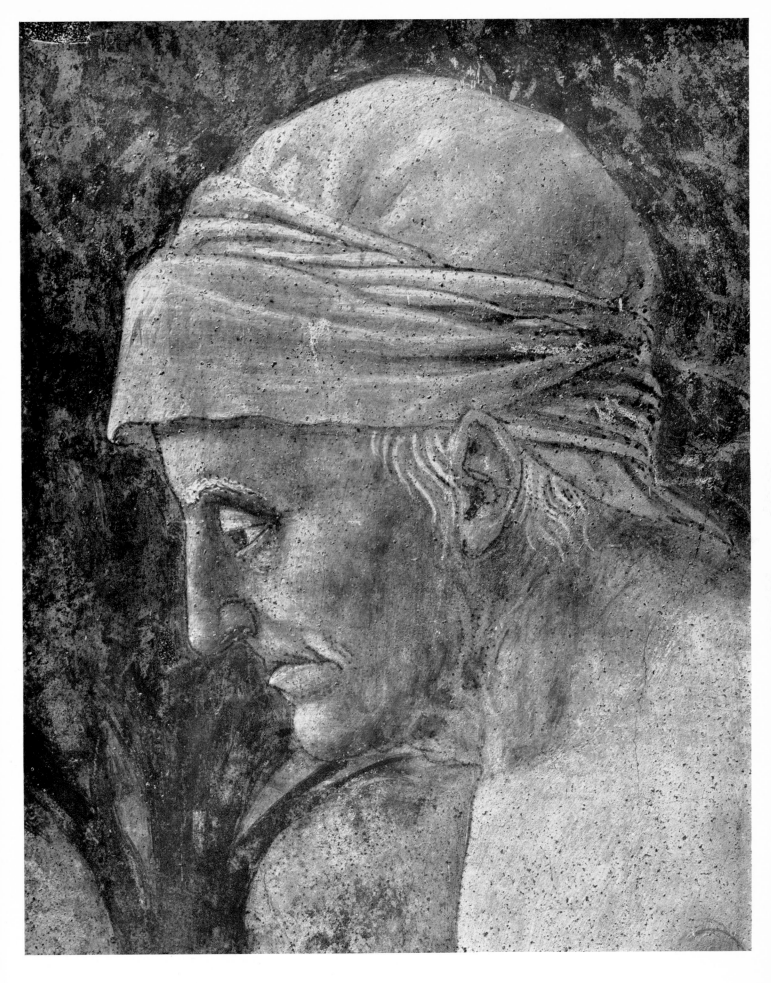

35. HEAD OF EVE. *Detail of Plate 28*

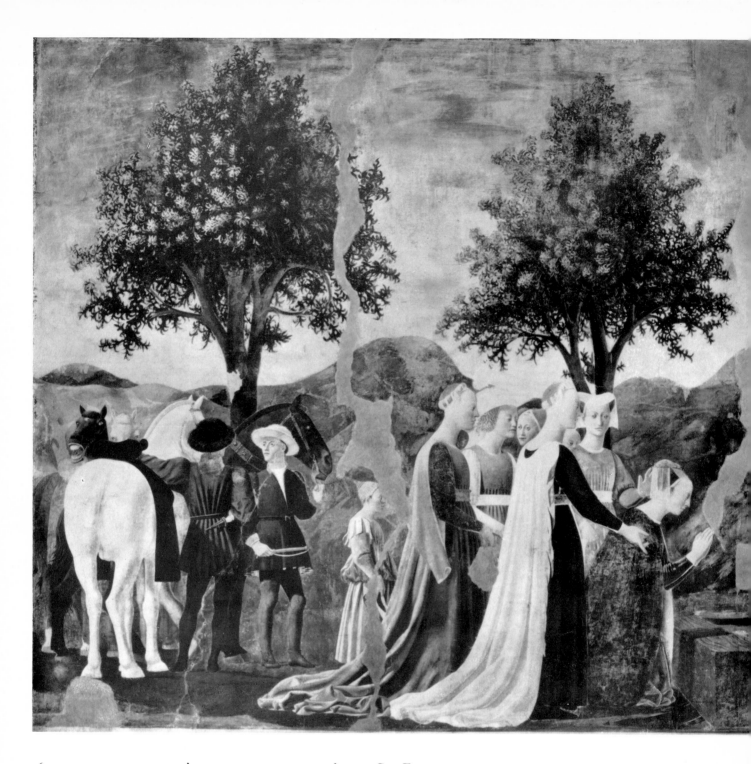

36. THE QUEEN OF SHEBA'S VISIT TO SOLOMON. *Arezzo, San Francesco*

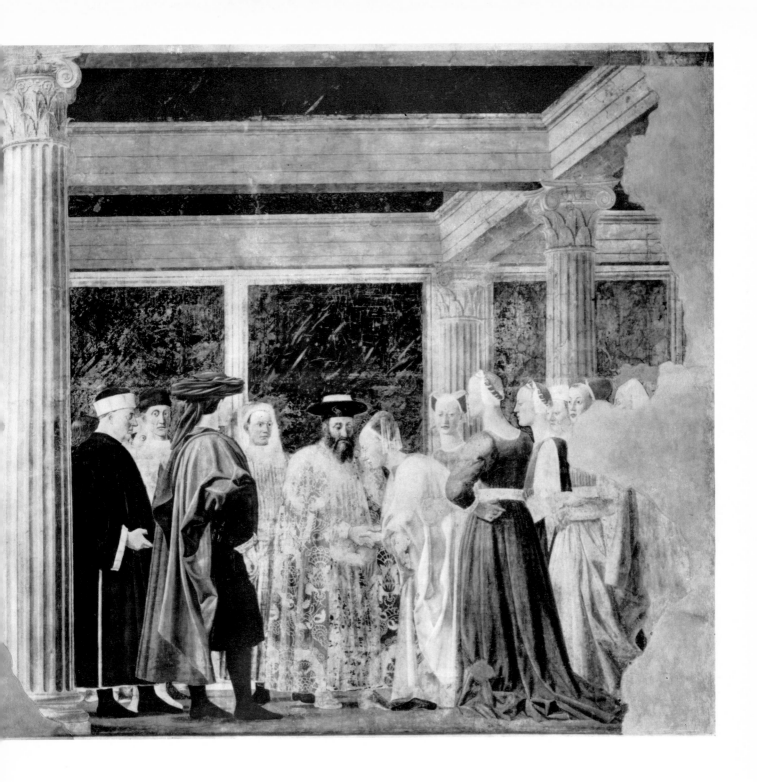

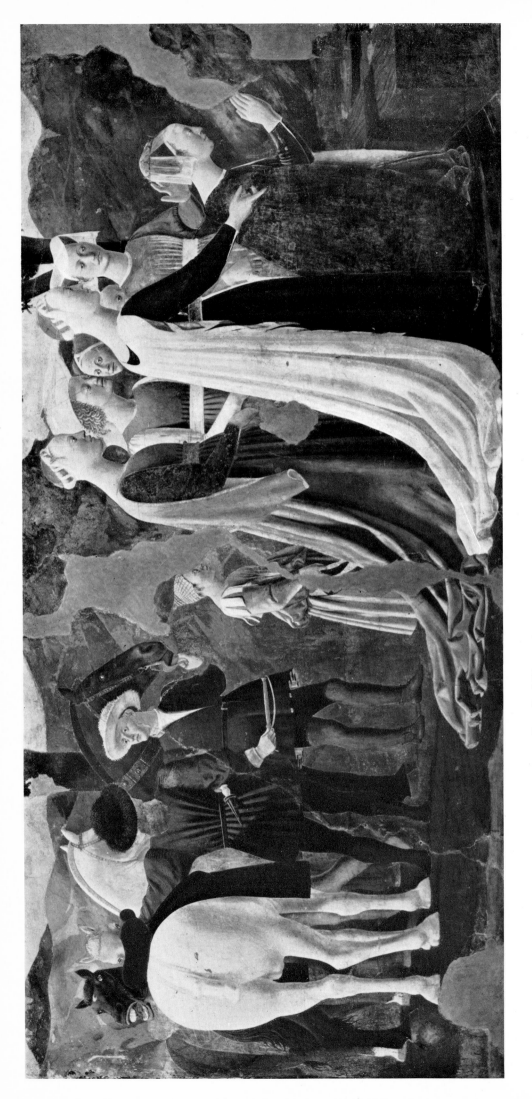

37 · THE QUEEN OF SHEBA ADORING THE HOLY WOOD. *Detail of Plate 36*

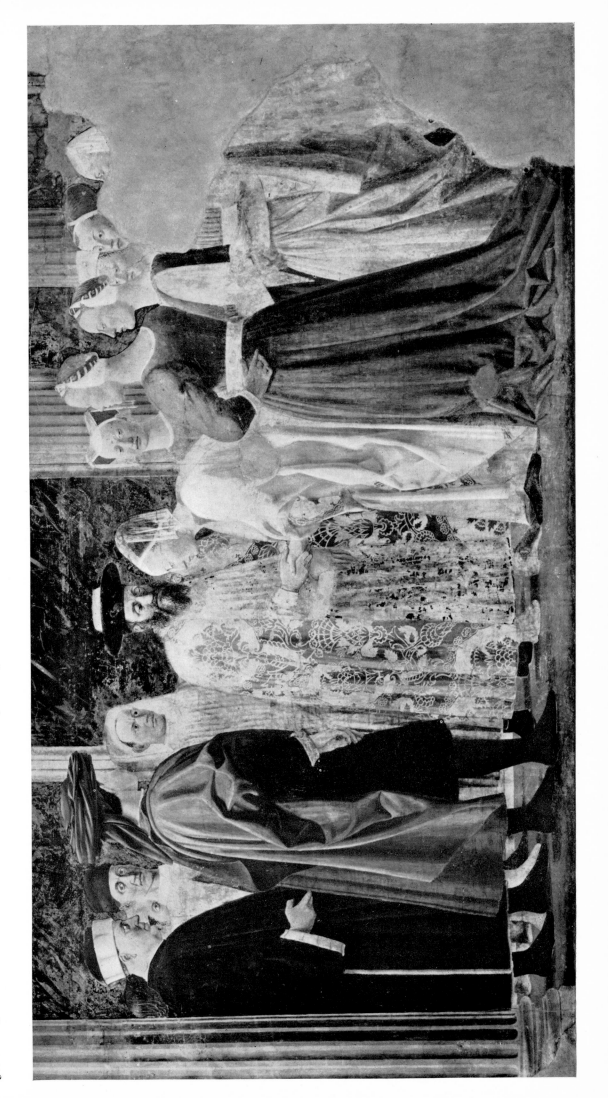

38. THE QUEEN OF SHEBA RECEIVED BY SOLOMON. *Detail of Plate 36*

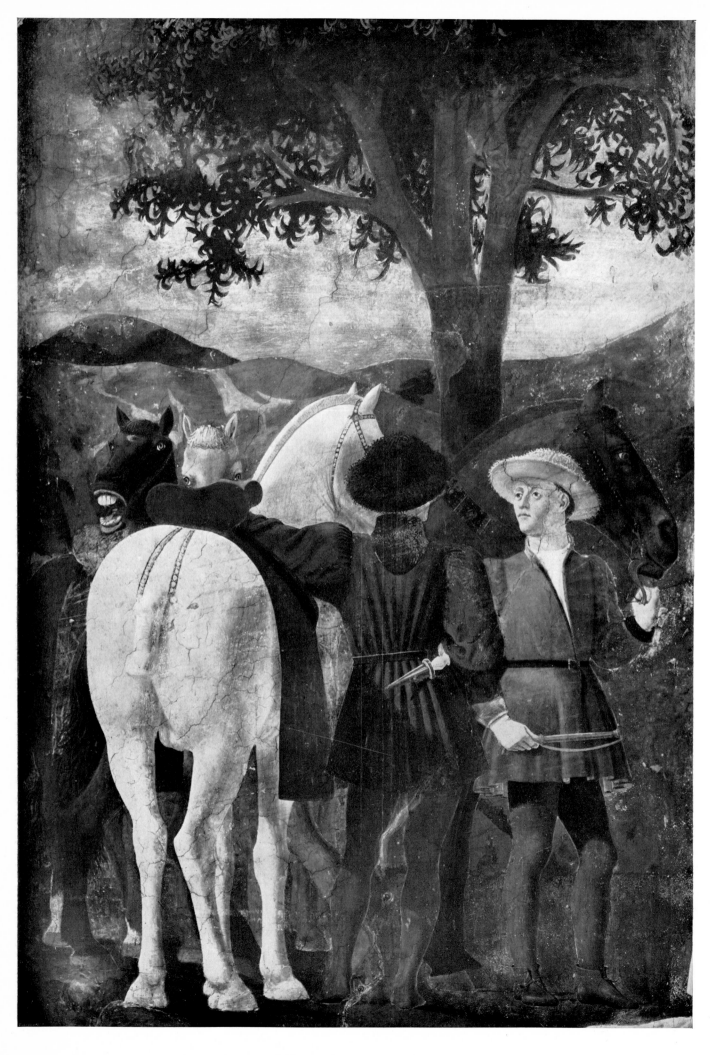

39. TWO GROOMS WITH HORSES. *Detail of Plate 36*

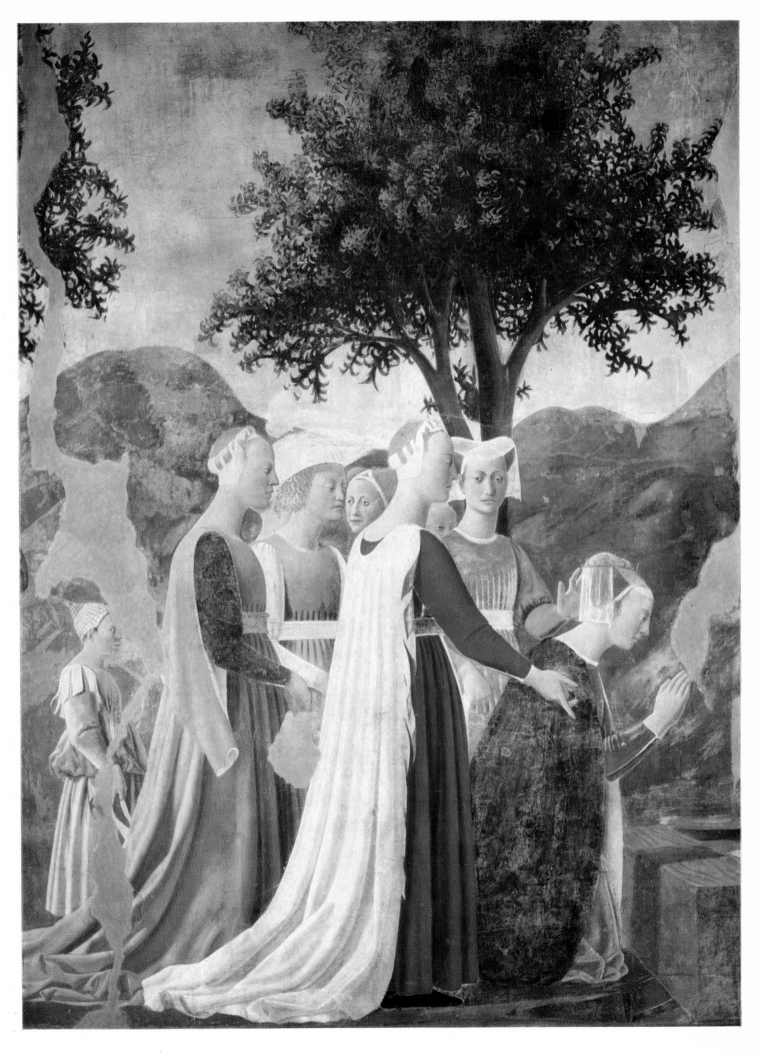

40. THE QUEEN OF SHEBA KNEELING, WITH HER RETINUE. *Detail of Plate 36*

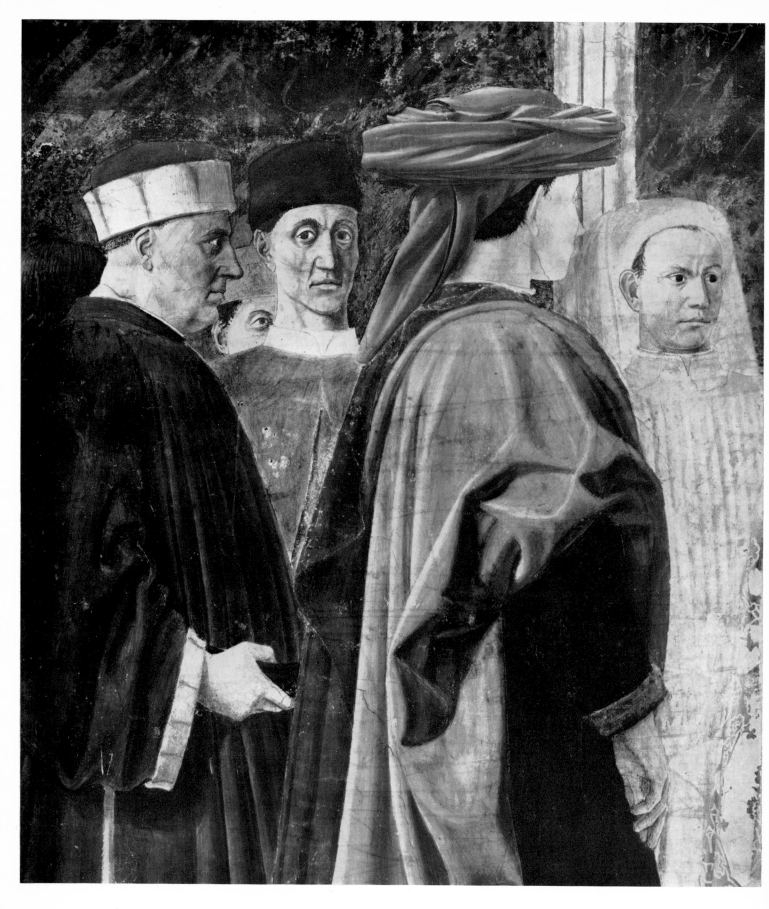

41. SOLOMON'S RETINUE. *Detail of Plate 36*

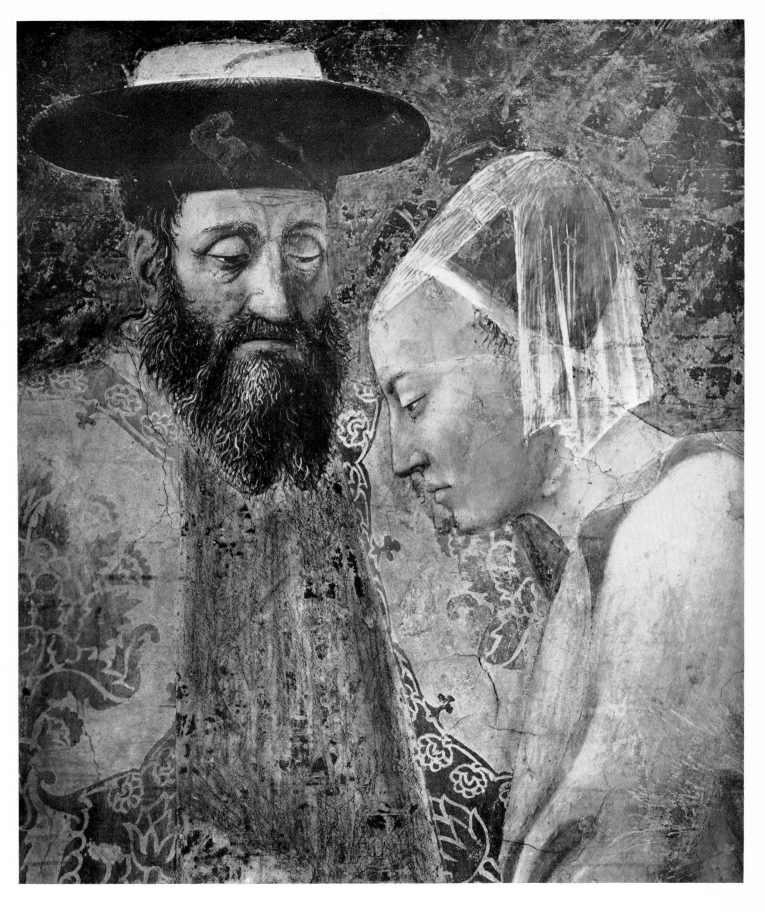

42. SOLOMON AND THE QUEEN OF SHEBA. *Detail of Plate 36*

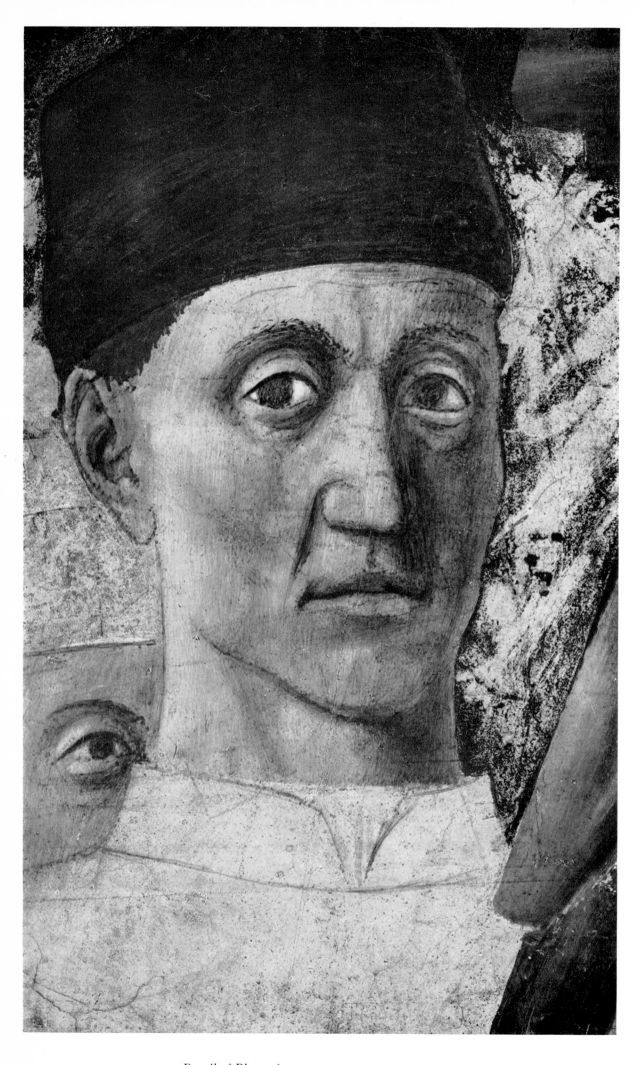

43. HEAD OF A COURTIER. *Detail of Plate 36*

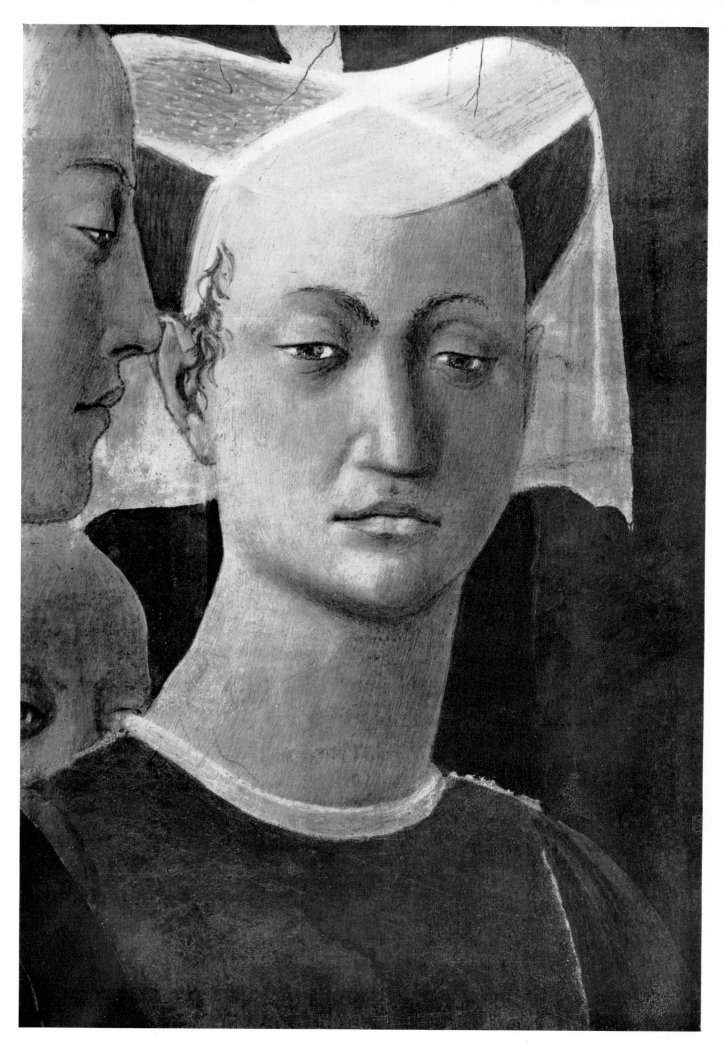

44. HEAD OF A LADY. *Detail of Plate 36*

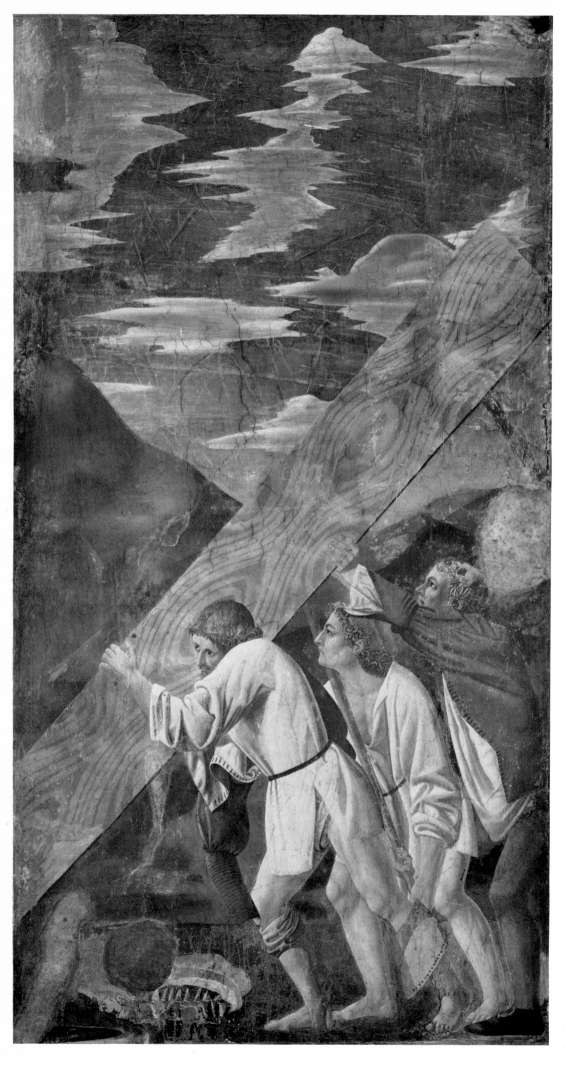

45. THE BURYING
OF THE WOOD.
Arezzo, San Francesco

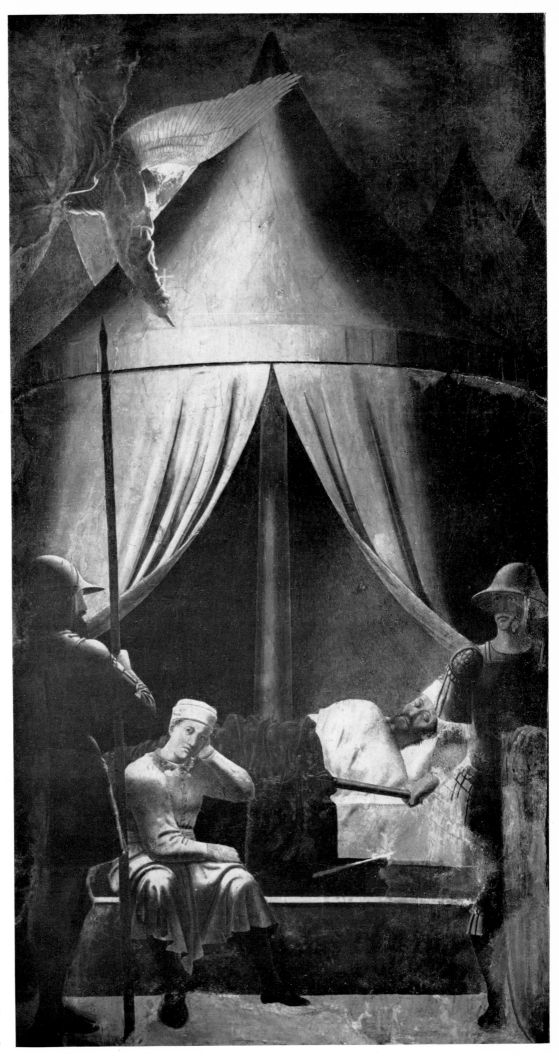

46. THE DREAM
OF CONSTANTINE.
Arezzo, San Francesco

47. THE ANGEL APPEARING TO CONSTANTINE. *Detail of Plate 46*

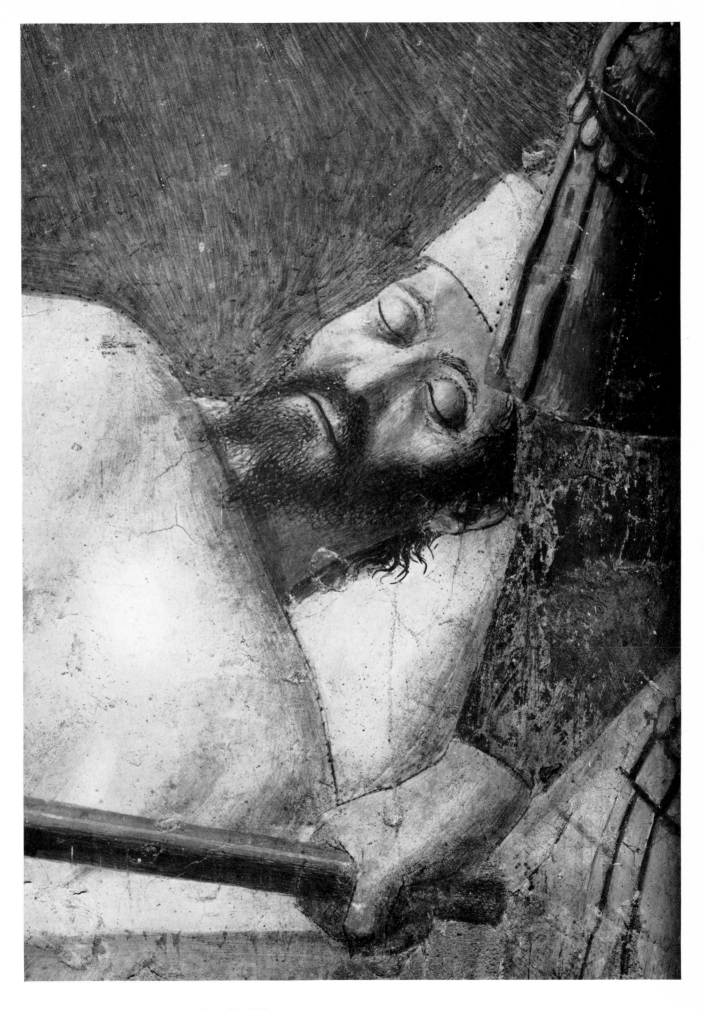

48. HEAD OF CONSTANTINE. *Detail of Plate 46*

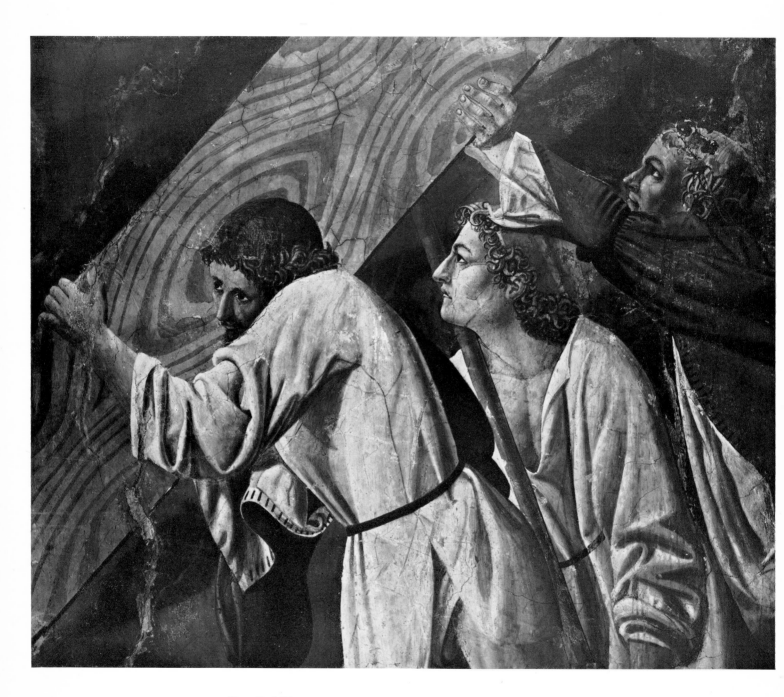

49. MEN CARRYING THE WOOD. *Detail of Plate 45*

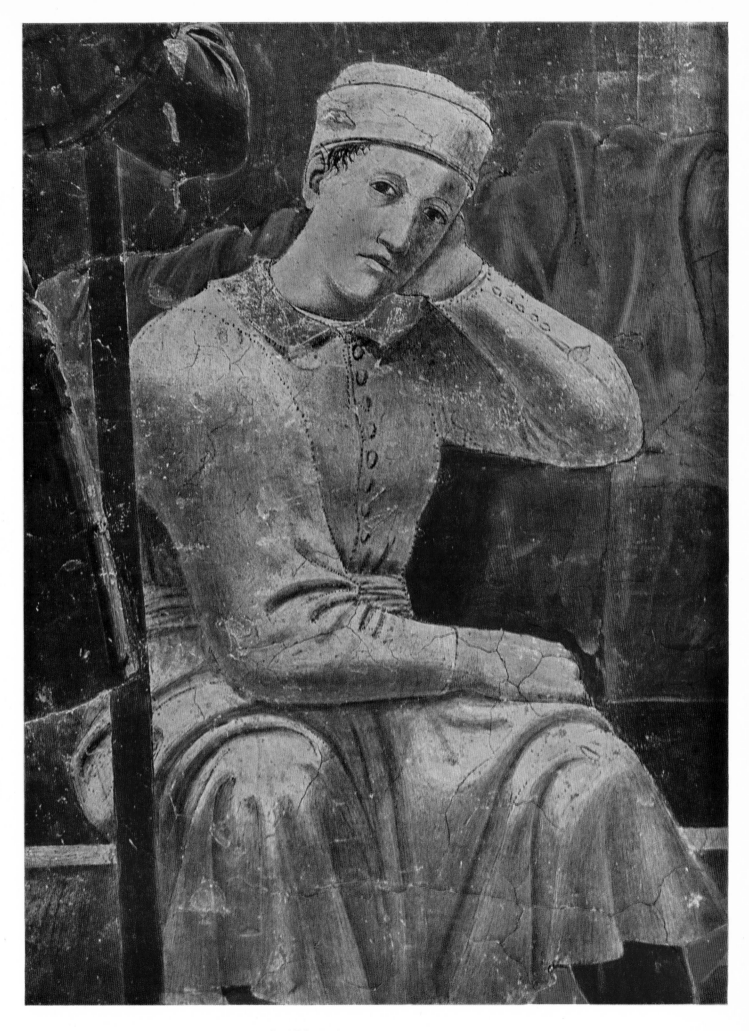

50. CONSTANTINE'S LIEUTENANT. *Detail of Plate 46*

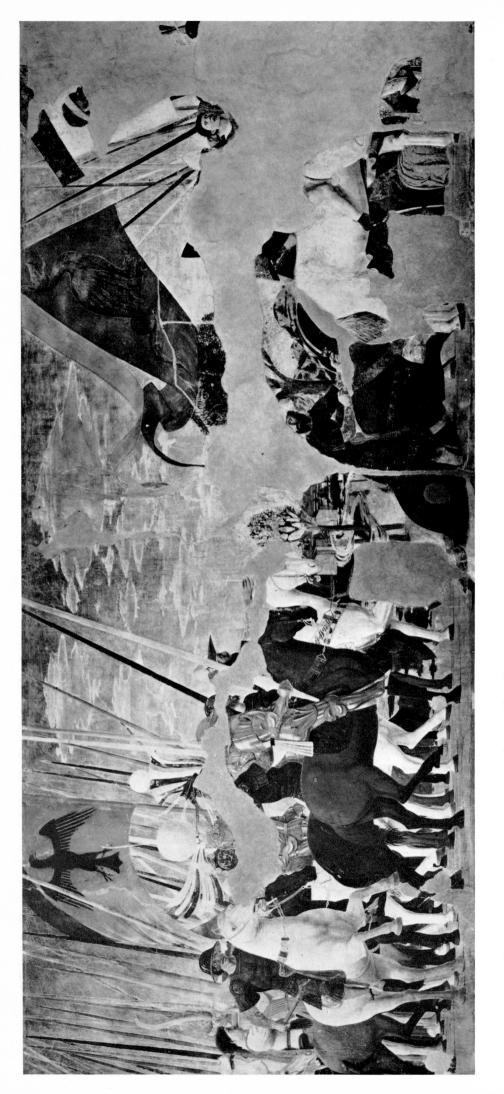

51. CONSTANTINE'S VICTORY OVER MAXENTIUS. *Arezzo, San Francesco*

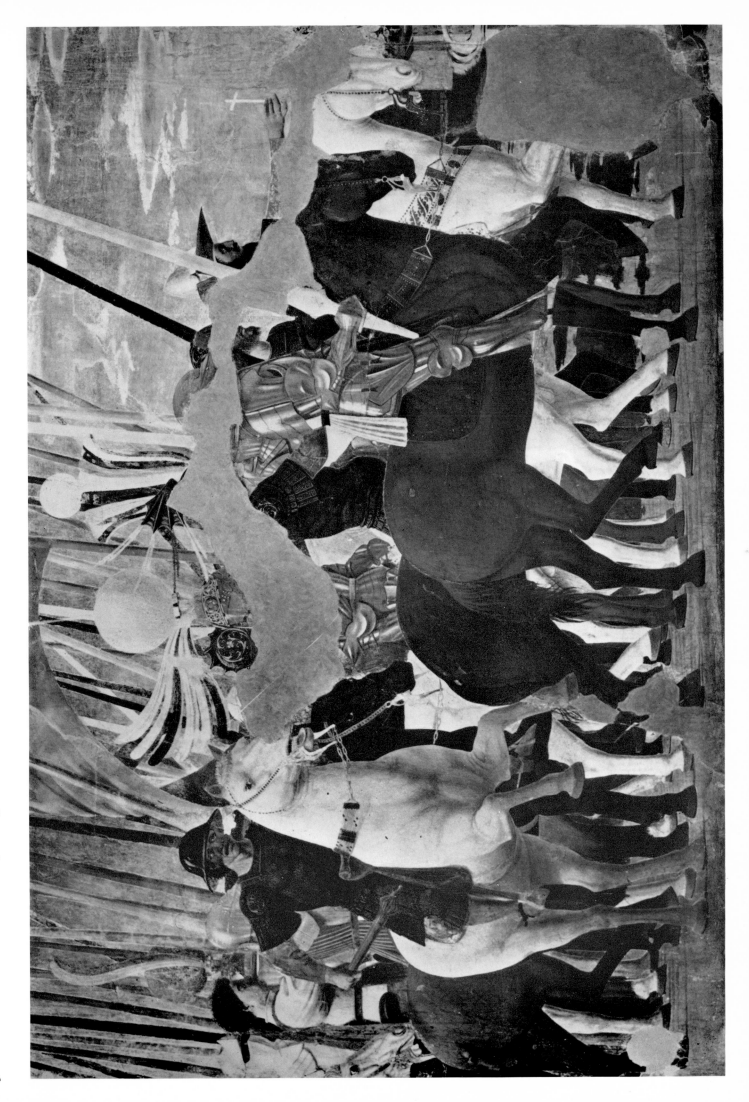

52. CONSTANTINE'S ARMY. *Detail of Plate 51*

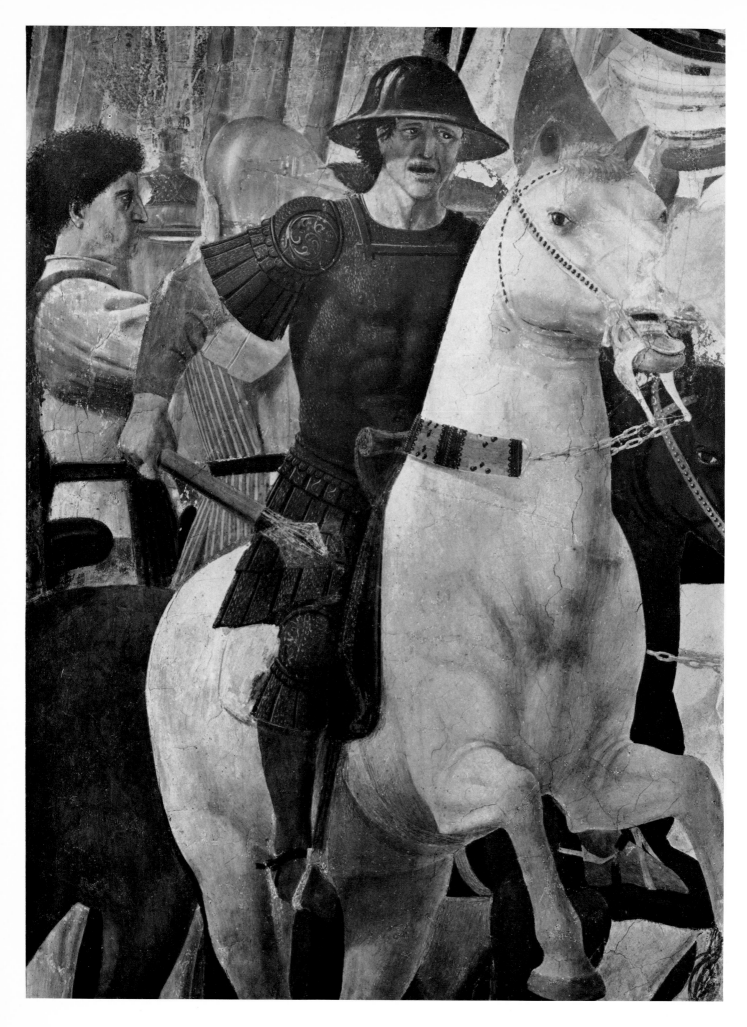

53. A HORSEMAN. *Detail of Plate 51*

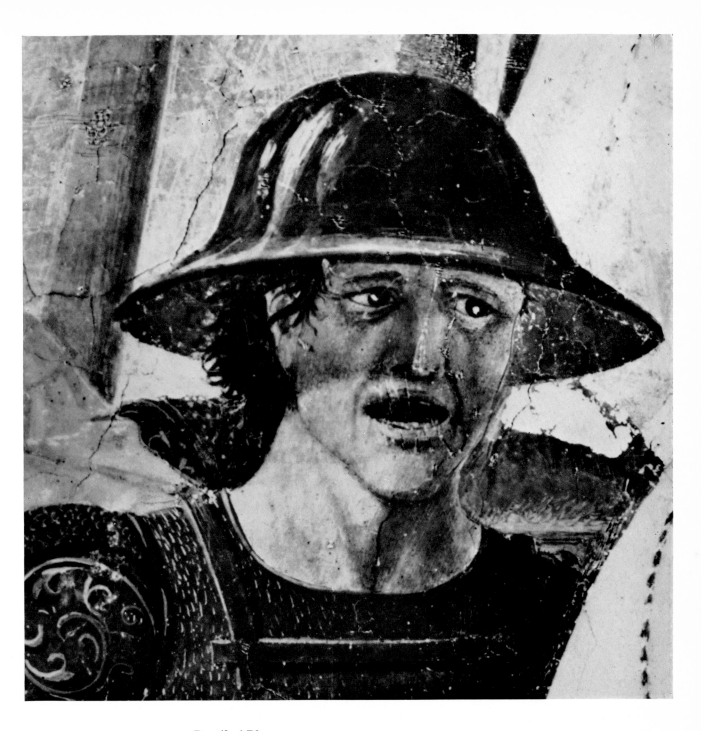

54. HEAD OF A HORSEMAN. *Detail of Plate 51*

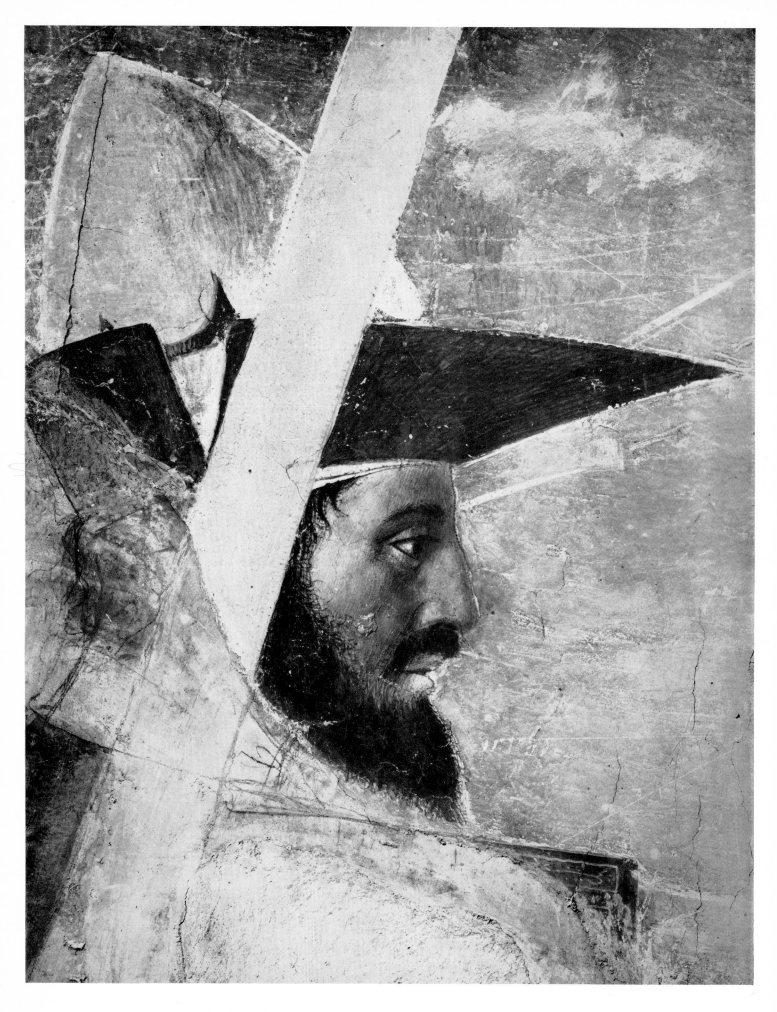

55. HEAD OF CONSTANTINE. *Detail of Plate 51*

56. CONSTANTINE'S STANDARD. *Detail of Plate 51*

57. LANDSCAPE WITH A TREE. *Detail of Plate 51*

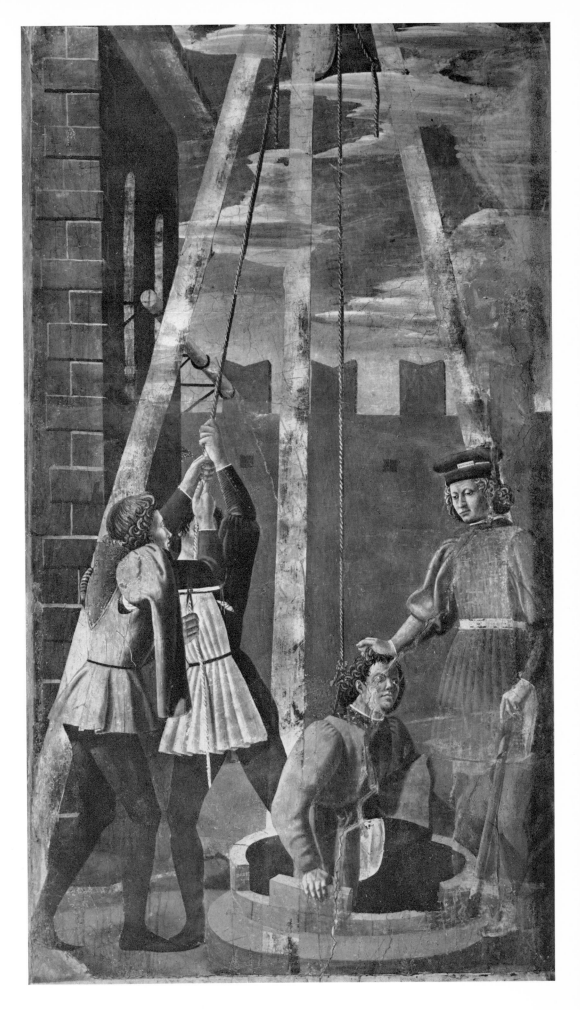

58. THE TORTURE OF JUDAS. *Arezzo, San Francesco*

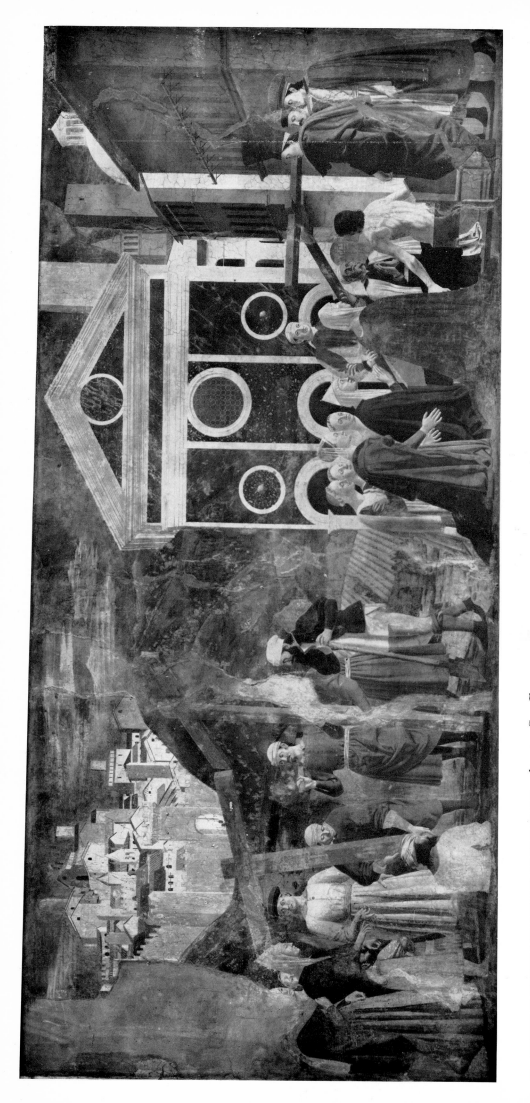

59. THE DISCOVERY AND PROOF OF THE CROSS. *Arezzo, San Francesco*

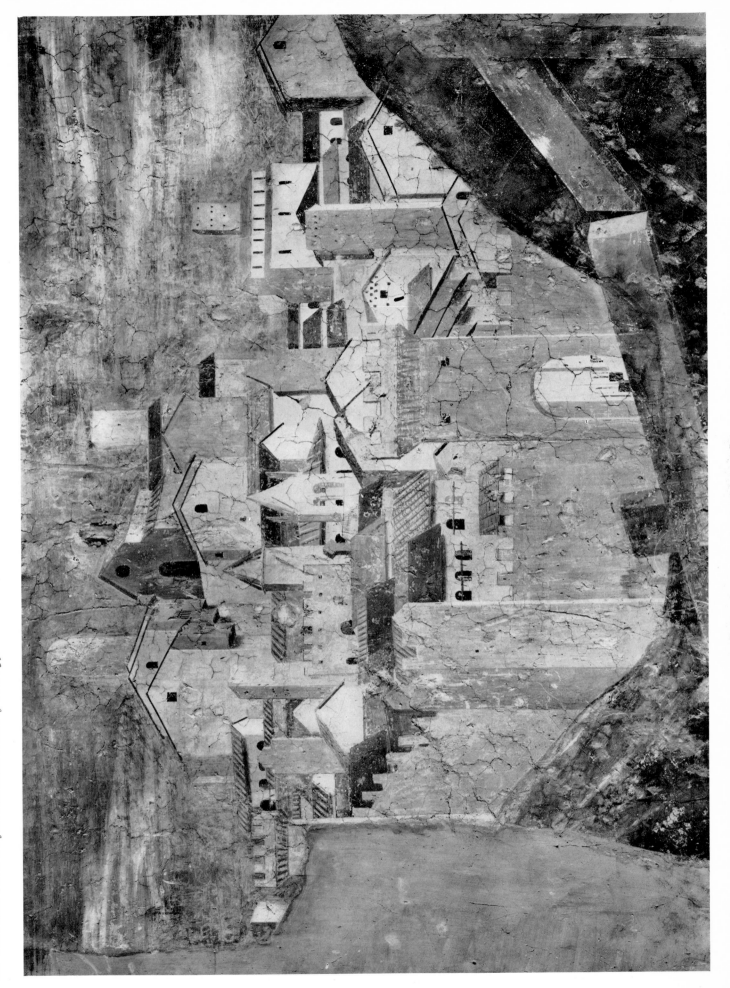

60. DISTANT VIEW OF JERUSALEM. *Detail of Plate 59*

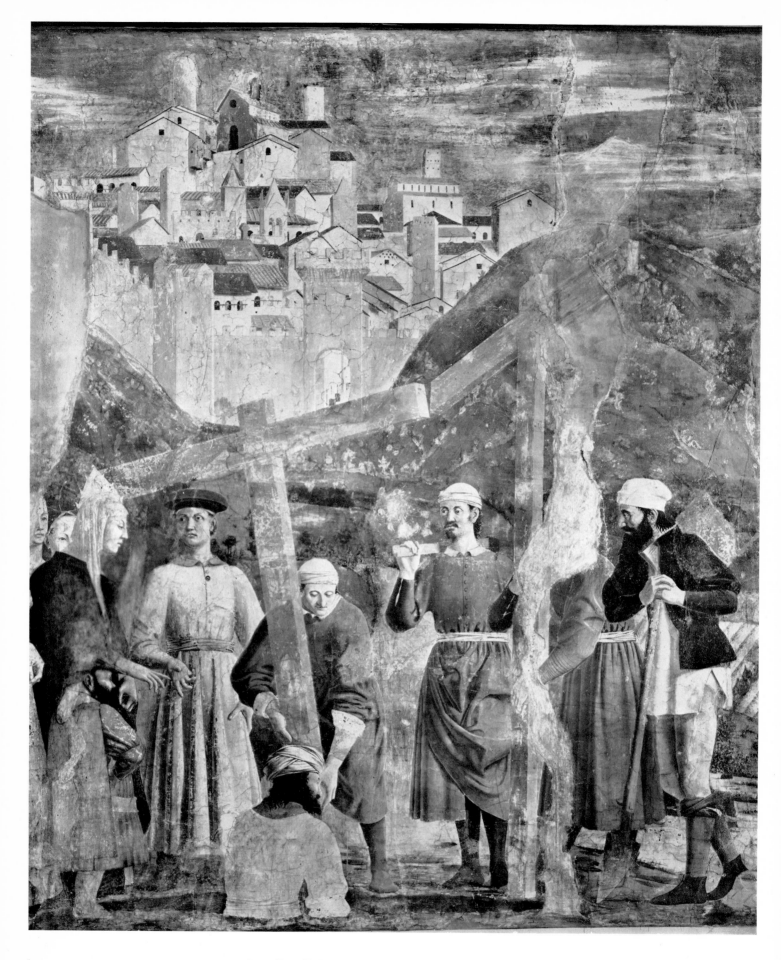

61. THE DISCOVERY OF THE CROSS. *Detail of Plate 59*

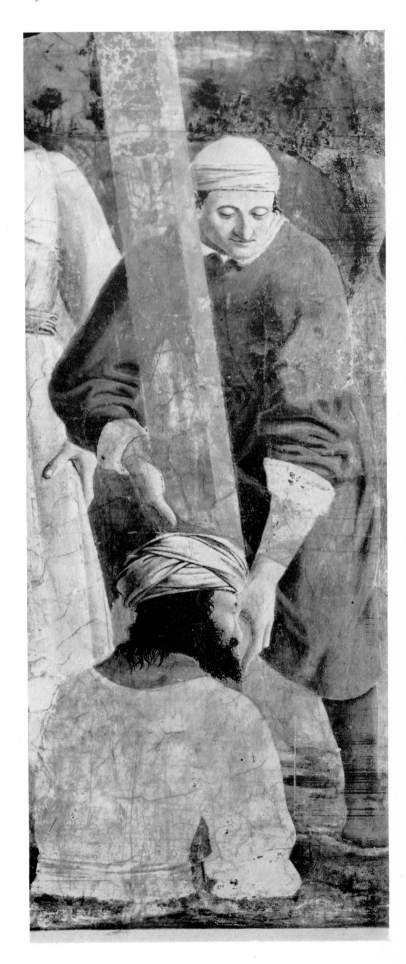

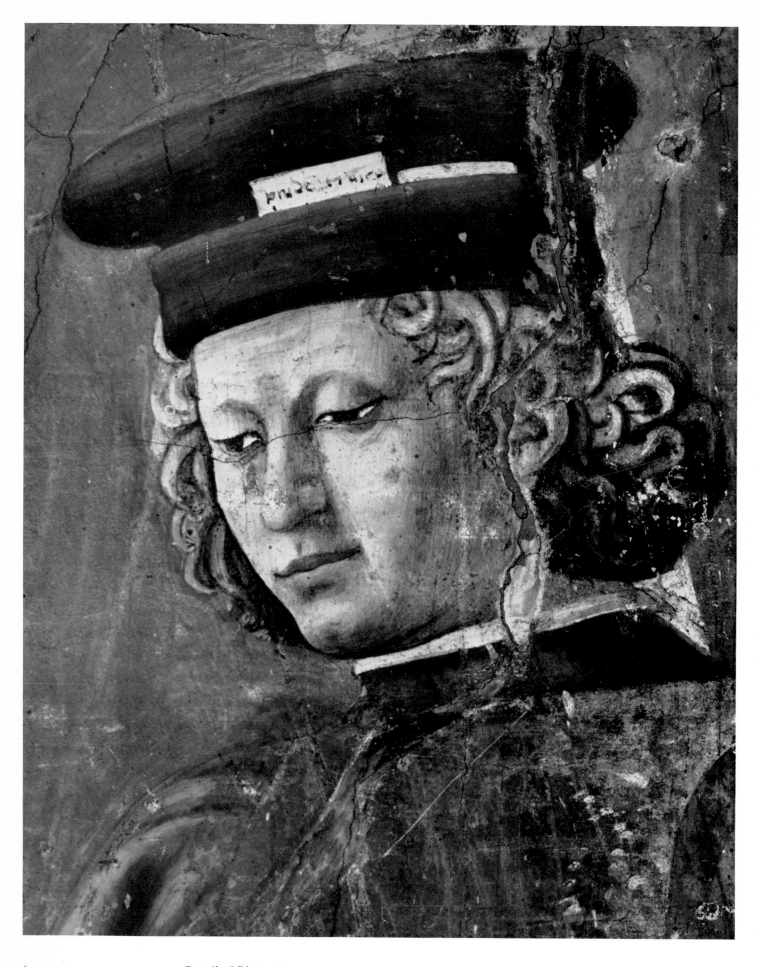

63. HEAD OF AN OFFICER. *Detail of Plate 58*

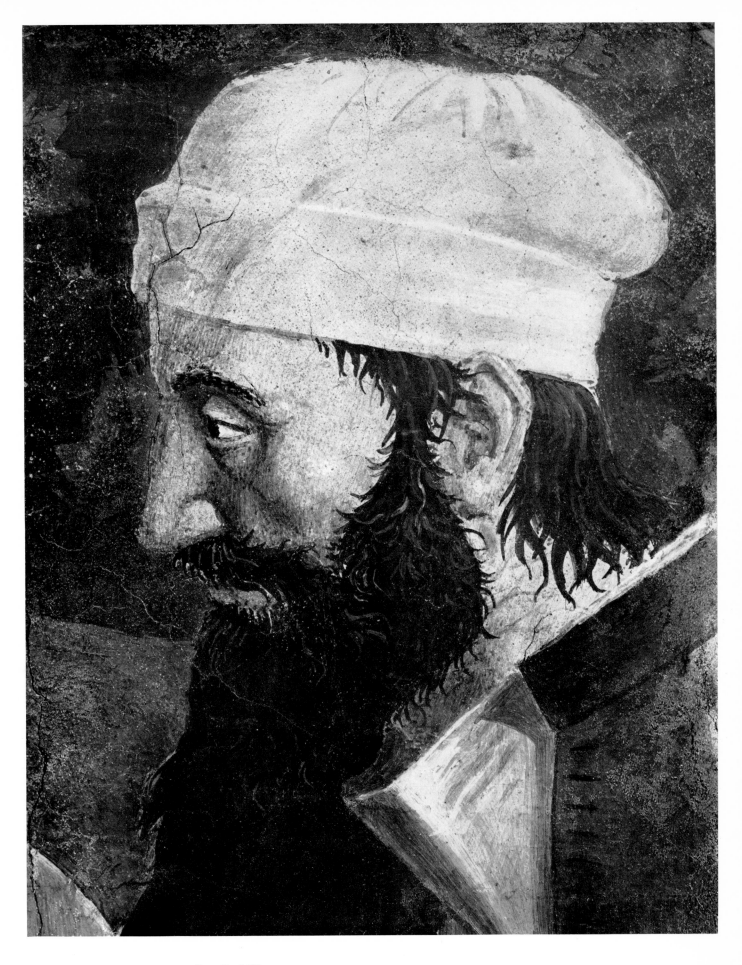

64. HEAD OF A WORKMAN. *Detail of Plate 59*

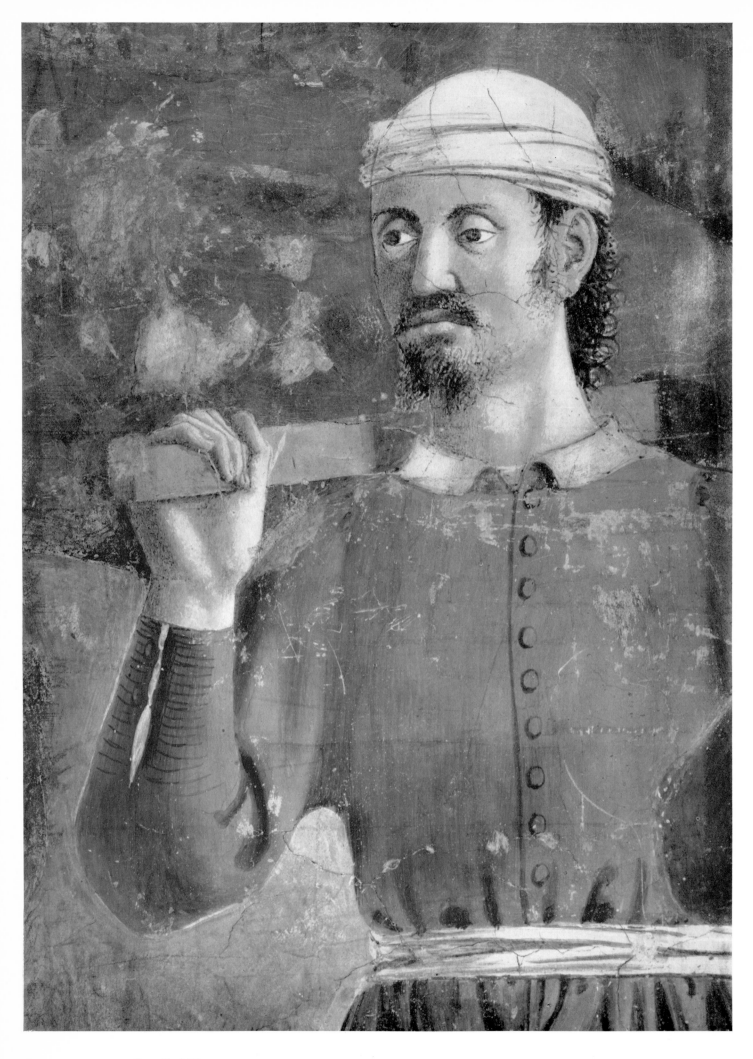

65. A WORKMAN. *Detail of Plate 59*

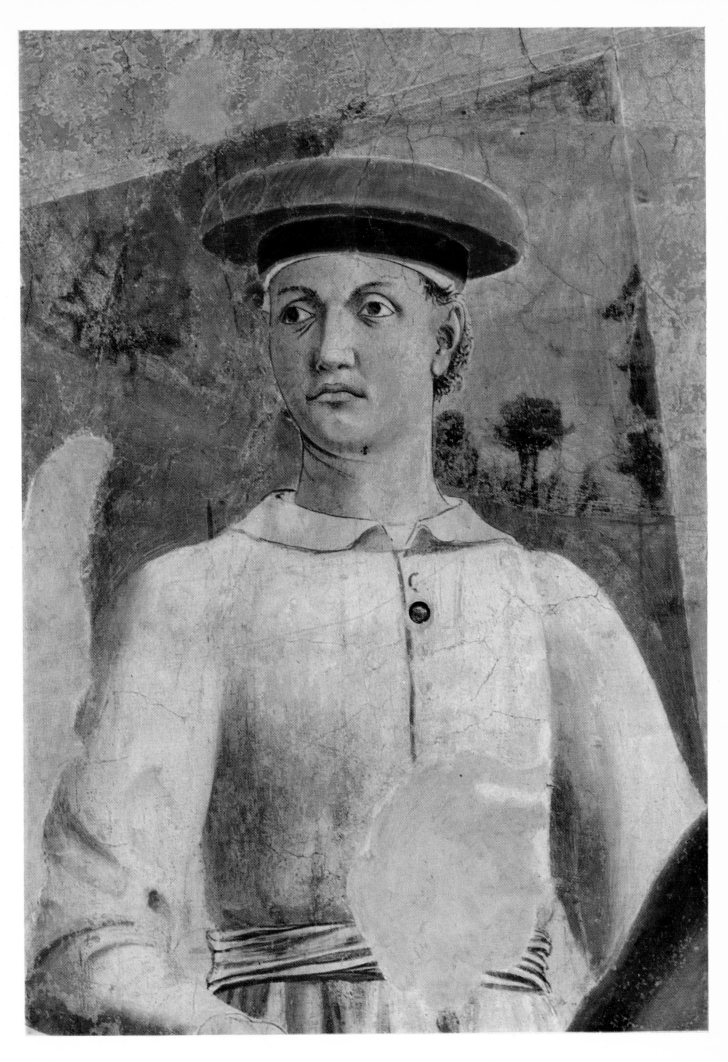

66. JUDAS. *Detail of Plate 59*

67. THE PROOF OF THE CROSS. *Detail of Plate 59*

68. ST. HELENA AND HER LADIES. *Detail of Plate 59*

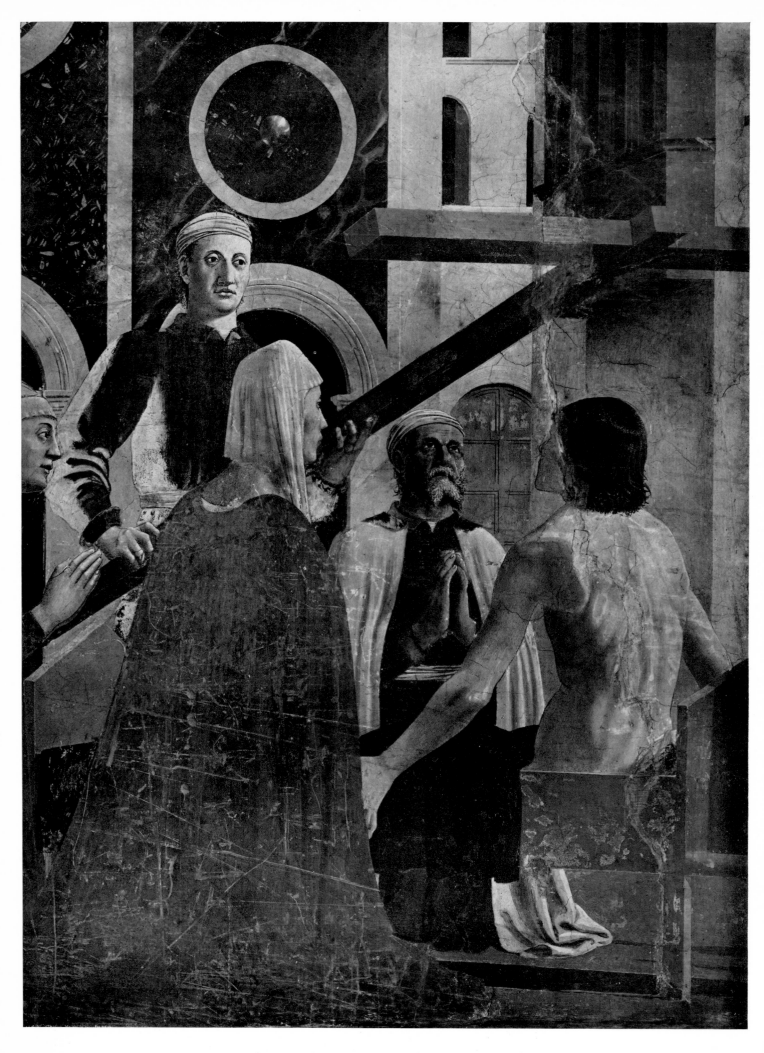

69. THE RESUSCITATED YOUTH. *Detail of Plate 59*

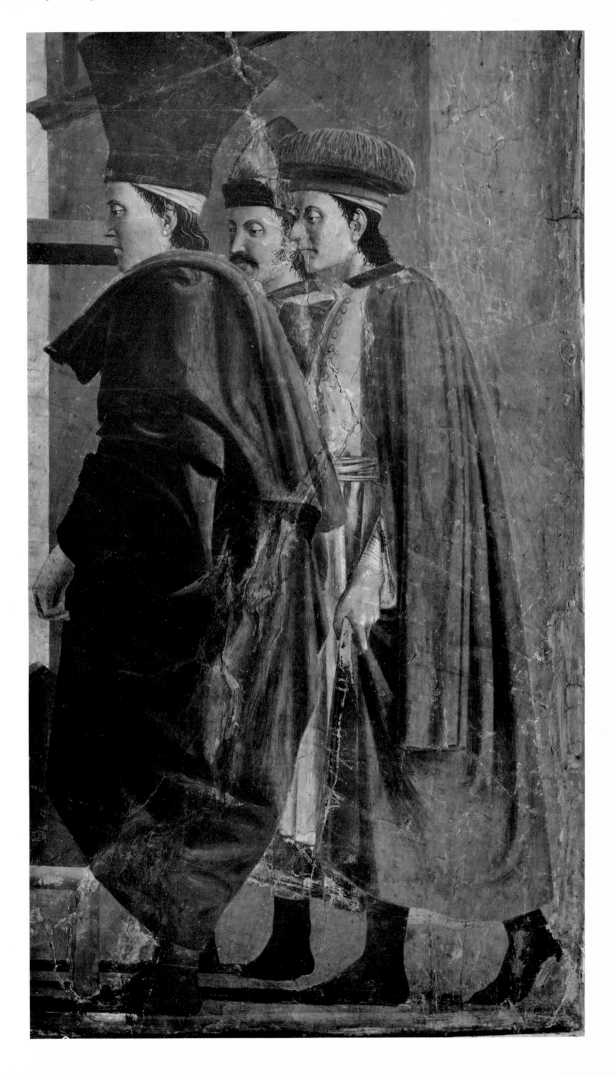

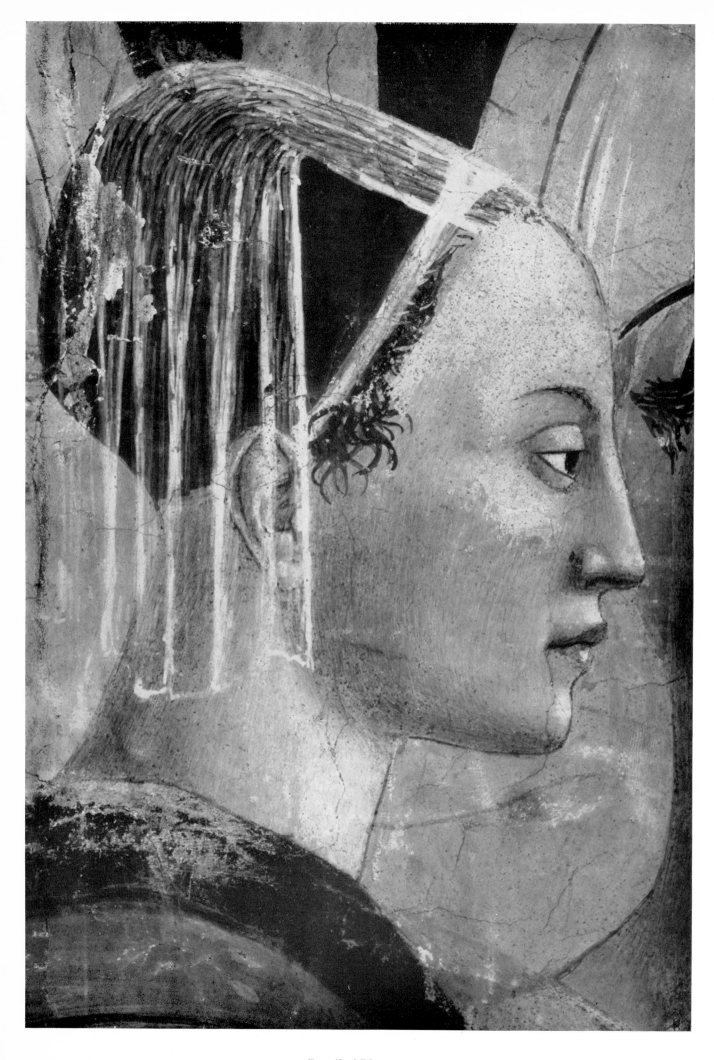

71. HEAD OF AN ATTENDANT OF ST. HELENA. *Detail of Plate 59*

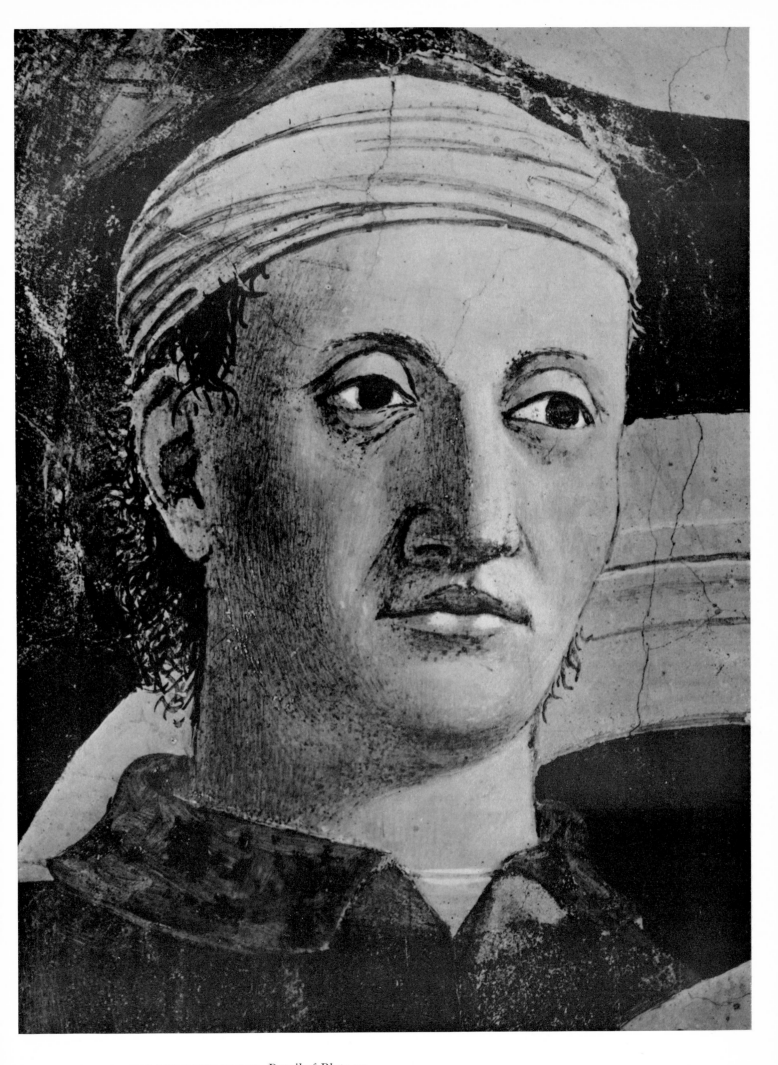

72. HEAD OF MAN HOLDING THE CROSS. *Detail of Plate 59*

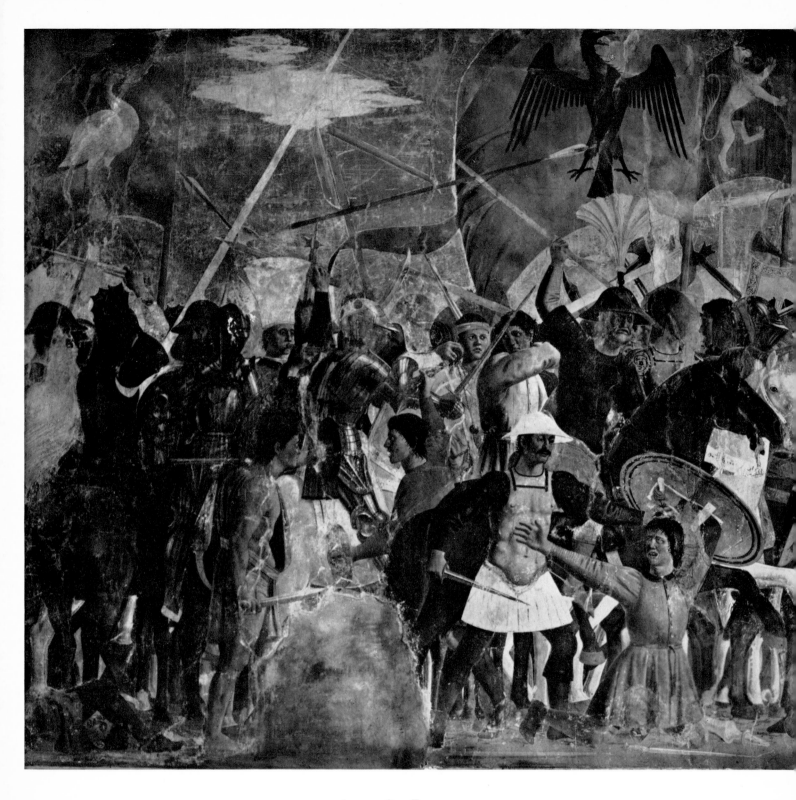

73. THE VICTORY OF HERACLIUS OVER CHOSROES. *Arezzo, San Francesco*

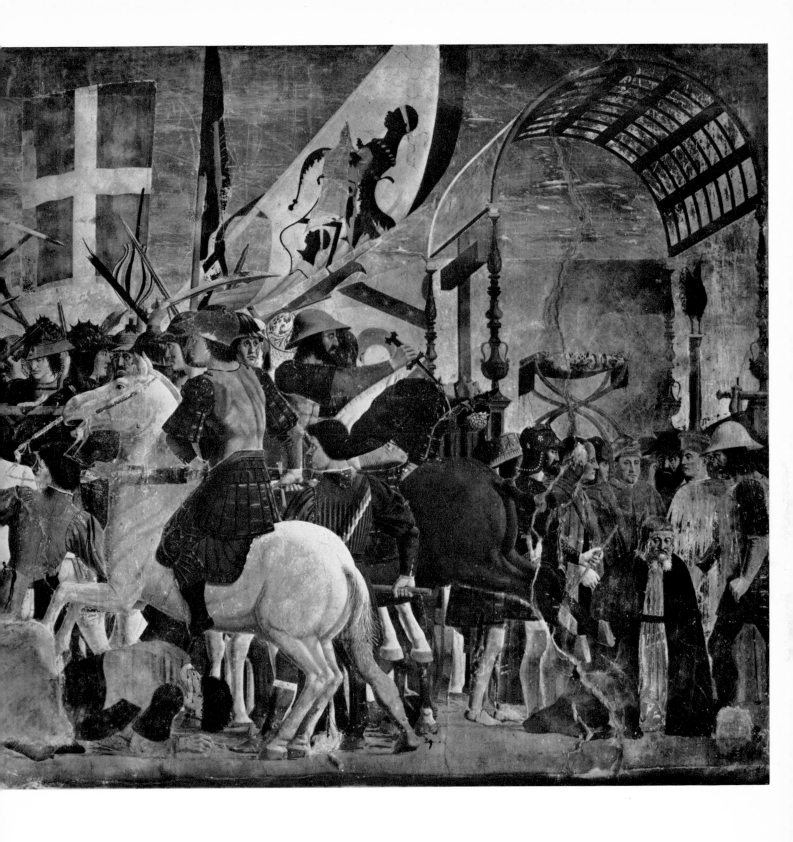

74. A BANNER. *Detail of Plate 73*

75. A BANNER. *Detail of Plate 73*

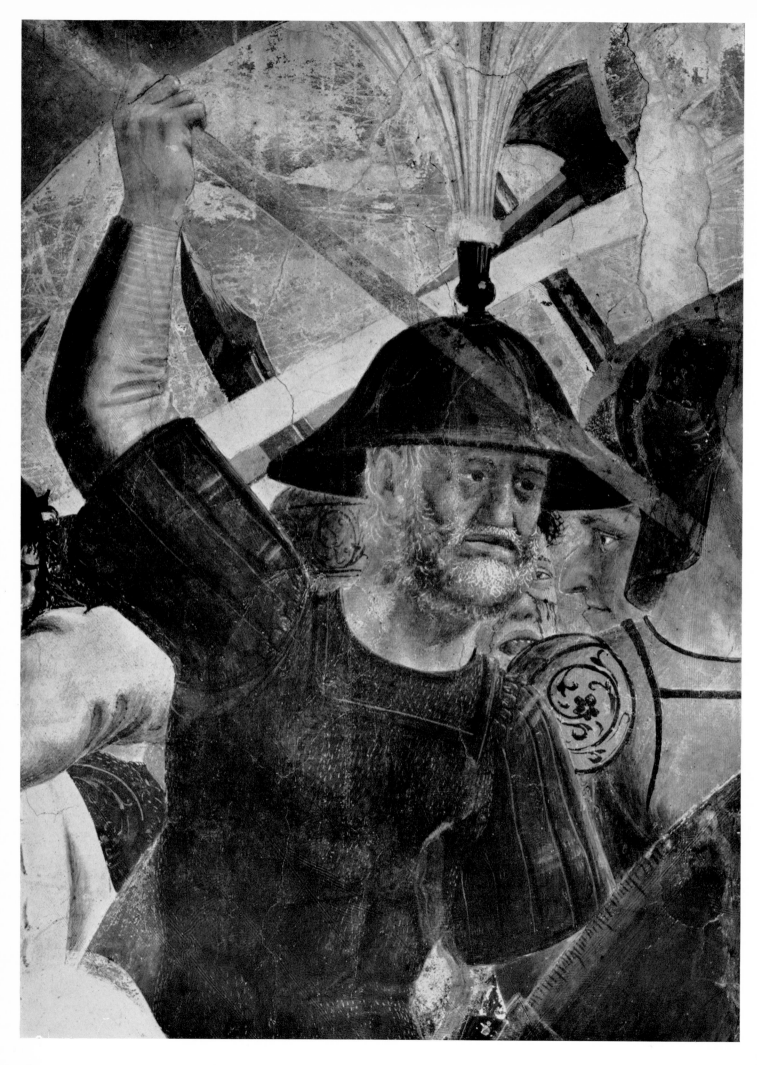

76. HEAD OF A HORSEMAN. *Detail of Plate 73*

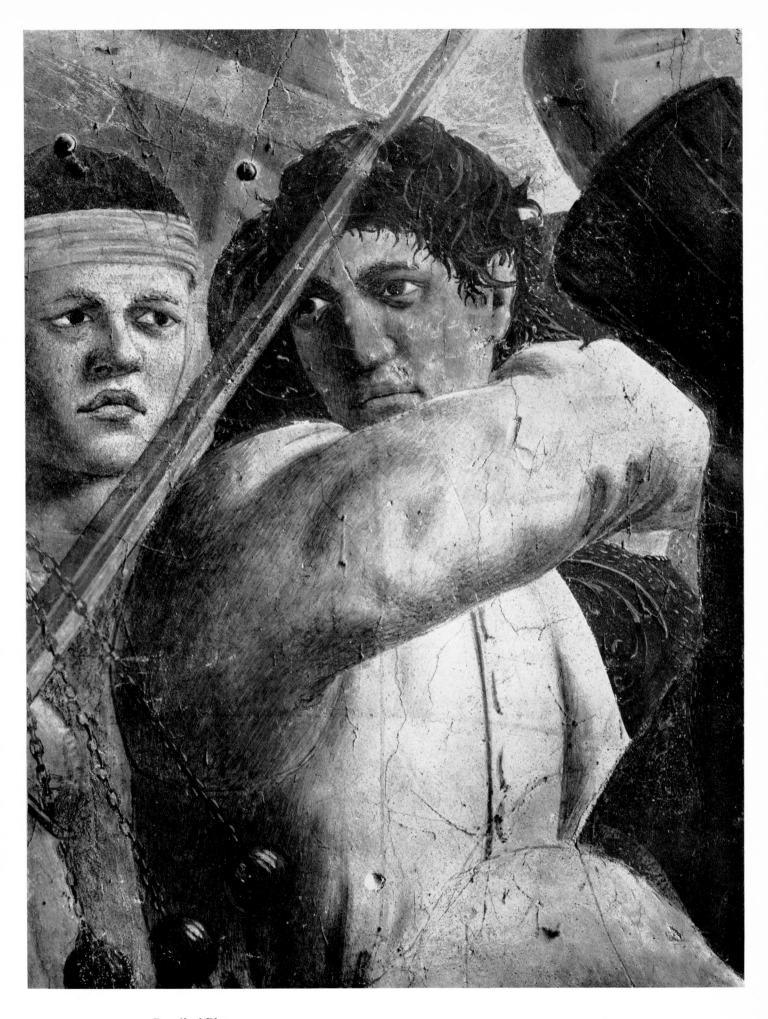

77. TWO SOLDIERS. *Detail of Plate 73*

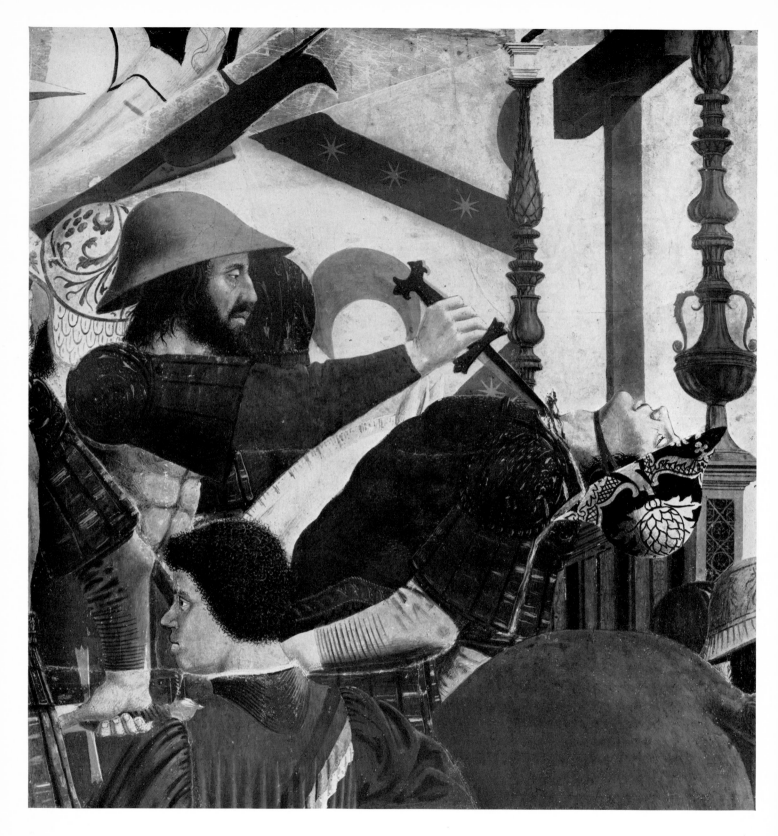

78. THE SLAYING OF THE SON OF CHOSROES. *Detail of Plate 73*

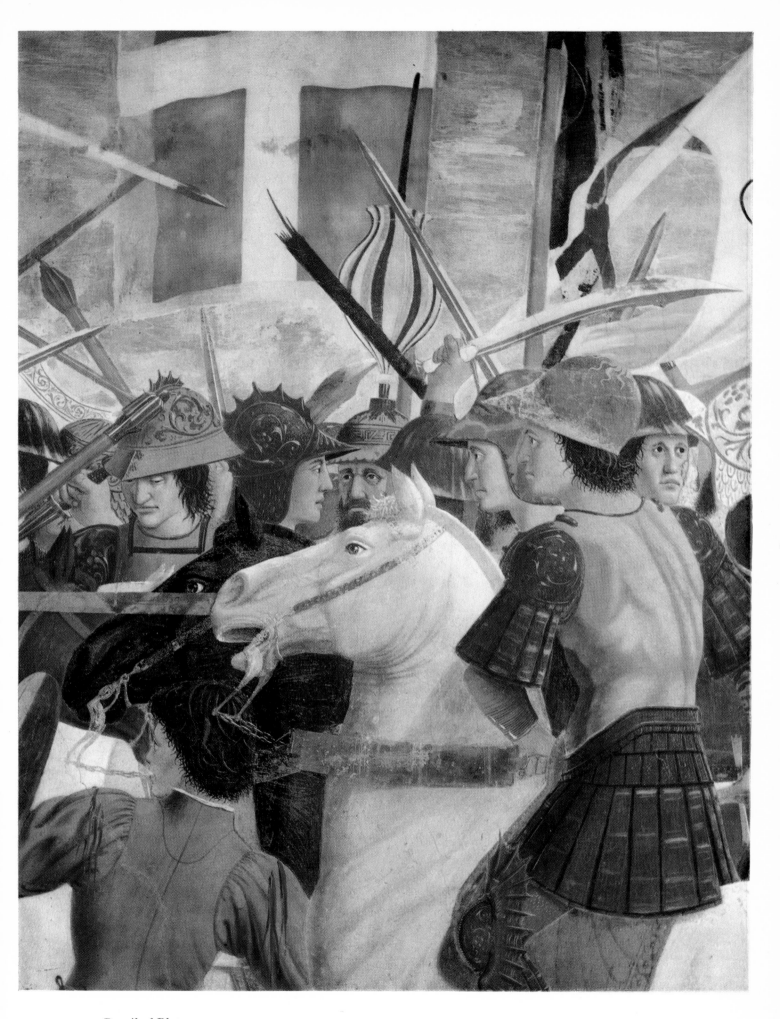

79. BATTLE. *Detail of Plate 73*

80. THE ELDERS OF JERUSALEM. *Detail of Plate 81*

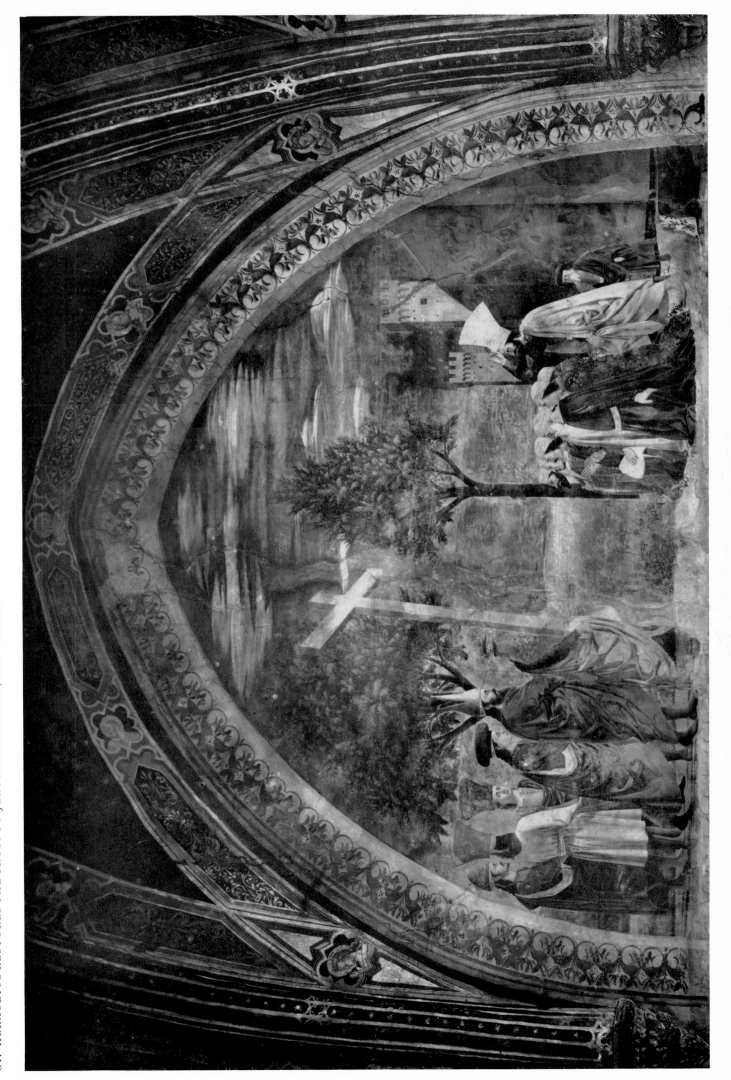

81. HERACLIUS RESTORES THE CROSS TO JERUSALEM. *Arezzo, San Francesco*

82 THREE HEADS. *Detail of Plate 81*

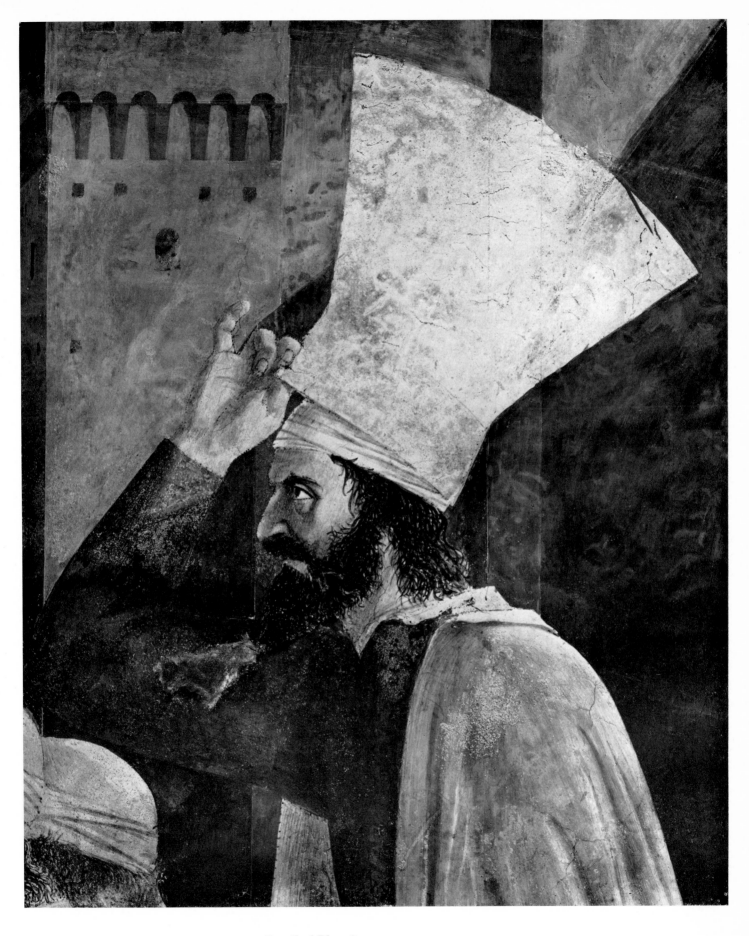

83. HEAD OF AN ELDER OF JERUSALEM. *Detail of Plate 81*

84. A TRUMPETER. *Detail of Plate 81*

85. KING HERACLIUS AND AN ATTENDANT. *Detail of Plate 81*

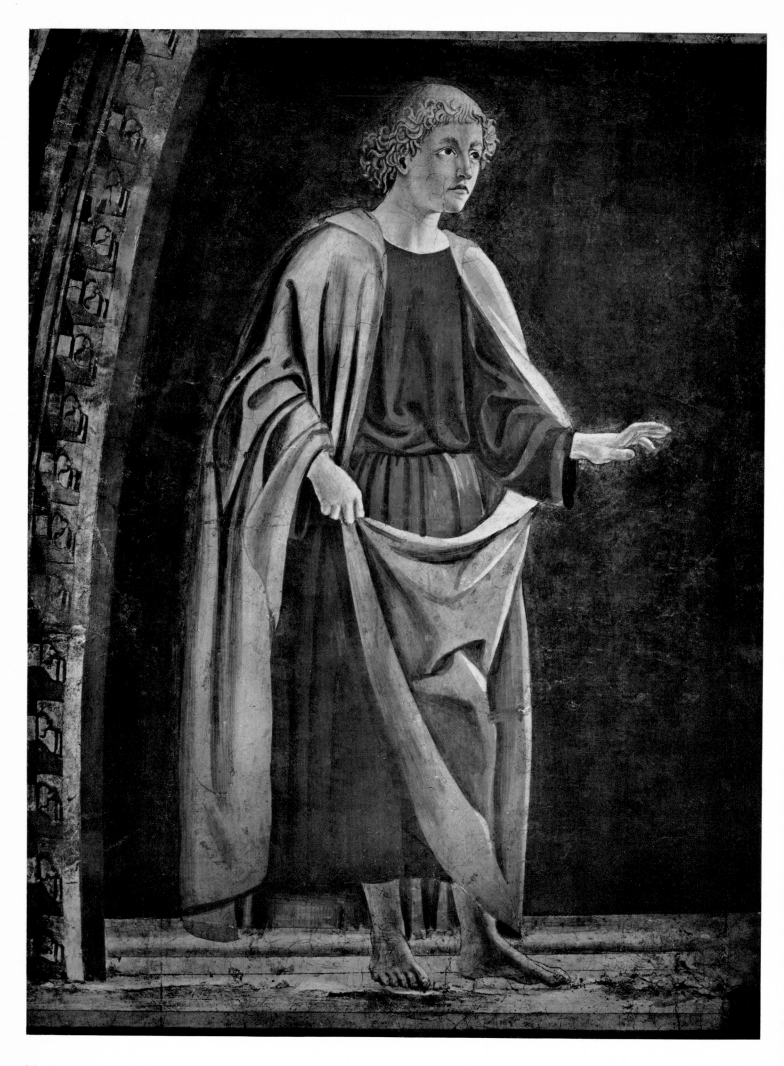

86. A PROPHET. *Arezzo, San Francesco*

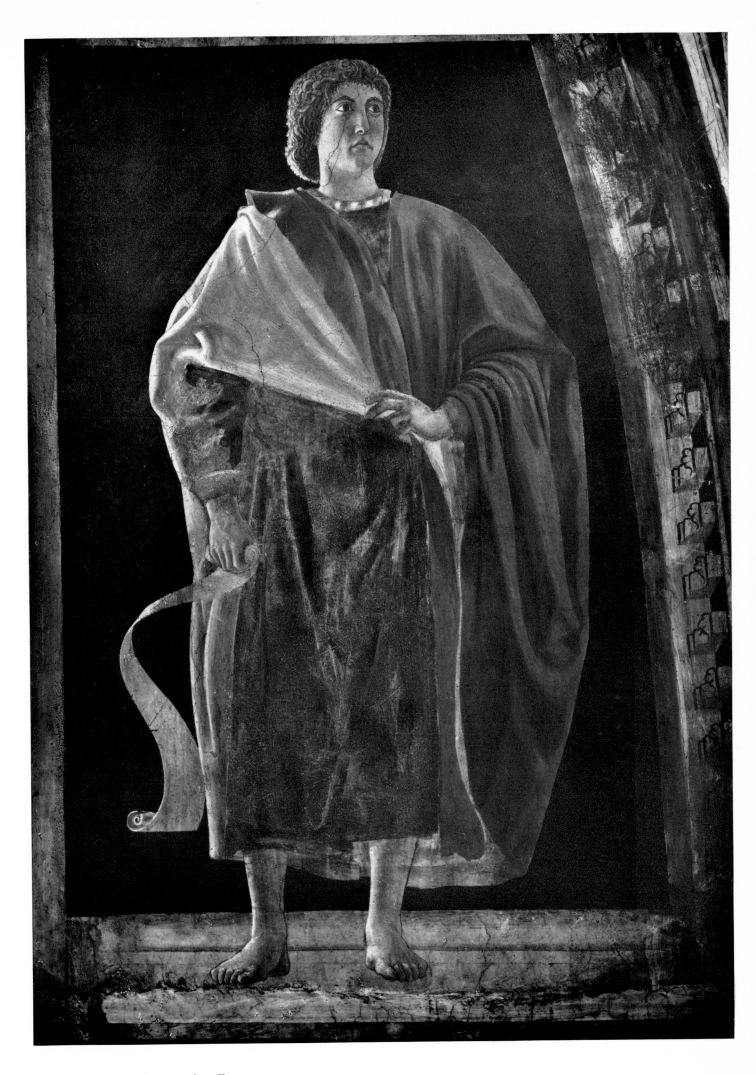

87. A PROPHET. *Arezzo, San Francesco*

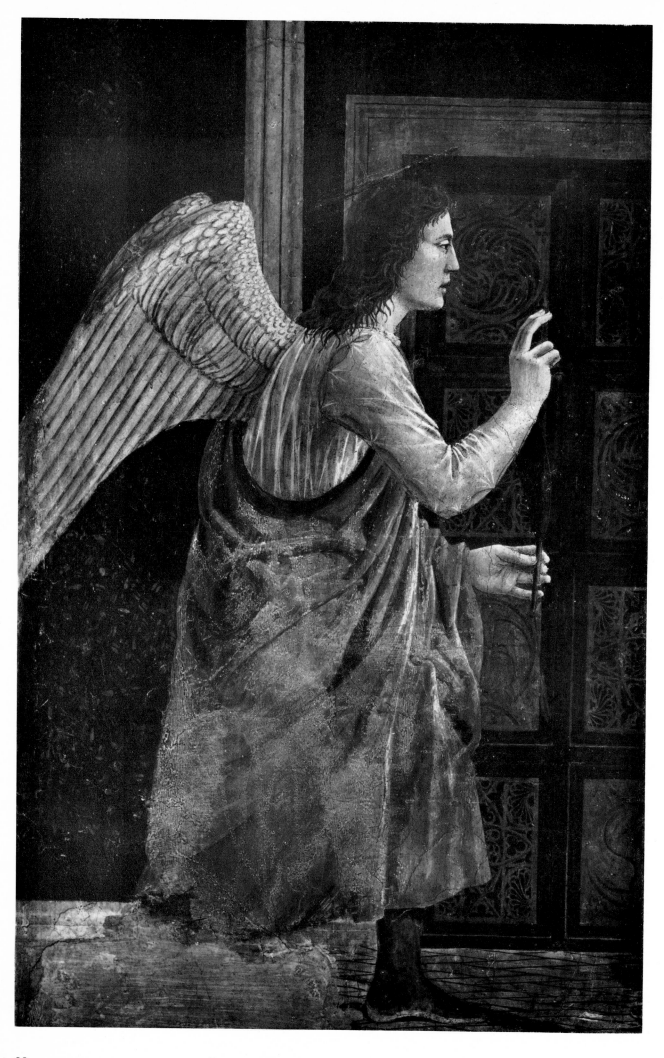

88. THE ARCHANGEL GABRIEL. *Detail of Plate 89*

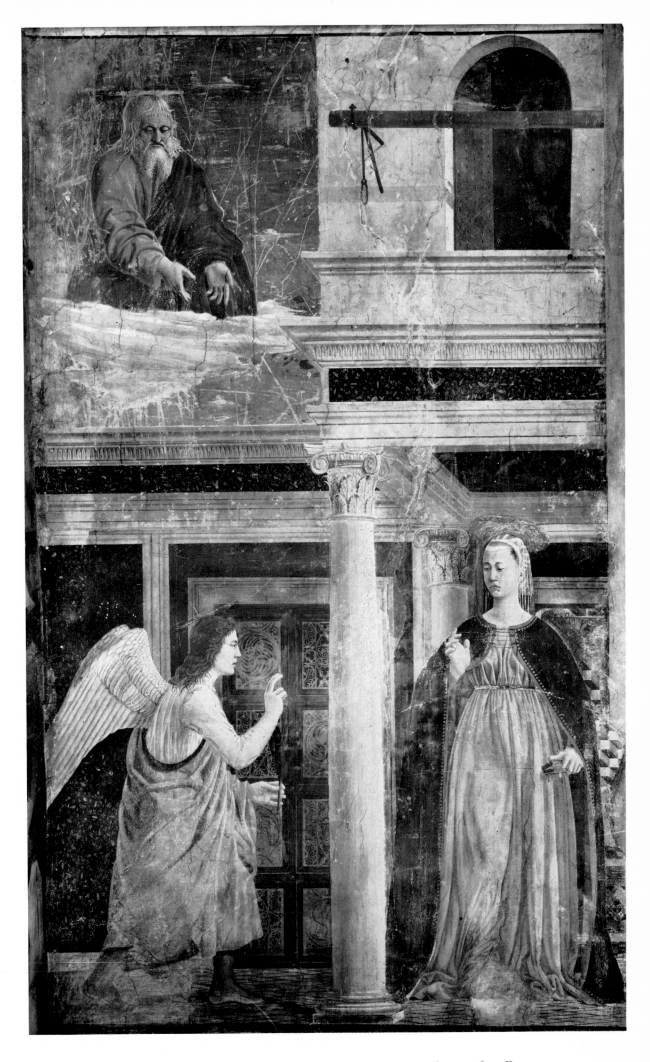

89. THE ANGEL GABRIEL APPEARING TO ST. HELENA, or THE ANNUNCIATION. *Arezzo, San Francesco*

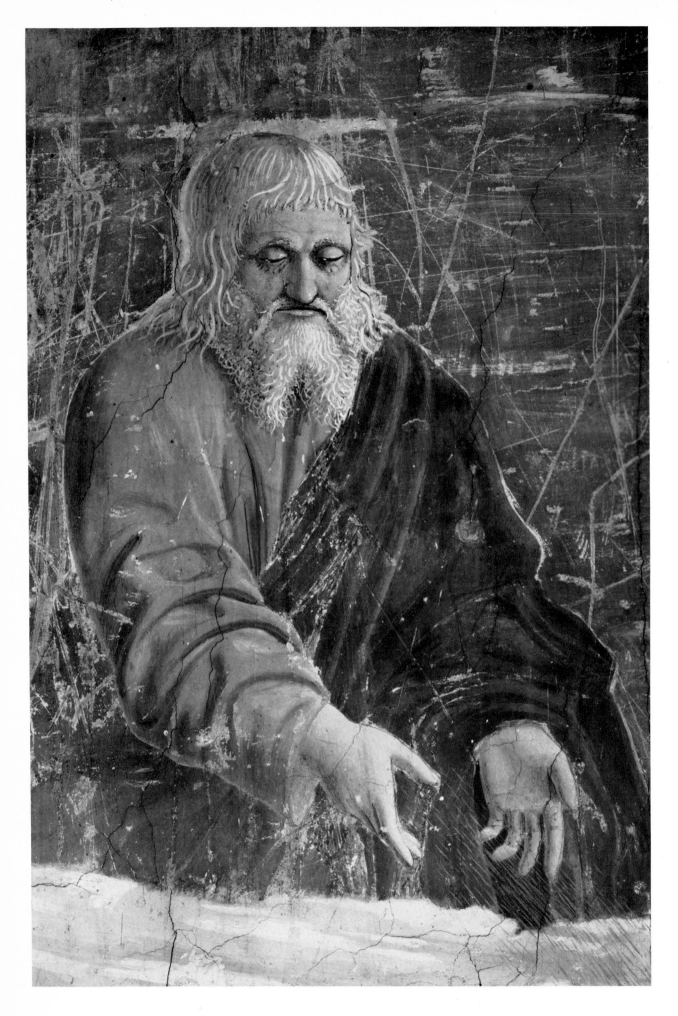

90. GOD THE FATHER. *Detail of Plate 89*

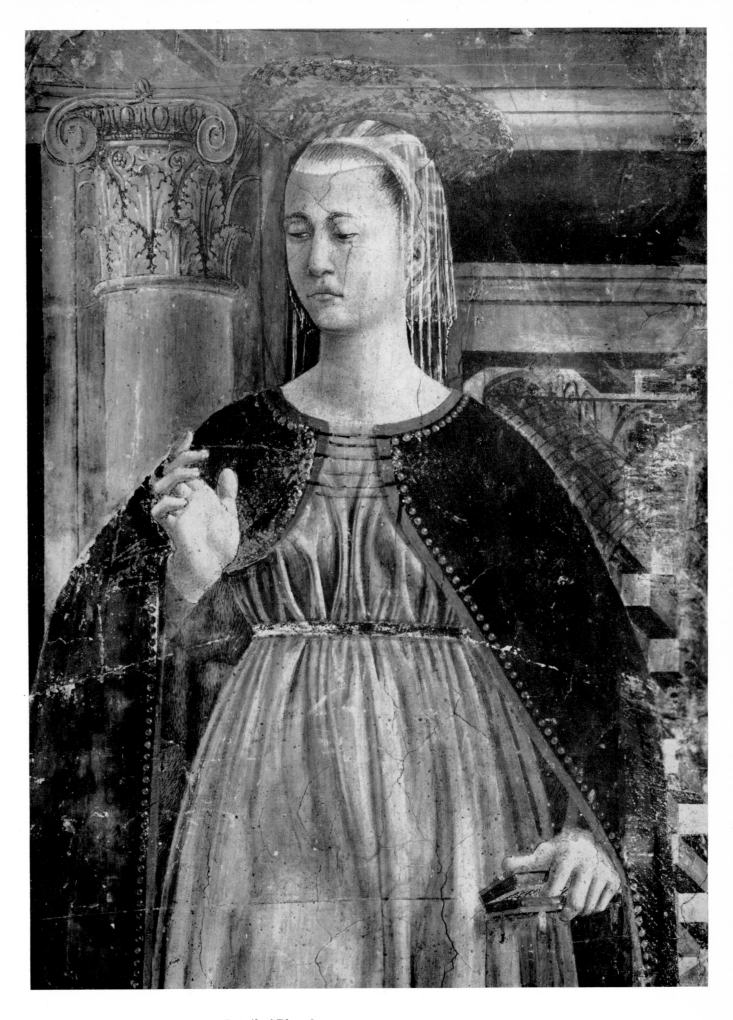

91. THE VIRGIN ANNUNCIATE. *Detail of Plate 89*

92. AN ANGEL. *Arezzo, San Francesco*

93. ST. JULIAN (?) *Borgo San Sepolcro, Palazzo Communale*

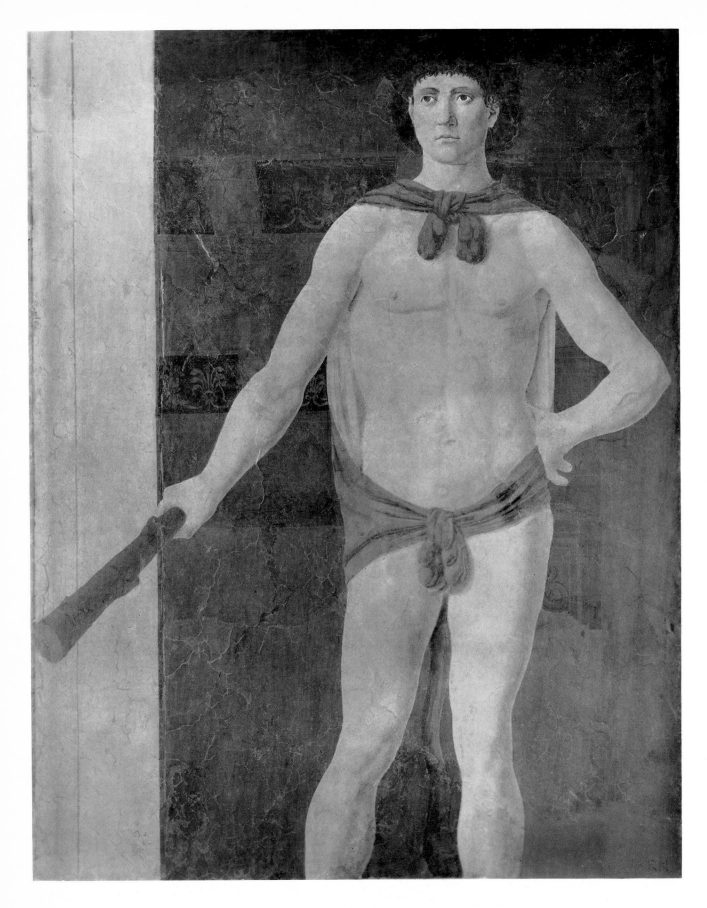

94. HERCULES. *Boston, Isabella Stewart Gardner Museum*

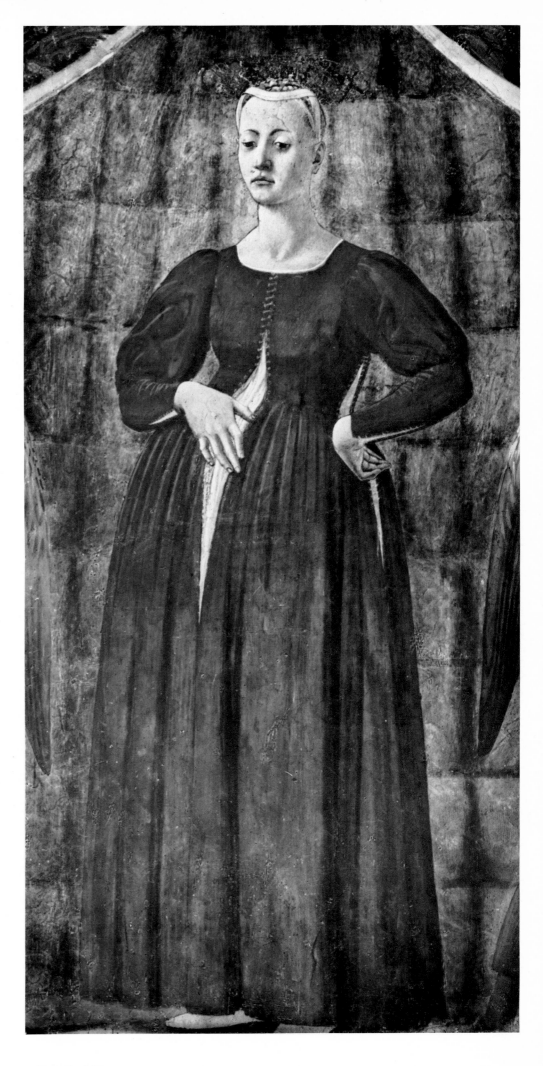

95. MADONNA DEL PARTO. *Detail of Plate 97*

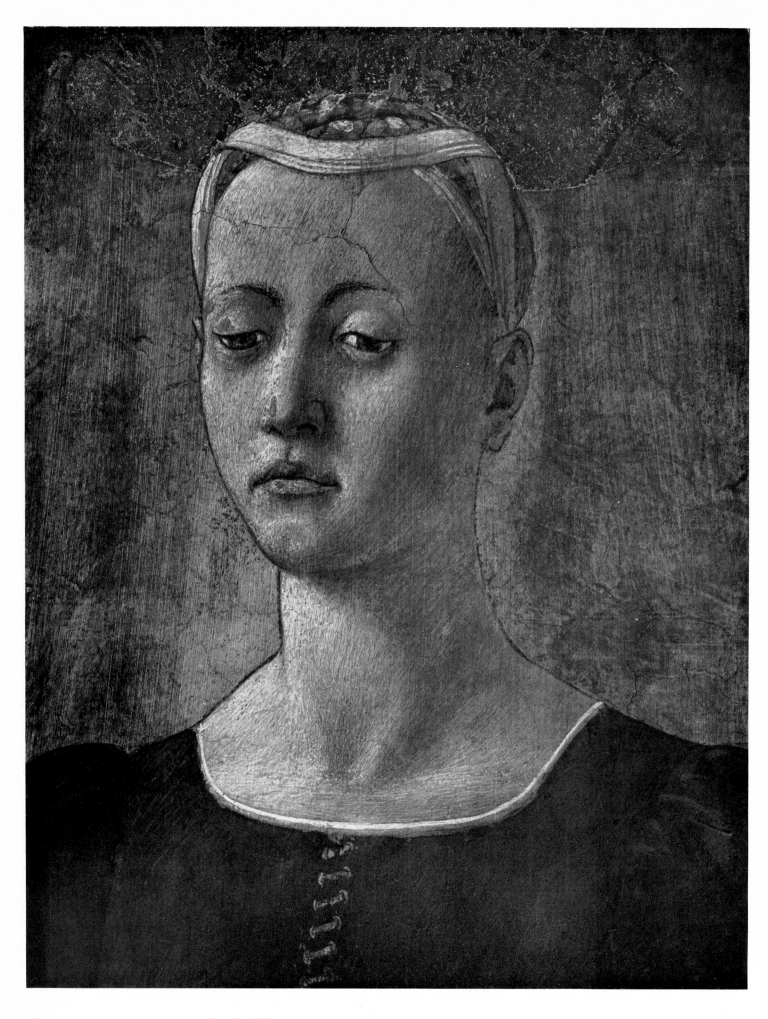

96. HEAD OF THE MADONNA. *Detail of Plate 97*

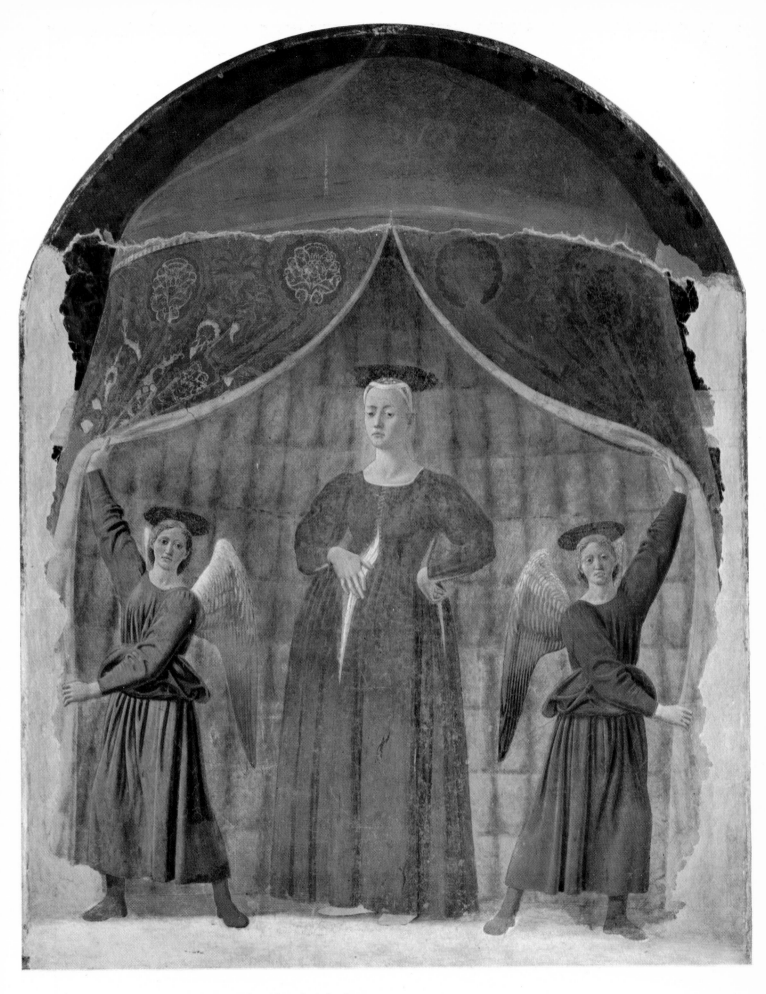

97. 'MADONNA DEL PARTO'. *Monterchi, Chapel of the Cemetery*

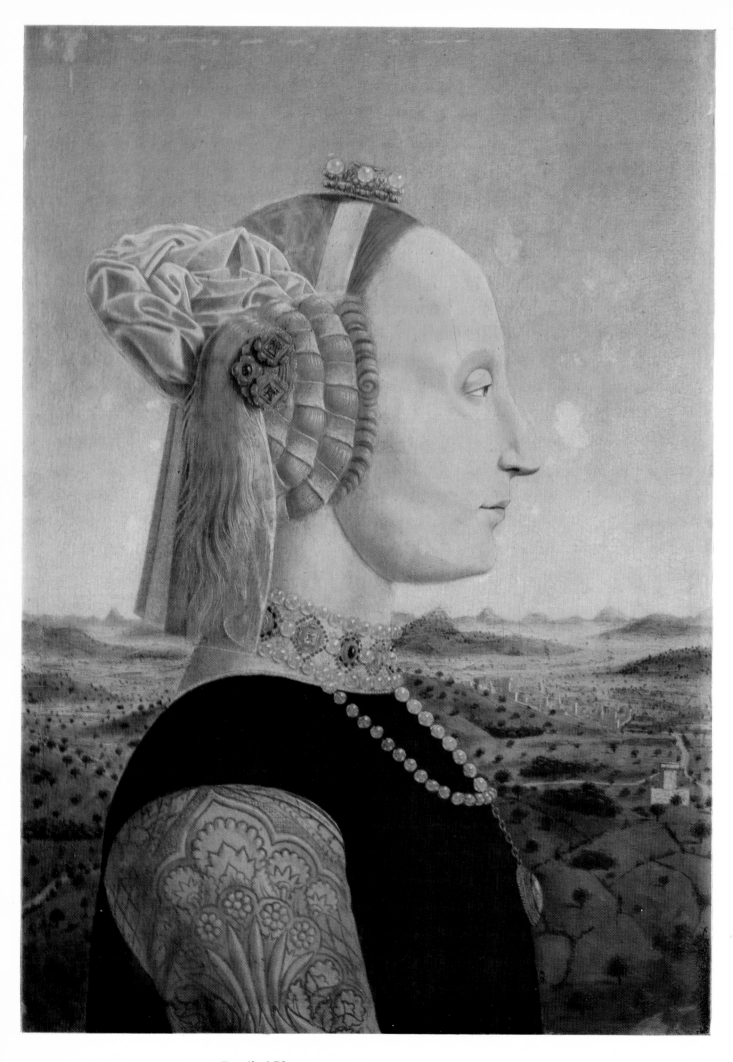

98. HEAD OF BATTISTA SFORZA. *Detail of Plate 100*

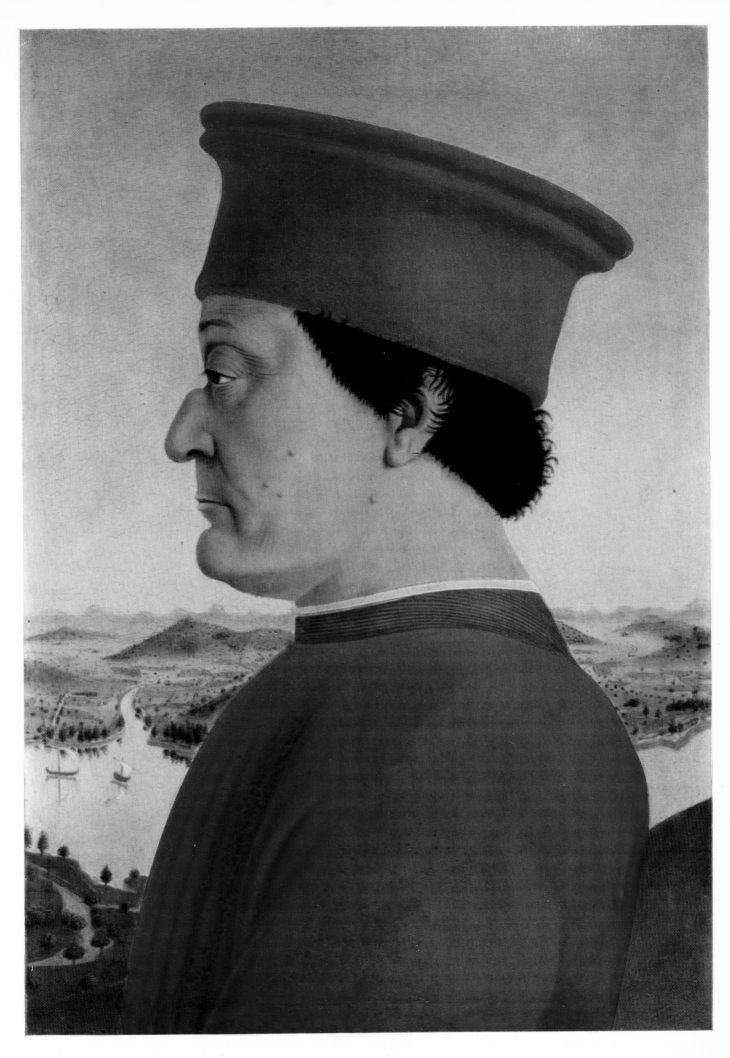

99. HEAD OF FEDERIGO DA MONTEFELTRO. *Detail of Plate 100*

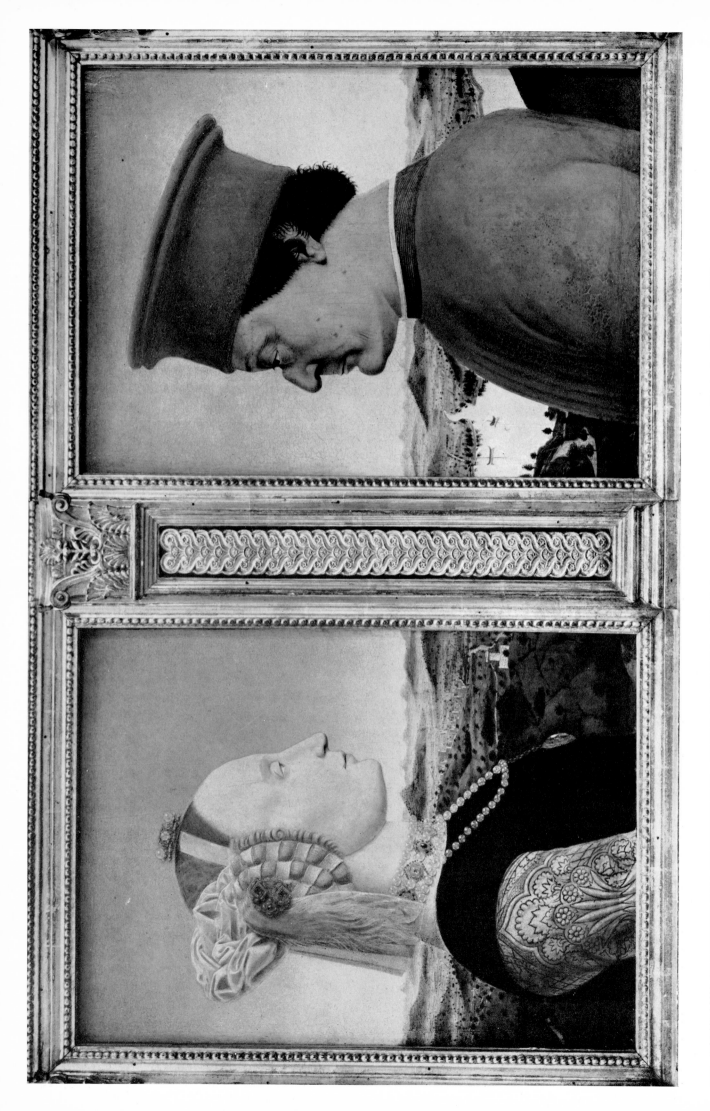

100. PORTRAITS OF FEDERIGO DA MONTEFELTRO, COUNT OF URBINO, AND HIS WIFE, BATTISTA SFORZA. *Diptych. Florence, Uffizi*

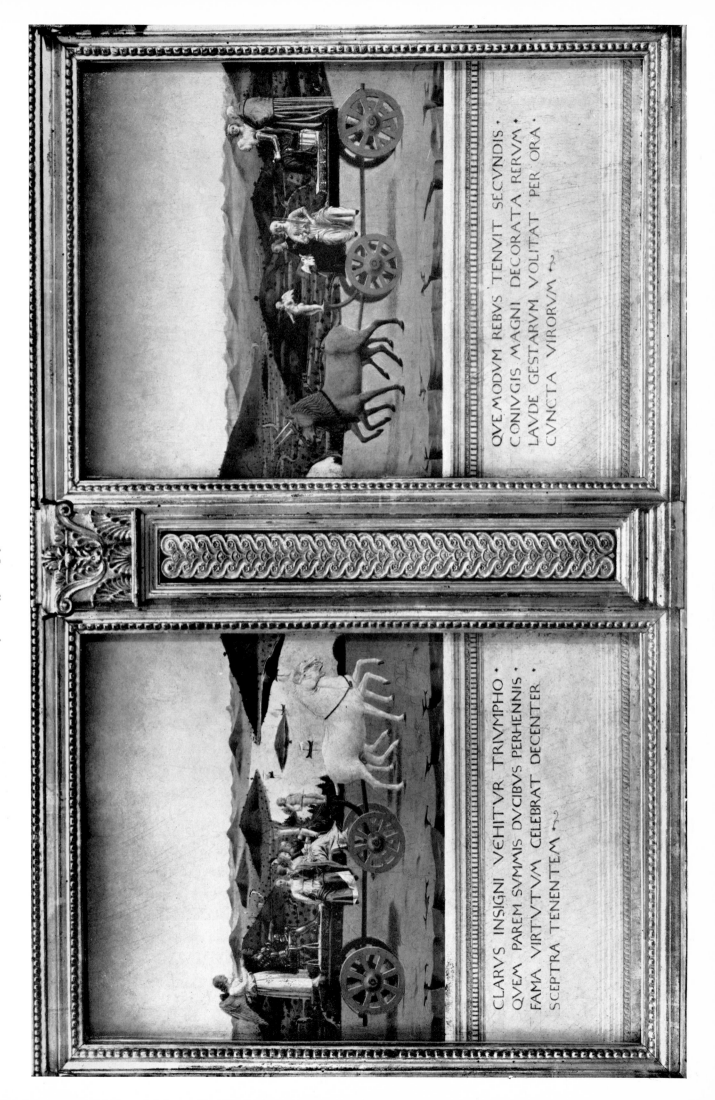

IOI. THE TRIUMPHS OF THE DUKE AND DUCHESS OF URBINO. *Reverse of the Uffizi diptych*

CLARVS INSIGNI VEHITVR TRIVMPHO
QVEM PAREM SVMMIS DVCIBVS PERHENNIS
FAMA VIRTVTVM CELEBRAT DECENTER
SCEPTRA TENENTEM

QVE MODVM REBVS TENVIT SECVNDIS
CONIVGIS MAGNI DECORATA RERVM
LAVDE GESTARVM VOLITAT PER ORA
CVNCTA VIRORVM

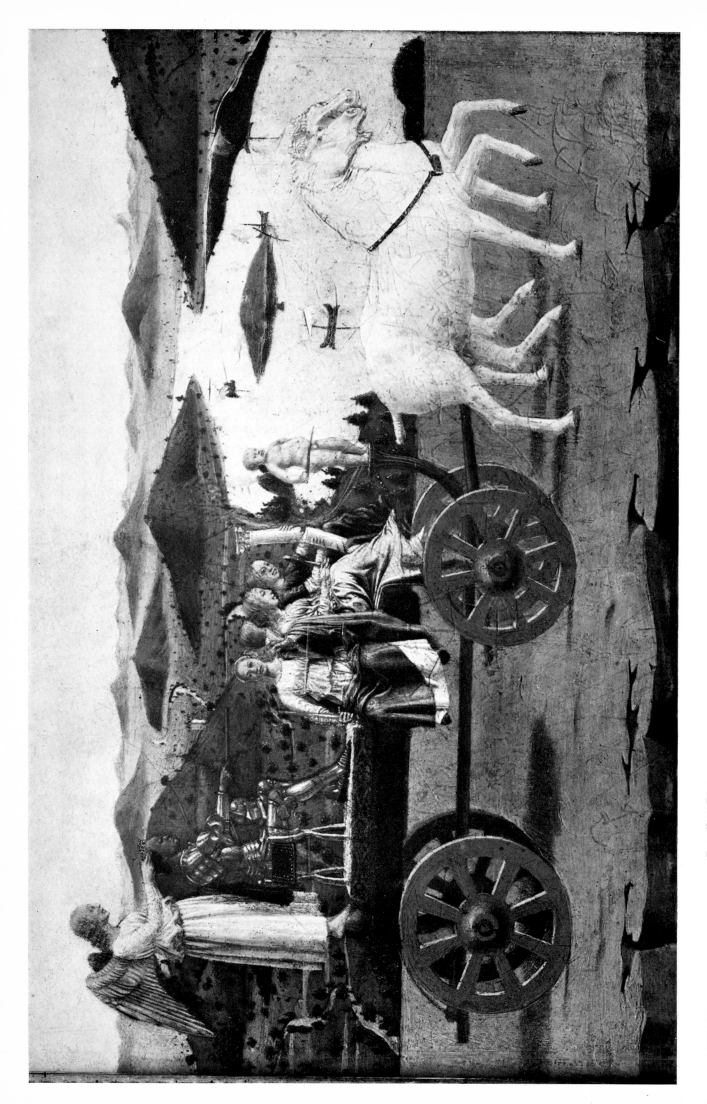

102. THE TRIUMPH OF THE COUNT. *Detail of Plate 101*

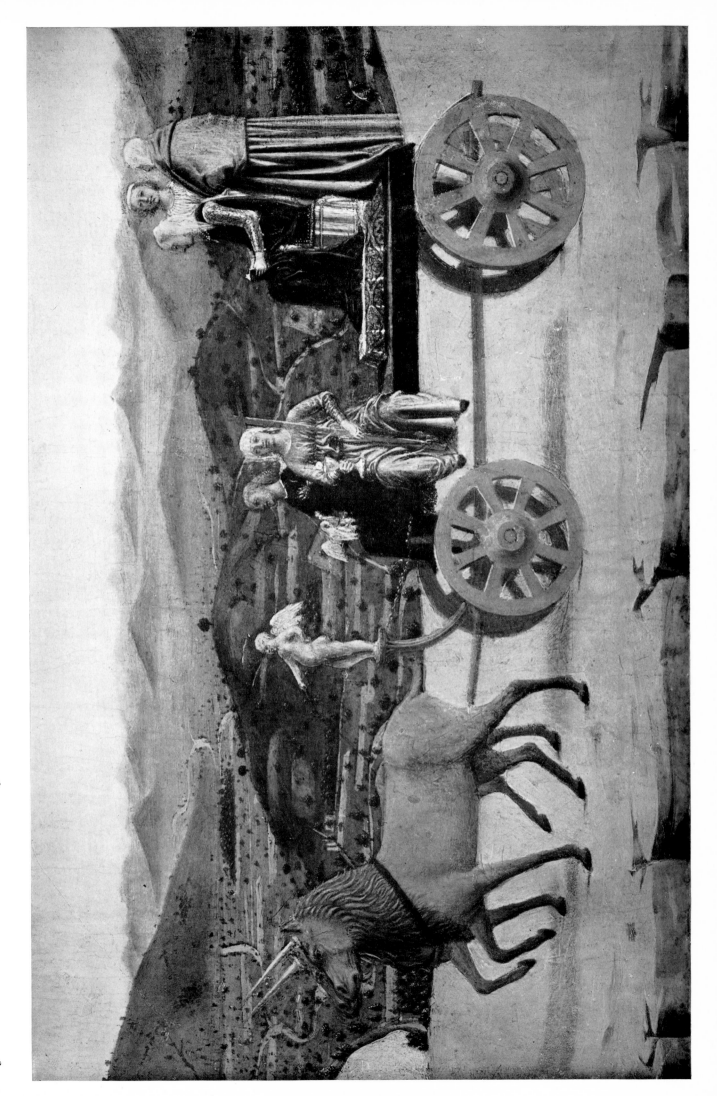

104. ST. LUKE. *Rome, Sta. Maria Maggiore*

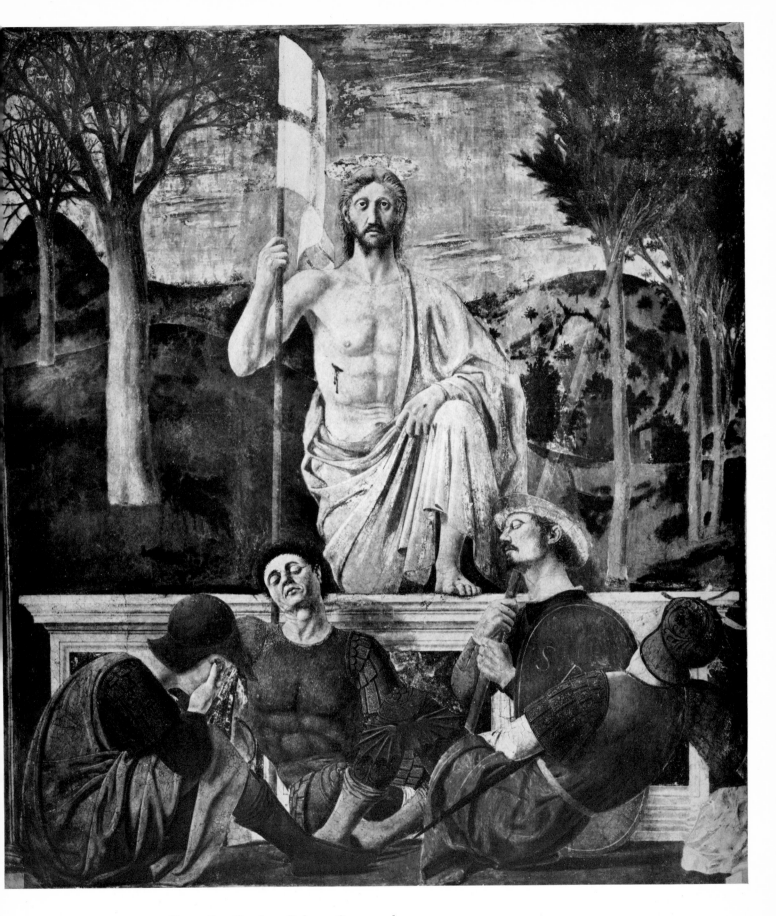

105. THE RESURRECTION. *Borgo San Sepolcro, Palazzo Communale*

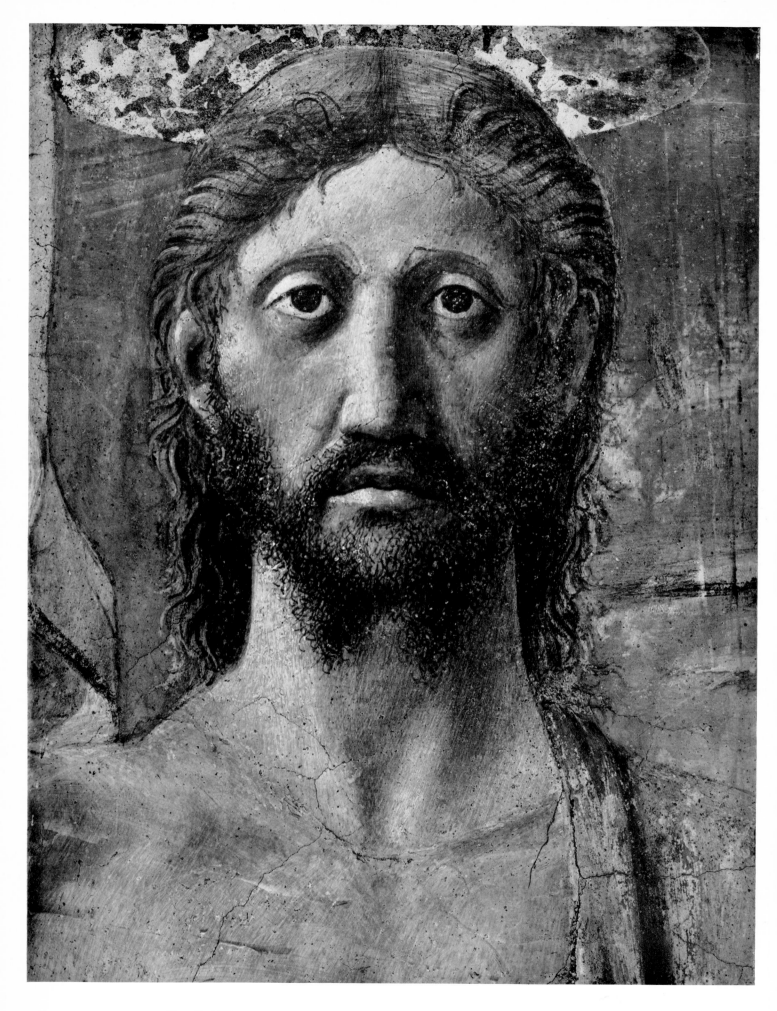

106. HEAD OF CHRIST. *Detail of Plate 105*

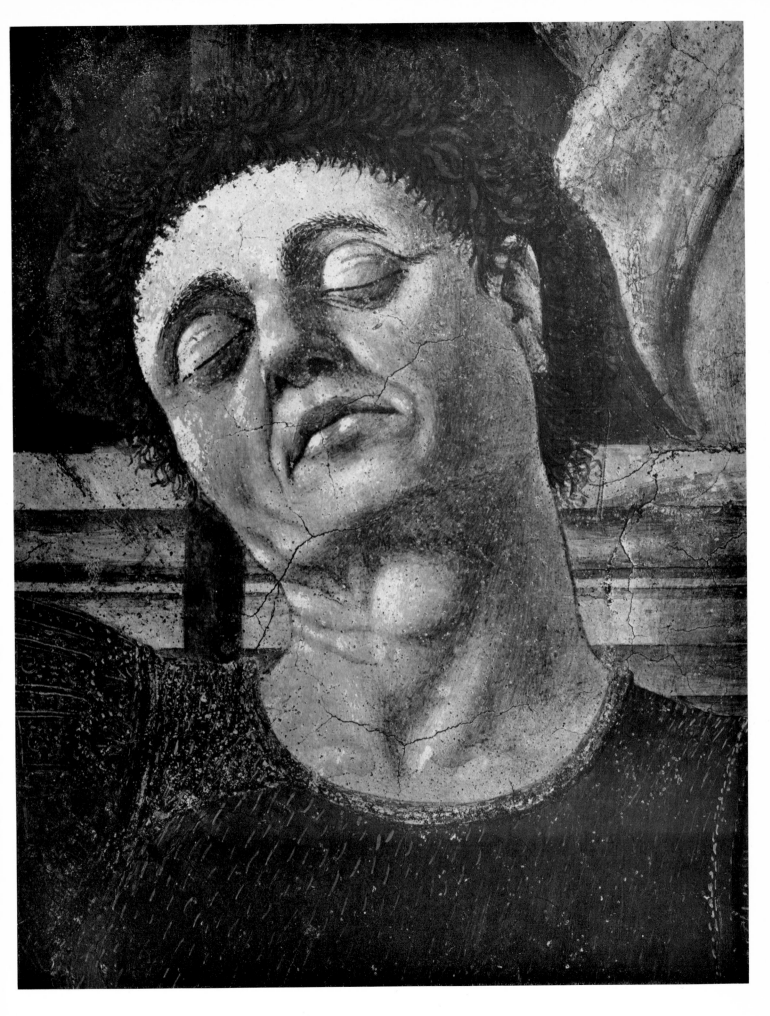

107. HEAD OF A SLEEPING SOLDIER. *Detail of Plate 105*

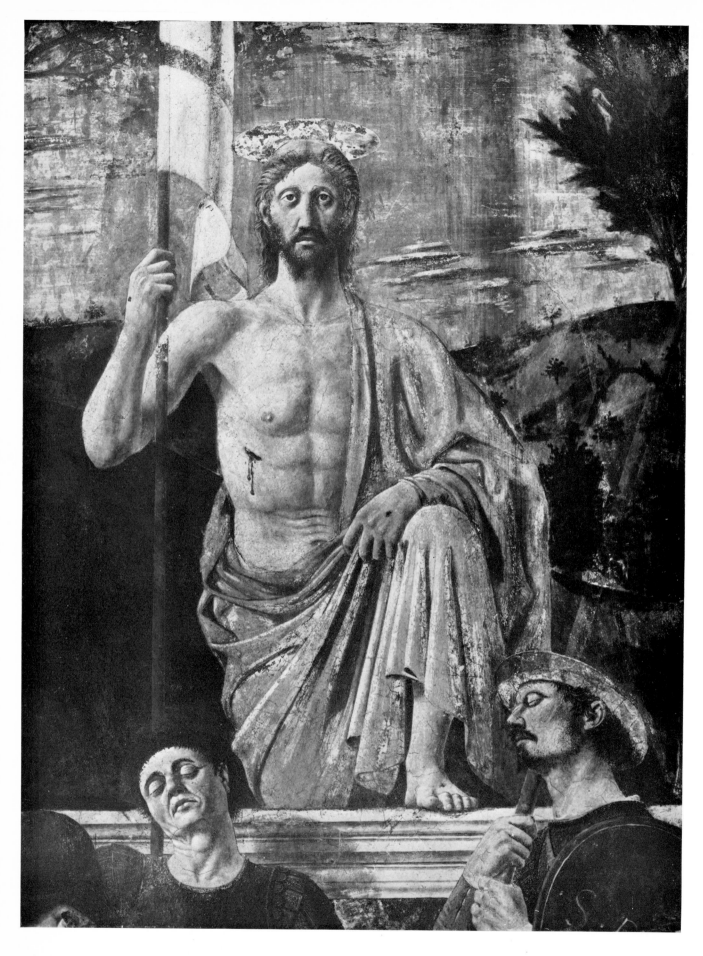

108. THE RISEN CHRIST. *Detail of Plate 105*

109. ST. MARY MAGDALEN. *Arezzo, Cathedral*

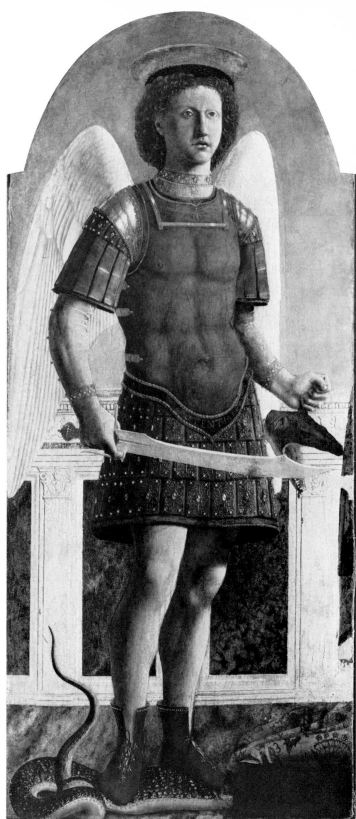

110. ST. AUGUSTINE.
Lisbon, Museum of Antique Art

111. ST. MICHAEL.
London, National Gallery

Four Saints from the Altar-piece of S. Agostino in Borgo San Sepolcro

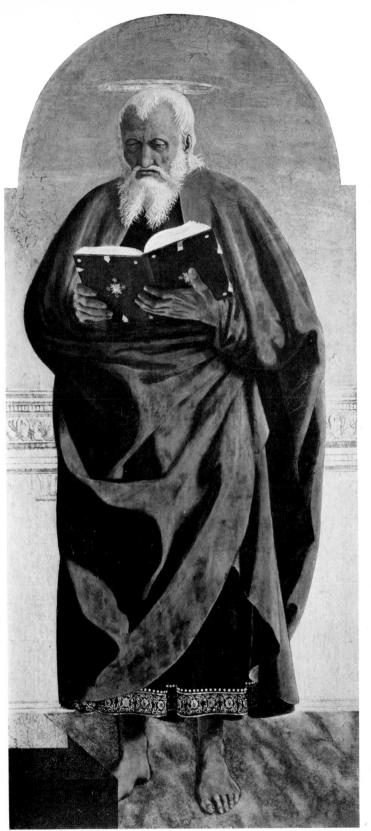

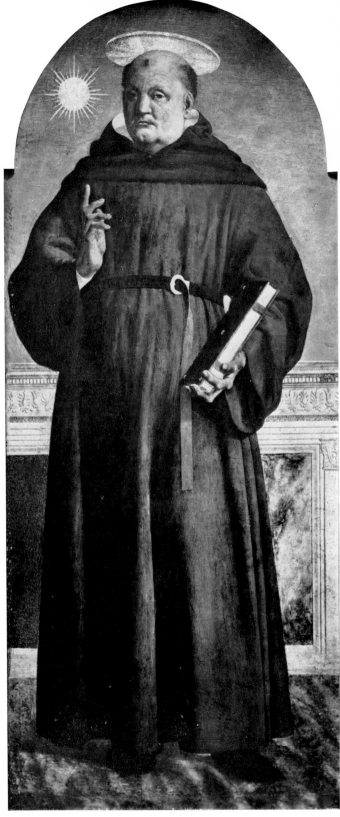

112. ST. JOHN THE EVANGELIST (?)
New York, Frick Collection

113. ST. NICHOLAS OF TOLENTINO.
Milan, Poldi-Pezzoli Museum

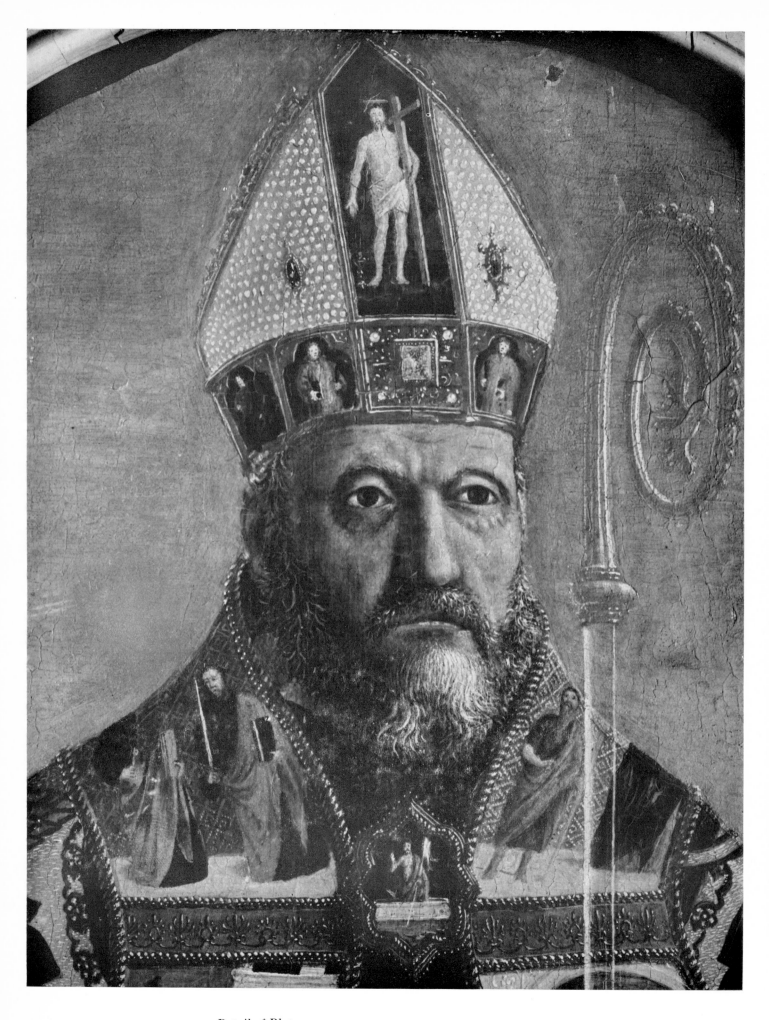

114. HEAD OF ST. AUGUSTINE. *Detail of Plate 110*

115. HEAD OF ST. NICHOLAS OF TOLENTINO. *Detail of Plate 113*

116. HEAD OF ST. MICHAEL. *Detail of Plate III*

117. HEAD OF ST. JOHN THE EVANGELIST. *Detail of Plate 112*

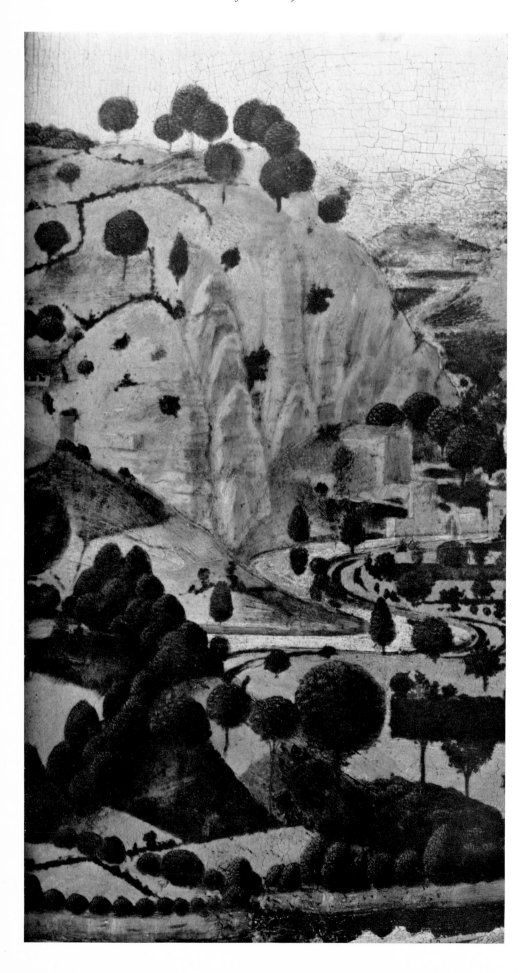

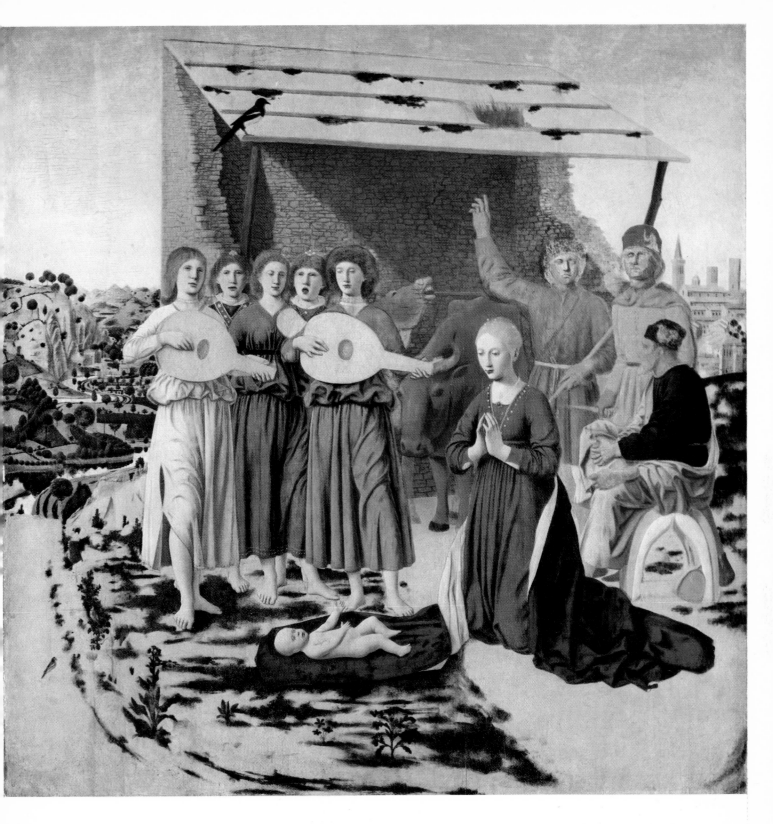

119. THE NATIVITY. *London, National Gallery*

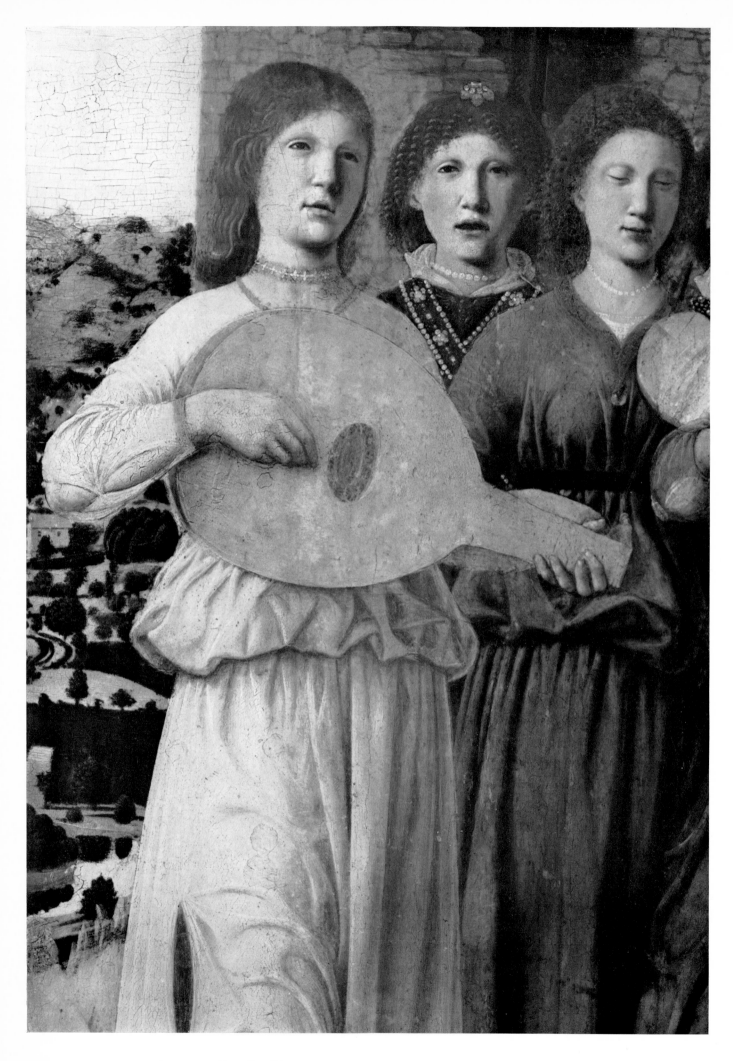

120. HEADS OF THREE ANGELS. *Detail of Plate 119*

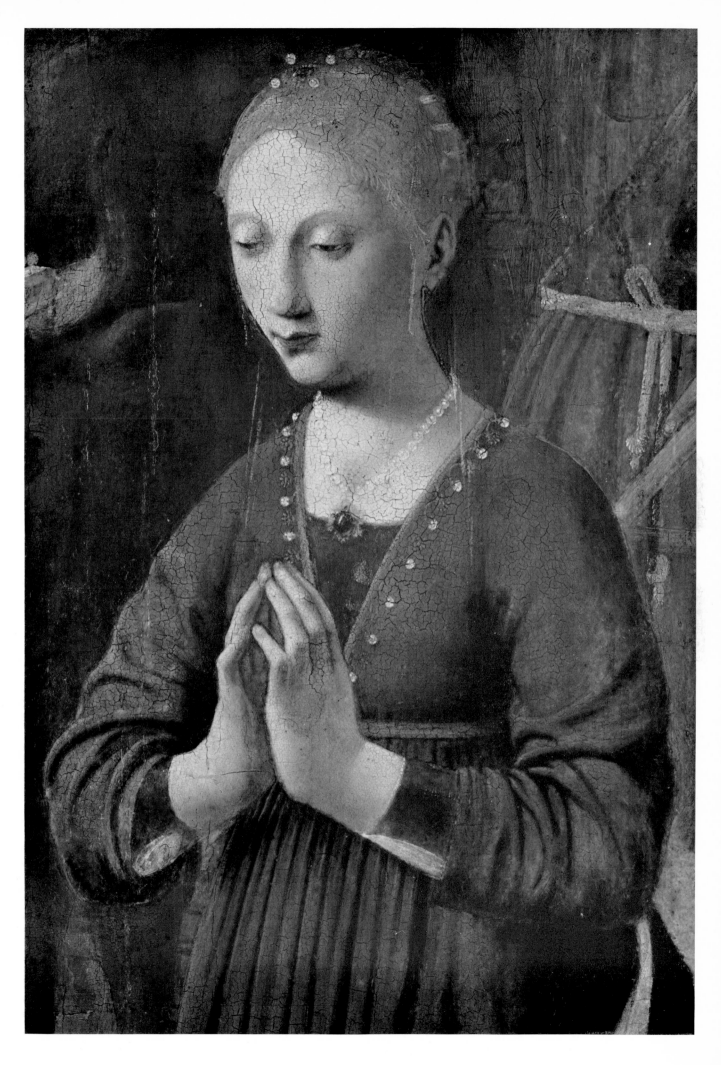

121. HEAD OF THE VIRGIN. *Detail of Plate 119*

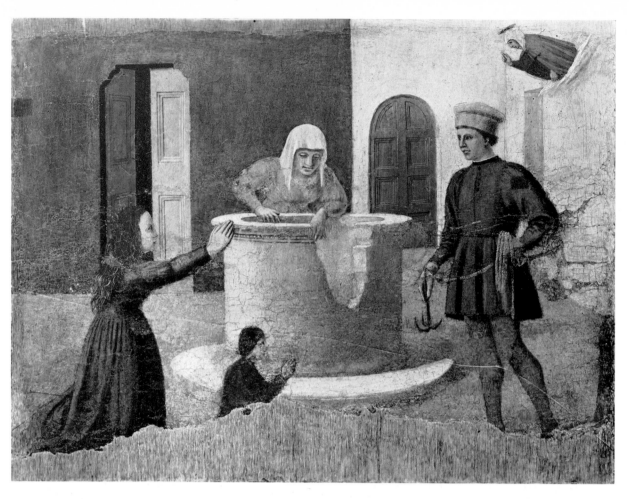

122–123. A MIRACLE OF ST. ANTHONY. A MIRACLE OF ST. ELIZABETH OF HUNGARY.
From the Predella of the Perugia Altarpiece, Plate 124.

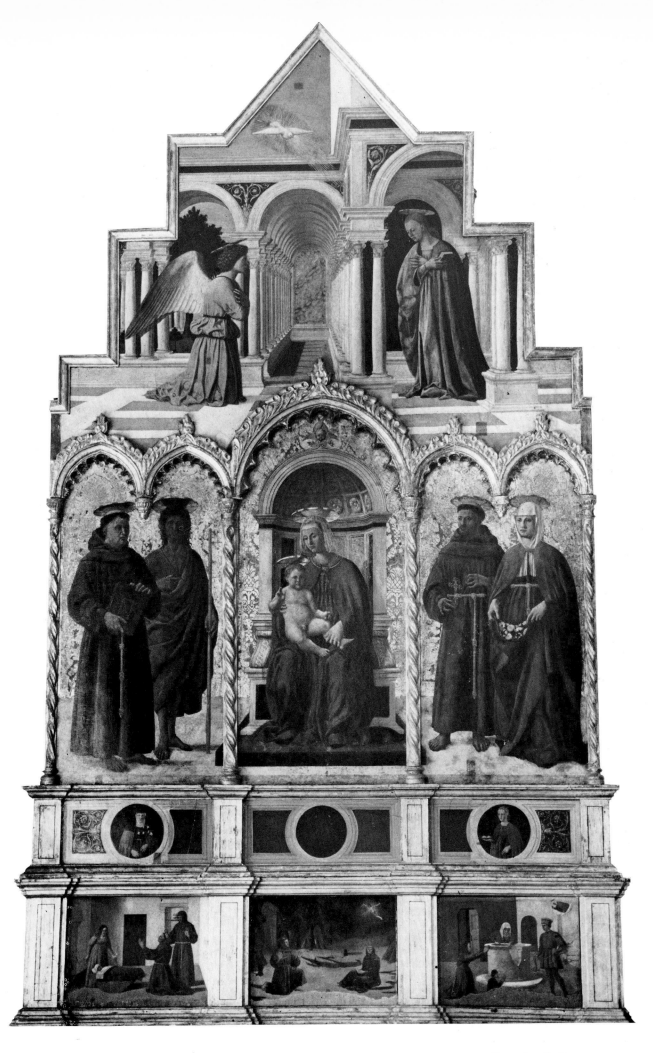

124. MADONNA AND CHILD WITH FOUR SAINTS; THE ANNUNCIATION. *Perugia, Gallery*

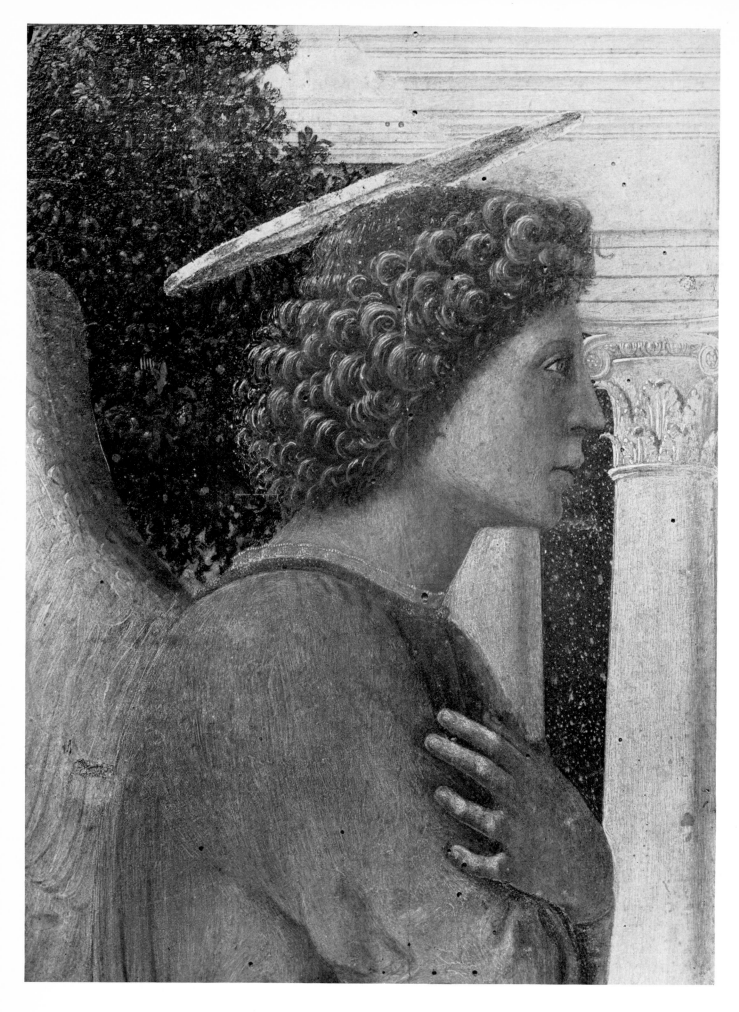

125. THE ARCHANGEL GABRIEL. *Detail of Plate 124*

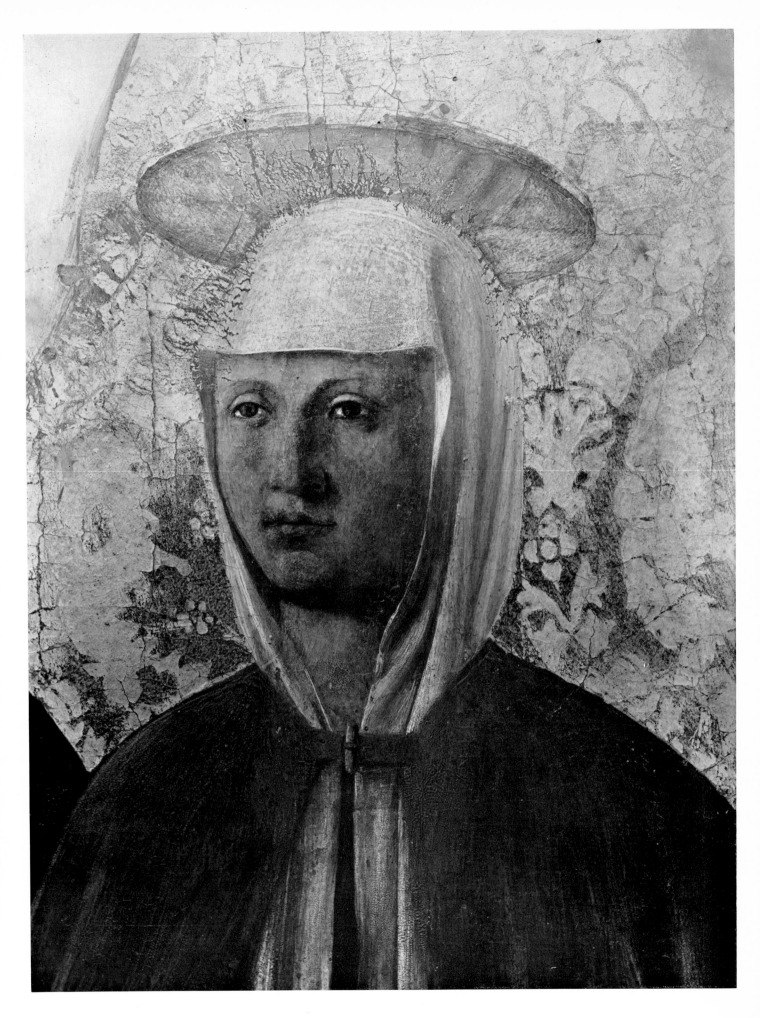

126. ST. ELIZABETH OF HUNGARY. *Detail of Plate 124*

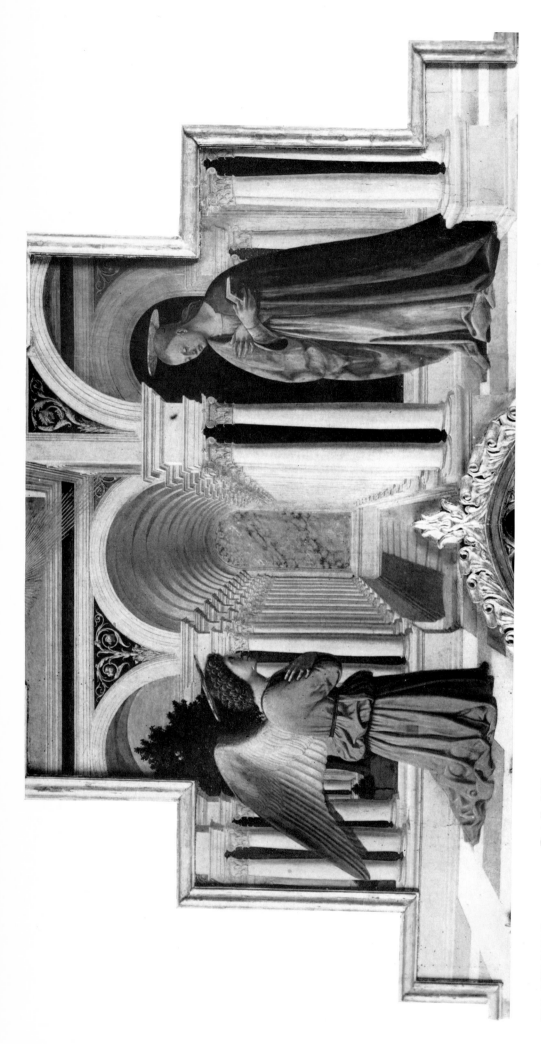

127. THE ANNUNCIATION. *Detail of Plate 124*

128. PERSPECTIVE VIEW OF AN IDEAL TOWN. *Urbino, Gallery*

129. MADONNA AND CHILD. *Detail of Plate 124*

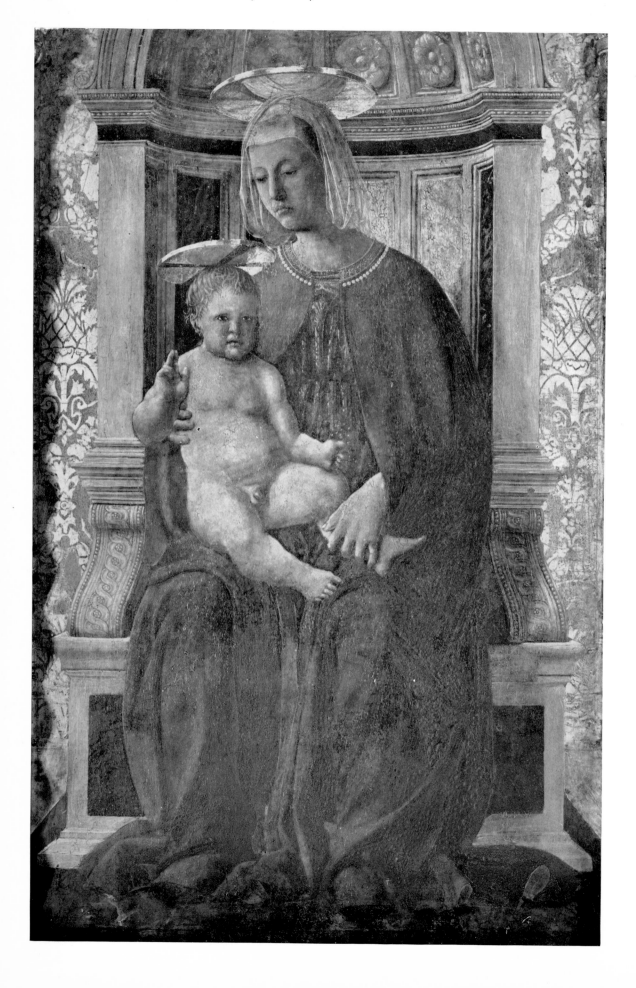

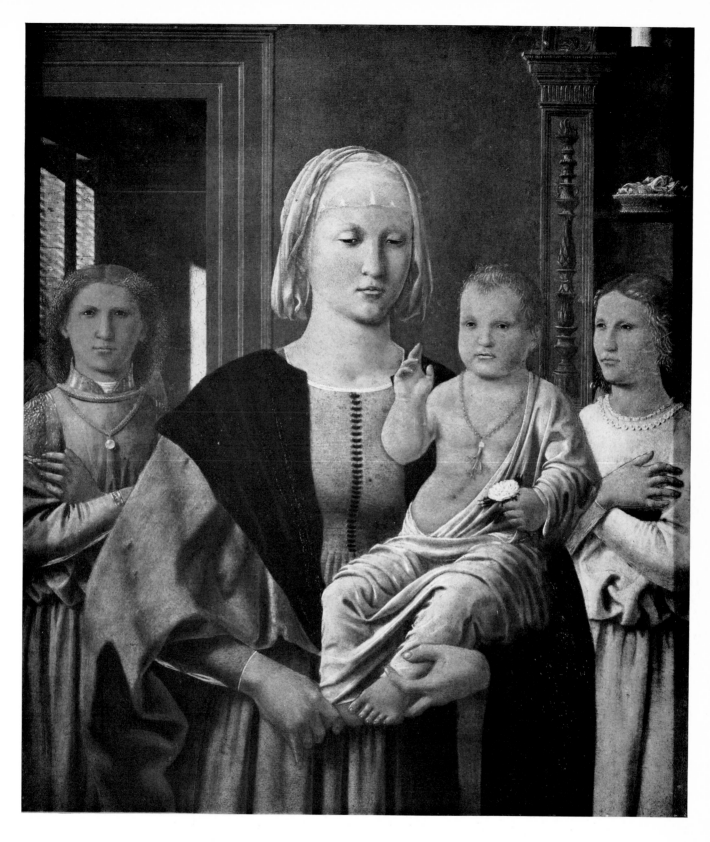

130. MADONNA AND CHILD WITH TWO ANGELS. *Urbino, Gallery*

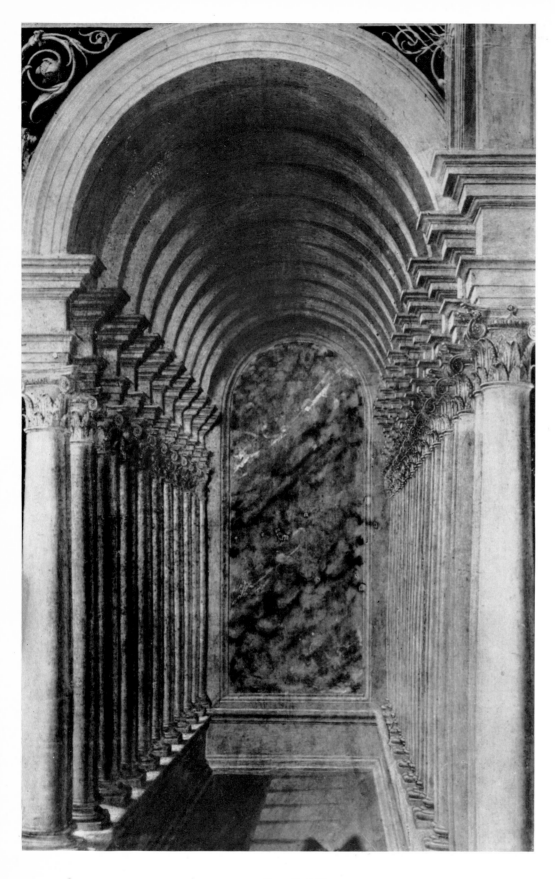

131. PERSPECTIVE VIEW OF A LOGGIA. *Detail of Plate 124*

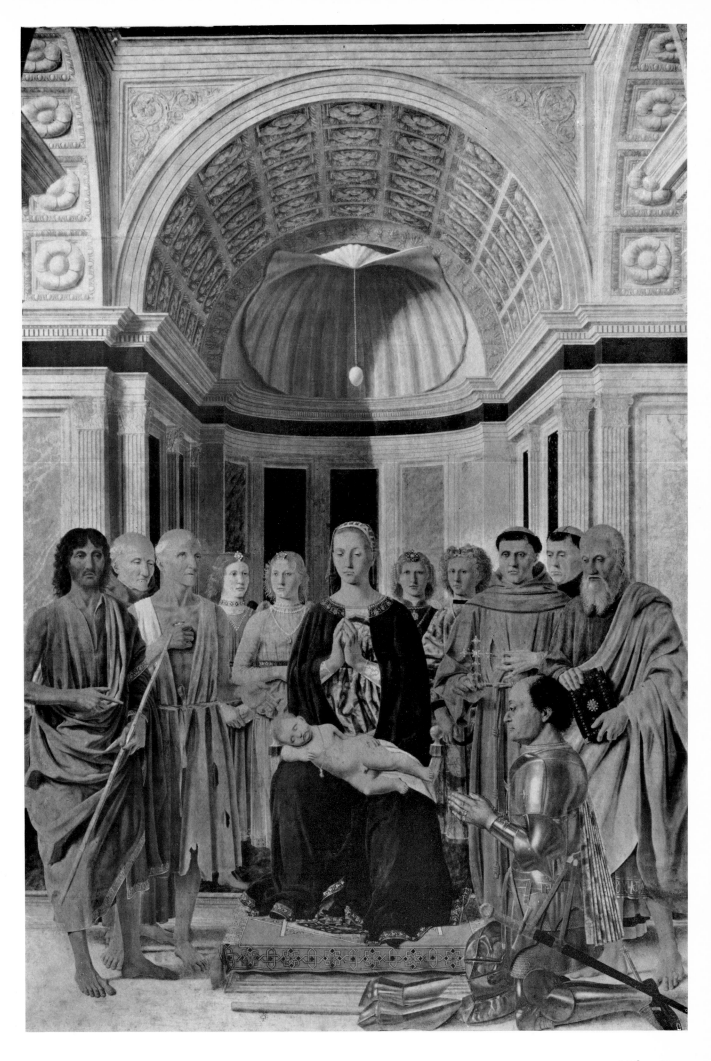

132. MADONNA AND CHILD WITH SAINTS AND ANGELS ADORED BY FEDERIGO DA MONTEFELTRO. *Milan, Brera*

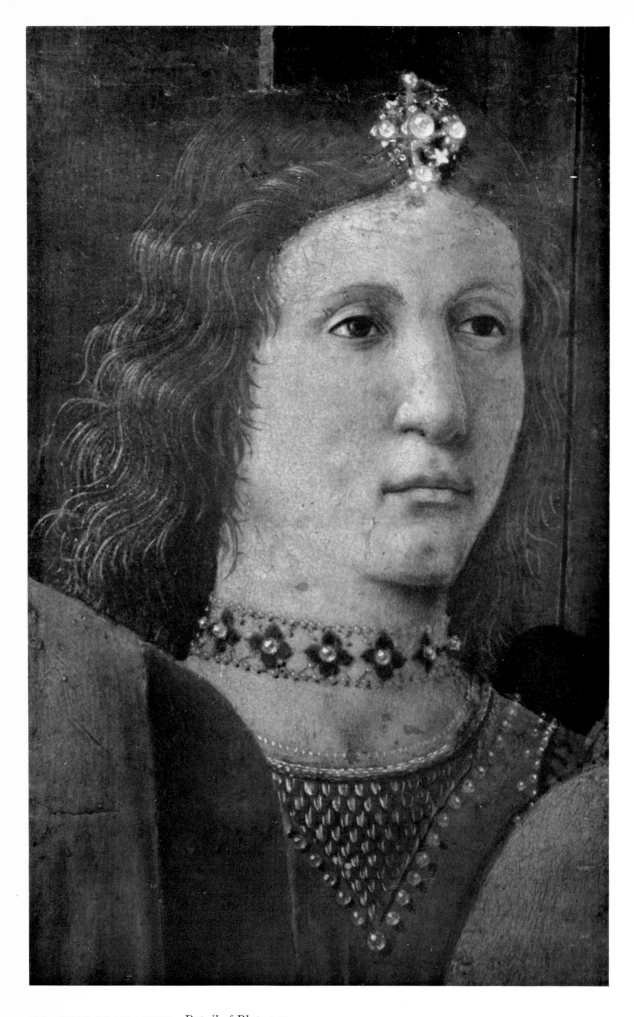

133. HEAD OF AN ANGEL. *Detail of Plate 132*

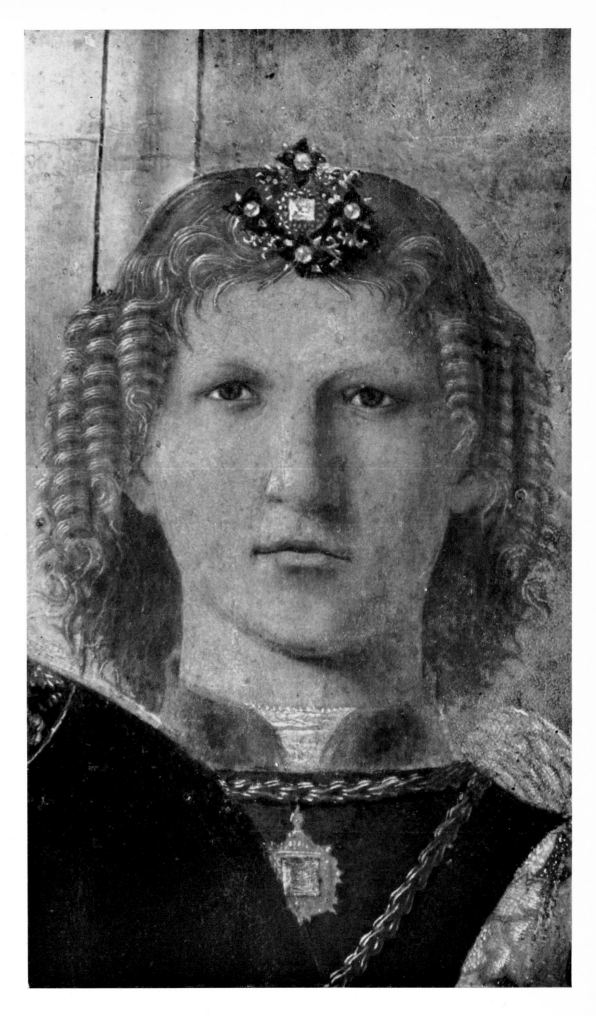

134. HEAD OF AN ANGEL. *Detail of Plate 132*

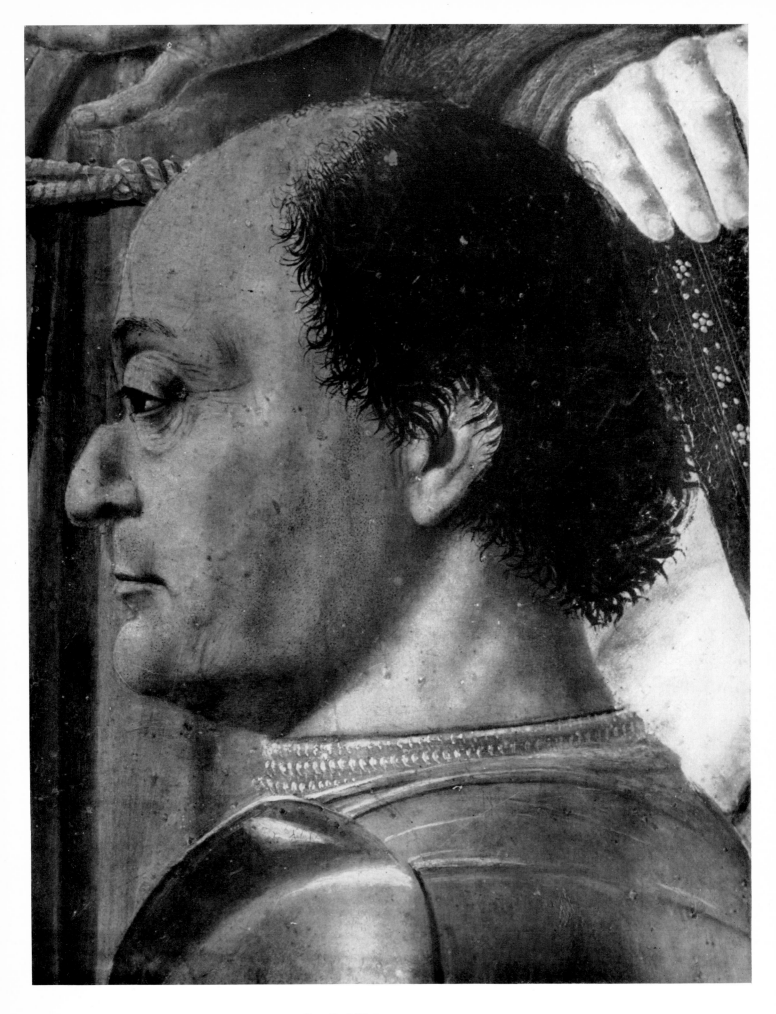

135. HEAD OF FEDERIGO DA MONTEFELTRO. *Detail of Plate 132*

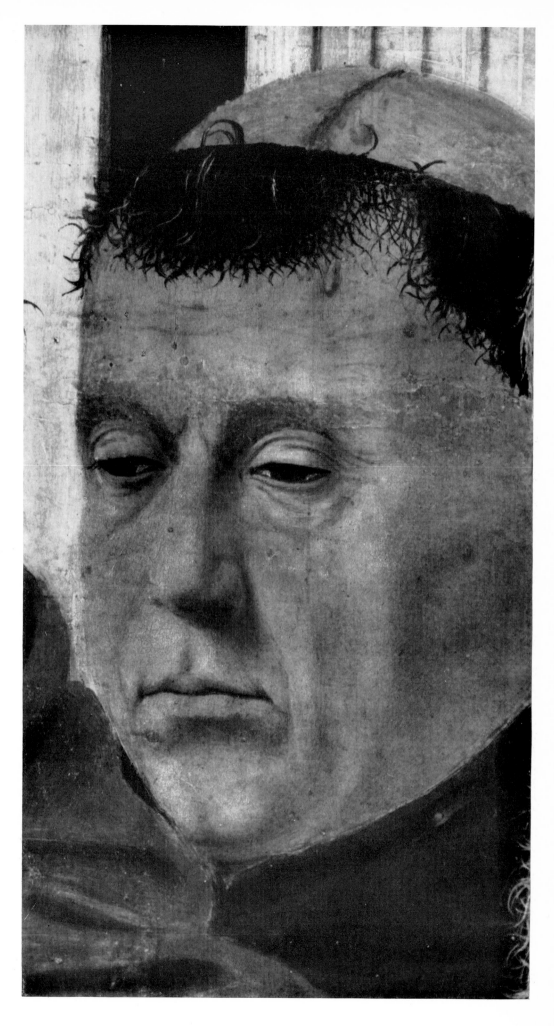

136. PORTRAIT OF A DOMINICAN AS ST. PETER MARTYR. *Detail of Plate 132*

137. THE EGG HANGING FROM THE SCALLOP. *Detail of Plate 132*

Notes to the Plates

The following notes to the illustrations are not intended as a catalogue of Piero's work, and do not include bibliographies. A historical bibliography up to 1927 will be found in Professor Longhi's monograph. It has since been brought up to date by an article in Paragone, *1963, pp. 3* et seq. *My notes do however, give references to the documents or earliest mention of each work. They also give an indication of date, degree of authenticity and condition, in that order; and touch on any iconographical peculiarity. References to Vasari are to Milanesi's edition (Florence, 1878); to Crowe and Cavalcaselle to the English edition edited by Langton Douglas and Tancred Borenius, 1914, vol. v.*

Plates 1–13

THE MADONNA OF THE MISERICORDIA

Palazzo Communale, Borgo San Sepolcro

Commissioned by the Company of the Misericordia of Borgo San Sepolcro on 11 January 1445 (Documents: Milanesi in *il Buonarroti*, 1885, p. 116). Painted at various dates during the next fifteen years. A payment made by the Company to Piero's brother Marco (in which he is referred to as *della Francesca*), dated 1462, probably refers to the same picture (Documents: Gronau, *Repertorium für Kunstwissenschaft*, 1900, p. 393). Mentioned in Vasari, ii. 494, who, however, states that it was in fresco.

In 1807 the Company was dissolved, the polyptych was dismembered, and the frame destroyed. Later the Company was allowed to re-establish itself in the church of S. Rocco. The picture was recovered and put together again in what seems to be the correct order.

In default of dated comparative material we can only guess when the various parts were painted: but of the larger saints the two on the right, St. Andrew and St. Bernardino, were probably painted after 1450, as St. Bernardino was canonized only in that year. Those on the left, St. John the Baptist and St. Sebastian, seem to be earlier, as they are the clumsiest and most Florentine part of the altar-piece. The Crucifixion also suggests a fresh memory of Masaccio and Donatello. The Annunciation was certainly later. Madonna and donors, on numerous grounds, may be dated either just before or just after his visit to Ferrara and Rimini in 1449–51.

The main figures, Crucifixion and Annunciation, were painted, as the commission enjoins, without the help of pupils. Of the smaller saints, the SS. Benedict and Francis, and a sainted Bishop, top right, seem to have been designed by Piero but executed, in part at least, by an assistant. The same assistant was then left to himself to complete the other saints. A different assistant executed the predella (see p. 18). Piero may have furnished sketches for some of the scenes, e.g. the Maries at the Sepulchre, and perhaps the Noli me Tangere, but they have been treated with considerable freedom. It has so far proved impossible to associate any other paintings with this highly individual artist; as in similar cases, this may mean that he was primarily a miniaturist.

The altar-piece is not in good condition. The two large saints to the right, and the Virgin Annunciate and St. Francis over them, must have been scorched so that the surface of the paint is like caked mud. In the central panel much of the gold is new. An area of damage above the Virgin's head makes her halo appear, at first sight, to be a peculiar hat and her right eyelid has been damaged beyond repair. Her cloak has also been repainted; but the heads of the worshippers are, on the whole, well preserved. Since cleaning, the Crucifixion appears to be in a relatively good state of preservation.

The local tradition that the man with his head thrown back is a self-portrait of Piero seems to be of considerable antiquity. Cf. L. Coleschi, *Storia di San Sepolcro*, 1886, p. 173.

107½ × 127½ in. (273 × 323 cm.)

Plates 14, 15

ST. JEROME AND A DONOR

Gallery of the Academy, Venice

Inscribed on the tree trunk to left PETRI DE BVGO SCI SEPVLCRI OPVS, and beneath the donor HIER. AMADI AVG. F.

Nothing is known about this picture before it entered the Venice Gallery with the Hellman-Renier bequest in 1850. There is no reason to suppose that it had been for long in Venice. Crowe and Cavalcaselle put forward the theory that the donor was Gerolamo, brother of Sigismondo Malatesta, who in 1464 married Federigo Montefeltro's daughter. But his father was called Carlo, whereas the inscription states that the donor was the son of Augustus. On the other hand the inscription beneath the donor seems to have been added later, so is not conclusive as evidence.

The landscape is similar to the background of the Baptism in the National Gallery; the St. Jerome to the nude young man with his head in his shirt in the same picture. So datable *c.* 1450–5.

All painted by Piero's own hand, and once of great delicacy, but it must have been hung in the sun, and the colours have faded. It has also suffered an early restoration.

The landscape appears to be a view of Borgo San Sepolcro seen from an angle slightly different from that in the background of the Baptism. However Longhi *op. cit.*, p. 20 maintains that it contains thirty-five domestic chimney pots of a type peculiar to the Veneto, and so represents a town in that region.

19½ × 16½ in. (49 × 42 cm.)

Plates 16–21

THE BAPTISM OF CHRIST

National Gallery, London

There are no documents for the commission, but it is known to have been painted for the Priory of San Giovanni Battista in San Sepolcro. In about 1465 two wings were added by Matteo di Giovanni. In

1807, when the Priory of San Giovanni was suppressed, it was transported to the cathedral. Bought from the Bishop and Chapter in 1859 by J. C. Robinson, on behalf of Matthew Uzielli. In 1861 acquired by Eastlake for the National Gallery at the Uzielli sale.

Some scholars, including Professor Longhi, give it as the earliest of Piero's works, painted between 1440 and 1445. Their reason for doing so is the similarity of the angels to figures by Masolino and Domenico Veneziano, in particular to the heads of two onlookers in the scene of St. Catherine and the pagan idol by Masolino in S. Clemente, Rome. Against this, it is hard to believe that such a refined and accomplished work is earlier than the St. Sebastian or the Crucifixion in the Misericordia polyptych. The landscape is very close to the Battle of Constantine in Arezzo. A certain lack of freedom in the painting of Christ's head recalls the St. Sigismund in Rimini. A date between 1450–5 seems open to the fewest objections, but is purely hypothetical.

The Baptism is painted entirely by Piero's own hand and is remarkably well preserved. The only repaint is on the central vertical crack, where two parts of the panel were joined. It is conceivable that the colours have faded slightly: but Crowe and Cavalcaselle's statement, 'A serious drawback to the enjoyment of this picture is the abrasion of its colour and its reduction to the condition of a preparation', shows how their eyes were conditioned to the crudities of Florentine colouring. However Eastlake himself speaks of 'its very ruined state', and adds 'This weighs with me so much that I am at this moment undecided whether to place it in the N. Gallery (where it cannot have a good place) or to take it myself'. See National Gallery Catalogue, 1951, *The Early Italian Schools*, p. 333.

$65\frac{1}{2} \times 45\frac{1}{2}$ in. (166×115 cm.)

Plates 22, 25–27
SIGISMONDO MALATESTA KNEELING
BEFORE HIS PATRON SAINT
Tempio Malatestiano, Rimini

Inscribed at the base of the Fresco: SANCTVS SIGIS-MVNDVS. SIGISMVNDVS PANDVLFVS MALA-TESTA PAN. F. PETRI DE BVRGO OPVS. MCCCC (LI), and underneath the *œil-de-bœuf* window to the right: CASTELLVM SISMVNDVM ARIMINENSE MCCCCXLVI. As the former inscription states, the fresco was painted for Sigismondo at the time of the decoration of the Tempio. The last two letters of the date, no longer visible, are recorded by all early authorities since 1794, when it was engraved by Rosaspina and published by Battaglini in his *Vita di*

S. P. Malatesta. The date in the second inscription clearly refers to the erection of the castle, although a foolish attempt has been made to apply it to the painting of the fresco.

The condition of the background evidently deteriorated at an early date and it was repainted to represent the sky. This was removed in 1948, but the present chaotic state of the surface is almost more disfiguring than the old repainting. We can see that Piero took great pains in the execution. As often happened (cf. Uccello's Adam and Eve in the cloister of Santa Maria Novella) only the heads and hands, and the two hounds were painted in *buon fresco*, and they have survived more or less intact. In all the rest the colour has crumbled away, except the lapis blue, which appears in the heraldic charges, the lining of St. Sigismund's cloak and the sky behind the castle; and the jade green of the swag. The pouncing of the outlines is, however, clearly visible in the greater part of the fresco.

Two erroneous statements are commonly made about this fresco (cf. for example, Crowe and Cavalcaselle, v. 6): first, that St. Sigismund is shown without a nimbus, secondly, that the Castle on the right is a grisaille, or intended to represent a relief. St. Sigismund's nimbus is clearly visible. It is in foreshortening, a device taken from Masaccio, and so has been confused with his hat, just as, in the Madonna della Misericordia, her nimbus has been confused with her crown. The view of the Castle is meant to be seen through a window. There is a typical Piero blue sky, with white clouds, and the painting of the Castle is as delicately atmospheric as the architectural backgrounds at Arezzo.

101×136 in. (257×345 cm.)

Plates 23, 24
THE FLAGELLATION OF CHRIST
The Gallery of the Marches, Ducal Palace, Urbino

There are no documents concerning this picture. It is first mentioned in early guides to Urbino, as being in the sacristy of the Cathedral, where it remained until a few years ago. As stated above (p. 33), it must have been painted after Piero's acquaintance with Alberti at Rimini in 1451, but before his journey to Rome in 1460. It is reasonable to suppose that the architectural design must date from about the same epoch as that of Solomon's Palace in the Arezzo frescoes, which it so closely resembles. This gives a date 1456–7.

The picture is almost entirely free from repaint and the colours are unfaded. Unfortunately it has suffered small damages in important places. The flaking due to a lateral crack runs through the head

of Christ, and that of one executioner. Other flakings occur on the head of the central figure to the right, and the bald man has lost his nose. This deterioration of the heads suggests that Piero may have achieved delicacy of modelling by the use of a slightly different medium at those points, perhaps by oil glazes added on the tempera. But it is worth noting that a similar deterioration is apparent in the work of the most atmospheric painter of the preceding century, Francesco da Rimini, whose technique resembles that of Piero.

For the interpretation of the subject see pp. 33–34.
$$23\tfrac{1}{4} \times 32 \text{ in. } (59 \times 81 \cdot 5 \text{ cm.})$$

Plates 28–85
THE LEGEND OF THE TRUE CROSS
S. Francesco, Arezzo

In 1427 a *denunzia* records that the Bacci family have put aside money for the decoration of the choir of S. Francesco (Girolamo Mancini, *Giorgio Vasari, Vite Cinque Annotate*, 1917, p. 11).

In 1447 they commissioned Bicci di Lorenzo to do the work. Bicci died in 1452. We have no further documents till 1466, when Piero is referred to as *il quale ha dipinto il Chupola maggiori di San Francesco d'Arezzo* (see pp. 57, 58).

Described at length in Vasari, ii. 495, where it is stated that the donor was Luigi Bacci, who, together with his brother Carlo and other gentlemen of Arezzo, is represented in the scene of the beheading of Chosroes.

For the interpretation of the various scenes see pp. 38–42.

Piero has made free use of assistants, but the degree to which their co-operation is evident varies considerably from one scene to another. In general, he has allowed them to execute the onlookers and subsidiary figures, and has painted the principals with his own hand. In the Death of Adam, for example, only the two children to the extreme left are obviously pupils' work; similarly in Sheba and Solomon the pages on the left, and some of the members of Solomon's court are executed by a less sensitive hand, although following closely to Piero's design. The Battle of Constantine seems to be almost entirely his execution. Two of the upright scenes on the window wall, the Carrying the Wood, and the Torture of the Jew, he left very largely to a pupil. They resemble so closely in style the altar-piece at Città di Castello, signed Giovanni de Piamonte, 1456, that we may fairly conclude that he was Piero's chief assistant at this period. Of the other frescoes on the window wall, one of the apostles may be by Giovanni de Piamonte, one by Piero; the Dream of Constantine is largely Piero's execution,

and where an assistant has been used he is apparently not Giovanni. On the east wall the top scene of Heraclius returning the Cross to Jerusalem is, for reasons suggested on p. 52, very largely executed by pupils. The chief of them has a marked style, but has not yet been associated with any signed work. His hand is still discernible in the scene of the Discovery and Proof, although this is mainly executed by Piero or directly under his supervision. The Battle of Chosroes raises a different problem. There is no clear division between parts painted by Piero and by his assistants. The whole must follow his design very closely, but it is almost all rather insensitive in handling. Either Piero had adopted a different method of working with his pupils, or he had found one of them to whom he could entrust a great part of the execution.

The condition of the frescoes in S. Francesco is first described in a letter home from Lord Lindsay, dated Easter Monday, 1842. 'In S. Francesco, alas!, the frescoes descriptive of the Invention of the Cross by Piero della Francesca . . . are absolutely in the last agonies of dissolution, hanging in flakes from the walls. They are admirable . . . Coutts compared the impression to that of the Elgin marbles . . . Yet he is totally unknown and unappreciated by modern historians, and alas, I again exclaim, the so solitary witnesses of his merit will be silenced for ever!' (Unpublished: kindly communicated to me by the writer's great-grandson, the Earl of Crawford and Balcarres.) This suggests that Rambroux's copies made only a few years earlier (figs. 33, 34) contain a certain amount of reconstruction. The first recorded restoration was in 1860 by Prof. Gaetano Bianchi (who also restored Giotto's St. Francis cycle in Santa Croce). To secure the walls it was found necessary to put in two girders which ran through the scenes of Solomon and Sheba, and the Restitution of the Cross, and can be seen in all early photographs. These were removed in a restoration by Professor Domenico Fiscali. During this restoration the areas of damage were tinted in a tasteful manner which had a slightly deadening effect.

Size of larger scenes *c.* 11 × 24 ft. (33$\tfrac{1}{2}$ × 73 m.)

Plates 86, 87
TWO PROPHETS
S. Francesco, Arezzo

These are the best preserved of the decorative figures which formerly accompanied the scenes from the legend of the True Cross. They are placed high up on either side of the window and cannot be seen clearly enough to allow of a definite opinion on their quality; but from photographs it is apparent that the prophet to the right is far superior, and may have

been executed by Piero himself. His stance is very similar to that of the central 'onlooker' in the Flagellation. As this figure is above the Burying of the Wood and the Dream of Constantine it must have been painted earlier, and so probably before 1459. The prophet to the left is a half-hearted attempt at a pendant, and perhaps not even from Piero's design. It is above the Torture of Judas, a scene which has also been left almost entirely to assistants, and so probably belongs to an epoch just after 1460, when Piero was occupied elsewhere and could give little time to the work at S. Francesco. The modelling of the eyes and the curious convention of the hair suggest that the assistant was Giovanni de Piamonte; but to distinguish between individual pupils when they are collaborating with their master is extremely difficult and should not, perhaps, be attempted.

We have no clue as to the identity of the prophets.

Plates 88–91
AN ANGEL APPEARS TO ST. HELENA
S. Francesco, Arezzo

Usually described as the Annunciation. But this subject has very little connexion with the legend of the True Cross and for this reason several scholars have suggested that it does not represent the Annunciation but an angel announcing to St. Helena her mission to discover the True Cross. They argue that the angel is not carrying a lily, but a reed cross. This theory is attractive not only because it allows us to include the scene in the whole series, but because it is in keeping with Piero's love of double meanings, of which the Burying of the Wood on the other wall is an unquestionable example. After long hesitation I have decided to accept this interpretation.

Whether or not this scene is outside the series iconographically, it may well have been painted later, perhaps when Piero returned to Arezzo in 1466. It seems to be almost entirely from his own hand, although the angel is close in type and style to figures in the Battle of Chosroes which may be the work of an assistant.

Plate 92
AN ANGEL
S. Francesco, Arezzo

A fragment of decoration from the archivolt which suggests that some part of this was executed by Piero himself, and probably belongs to the first period of his work at S. Francesco.

Plate 93
ST. JULIAN (?)
Palazzo Communale, Borgo San Sepolcro

A fragment discovered in the choir of S. Agostino in 1954. Its provenance suggests a date after 1454 when Piero was commissioned to paint the high altar. But stylistically similar to the prophet on the window wall of S. Francesco, so dateable *c.* 1460. Hendy, *op. cit.* p. 120, rightly points out a reminiscence of Castagno.

54×41⅜ in. (137×105 cm.)

Plate 94
HERCULES
Isabella Stewart Gardner Museum, Boston

Said to have been painted for the Casa Graziani, perhaps once Piero's dwelling in San Sepolcro. The painting was uncovered in 1860–70 by Senator Collachioni, who took it to his villa outside the town. Brought back to the Casa Graziani in 1896. Sold to Volpi in 1903, and by him to Mrs. Gardner in 1906.

Probably of the same date as the east wall of S. Francesco, i.e. 1460–6.

An authentic fragment of a larger scheme of decoration, no doubt similar to that of Castagno at the Villa Legnaia, which seems to have influenced Piero (cf. Note 47, p. 79). Considerably damaged, and restored.

59¼×49½ in. (151×126 cm.)

Plates 95–97
THE MADONNA DEL PARTO
Mortuary Chapel, The Cemetery, Monterchi

There are no documents for this picture, or early references. According to Longhi it was first mentioned in 1889 by Funghini in *La Provincia di Arezzo*.

Although less freely painted than the Arezzo frescoes, it seems to be of the same date as the second series, i.e. soon after 1460. The Madonna's head is entirely by Piero's hand. The angels show traces of an assistant, perhaps Lorentino, but Piero superintended the whole work.

The colours have faded slightly, and the drapery is no doubt flatter than it was; but on the whole well preserved.

The iconography of Piero's pregnant Madonna seems to be unique in Italian art. A somewhat similar motive is fairly common in Venetian and in Spanish painting (the so-called Virgin de la Esperanza), but in most of these the child in the Virgin's womb is represented symbolically. It is worth noting that the Venetian sculptor, Bartolomeo Buon, in a relief in the Victoria and Albert

Museum, from the Scuola della Misericordia, Venice, datable about 1450, has combined the motives of the Madonna della Misericordia and the Madonna de la Esperanza.

Motives of this kind usually came from the revivalist sects of Flanders and South Germany, and Piero may have derived it from a German or Flemish woodcut or manuscript. On the other hand, the fact that it occurs in the Hispano-Flemish art of Provence, with which he had so many close connexions, is extremely suggestive.

Slightly less than life size.

Plates 98–103
THE URBINO DIPTYCH
Uffizi, Florence

The front of the diptych represents Federigo Montefeltro, Count (later Duke) of Urbino (1422–82) facing his wife, Battista (1446–72), daughter of Alessandro Sforza, Lord of Pesaro. On the reverse they approach each other in triumphal chariots. The Count is crowned by Fame, and accompanied by the four Cardinal Virtues, Justice, Prudence, Fortitude and Temperance, the Countess by the three Theological Virtues, Faith, Hope and Charity. Beneath the Triumphs are two Latin verses in Sapphic metre. That beneath the Count describes his triumph, that beneath the Countess extols her restraint. They are inscribed in Roman uncials with the same form as Piero's signatures and other inscriptions, and seem to be from his own hand. Cf. the peculiar form of the S. in the inscription on the fresco of Sigismondo Malatesta. After the extinction of the Dukedom of Urbino in 1631, the diptych passed to Florence, with other possessions of the della Rovere family, and so to the Uffizi.

Cinquini, *l'Arte*, 1906, p. 305, drew attention to a poem by the humanist, Ferabo, entitled *The likeness of the Prince painted by Piero di Borgo addresses the Prince himself*. Ferabo was in Urbino in 1465, and left the next year, when Piero himself is known to have been in Arezzo; and it has generally been assumed that this gives a date for the diptych. But this poem does not mention the portrait of the Duchess, so may refer to another portrait. In spite of the fact that the Duchess's head does not seem to have been painted from life, the brilliant, spontaneous handling of the Triumphs seems to exclude a date after 1472, the year of her death.

Both front and back are painted by Piero's own hand, and with particular care. The fronts are very well preserved. The backs were disfigured by a number of deep scratches, but few of them pass through figures, and after a recent restoration they do little to injure the general effect.

On the Duke's portrait there is an interesting alteration. The line of his neck was originally drawn further in and was more articulate, as if drawn direct from nature. The present outline accentuates the monumental character of the silhouette.

Each panel 18½ × 13 in. (47 × 33 cm.)

Plate 104
SAINT LUKE
Santa Maria Maggiore, Rome

According to Vasari, iii. 48, the chapel in which this fresco is to be found was decorated by Benozzo Gozzoli, and this tradition was followed until Professor Longhi published the St. Luke in his monograph, pp. 78 and 177, as the only surviving work by Piero in Rome. The head is comparable to several in the later frescoes at Arezzo, notably to the lieutenant in the Torture of Judas (Plate 63). This was probably executed by an assistant, and the St. Luke also seems to be too coarse and uncertain in drawing to be by Piero's own hand. It does, however, seem to be from his design, and is valuable testimony to his residence in Rome.

Plates 105–108
THE RESURRECTION OF CHRIST
Palazzo Communale, Borgo San Sepolcro

Mentioned in Vasari, ii. 494, as the best work of Piero in San Sepolcro, but apparently covered with whitewash in the eighteenth century, and unknown to Lanzi. Recorded in Rosini's *Storia della Pittura Italiana*, 1839, vol. iii. It does not occupy the position in the Palazzo Communale (then known as the Palazzo de' Conservatori) for which it was painted, but must have been moved very early, perhaps even in 1480, when some question arose about its restoration. This date would be in agreement with the architectural style of the room as it now stands. The scene was originally shown as taking place between two Corinthian columns in Piero's characteristic style. Of these only the inner edges have survived: the rest is a crude restoration, done, ironically enough, without knowledge of perspective.

There are no contemporary documents for the Resurrection, but on grounds of style it seems to be contemporary with the later scenes on the east wall at Arezzo, especially the Discovery and Proof: thus datable *c.* 1463.

The Resurrection appears to be painted almost entirely by Piero himself. It is slightly faded, and has suffered various rubbings and scratchings, presumably when the whitewash was removed. But it is not seriously repainted, and its condition does not impair the general effect.

Slightly less than life size.

Plate 109
ST. MARY MAGDALEN
Cathedral, Arezzo

Mentioned by Vasari, ii. 497. Stylistically it falls between the last frescoes at S. Francesco and the Saints from the S. Agostino altar-piece. So datable about 1466, and perhaps executed when Piero was in Arezzo arranging the contract for the banner of the Annunciation (cf. p. 41).

The architectural frame painted in grisaille to represent carving in low relief still recalls the surround of the Sigismondo fresco, but the round top and the architectural style generally indicates a much later date.

All painted by Piero's hand, but damaged and restored.

Slightly less than life size.

Plates 110–117
SAINTS FROM THE S. AGOSTINO ALTAR-PIECE
Borgo San Sepolcro

This altar-piece was commissioned on 4 October 1454, by a citizen of Borgo San Sepolcro, Angelo Giovanni Simone Angeli, who undertook to present it to the church of S. Agostino. This document refers to another more detailed specification now lost. As usual the contract is entirely medieval in tone and lays most emphasis on the frame, the gold and silver ornaments, etc. The altar-piece was to be completed and set up in eight years. In fact Piero received payment for it on November 14, 1469. The document states that a further payment is to be made, but as the sum is named the picture may have been completed. (Documents published by Milanesi in *il Buonarroti*, 1885, p. 141, and 1887, p. 218; both reprinted in the admirable reconstruction of the altar-piece by Millard Meiss, *Art Bulletin*, xxiii, 1941, p. 53). Mentioned in Vasari, ii. 493. At some point there was substituted for it a picture of the Assumption of the Virgin by an Umbrian imitator of Perugino, now in the Gallery of San Sepolcro. This probably took place in 1555, when the church passed from the Augustinian to the Clarissan order. Some of the small side panels or predelle may have been left behind, because pictures by Piero della Francesca are mentioned as being in the Choir of Sta Chiara as late as 1832, cf. Marcini, *Istruzione Storico-Pettonico . . . di Cita di Castello*, 1832, II, p. 272.

The central panel of Piero's original altar-piece is generally presumed to have represented a Madonna and Child enthroned. The ends of two steps are visible in the bottom corners of the two adjoining panels, the left-hand corner of the St. John and the right-hand corner of the St. Michael, where the step is half covered with a piece of drapery. It is, however, worth noting that the Assumption of the Virgin which replaced Piero's picture contains a marble balustrade which is clearly imitated from that which was behind his four Saints. There is a picture by Matteo di Giovanni in the Gallery of Borgo San Sepolcro, dated 1487 (formerly in the Servi), which consists of the Assumption in the central panel and two Saints in each of the wings. These Saints appear to be inspired by Piero's S. Agostino altar-piece, and it is therefore possible that his lost central panel also represented an Assumption, although in that case it would be difficult to account for the steps. Other scholars believe that it represented a Coronation of the Virgin. Cf. Mirella Levi d'Ancona, *Catalogue of the Frick Collection*, Supplement, 1955, p. 61.

The marble balustrade which rises behind all four saints has an entablature almost identical with that in the Brera altar-piece, except that the frieze is a palmette instead of a band of porphyry.

Although the documents make no mention of assistants it is evident that Piero used at least two, one who painted details such as St. Augustine's stole, and one who executed the three smaller saints and was later to be employed on the Perugia altar-piece.

Each panel about 52×24 in. (133×60 cm.). For exact sizes see article by Millard Meiss cited above.

Plates 110, 114
ST. AUGUSTINE
National Museum of Antique Art, Lisbon
(purchased 1936 from the Count of Burnay)

The general design, the head, and many details such as the mitre and crozier, seem to be by Piero's hand. The scenes on the cope are by an assistant whose work is not otherwise identifiable. They seem to be free reminiscences of Piero's designs, e.g. the Annunciation recalls the treatment of the same subject in the frescoes of S. Francesco at Arezzo, the Presentation goes back to the same original as a school piece, formerly in the Cook Collection, now attributed to Giovanni Santi; and the Agony in the Garden may reflect the lost composition mentioned by Vasari, ii. 497, in the church of Sargiano.

The panel has been cut to fit a frame, but is substantially well preserved.

Plates 111, 116
ST. MICHAEL
National Gallery, London.
From the Fidanza collection, Milan

Inscribed on St. Michael's lorica B ANGELVS POTENTIA DE LVCHA, Angelus seems to be an allusion to the donor's name, and perhaps to the Beato Angelo Scarpetti, who was buried under the high altar on which the picture stood but Potentia dei Lucha cannot be explained. The distinction between Piero's own hand and that of an assistant is even harder to make than with the St. Augustine. The head is much less well preserved.

Plates 112, 117
ST. JOHN THE EVANGELIST (?)
Frick Collection, New York (from the von Miller collection, Vienna; formerly in Milan)

The identity of this Saint is conjectural. Mr. Meiss suggests that, as the donor's father and wife, mentioned in the commission, were called Giovanni and Giovanna, he may be St. John. He is very similar to the Saint on the right of the Brera altar-piece, who has also been identified as St. John the Evangelist. For an analysis of condition cf. Millard Meiss loc. cit. The Saint has also been identified as St. Simon Zelotes.

Plates 113, 115
ST. NICHOLAS OF TOLENTINO
Poldi Pezzoli Museum, Milan

Formerly known as St. Thomas Aquinas. First identified as St. Nicholas of Tolentino by Borenius in *The Burlington Magazine*, xxix. 162. It was this hint which led to the reconstruction of the S. Agostino altar-piece. The head makes the impression of a portrait, and may represent the donor, Angelo Giovanni. The head is as well preserved as the St. Augustine, but the hand raised in blessing has been damaged, and is largely modern. The gold star (the symbol of St. Nicholas: it shone at Tolentino at his birth) is also new, although there appears to have been an old one underneath.

Figure 65
VIRGIN AND CHILD WITH FOUR ANGELS
Clark Institute, Williamstown, Mass.

I have not seen this picture and can judge it only from photographs. From these it appears to be unusually well-preserved. It is accepted as authentic by practically all students of Italian art. Nevertheless it has some puzzling features. The architectural scheme, recalling the fresco of Sigismondo Malatesta, would suggest an early date, and Hendy, *op. cit.*, p. 61, considers it an early work, in which Piero has not yet achieved his mastery of space. On the other hand the types of the angels suggest a late work, and this is born out by the Flemish character

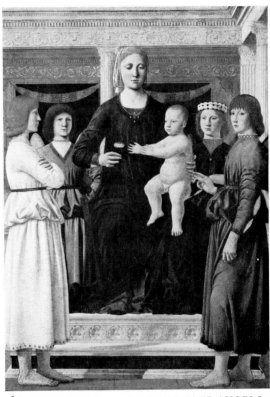

65. VIRGIN AND CHILD WITH FOUR ANGELS. *Williamstown, Mass., Clark Institute*

of the Child which is similar to that in the National Gallery Nativity. The angels' dresses resemble those of the angels in the Brera altar-piece, and although it is always dangerous to be dogmatic on questions of costume, I doubt if they would have been possible before 1470. If, therefore, it is a genuine work it must be dateable in the 1470s.

Panel, 42 × 30½ in. (106 × 78 cm.)

Plates 118–121
THE NATIVITY
National Gallery, London

There are no documents or early references to this picture, which is first mentioned in a note to Vasari, ii. 488, as belonging to the painter's descendant, Signor Marini Franceschi, but having been placed in custody in Florence with Cavaliere Frescobaldi. It was sold in 1861 to Mr. Barker, and purchased for the Gallery in 1874 from the Barker sale.

Both iconography and the strong Flemish influence suggest a late work. The Child has so much the character of Hugo van der Goes that we may hazard that it could not have been painted till after the arrival in Urbino of Hugo's fellow pupil, Justus of Ghent, which took place after 1468. The landscape is also of a Flemish character which does not appear in Italian art before that date. The types are

229

not very different from those in the Brera altar-piece of 1472–5, but far more sensitive in handling.

Clearly painted by Piero himself. The difference in handling between this picture and the other late works increases the mystery of Piero's late style, and could be used as evidence that the altar-pieces in Milan and Perugia were entirely pupils' work, were it not for the documents for the S. Agostino polyptych.

The Nativity has always been considered unfinished, but a recent restoration, which has permitted closer examination, proves that this is not the case. The unfinished parts (i.e. the shepherds' heads and bodies) have been scraped down by some earlier restorer who was probably trying to remove some old repaint. In places he has got down to Piero's original priming and drawing, but enough small fragments of paint are left to show that the heads were once finished. At no point are they painted as in a sketch. This is clearly seen in the feet and hands of Joseph, where the surviving parts are perfectly finished, although in other places the restorer has scraped down to the outline. Evidence of such drastic treatment leads us to suppose that the rest of the picture has been severely cleaned, and in fact both heads and draperies have lost a glaze. The braying ass was thinly painted *alla prima*, and has now become almost transparent.

As usual with Piero there are numerous alterations, e.g. St. Joseph's forehead, the right-hand shepherd's hand, etc. Under the pointing shepherd there are traces of a nude roughly sketched in as an indication of structure.

$49\frac{3}{4} \times 48\frac{1}{4}$ in. (126 × 123 cm.)

Plates 122–127, 129, 131
MADONNA AND CHILD WITH FOUR
SAINTS AND THE ANNUNCIATION
Pinacoteca Vanucci, Perugia

The saints are St. Anthony of Padua, St. John Baptist, St. Francis and St. Elizabeth of Hungary. In two roundels on the predella are St. Claire and St. Agatha. The three predelle represent the Stigmatization of St. Francis, St. Anthony reviving an infant, and St. Elizabeth saving the life of a child who had fallen down a well.

From the convent of S. Antonio delle Monache; removed to the Pinacoteca in 1810.

There are no contemporary documents. Mentioned by Vasari, ii. 498, who says that 'the Angel of the Annunciation seems to have come from heaven; and what is more, there is a perspective of diminishing columns, beautiful indeed'.

Some of the saints are certainly by one of the assistants who worked on the S. Agostino altar-piece, finished in 1469; but perhaps slightly later, as the Child is so close to the Sinigallia Madonna. For the degree of pupils' co-operation see pp. 63, 65. The Annunciation is well preserved; the Madonna and Saints are rubbed and discoloured, but seems to be free from major damages and repaint. The predella is badly damaged, and the lower part of each panel is worn away.

$133 \times 90\frac{1}{2}$ in. (338 × 230 cm.)

Plate 128
PERSPECTIVE VIEW OF AN IDEAL TOWN
Gallery of the Marches, Ducal Palace, Urbino

This is one of four similar works all of which seem to have been executed in Urbino under Piero's influence. The others are in the Walters Collection, Baltimore, the Gemäldegalerie, Berlin and, formerly, the Schlossmuseum, Berlin. The last of these has been attributed to Francesco di Giorgio. The Urbino panel is far superior to the others both in tone, colouring and technique. It is painted in the blues, greys and whites peculiar to Piero, and the actual handling is closer to his best work than either the Perugia altar-piece or the Sinigallia Madonna. It has, however, been much disputed. In 1889 Reber attributed it to the architect Luciano Laurana on the basis of a passage in Bernardino Baldi's *Memorie concernanti la Citta di Urbino*, p. 45, which credits him with 'certain scenes, drawn and coloured in perspective, on which he put his name and other things in the Slav language'. Later it was claimed that there were traces of writing in the top left- and right-hand corners of the Urbino panel, from which could be deciphered the letters VRANNA. In support of this thesis, Fiske Kimball, *Art Bulletin*, 1927, pp. 125 seqq., observed certain similarities between the buildings in the Baltimore panel and the Colosseum at Pola in Laurana's native Dalmatia. These are not convincing; and the present writer finds it impossible to persuade himself that any of the blots and scratches in the corners of the Urbino panel ever constituted letters, either Roman or Slav. The evidence concerning Laurana's architecture is slight enough; that concerning his painting cannot be taken seriously, especially as it reproduces a similar kind of story told about both Brunellesco and Alberti.

The picture was originally the front of a chest. That formerly in the Schlossmuseum is still so placed; the motive of architectural perspectives is usual in intarsiated chests. The motive probably goes back to Brunellesco's famous exercise in perspective (see above p. 70), but the architecture shows very clearly the influence of Alberti, and is almost like an illustration to his *De Re Aedificatoria* Book

VIII, Chapter VI. The round temple in the centre is referred to in Book VII, Chapter XV. Perspective schemes very similar to the wells and to the house on the left are in the *De Prospettiva Pingendi*.

$79 \times 23\frac{1}{2}$ in. (200 × 60 cm.)

Plate 130
MADONNA AND CHILD WITH
TWO ANGELS
Gallery of the Marches, Ducal Palace, Urbino

From the church of Santa Maria delle Grazie, near Sinigallia.

There are no documents for this picture, which is first referred to in 1861 in the joint work of Cavalcaselle and Morelli, *Catalogo delle opere d'arte delle Marche e nell' Umbria*.

On stylistic grounds there is no doubt that this is one of Piero's last surviving pictures, although whether painted before or after the Brera altar-piece it is impossible to say. The date is therefore *c.* 1472-5. The whole picture appears to have been painted by the same hand and is unusually well preserved. It is therefore an indication of Piero's smooth and lifeless handling in his later years.

24×21 in. (61 × 53·5 cm.)

Plates 132-137
MADONNA AND CHILD, WITH SAINTS
AND ANGELS, AND FEDERIGO
MONTEFELTRO KNEELING BEFORE HER
Brera Gallery, Milan

From the high altar of the Church of S. Bernardino near Urbino, but not originally painted for that position.

The authorship of this picture has been the source of much speculation, owing to the confusion of two traditions, both equally untrustworthy. One of these is contained in Vasari's life of Bramante, iv. 147, where he says that as a boy Bramante studied the pictures of Fra Carnovale of Urbino 'who painted the picture in Santa Maria della Bella'. The other derives from a note in the records of the convent of S. Bernardino of Urbino which says 'about this time (1472) the altar-piece of the high altar was painted by Fra Bartolommeo, called Fra Carnovale, because the Virgin is a portrait of the Duchess Battista Sforza, and the infant on the Virgin's lap is the likeness of the son born to the Duke by the said Duchess'. This note, first quoted by Pungileoni, *Elogio Storico di Giovanni Santi*, 1822, p. 53, was seen by Crowe and Cavalcaselle, who state (vol. v, p. 30) that it was in an eighteenth-century hand. The two traditions were combined in one, partly because of the unusual name of Fra

Carnovale (by whom no authentic work survives) and partly because the architecture in the picture at San Bernardino is precisely such as must have inspired the young Bramante. A picture mentioned by Vasari in this connexion is lost. Although these two records taken separately cannot be considered sufficient evidence for attributing the picture to Fra Carnovale, it is suggestive that the Brera Altar-piece should have aroused these doubts so early. Crowe and Cavalcaselle say 'Fra Carnovale's name may be taken as a conventional one to indicate works bearing the impress, but not revealing the perfect manner, of a great master'. This is no doubt the easiest way of disposing of the problem of the late Piero, and was followed by Venturi, *Storia del Arte*, vii. 11; unfortunately it is not consistent with the fact that the documents for the S. Agostino altar-piece make no mention of payment to an assistant.

Although the painting of the Brera altar-piece is uniformly dead and cramped, it is difficult to indicate any one part which suggests, more than another, the hand of a pupil. The touch seems to be that of Piero himself, but without the largeness and freedom of his earlier work. Frizzoni seems to have been the first to point out that the Duke's hands were added by one of the painters who afterwards executed the series of Poets and Philosophers for the Duke's Study. These were Justus of Ghent, who painted the great *Communion of the Apostles*, now in the gallery of Urbino, and Pedro Berruguete. Justus received his first payment for the *Communion* in February 1472. The name of Pietro Spagnuolo is recorded as employed at the Court of Urbino in 1477, cf. Pungileoni *Elogio Storico di Giovanni Santi*, 1822, *loc. cit.* Gamba, *Dedalo* 1926-7, pp. 638-662 identified Pietro Spagnuolo with Pedro Berruguete on account of a resemblance between the Philosopher at Urbino and the *retablos* of S. Dominic in the Prado. On the whole this identification is convincing although the *facture* of the retablos is much harder. The Philosophers, now divided between the Palace of Urbino and the Louvre, are a joint work of the two painters. In a few instances one can identify with confidence the hand of Justus, and in others a third artist seems to have been involved. Given this degree of collaboration it is impossible to say whether the Duke's hands were painted by Justus or Berruguete; it is even difficult to say which was responsible for the portrait of the Duke and the Infant Guidobaldo, although in both cases I incline towards Justus.

The egg which hangs in the apse has great iconographical interest. Not only is it a Christian symbol of the four elements often referred to in medieval literature, cf. *Journal of the Warburg and Courtauld Institutes*, vol. ix, p. 27; but it is also, in many Eastern religions, a symbol of the creation; and for

this reason an ostrich egg used to be suspended in the apses of churches in Abyssinia and other sections of the Christian East.

Beneath a dull surface the picture is well preserved, except for the horizontal crack which unfortunately runs through the Virgin's eyelids (the eyelashes are original). The area of damage created by this crack is narrower at the sides, e.g. it hardly affects the head of Peter Martyr.

$66\frac{1}{2} \times 97\frac{1}{2}$ in. (170×248 cm.)

List of Text Illustrations

Acknowledgement

The Author and Publishers wish to thank all who have made photographs available for this publication, and kindly given permission for reproduction.

Index

Index